ISLANDS

100 ULTIMATE ESCAPES

ISLANDS

100 ULTIMATE ESCAPES

Edited by Sabrina Talarico with Stefano Passaquindici

UNIVERSE

Islands are physical places, but also dreamlike utopias. They are enchanted worlds, unreachable destinations, the terrain of castaways. They are off the beaten path, pristine, untouched. In history and literature, in the arts and philosophy, the island has often represented a "non-place," something fleeting, a natural barrier between the seas, and a means to preserve a natural and cultural patrimony. In Jules Verne's novel *The Mysterious Island*, the island is a place where people find both salvation and shelter from everyday life.

Islands have an undeniable allure. They conjure up contrasting feelings of joy, euphoria, anxiety, and melancholy. The island is a metaphor that symbolizes everything people isolate themselves from, as well as everything that remains isolated from them. An island is a place that's hard to reach and hard to leave behind.

Islands: 100 Ultimate Escapes is the product of extensive travel, and was compiled by the best Italian photographers and travel writers. It is not intended to be a collection of the most beautiful islands, but rather a survey of those that have something special, something that sets them apart and makes them unforgettable.

This book features 100 islands scattered throughout the world, from the Mediterranean Sea to the farthest oceans, from cold northern climes to the warm waters of the tropics. Some of the islands are found in lakes, others are part of an archipelago. Nearby or faraway, frequently visited or only dreamt of, loved or hated, conquered or liberated, each island has its own tale.

The islands featured herein have been conveniently grouped according to themes: islands with singular culinary traditions, which are the best places to sample local delicacies; islands that have been the setting of films or books; islands that have been explored or rediscovered; islands that have long been considered natural paradises; and those where history and ancient civilizations have left their indelible mark.

The "Islands of Taste" section focuses primarily on seafood and how it's prepared: grilled or poached, with or without sauce, and invariably fresh—like the dishes served in the Azores accompanied by a glass of Verdelho do Pico wine, or those of Madeira, enjoyed with a dry, amber-colored Sercial. Looking beyond the bounty of the sea, there are also rich terrestrial tastes—like the highly prized coffee that grows in Java, where one variety sells for over $700 a pound, or exotic fruits and spices such as the cloves that flourish in Zanzibar.

In "Traces of Civilization" we visit a number of unique places: La Gomera, where Christopher Columbus stopped prior to his epic voyage to America; Hong Kong and its many temples; the austere fortress of Saint Nicholas on Rhodes; and the

scenic Cabot Trail roadway on Cape Breton. Other islands are conjured up through storytelling: several books and films from the James Bond series took place in the Bahamas; Ernest Hemingway narrated Cuba like no one before or since; Clint Eastwood created his own Alcatraz; director Robert J. Flaherty brought his knowledge of the Aran Islands to the entire world; Lanzarote has been shaped by artist and architect César Manrique; and Stromboli was a key muse for the great Italian filmmaker Roberto Rossellini.

Among the "Dream Destinations" and "Natural Paradises," we explore Lakshadweep, the inlets of Porquerolles, the *marae* (sacred places) of Bora Bora, the crystalline waters of the Wakatobi Archipelago, the Marian sanctuary on the island of Bled, Tasmania's nature reserves, Marettimo's widows, Kyushu's volcanoes, San Blas's shaman, Comino's Blue Lagoon, the gigantic statues of Easter Island, and the Lofoten Islands' midnight sun.

We've chronicled countless beaches, be they blindingly white or sparkling with black volcanic sand, powder-soft or pebbly, wide expanses or narrow strips, deserted or crowded, famous or undiscovered. And of course we also venture out into the deep blue sea, whose tides engulf those beaches in mystery. The tales of travel recounted here are made up of two fundamental and much-loved elements: sea and island, which unite to give us a sense of what it truly means to be on vacation— just consider the term's Latin root, *vacatio*, which literally means "existential break."

There were many islands and many travelers involved in this collaboration, but the work of the journalists and photographers of GIST (*Gruppo Italiano Stampa Touristica*, the Italian Travel Press Association) went beyond all expectations. Each person wanted to share an island, a magical spot they'd come across, and the end result was quite a surprise. I'd like to extend particular thanks to: Marco Ausenda at Rizzoli, who came up with the idea for this book; the writers and photographers who believed in this project; Gianluigi Sosio (Peps), who dedicated a lot of time and helped select the images; and to Ada Mascheroni for all her generous effort and enthusiasm.

Finally, I'd like to acknowledge the many islands that don't appear within these pages; I humbly ask their forgiveness, and trust the winds will deliver our message. We had to narrow it down to 100, so we knew some were going to be left out. What matters is that all islands, even those not selected, are equally beautiful, simply for the fact that they are islands—unique places of imagination and fantasy, evocative sanctuaries for dreamers and lovers.

Sabrina Talarico

contents

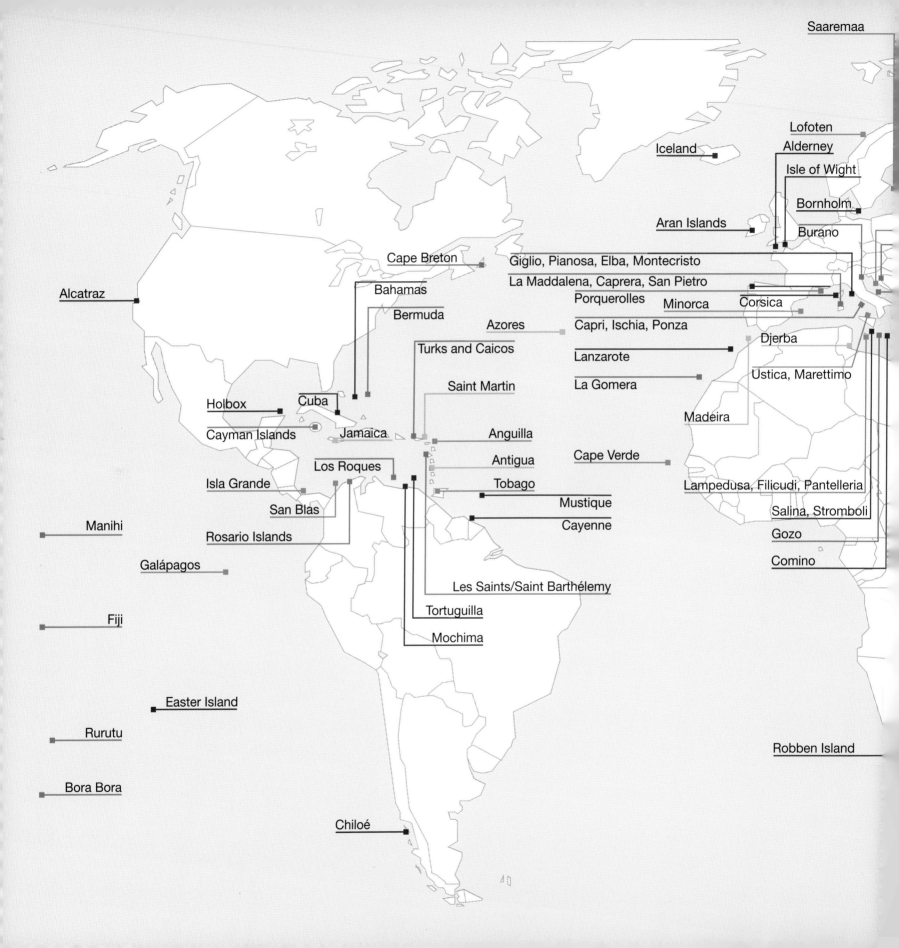

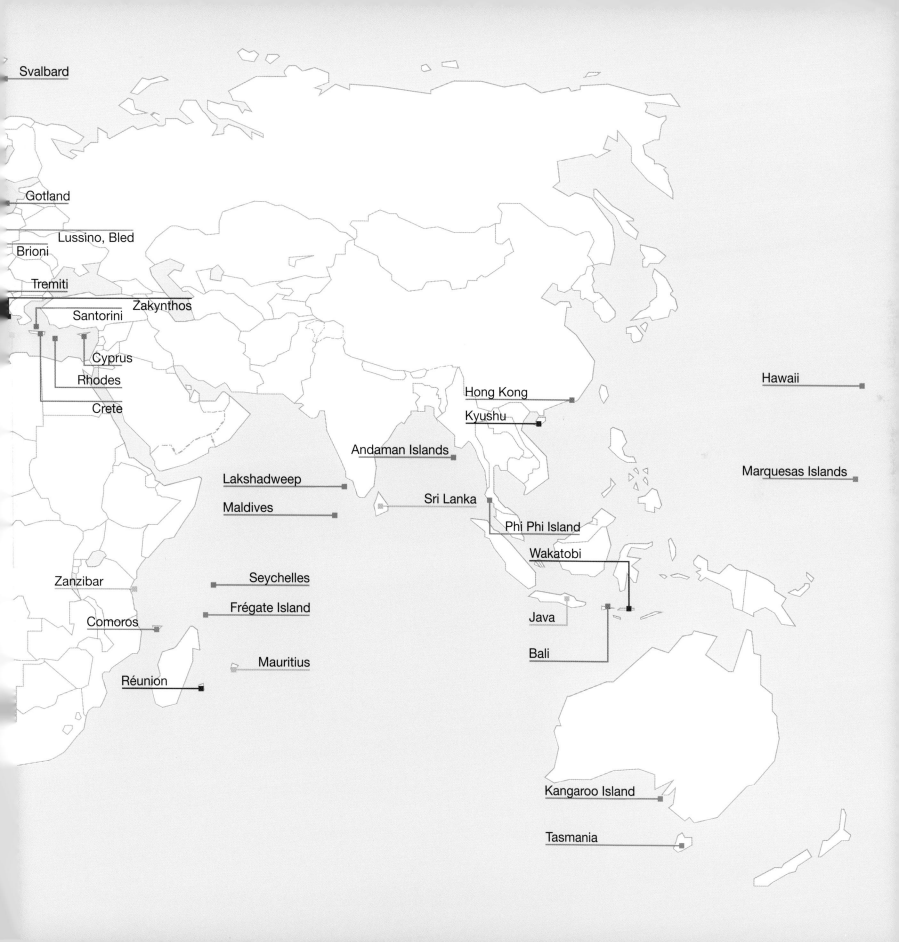

Svalbard

Gotland

Lussino, Bled

Brioni

Tremiti

Zakynthos

Santorini

Cyprus

Rhodes

Crete

Hong Kong

Kyushu

Hawaii

Andaman Islands

Marquesas Islands

Lakshadweep

Maldives

Sri Lanka

Phi Phi Island

Wakatobi

Zanzibar

Seychelles

Frégate Island

Comoros

Java

Bali

Mauritius

Réunion

Kangaroo Island

Tasmania

These specks of earth hover on the line where the ocean meets the sky, and are ancient lands that have hosted countless different civilizations. They include magical islands like Bali, with its holy springs; futurist islands like Hong Kong, studded with skyscrapers and temples built on cultural crossroads; islands full of history, like Cyprus or Crete, where over the centuries wave after wave of seafaring adventurers has made landfall. These unique destinations are governed by the ebb and flow of millennial tides.

[Paola Brambilla]

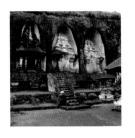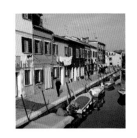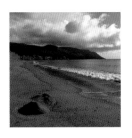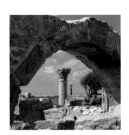
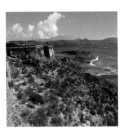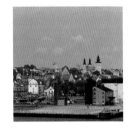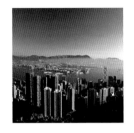
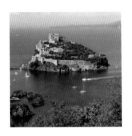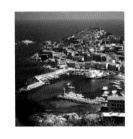
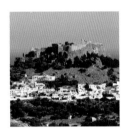

TRACES
OF CIVILIZATION

BALI

Close to Java, Bali is a small Hindu enclave in Indonesia. A certain gentleness pervades all things on the island, be it the rice paddies, the kites that sail high up in the sky, the residents' welcoming smiles, or the little gift offerings that the Balinese set out each day on the seashore, on doorsteps at home and in shops, and at small domestic altars. It's a gentleness that turns lavish during temple ceremonies, when women in silk sarongs carry in pyramids of fruit, rice cakes, and flowers on their heads. Here, animism and Hinduism have led to a spirituality based on a harmonious order, one that constantly pits good against evil. The good Barong, a mythical creature that's half dog, half lion, and the evil Rangda, a demon witch, continuously face off in dances, rituals, and processions used to ward off evil spirits from villages. Even architecture is a means to express spirituality, and every home has a family temple where the Balinese worship their ancestors with offerings of flowers and incense. In fact, from birth right up until death, when locals' ashes are collected into coconuts and scattered at sea, magic and rituals are constants in the life of every Balinese.

On the southwestern coast, beautiful temples such as the Pura Luhur Uluwatu and Pura Tanah Lot, which is reachable by foot at low tide, are within sight of each other. Sunsets in Bali are shrouded in a thin veil of magic and reveal, in the presence of the sea, the sacredness of time. The beach thus becomes a place for reflection. At Jimbaran, many *warung*, small eateries that serve outstanding seafood not far from the fishing boats, put out tables and chairs on the sand for a dinner next to the calming waves. During the day, life passes by uneventfully as women sell fish, kids play, and fishermen return ashore.

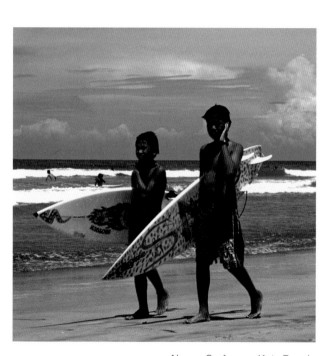

Above: Surfers on Kuta Beach.

Right: Royal tombs at the Gunung Kawi Temple.

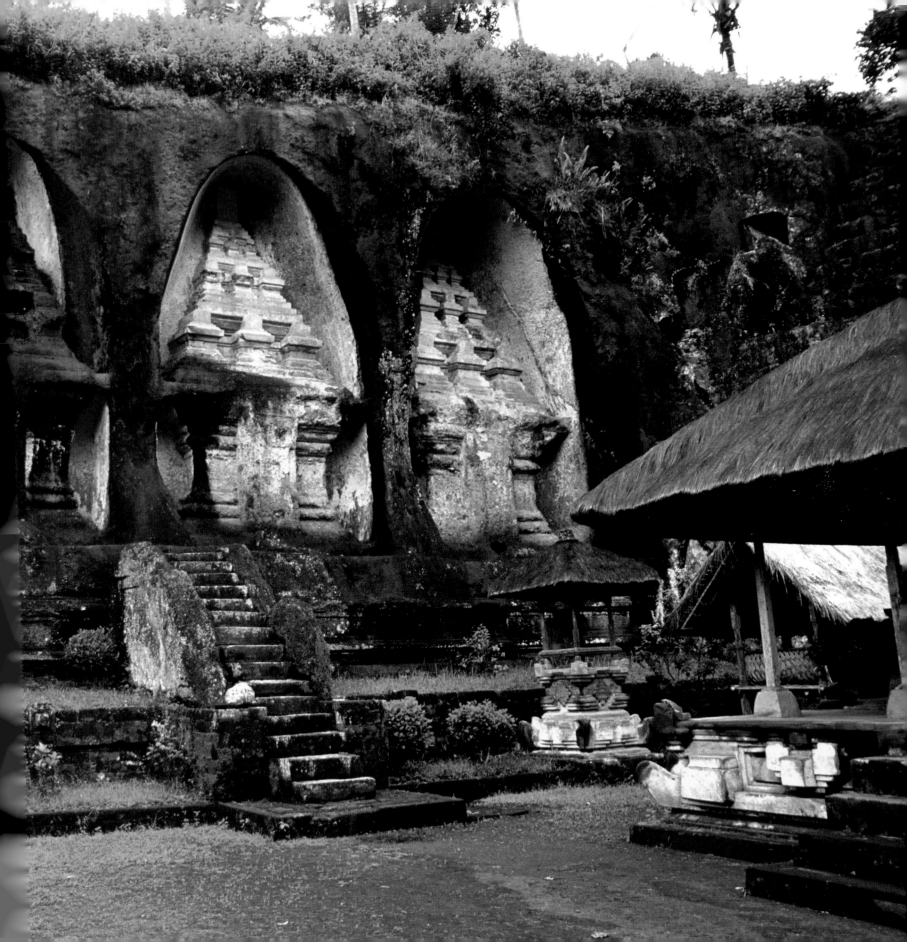

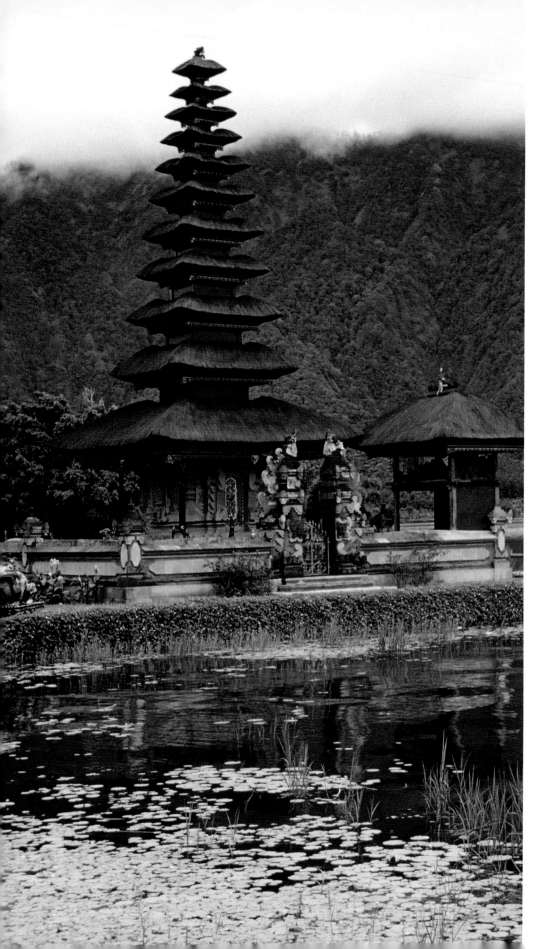

The serenity of the Balinese and their natural inclination toward the beautiful are reflected in their elegant handicrafts as well as in less permanent creations such as rice flour cookies, miniature sculptures, or the massive funeral towers that are burned during cremation. All this time and effort dedicated to making things that are destined to vanish is a sign of a deep-seated spirituality, one that is cloaked in gentleness and visible even in life's most simple daily gestures, which are imbued with a subtle charm.

Balinese art also follows this refined aesthetic sense and Ubud, the artists' town in the foothills of the island's central mountain range, is filled with galleries, art schools, and high-quality handicrafts. Surrounding the town are terraced rice paddies forming soft geometric lines in the verdant landscape. To visit Ubud is to lose yourself in a humid sanctuary where the charming setting invites you to think relaxing thoughts. Different emotions are felt at Gunung Batur (5,633 feet), an active volcano with a lake and numerous craters. Here, the dawn gives way to an extraordinary experience whereby your heart-beat can synchronize with the Earth's pulsating core.

Must See

In the town of **Ubud**, Western audiences will be enthralled by the elegance and tradition of Balinese dances that reenact age-old myths. The **Kecak** dance, with a chorus that mimics the sounds of a tribe of monkeys, is breathtaking and will have you moving along to the rhythm right up until the grand finale, when an actor-performer walks over hot coals to show off the magical powers of this trance-inducing dance. Among the most elegant dances, the graceful and feminine **Legong** is not to be missed; performed by young girls in slow, rhythmic movements, it evokes scenes from nature—such as the flight of the dragonfly or swaying trees—in order to retell an ancient legend.

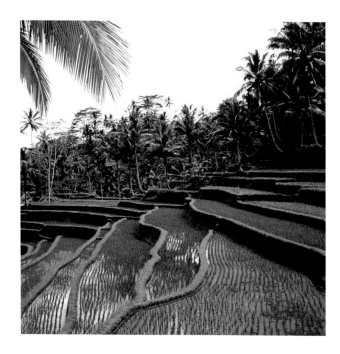

Above: Terraced rice paddies in Kikunung Kawi.

Right: A woman performs a Barong dance at the village of Batubulan.

Opposite: Ulun Danu Temple.

Below: Suluban Beach between the rocks at Nusa Dua.

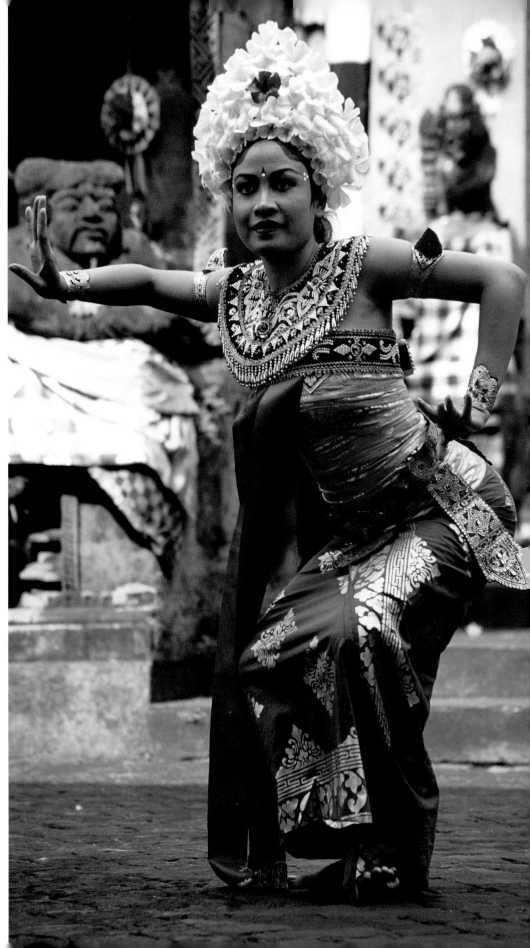

BERMUDA

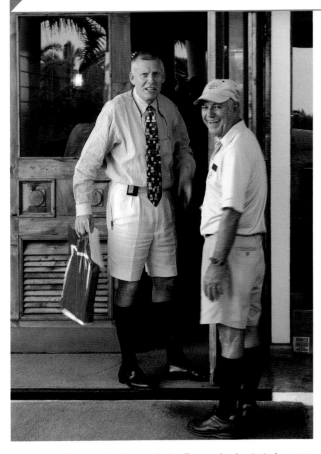

So small and yet so varied thanks to its many coves, breathtaking beaches, rich vegetation, and varying vistas, it's no accident Bermuda has long been considered one of the world's most alluring places. Over the centuries this charming locale has been a destination for politicians, tycoons, adventurers, and artists looking to build a home—big or small. Having a house here has always been seen as a status symbol.

First colonized in 1609 by settlers en route to Virginia to work in the tobacco trade, Bermuda today remains a colony of the British crown. Strategically located between England and North America, the island has never suffered a downturn. The absence of indigenous people hostile to the establishment of a colony favored the island's settlement and subsequent construction of many important buildings. Limestone similar to that found in the Old World is the most frequently used material. Though not particularly hard or pretty, the stone is enlivened by boldly colored walls, a sight not uncommon in these latitudes (the stone's original shade is white but contact with atmospheric agents turns it gray). This material is sometimes paired with a sturdy and reliable cedar, though the wood's use is not widespread. Some residences are hybrids, halfway between the local vernacular and Victorian style, while others resemble country homes—a few even reveal more neo-Gothic roots. At first, porticoes were popular but then tastes shifted toward the Georgian style that was imported from the nearby United States. Still, Bermuda is a unique island in many respects: fashion (the famous Bermuda shorts are worn even to formal events); finance (it's home to many insurance companies); and fiscal policy (it remains a prominent tax haven).

Above: The local fashion calls for Bermuda shorts to be worn with knee-length socks and English shoes.

Below: Typical residences made out of stone.

Opposite: Horseshoe Bay.

Must See

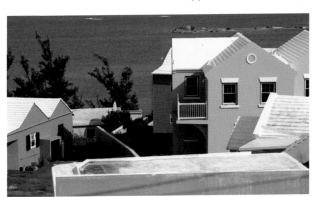

A moped rental lets you move around with ease and allows you to savor the island's sea breezes. As per local custom, you should wear Bermuda shorts with knee-length socks and classic footwear when moving about the island. In Hamilton, **Little Venice** is the best Italian restaurant and worth a stop, as is the adjacent **Wine Bar**, after a visit to **Camden House** and its botanical gardens or **Fort Saint Catherine**, Her Majesty's impressive stronghold that's now a museum. **Cambridge Beaches** is a resort as well as a piece of history, and the main building is typical of the local architectural style. Stunning beaches are found at **Horseshoe Bay** and **Jobson's Cove**.

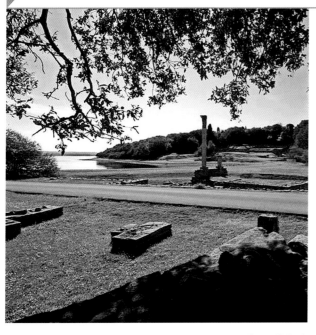

Above: Archeological site on Great Brioni.
Below: Austrian fort inside the Brioni National Park.

Opposite: Great Brioni, the largest
of the archipelago's 14 islands.

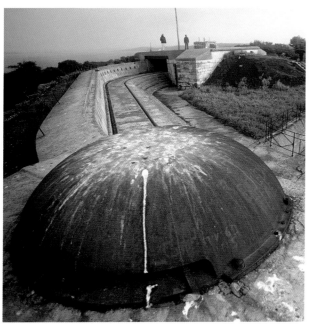

One of the most popular destinations in Croatia, Brioni is an attractive collection of islands in the northern Adriatic. Just off the southwest coast of Istria, the two-mile-wide Fazana Channel separates the archipelago from the mainland. Known for its sinuous coastline, dark blue waters, and maritime pines that extend right to the shore, the islands lie within a national park and are therefore protected from mass tourism.

Previously inhabited during Neolithic and Roman times, Brioni was long under the dominion of the Venetians before being sold to a Viennese steel magnate who was attracted to the archipelago's beauty and temperate climate. The industrialist transformed the area into a fashionable bathing spot, erecting art-nouveau buildings that hosted the likes of Thomas Mann, James Joyce, and Robert Koch, a bacteriologist who in the early 20th century succeeded in eradicating malaria from the archipelago. Following World War II, the islands became the summer retreat of Yugoslavia's President Tito, who in 1956 signed an agreement here together with Nasser and Nehru to establish the Non-Aligned Movement. These historical events can be revisited at the museum, which is part of a guided tour and includes a train ride on Great Brioni, the largest island, featuring two hotels (Neptun-Istra and Karmen) and several beaches. Archaeological sites to visit include: the church of Saint Mary, which in the 13th century belonged to the Knights Templar; two acres of Roman ruins at Castrum; and a Roman villa at Verige Bay built in the 1st century AD.

In Brioni, visitors walk or cycle in silence, following the rhythms of yesteryear. During the high season, the island's 300 rental bikes are often fully booked. And while Istria itself offers a memorable experience for cycling fans, the tour of Great Brioni's 15 miles of paved bike lanes and challenging dirt trails is truly unforgettable.

Must See

Visit the archaeological site at **Verige**, which features the ruins of a Roman villa built next to the sea. On Great Brioni, there's the **Cretaceous Park** where hundreds of dinosaur footprints have been unearthed. An organized tour by boat around the tiny archipelago reveals the sharp contrast between the green vegetation of the islands and the azure waters of the Adriatic. Biking on Great Brioni is made easy thanks to the many flat and shaded cycling routes, though there are trails for more experienced riders. Sports enthusiasts will not want to miss the **Brioni Polo Classic** that's held in the summer.

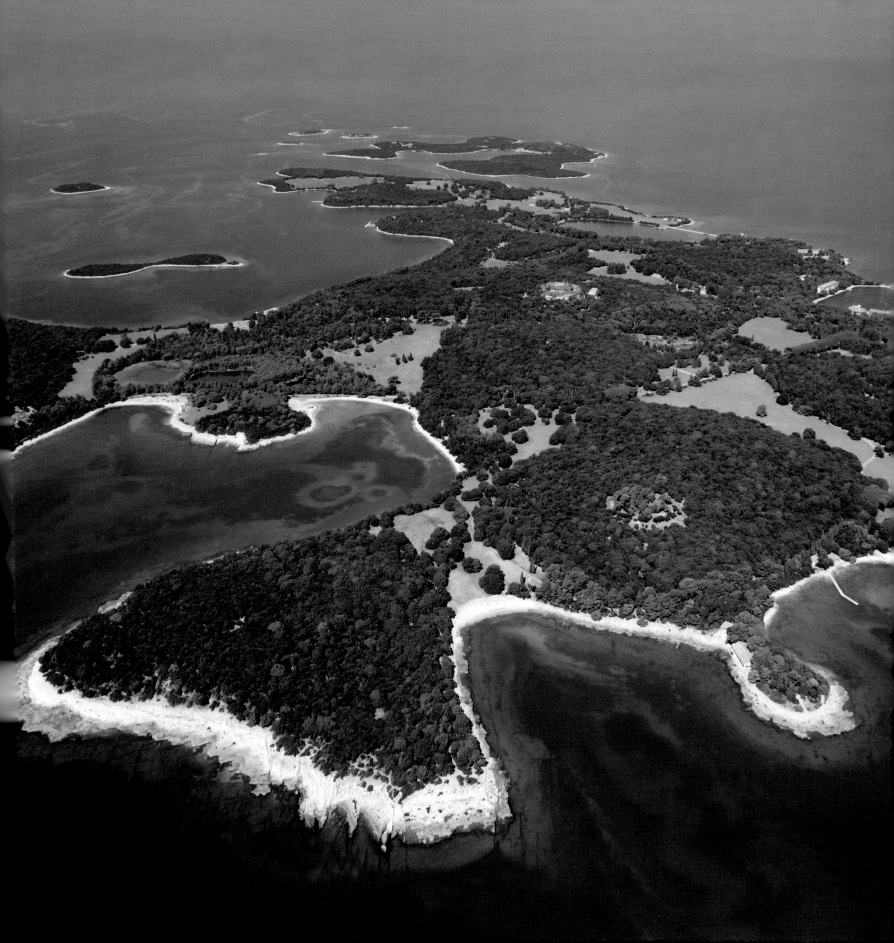

BURANO

Above and Opposite: Two views of the island.

Below: A lacemaker at work in her shop.

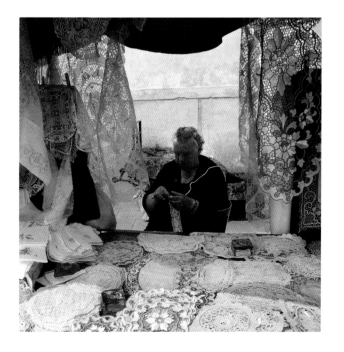

Burano's aqueous soul stretches across water, shoals, and islands. This unique island floats within the Venetian lagoon's delicate eco-system, and its chromatic buildings become brushstrokes of color reflected in the canals.

Here, history has been turned to stone, and is inseparably linked to the destiny of the land's blurry and fleeting borders—a microcosm made up of four tiny islands a few miles from Venice, a maze of bridges, streets, and squares. The island's vaunted main square is dedicated to its most illustrious figure, the composer Baldassarre Galuppi (1706–1785), also known as *Il Buranello*. The square's choreography centers on the statue of the musician (sculpted by Remigio Barbaro), the Gothic city hall, home to the Civic Museum of Lacemaking and the School of Lacemaking, and the Church of San Martino Vescovo, built in the medieval period and renovated in the 16th century. A veritable treasure trove, the church contains *La Crocifissione*, an early work by Giambattista Tiepolo from around 1725; just beside that, in the chapel to the left of the main altar, there is a fine example of painting by the Veneto school, *Processione dei santi patroni di Burano*, dated to the end of the 17th century. Outside, Andrea Tirali's 18th-century bell tower soars above the surrounding buildings, with its strange tilt of nearly seven feet because of the ground giving way underneath. It's a setting in which the rhythms of life flow with the seasons, and while time makes its mark on the monuments, the streets echo with the chatter of fishermen who work the shoals and recount ancient legends. This mixture of fantasy and reality permeates the lagoon's mist and comes to life in the masterpieces crafted by the expert hands of the lace-makers; their ancient art has roots dating to the 16th century, when it was first promoted by Venetian noblewomen, and later spread throughout the world in the late 19th century.

Must See

Don't miss the historic crafts of Burano. Walking across the island, you run into men scraping their boats and mending their nets. But it's less common to meet a lacemaker. Shoal fishing is signaled by nets hanging on poles and characteristic vessels moored on the shore. In the streets, meanwhile, the in-creasingly rare embroiderers ply the craft that spawned the island's tradition of lacemaking. For a perfect execution, as in centuries past, five steps must be followed, each performed by a different person. Special attention goes to the phase that brings the pattern into relief, with various finishes. Another absolute must is a plate of **risotto alla buranella**, a local seafood delicacy.

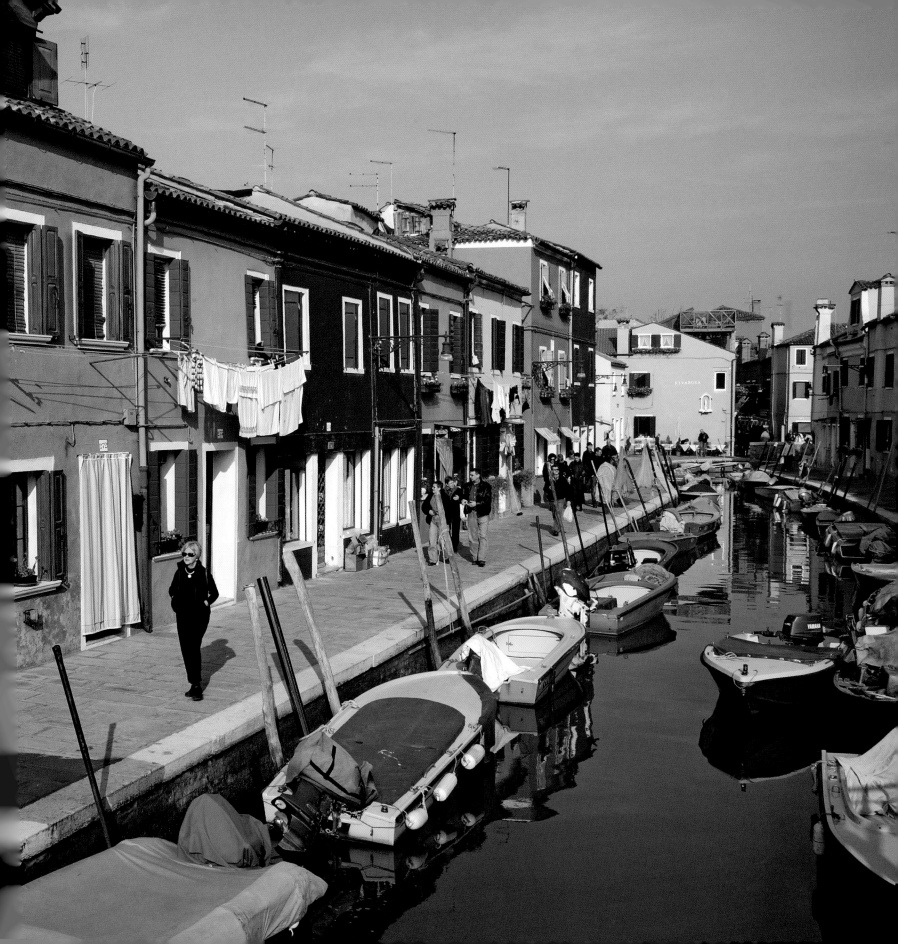

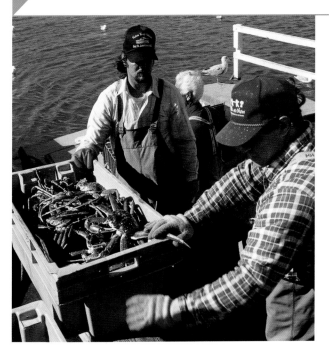

Above: Crab fishermen in the village of Bay Saint Lawrence.
Below: A typical Acadian home.

Opposite: Aspy Bay, where John Cabot made landfall.

Cape Breton remains the most untamed land in Nova Scotia, and still has strong ties to its French heritage. Locals refer to this as their Acadian heritage, as the area was colonized by French settlers in the late 16th century and went by the name of Acadia until falling to the English, who expelled the settlers between 1755 and 1763. Chéticamp, a picturesque fishing village, is quintessential Acadia. Here, homes are painted in the French tri-color with a yellow star, a symbol of the Acadian culture. The town is renowned for its handcrafted hooked rugs and the Acadian Museum, open from May to October.

In 1497, the Genoese explorer Giovanni Caboto, more widely known as John Cabot, was placed in command of an English vessel that had departed from Bristol and landed at Cape Breton, becoming the first European to set foot in North America. The Cabot Trail, a scenic roadway that covers much of this rugged island, is dedicated to him. More than 185 miles in length, stretches of this windy road are covered in gravel and have sheer drops to the sea. The route passes through incredible mountain scenery and cuts through the dense forest of the Cape Breton Highlands National Park, where the mountains touch the sea. The most spectacular spots are found traveling up the coast to French Mountain (1,506 feet), where one finds the Lone Shieling, a replica of a crofter's cottage. Further on, Beulach Ban Falls appears virtually out of nowhere in the forest. From South Harbour, take a detour to the charming fishing village of Bay Saint Lawrence and make a stop at Aspy Bay, the place where Cabot is said to have made landfall. At the eastern entrance to the national park, near Ingonish Beach, the Cabot Trail passes through the lively community of Ingonish and arrives at the Gaelic Coast, named after the Gaelic-speaking Scots who settled here.

Must See

Cape Breton is a magnet for tele-communications buffs. At **Glace Bay**, amid Scandinavian-like scenery, there's a museum dedicated to Guglielmo Marconi. In 1902, the Italian inventor sent the first transatlantic wireless message from here. At **Baddeck**, Alexander Graham Bell, who gave us the first working telephone, lived out his final years. Also worth a visit is **Keltic Lodge**, which lies along the Cabot Trail. Like elsewhere in Nova Scotia, fishing is an important livelihood on Cape Breton. One of the locals' favorite dishes is **lobster**, which you can sample even in the simplest of eateries on the island.

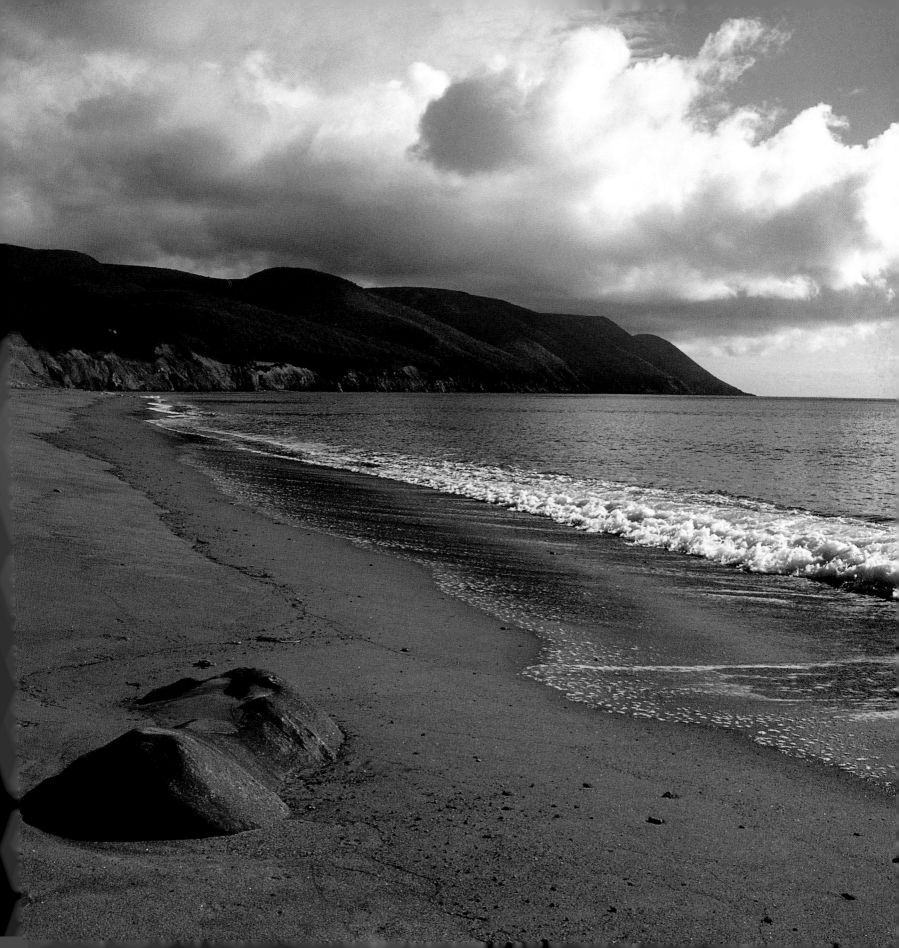

CYPRUS

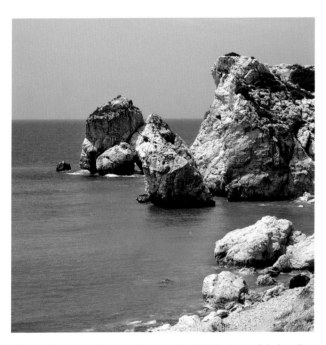

Above: Petra tou Romiou, the mythical birthplace of Aphrodite.

Right: The archaeological ruins of Kourion, a former Roman city and port.

Cyprus tells the story of an ancient goddess, a bearer of love and beauty from the Middle East who landed on the shores of the Mediterranean and the Aegean. She has enriched both history and myth with traces of a mysterious civilization that dedicated its rituals to fertility and the earth. Homer sang of Aphrodite, referring to her as "a golden Cypriot." Ishtar, Astarte, Aphrodite, Venus—she was the goddess of many names and countless aspects that are still undeniably present along the shores of this island. The sacred pilgrimage sites dedicated to her are now stops on a cultural itinerary run by the Cyprus Tourism Organization.

At Petra tou Romiou, massive boulders appear to have been tossed about by the hands of the gods. These giant sentinels, motionless custodians, stand watch to protect the pledges of love exchanged between sweethearts. As legend has it, Venus was born here from the foam (*aphros*) of windswept waves. The beach still preserves an aura of inviolability, so much so that it's hard for visitors in rowboats to disembark with their colorful beach umbrellas. This island's beauty thus remains unspoiled, its sacredness underscored by the little notes and white ribbons tied to shrubs that encircle the bay. Like silent love letters, the gentle sea breezes whisper their secret requests.

The itinerary of sacred sites dedicated to this goddess leads to the area around Paphos. Palaepaphos, the ancient settlement that stood on the site of the present-day village of Kouklia, was one of the most celebrated pilgrimage sites of the ancient Greeks. The remains of Aphrodite's sanctuary date to the 12th century BC and a large portion of its stones

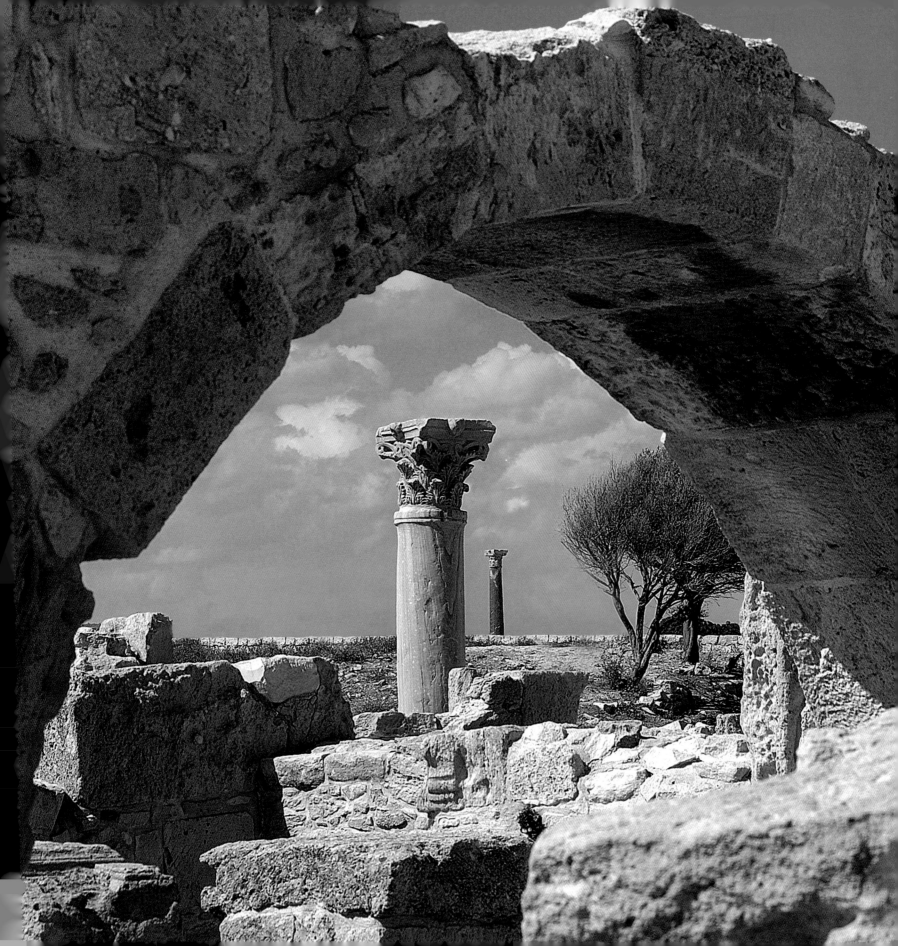

were reused later to build a medieval Lusignan castle and other homes in the vicinity. The interior of the castle, which belonged to French knights who settled in Cyprus after the Crusades, houses an interesting museum filled with archaeological finds recovered from the sanctuary, the old city, and the necropolis. The venerated site's hillside location also grants it an enchanting view of the coastline. The steady breezes and sweet rustling of trees preserve a certain magic, as if the scent of incense and the silhouettes of priestesses in white practicing the ancient pagan ritual honoring the goddess of love still lived on today. A foreign visitor would have been able to pick one of the maidens to savor the pleasures of an amorous encounter, while kings could aspire to wed one of the priestesses in order to gain entry into the love goddess's occult world.

In classical iconography, Aphrodite has been depicted with auburn hair. The explanation for this is the word *kypr*, which etymologically refers to copper, deposits of which are found on Cyprus. The same root word can also refer to a seashell, an object as sacred as the myrtle, rose, tamarind, rosemary, pomegranate, and cone-shaped stones that in antiquity were used to represent the goddess.

Must See

Present-day **Paphos** has lots of eateries and bars that look out onto its port. This city was the island's capital for 600 years, and today its archaeological remains are a UNESCO World Heritage Site. Besides **Aphrodite's sanctuary**, you'll not want to miss the four **Roman villas** containing beautiful mosaics that detail scenes from Greek mythology, considered some of the most exquisite and best-preserved examples in all of the eastern Mediterranean. Another unforgettable stop is the underground **Tomb of the Kings**, carved out of rock and adorned with Doric columns. Other monuments worth a visit are the sanctuary (*asklepieion*), the theater (*odeon*), the market (*agora*), and the fort of Saranta Kolones.

Above: Orthodox church in Paphos.

Right: The coast near Latchi.

Opposite: Archaeological site at the ancient city of Kourion.

Below: Frescoes in the Agios Neophytos Monastery.

CRETE

O n Crete, in a cave filled with golden honey, the goddess Rhea was said to have given birth to Zeus, king of the gods. Here, the Minotaur—the part man, part bull born of the accursed union between Pasiphaë and Minos—was imprisoned in the fabled labyrinth. It was also here, around 2800 BC, while the rest of Europe was in the throes of barbarism, that a thriving civilization unlike any the world had ever seen came to the forefront. Magnificent palaces like the one at Knossos, the administrative capital, were erected along with others at Phaistos, Malia, and Hagia Triada, and their noble ruins still pay testament to a flourishing and highly developed society. The same can be said of Gortyn, the Roman capital of Crete, with its amphitheater on whose walls the Gortyn Code of laws are inscribed.

Today, however, the port cities of Heraklion and Chania are the island's focal point. Spiritual sites like the Byzantine monasteries of Arkadi and Preveli, were built during the Cretan Renaissance, and Rethymnon preserves important works of Venetian and Turkish architecture. In the south, Agios Pavlos's breathtaking cliffs rise above bays with fine sand beaches separated by jagged slabs of rock. On the coast facing the Libyan Sea, an inviting set of coves brings you to Plakias, flanked by the Kakomouri and Stavros promontories. The nearby Frangokastello fort is linked to Crete's revolutionaries and is part of the Sfakiá region, where barren hills yield to a crystalline sea. Eastern Crete, meanwhile, is the opposite. Here, the Lasithi plateau features thousands of windmills and the pretty village of Psychro, site of Zeus's cave. In Lasithi's capital, Agios Nikolaos, the former fishing village has transformed into a charming town where life still revolves around the harbor and Lake Voulismeni, which is linked to the sea via a canal.

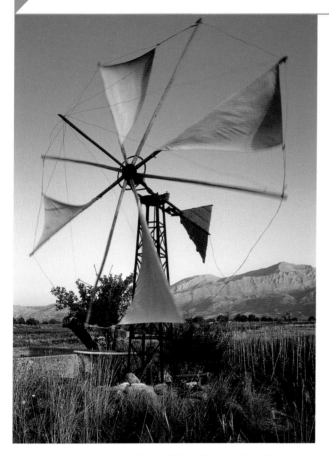

Above: Windmill on the Lasithi plateau.
Below: Samaria Gorge, a UNESCO-designated reserve.

Opposite: Elafonissi Island near Paleohora.

Must See

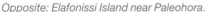

In addition to its ravines and creeks, the **Samaria Gorge** is home to wildlife. The reddish beaches on the tiny island of **Elafonissi** are reached by walking across a shallow lagoon. **Spinalonga Island** features a fort built by the Venetians, while on **Vai Beach** a forest of palms greets bathers. On **Chrissi Island**, there are rows of cedar trees and two beaches, one with golden sand, the other pink. Situated at the base of a horseshoe bay is **Matala Beach**, which was discovered in the 1960s by hippies who often climbed up the rocks and slept in the caves located on the northern side of the bay.

28

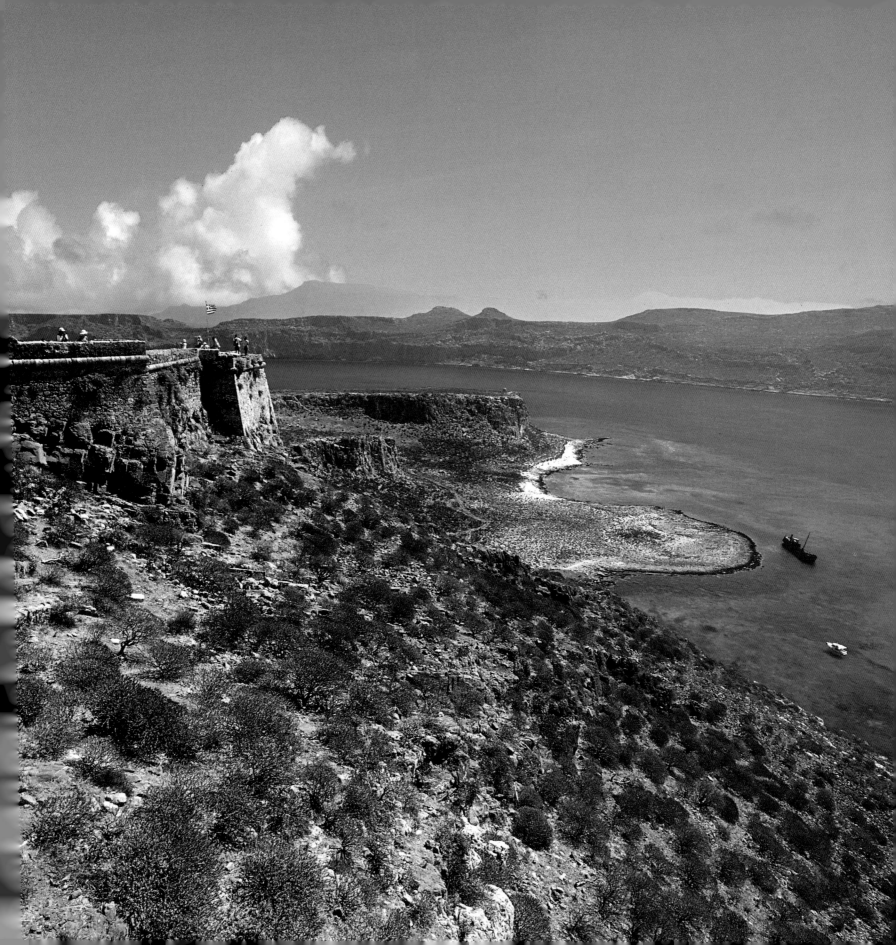

LA GOMERA

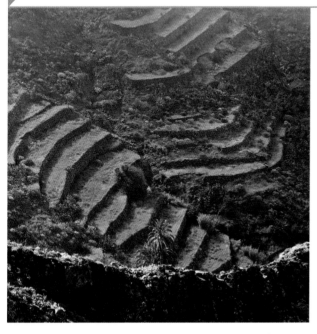

*Above: The green terraces of Valle Gran Rey alternate with undulating stone walls.
Below: Strelitzia, a typical flower of the island.*

Opposite: Roque de Agando, a volcanic rock formation.

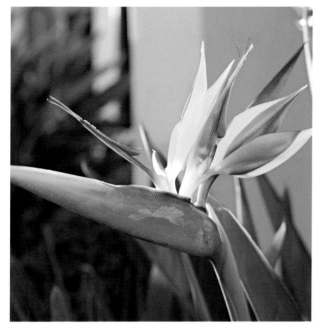

La Gomera is frequently referred to as "Colombina Island," in honor of Christopher Columbus, who stopped here before his voyage to the Indies in order to pick up provisions of fresh water and remained fascinated by its stark wilderness.

La Gomera is one of the lesser-known Canary Islands, although it is just as captivating as its more famous "six sisters." It has postcard landscapes, a mild climate all year round, and many beaches: La Calera, Valle Gran Rey, and El Inglés (a popular nudist destination). The principal attraction, however, is the Garajonay National Park, which gets its name from the legend of two young lovers, Gara and Jonay, who in order to avoid renouncing their love climbed to the highest point on the island (4,869 feet) and in a tight embrace stabbed each other with a sharpened cedar branch. The verdant park is known locally as the "island's lungs," full of ferns, laurels, holly, moss, and rock rose. Such beauty could not escape UNESCO's attention, which designated it a World Heritage Site in 1986—the *laurisilva*, a millennial laurel rain forest, is worthy of conversation. Besides Garajonay National Park, there are several other natural monuments that characterize La Gomera: fantastic rock formations such as La Fortaleza, a flat mountain that looks like an enormous cream-filled cake, and the local King Kong—made of rock, not celluloid—known as Roque de Agando, which really does resemble a gorilla. All around the island there are terraced fields, often above deep ravines known as *barrancos*, which have been gouged out of the volcanic rock by erosion. All of this contributes to La Gomera's bucolic charm.

Must See

La Gomera's supreme gastronomic delight is the **miel de palma**, or palm honey. But bees have nothing to do with this sweet; rather, the production is entrusted to human labor and patience. Men climb up to the tops of canary palms (the island has about 125,000 of them) and with a little hatchet they scrape the bark to extract a small stream of sugary sap. This is *guarapo*, and when heated and stirred it turns into sweet honey, good for desserts and cheeses. Once the palate is satisfied, find acoustic pleasure listening to locals communicate in *silbo*, an odd, whistled language used by shepherds to communicate across the ravines.

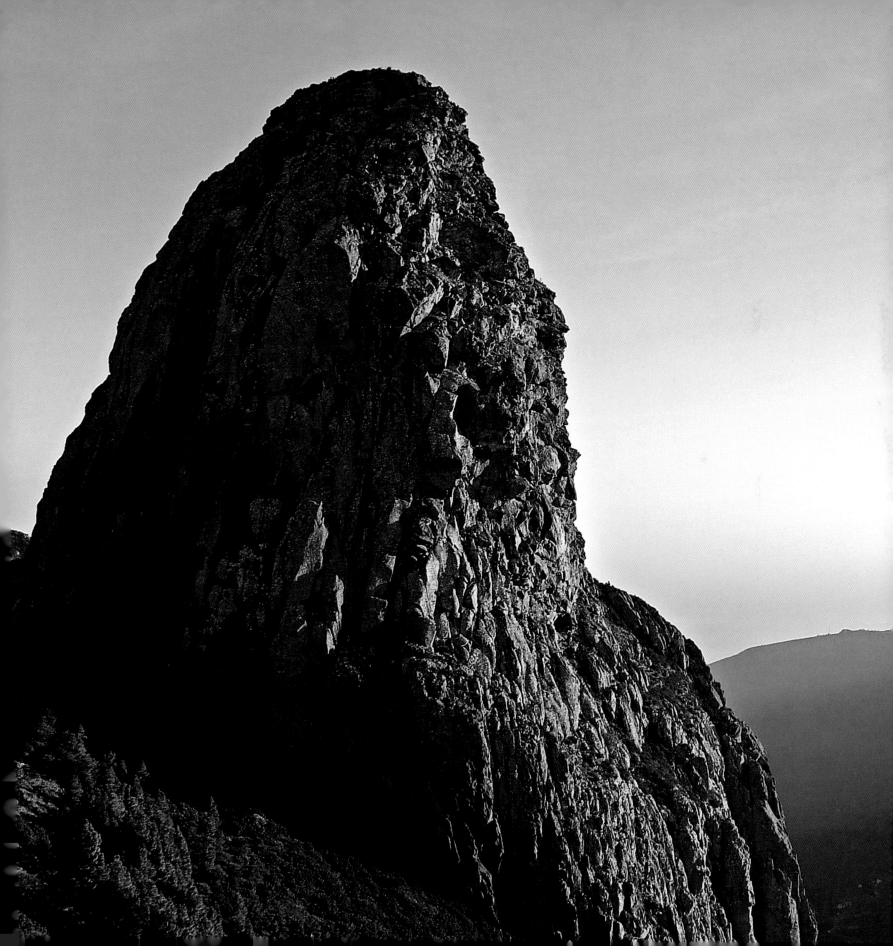

GOTLAND

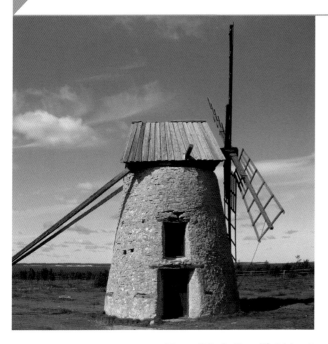

Above: Windmill on Fårö Island.
Below: Calcareous stacks at Langhammars.

Opposite: View of Visby. The city's medieval prisons are largely intact.

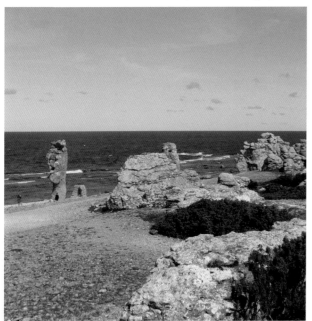

Sweden's second-largest island, Gotland seemingly appears out of nowhere from the waters of the Baltic Sea. Two hours from the mainland, this flat and elongated strip of land is known for its mild and sunny climate, verdant farmland, and blue waters, as well as for its settlements that have survived the passage of time largely intact. In 1995, the island's capital, Visby, was named a UNESCO World Heritage Site for its stone buildings dating back to the city's time as a member of the Hanseatic League, for its half-timbered residences of the 17th and 18th centuries, and for its stone ramparts. The defensive wall measures more than two miles in length, rises to a height of 36 feet, and boasts more than 50 towers and three imposing gates. Behind it lies a quaint urban core of churches, museums, squares, and ruins interspersed among bars and restaurants on pedestrian-friendly streets. Visby, whose name comes from the word *Vi*, which in Norse means "sacrificial place," has often been called the "city of roses and ruins." Among the many historical sites inside its walls visitors will discover a beer hall built in 1852 that now houses a hotel—rooms have been carved out of a block of residences that look out onto the old town.

A leisurely tour of Gotland's countryside by bike will uncover impressive Gothic churches adorned with frescoes. And from the island's northern tip, a free ferry runs the two-minute trip to Fårö, a geological wonder whose beaches are dotted with small stone monoliths. Swedish film director Ingmar Bergman chose this unspoiled and isolated island for his retreat. Visitors will be struck by its rugged landscape, and lovers of peace and quiet will find it perfect.

Must See

During a walk inside the walled city of Visby don't forget to visit the back lanes that slope down toward the sea, lined with colorful shops selling local crafts. Housed in an 18th-century building that was once a distillery, the city's history museum is recommended for its collection of **runic** inscriptions carved in stone. Outdoor lovers might prefer to pedal down country roads in search of the island's many medieval chapels and churches situated on farmland and amid peaceful woodlands. Those with time for a 20-mile trek can explore the rocky terrain and windswept beaches on **Fårö.**

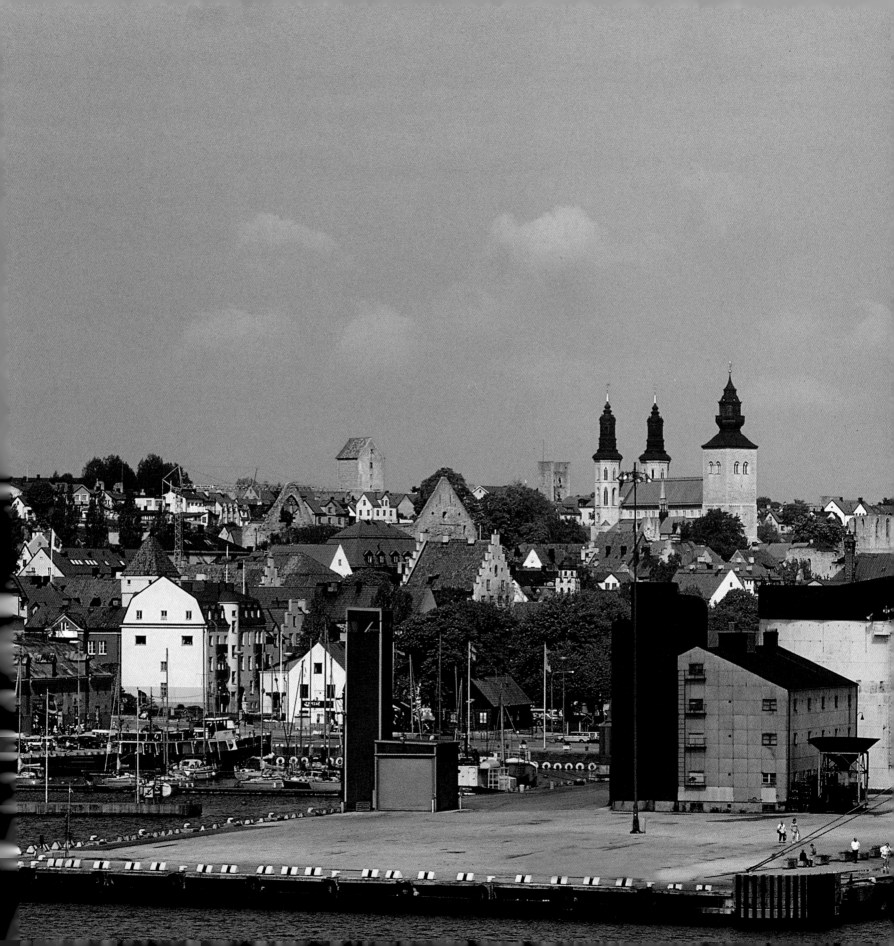

GOZO

opularly known as the "Island of Calypso," described in Homer's *Odyssey* as the fabled island where the nymph kept Ulysses prisoner for seven years, Gozo is situated four miles northwest of Malta, just beyond the isle of Comino. Blessed with stunning views and an incredible seabed for divers, it also features a collection of temples dating back to 3500 BC. Part of a fertility cult, the temple complex at Ggantija was used by the islanders' ancestors to worship a goddess whose robust figure was said to represent Mother Nature.

As far as beaches are concerned, one of the most sought after is at Ramla Bay, with its golden-red sand that leads up to the site of the mythical cave of Calypso. Other popular bathing spots include Xlendi Bay, shaped like a miniature lake with a reef in the middle, Marsalforn, and Xatt L-Ahmar Bay. At Mgarr, Fort Chambray overlooks the town's port, where ferries depart hourly to Malta. Residential architecture here mimics the rest of the archipelago, with homes built from the traditional white stone. In some of the surrounding villages, time appears to have come to a standstill. The landscape is dotted with large windmills once used to grind grain into flour—one of the largest in Xaghra now serves as a museum. On summer weekends, patron saints are honored with fireworks, processions, and lively performances by local bands.

In terms of history, Gozo has experienced a fate similar to that of Malta. All over its 26 square miles of territory there are reminders of the former powers who once ruled over this island. Traces have been left by Copper and Bronze Age settlements, as well as by later arrivals such as the Phoenicians, Romans, Arabs, Normans, Knights of Saint John, and English.

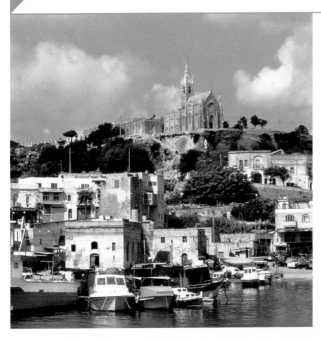

Above: The neo-Gothic Our Lady of Lourdes church overlooking the town of Mgarr.
Below: Azure Window, a natural landmark.

Opposite: A street in Victoria, Gozo's capital.

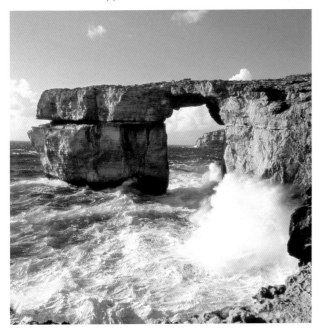

Must See

The megalithic temple complex at **Ggantija** is one of the oldest examples of Cyclopean masonry. Like other temples of its kind, the site faces southeast to align with the sunrise. At **Xatt L-Ahmar**, a natural jetty in the shape of a dragon marks the site of a scuba divers' paradise where the ocean floor contains a host of surprises, including two shipwrecks. **Dwejra** is home of the so-called **Fungus Rock**, said to foster a special plant used for medicinal purposes, while the **Inland Sea** is a natural lagoon linked to the open sea via a cave—on the coastal side, visitors can admire the **Azure Window** rock arch.

HONG KONG

V ibrant and dynamic, Hong Kong's soul is also full of contrasts. It's a unique combination in which ancient Chinese traditions unite in perfect synthesis with the modern globalized world. Owing to its location and its many sheltered bays, it was once a haven for marauding pirates as well as a prosperous land of fishing villages, many of which still survive today. In the town of Tai O, on Lantau Island, descendants of Hong Kong's oldest community live between wooden skiffs and stilt houses, while just a few miles away ultra-modern skyscrapers stand out prominently on the skyline. Seemingly alive, these buildings are the unquestioned protagonists—observing them from afar, they swarm with people who live and work at a pace that's more frenetic than most traditional depictions of the East. These contrasts between the past and the future are what make up the story of Hong Kong.

From the Opium Wars of the 19th century to later British rule, the city has become a major port and a dynamic commercial and manufacturing hub. And yet even today it is surrounded by nature in a somewhat unusual harmony. There are still areas that remain unspoiled and uninhabited. Sandy beaches intermix with a rocky and untamed landscape. The hills, dense with vegetation, have been turned into nature reserves with well-kept trails, and make for a surreal and silent picture frame revealing the gray-blue highlights of the glass and steel buildings, all set perfectly before a backdrop of sea and sky made up of ever-changing colors. Even the glitziest skyscrapers here give a nod to tradition: many are built according to the ancient Feng Shui philosophy, and even the

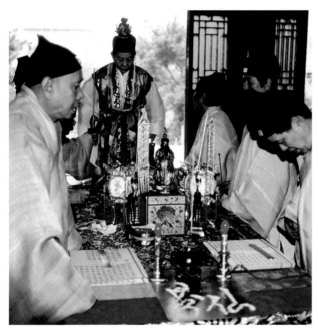

Above: Ritual at a funeral ceremony.

Right: View of the city's skyscrapers from Peak Tower.

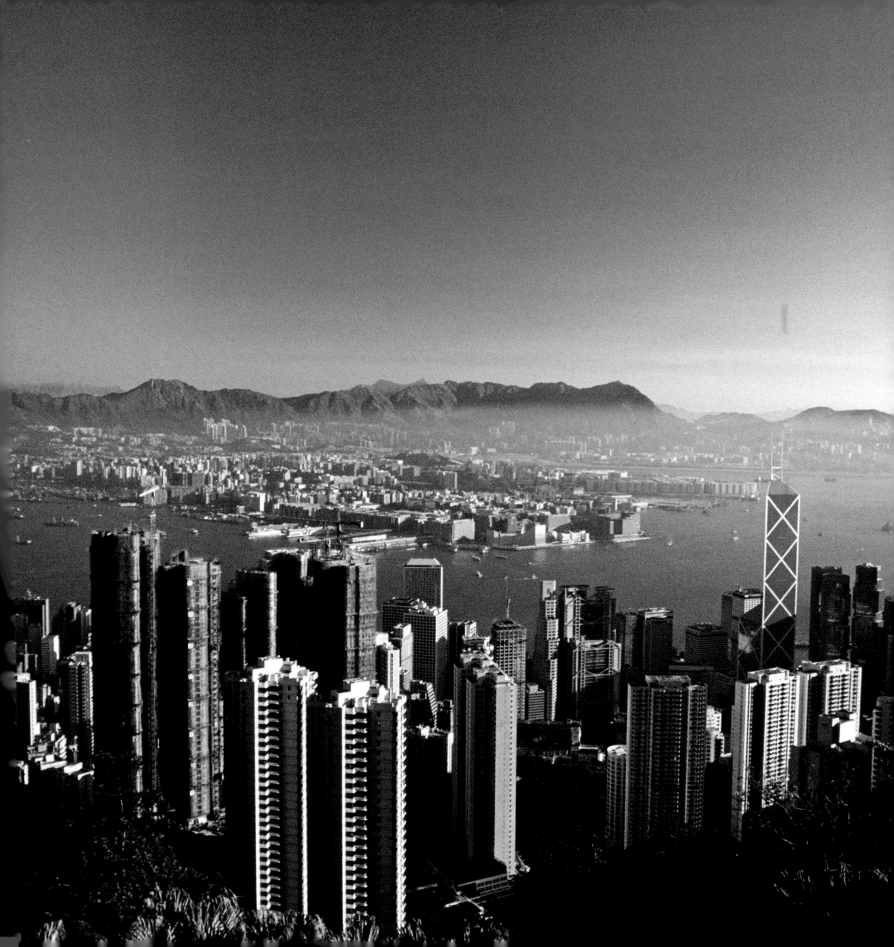

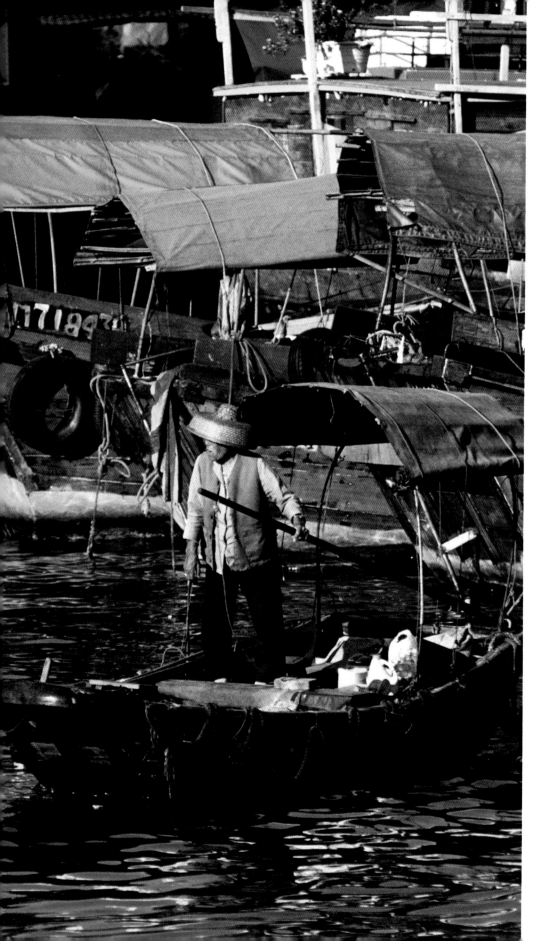

most ultramodern residence has a "hole" in the middle so as not to obstruct the path of the dragon that, according to tradition, may wish to pass through. Below, the chaotic streets are filled with the commotion of residents and tourists. In this shoppers' paradise, there are stores and markets of every kind where for a few dollars you can buy anything from fine silk to the latest gadgetry, from traditional Chinese medicine to exotic remedies. You can have your palm read by a fortuneteller at one of the city's curbside stalls or you can seek out one of the ultra-quiet temples to say a prayer or meditate in the darkness amid the smell of incense. Here, Buddhism and Taoism are the most common religions. In the heart of Hong Kong senior citizens, impervious to the frenzy around them, practice Tai Chi or meet up at the market, which remains a favorite gathering spot. Some locals sit and smoke, bare-chested, seeking shelter from the sun under a straw hat; others go around on bikes or in place of a dog on a leash take nightingales to the park inside their handcrafted cages. And in the chic restaurants, young managers on their lunch break bring silk scarves to protect themselves from the air conditioning, which is always set on high.

Must See

Take the tram ride up to **Victoria Peak** to see Hong Kong's bay from **Peak Tower** or go on a shopping tour of the **Stanley Market** or the **Jade Market**, home to jade and semiprecious stones. Pay a visit to **Lantau Island** and go around by boat to see the stilt homes built out on the water and the fishing boats at the village of **Tai O**, where fish are hung out to dry alongside the laundry. Also worth viewing: a flawless demonstration of kung fu by **Shaolin Masters**; a stop at the port after sunset to see "**A Symphony of Light**," the show that illuminates 30 skyscrapers on the skyline to the rhythm of music; and a dinner in the cosmopolitan district of **SoHo**, followed by the nightlife on **Hollywood Road**, where the trendiest nightclubs are found.

Above: The urban area of Kowloon.

Right: Hong Kong perfectly blends tradition with modernity.

Opposite: Aberdeen Harbour. Thousands of people live on traditional junks, turning the port into a floating city.

Below: An elderly woman in traditional dress smokes a pipe.

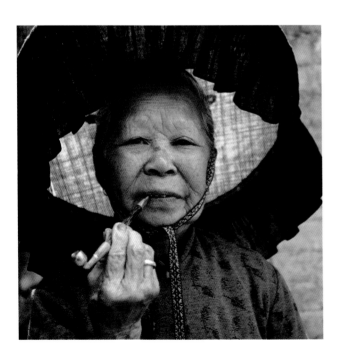

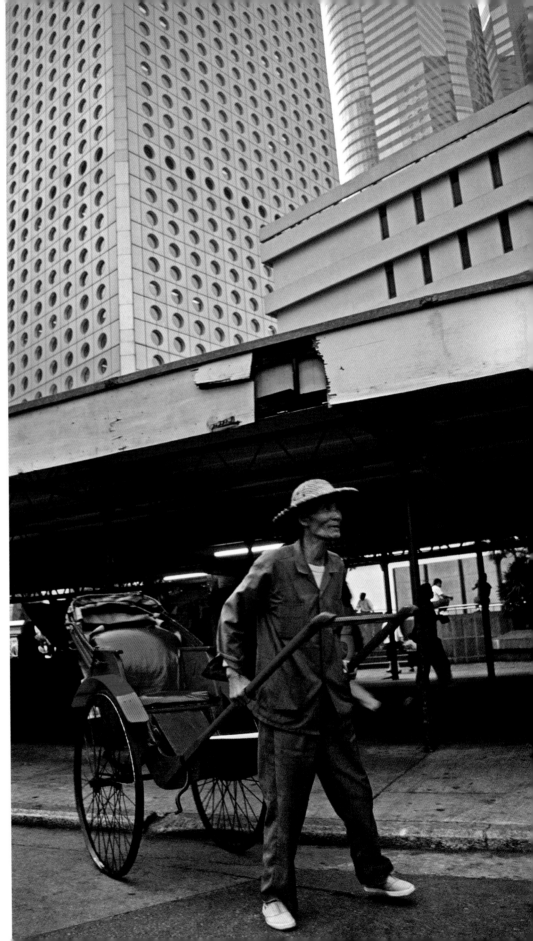

ISCHIA

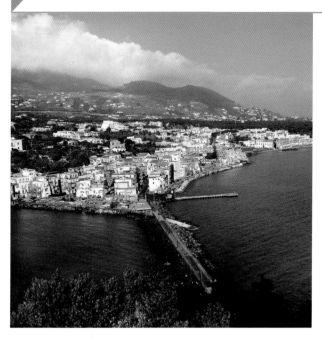

*Above: View of Ischia Ponte with the Punta Molina.
Below: Poseidon Thermal Gardens, Forio.*

*Opposite: Castello Aragonese, Ischia Ponte.
This fortress dates back to 474 BC.*

Ischia—either it's love at first sight or you hate it. There's no middle ground. Then again, if you open your heart, you will remain. Situated at the northwestern end of the Gulf of Naples, six towns dot this little pearl on the Tyrrhenian: Barano d'Ischia, Casamicciola Terme, Forio d'Ischia, Ischia, Lacco Ameno, and Serrara Fontana. The ancient Greeks called it Pithekoussai, which, according to some linguists, meant "island of the monkeys" (from *pithekos*, or ape), a reference to the legend of the Cercopes of Ischia and their transformation into monkeys. Based on recent studies, the supposed "monkeys" could have been the local residents that the Greeks encountered—they were viewed as primitive since they lived on the edge of the known world. The poet Virgil called the island Inarime or Arime; the term is found in the *Iliad*, which tells the story of Typhon, a monster imprisoned among "the Arimi."

Moving beyond Ischia's literature and etymology, we discover the pearls of this little jewel where the Aragonese and Bourbons have also left their mark. While its jagged coastline alternates between pleasant beaches and craggy outcrops, Ischia's highest point is actually at its heart: Mount Epomeo (2,589 feet) is the result of volcanic activity thousands of years ago. And though there's a mild climate year-round, visitors from all over prefer to set foot on its many beaches during the summer. But Ischia is not just about the sea. Simply venture inland and take in the many hues of the varied flora, a colorful landscape just waiting to be explored. Always attentive to a high living standard, the island is not only a hub of international tourism, but also a wellness capital. For millennia, Ischia's curative waters have had a therapeutic effect thanks to a hydrothermal heritage that's considered one of the world's richest.

Must See

Known for its beaches and refreshing sea breezes, Ischia's landscape is also characterized by picturesque views of **Mount Epomeo's** rocky cliffs, fragrant hillside vineyards, and shady pines. Its 29 thermal baths, 67 steam vents, and 103 hot springs have made it famous since the days of Pliny and Strabo, and turned the ancient land of Inarime into a sort of enchanted garden where one can enjoy the benefits of these fountains of youth. Also worth a visit are **Villa La Colombaia** (Lacco Ameno—Forio), **Giardini La Mortella** (Forio—San Francesco), **Castello Aragonese** (Ischia Ponte), **Torre di Guevara** (Cartaromana), and the **Chiesa del Soccorso** (Forio).

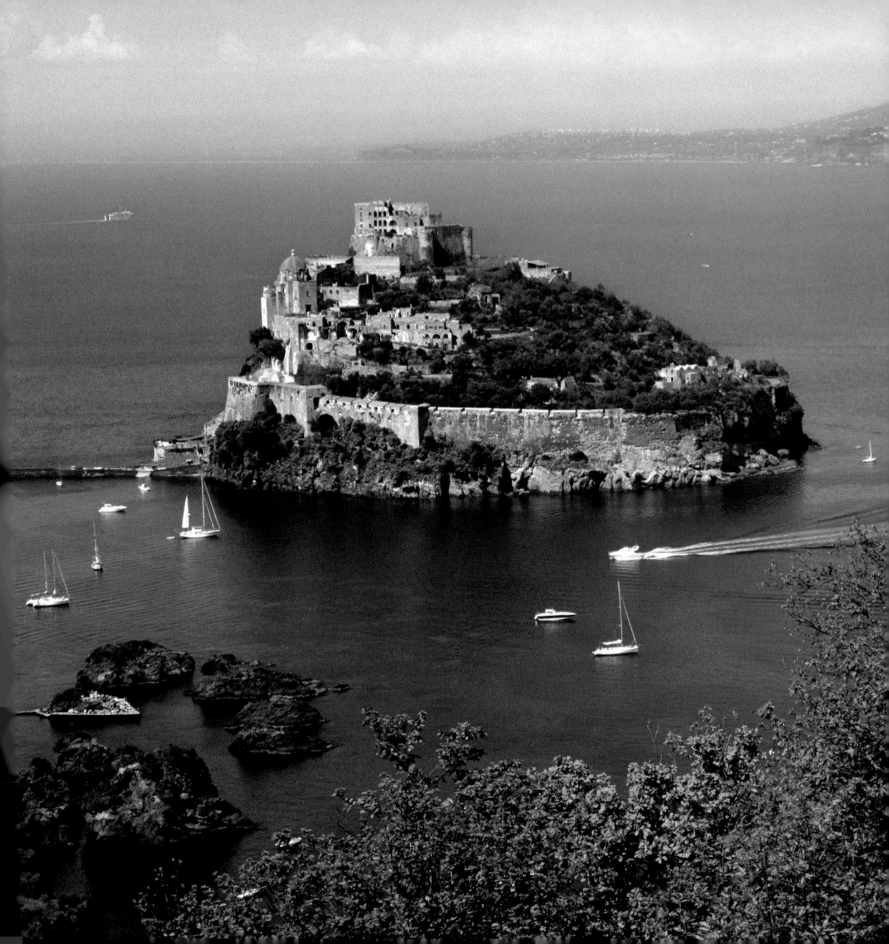

GIGLIO

Above: The beach at Cala delle Cannelle.
Below: The incredibly pristine sea floor is protected by environmental legislation and is a big draw for scuba divers.

Opposite: The island's port, characterized by multicolored homes.

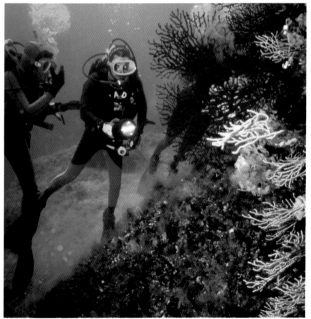

In Caletta del Saraceno, or Saracen's Cove, at the water's edge, you can just make out part of the imposing Roman villa of Domizi Enobarbi (built by the family of the notorious emperor Nero) and the chipped walls of ancient tanks where moray eels were raised. Today, aspiring scuba divers practice here, and everything is contained within an area surrounded by walls: mosaics, frescoes, and even a hanging garden. There are no traces of goats, even though its ancient name was Aegylon—the aegis, shield, and armor were all made of goatskin during the time of the ancient Greeks. This is also the phonetic source of its modern name: Giglio, or Isola del Giglio, is the second-farthest island in the National Park of the Tuscan Archipelago. The island has been inhabited since the Iron Age, and was also mentioned in Julius Caesar's *De Bello Gallico* (*The Gallic War*). It later fell prey to the Saracens of Khayr al-Din, known as Barbarossa, who sacked the island in 1544 and took more than 700 inhabitants as slaves.

Enormous, narrow promontories jut out from the craggy coast, and its otherwise straight line of cliff walls is interrupted by bays such as Cala di Arenella, Cala delle Cannelle, and the enchanted Campese Beach. There are no goats here either, but the hares and migratory birds from nearby Capraia are plentiful. Aleppo and maritime pines as well as cypresses—windborne offspring of those found on Tuscany's mainland—make the landscape soft and incomparably beautiful.

The island's origins are attributed to the mythological Aphrodite, goddess of love and beauty. A necklace given to her by Paris slipped out of her hand and wound up in the sea in front of the Tuscan coast, between Livorno and Argentario. As they touched the sea the necklace's seven gems were instantly transformed into islands: Gorgona, Capraia, Pianosa; Elba in the middle; then Montecristo, Giglio, and the nearby Giannutri, accessible to visitors even though it is private property.

Must See

Giglio Castello, with its imposing walls, three circular towers, and seven rectangular towers, is well worth a visit. Many of its quaint little streets are spanned by arches, and *balzuoli*, or external staircases, leading to the upper floors of older buildings. There's the impressive **Rocca Aldobrandesca** and the Church of San Pietro Apostolo with an ivory crucifix attributed to Giambologna and a 1724 reliquary with the right ulna bone of Saint Maximilian. **Campese** lies on an enchanted bay, with a promontory on one side and the imposing **Torre Medicea** on the other, built around the turn of the 18th century. There are also many wine cellars making the local **Ansonaco wine**.

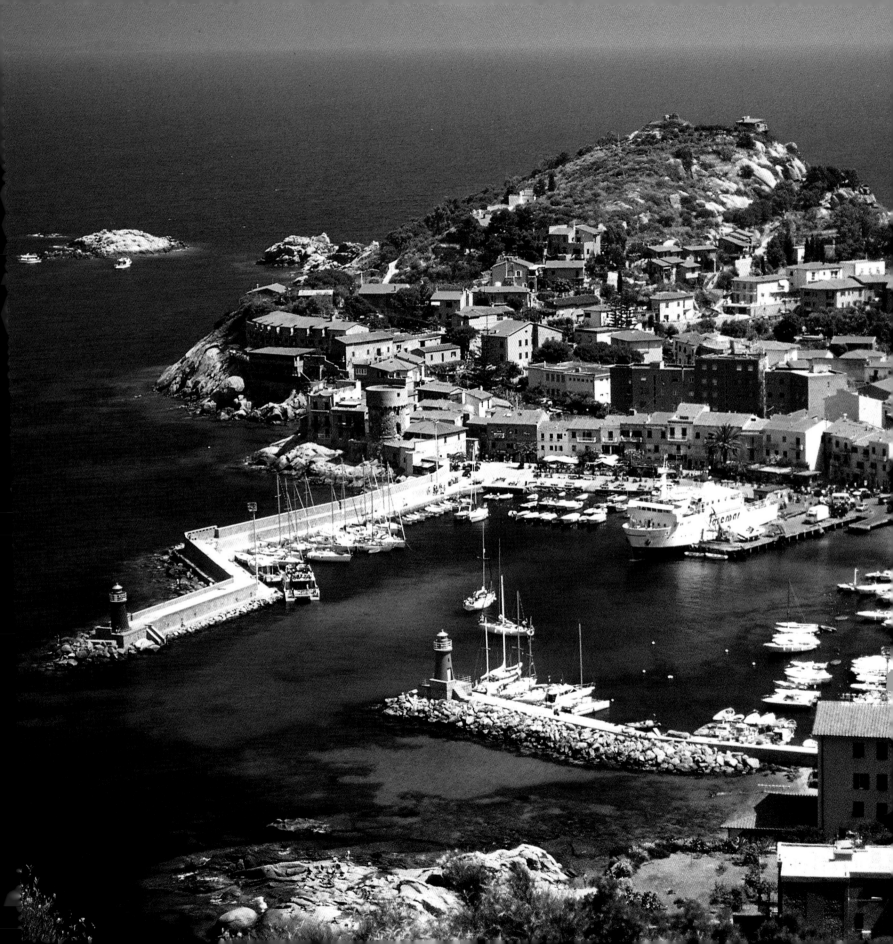

LA MADDALENA

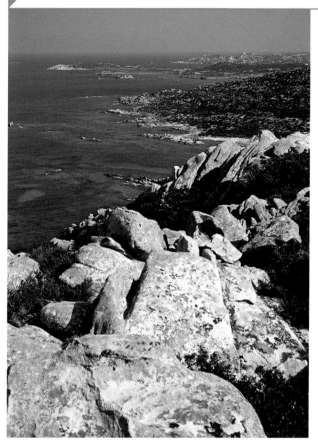

Above: Punta Abbatoggia seen from Punta Testiccia.
Below: View of the port area.

Opposite: Mediterranean garrigue and granite dominate the landscape.

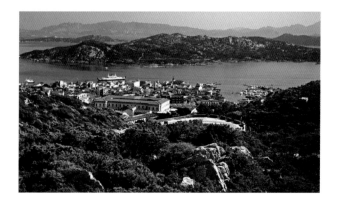

S eductive, bewitching, inviting—there are few adjectives that can really describe La Maddalena, the archipelago that sits between Sardinia and Corsica on the Strait of Bonifacio. It is marked by crystal clear waters, white and pink sand beaches, and a landscape made up of aromatic shrubs, ravines, and granite rocks sculpted by the rebellious winds blowing over waters where dolphins and big fish freely swim. La Maddalena is recognized as one of Sardinia's rare natural beauties and the land, along with its historical and cultural heritage, is protected by a national park so that all may enjoy it.

Those fortunate enough to set foot on La Maddalena, the largest island of the eponymous archipelago, might think they have come across a terrestrial paradise. Its radiant light, pleasant climate, and pristine, transparent sea all help to preserve the charm of a fishing village that stands in contrast to the tourist towns along the Sardinian coast. Along the waterfront are 19th-century buildings and the town center, around Piazza Garibaldi—also called the red square due to the color of the old pavement—and the parish church of Santa Maria Maddalena, with its baroque interior. Just beyond is the Gavetta neighborhood and its suggestive 18th-century residences, and opposite lies Piazza Umberto I, seat of the admiralty. From here, the road heads into the interior, offering sweeping panoramas of the hinterland. En route to Caprera, considered an appendix of La Maddalena, you will pass over a wooden bridge that leads to Pineta, home to wild boars that are visible only at certain times of the day. Caprera is where many visitors go for dolphin watching. From here, take the 40-minute walk up to the top of Mount Teialone, which offers impressive views of the entire archipelago.

Must See

A boat excursion reveals wind-sculpted rocks, coves, beaches with extra-fine sand, and a colorful sea that turns from blue to green to white. The underwater world is populated by hundreds of species of marine life, as well as shipwrecks and archaeo-logical relics. On dry land, behind the beaches, vegetation blends perfectly with the granite rocks. Encircling La Maddalena are the archipelago's other islands: **Budelli** and its pink sand beach; **Santa Maria**, a retreat for the lucky few and the only other inhabited island; and **Mortorio**, **Razzoli,** and **Spargi**, natural destinations for visitors in search of the best, with a sea even the Caribbean would envy.

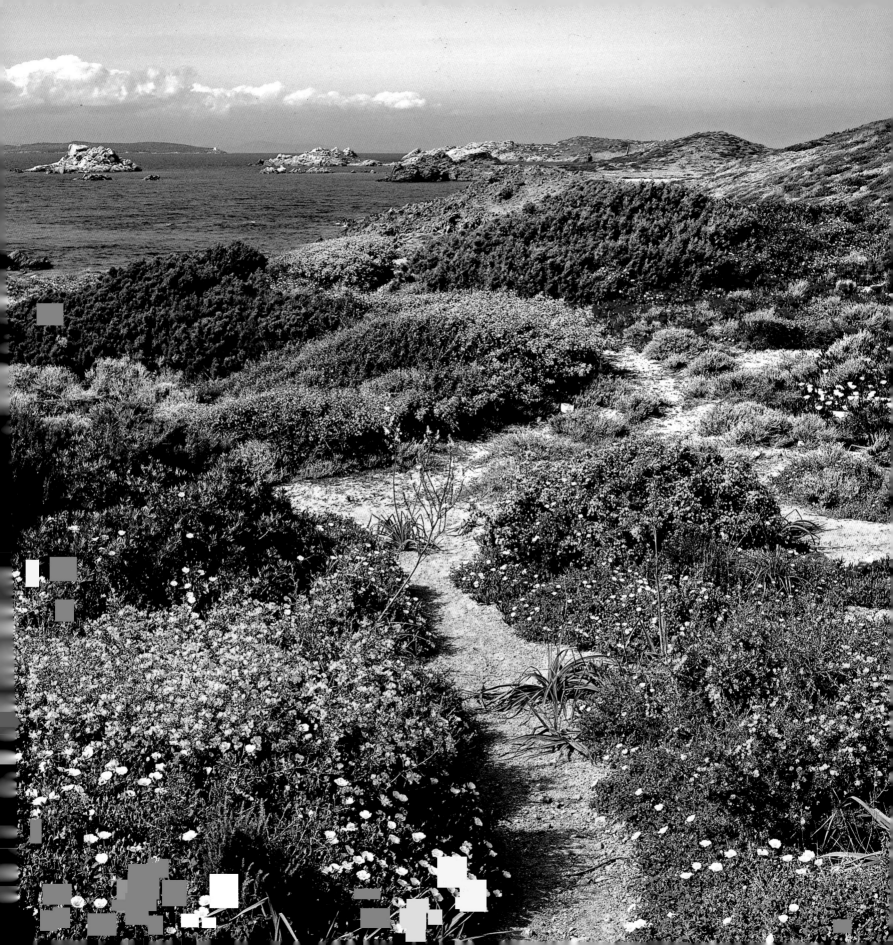

PONZA

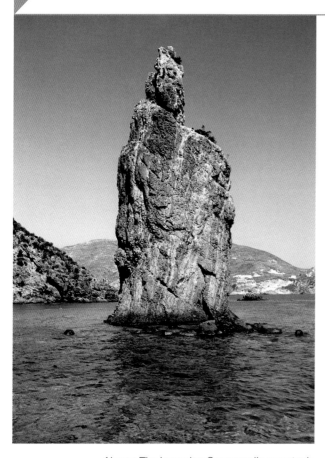

History has left a strong imprint on Ponza, intertwining with age-old myths that, in turn, have been nourished by the rugged landscape. The island's rich past is evident from the first glance, at the entrance to the ancient Roman port. Here, between ships and small boats, towering sea stacks that elsewhere would be big attractions pass unnoticed. There's the pointed "finger" of Ravia and the Casocavallo monolith, source of a thousand legends. Apart from the tourists, not much has changed on land since the time of the Bourbons, whose architects were responsible for the present state of the port and the colorful homes fanned out around it in a semicircle. The lighthouse, with its distinctive octagonal base, has survived along with the well-worn Molo Musco quay, polished by 300 years of foot traffic.

It's nice to lose oneself in the town's maze of alleyways that, without warning, widen to reveal glimpses of the island's craggy contours. On the road to Punta della Madonna, the Cyclopean walls have stood since the time of the ancient Volsci. But the Caves of Pilate, just beyond the port, are the most moving trace of this past civilization. Carved out of rock, the impressive hydraulic system of five basins was used as a fish-breeding farm during Roman times. Accessible only by sea, it's the first stop on an unforgettable island tour that offers one surprise after another. There are the multicolored reefs that every few feet change color from calcium white to ocher yellow, from bluish and green hues to red and black tones. Volcanic activity has had its way with Ponza, creating arches, natural swimming pools, magnificent sea stacks, and bizarre "printed" images on the sheer rock—such as the so-called bleeding heart of Cala Core, which seems impressed onto the cliff face—as well as the geometric evenness of the grottos, coves, and bays like Chiaia di Luna, with its crescent-shaped wall of rock.

Above: The imposing Casocavallo sea stack.
Below: The approach to the island is considered one of the most beautiful in the Mediterranean.

Opposite: The caves of Pilate, which attract thousands of divers annually.

Must See

Palmarola, one of six islands located eight miles from Ponza Porto, is Ponza in miniature. It offers an incredible collection of rocks, reefs, sea stacks, and sheer cliffs that is practically an open-air museum of geology and mineralogy. Its waters are perhaps even more spectacular than its bigger "sister." Also worth visiting are the cliffs of **Cappello**, il **Faraglione**, and **San Silverio Beach**, dedicated to the island's patron saint, with many cave houses. Nearby Cala del Porto is populated each summer with restaurants. To the north are the so-called cathedrals, named for the seemingly Gothic rock formations that fall into the limpid waters, creating the perfect spot for a swim.

RHODES

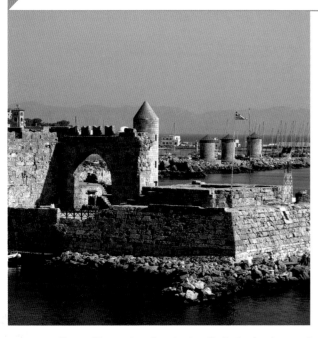

Above: The port and ancient walls. In the background are three Byzantine-era windmills.
Below: A panorama from the Acropolis.
Opposite: View of Lindos with its whitewashed houses and the Acropolis above it.

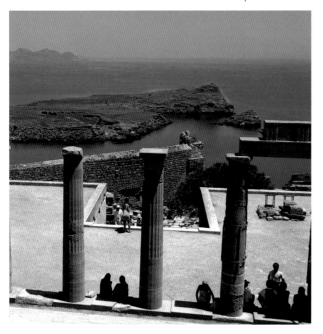

The island of Rhodes resembles the back of the left hand, at least in its physical layout, and at the end of its middle finger lies the capital city, Rhodes. Traveling westward, to the tip of the pinky, you arrive at Kameiros, with its famous ruins, and further inland the Petaloudes Valley—Greek for "Valley of the Butterflies." On the opposite side, at the tip of the thumb, is Lindos, undoubtedly the most picturesque place on the eastern coast of Rhodes, and certainly the most frequented by vacationing travelers.

Where the hand ends, toward what would be the wrist, the island also ends, and here you find Prasonisi, about eight miles from Kattavia, the southernmost town in Rhodes. Prasonisi cape is a mile-long strip of sand. Getting there is exciting because upon arrival you get a sense of its endless space; here the sky and earth blend together and the sea takes on different shades of color, like beautiful precious stones—from aquamarine to turquoise and from emerald green to sapphire blue. Scuba enthusiasts can explore the rich sea floor, and hikers can climb up to the Tsambika Monastery.

Three impressive windmills welcome tourists to Mandraki Harbor, the port of Rhodes. Statues of a deer and a doe, symbols of the city, flank the entry to the harbor, softening the austere image of the fort of Agios Nikolaos, built by the Knights Hospitaller. Legend has it that this is where, with legs spread and his hand holding a torch raised above his head, the seventh wonder of the world, the Colossus of Rhodes, formerly stood—a 115-foot-high bronze statue that was eventually destroyed during an earthquake in 226 BC, only about 60 years after it was built. The city of Rhodes is divided between old and new sections, and there are many monuments from various historical periods in both of them. Yet another wonder is that this sun-kissed island enjoys, on average, 300 days of clear blue skies each year.

Must See

The main attraction for nature lovers on Rhodes is **Petaloudes**, the "Valley of the Butterflies." Among the shady leaves of ancient forests, splashing waterfalls, and a variety of trees, the place is home—between June and September—to millions of reddish-brown tiger moths (*Panaxia quadripunctaria*). Perfectly camouflaged, they appear to resemble the color patterns on the very tree trunks whose resinous sap they feed on. You have to focus carefully in order to make them out, ideally without making any noise so they don't fly away—when they do, it's with a delicate flap of the wings, in complete silence.

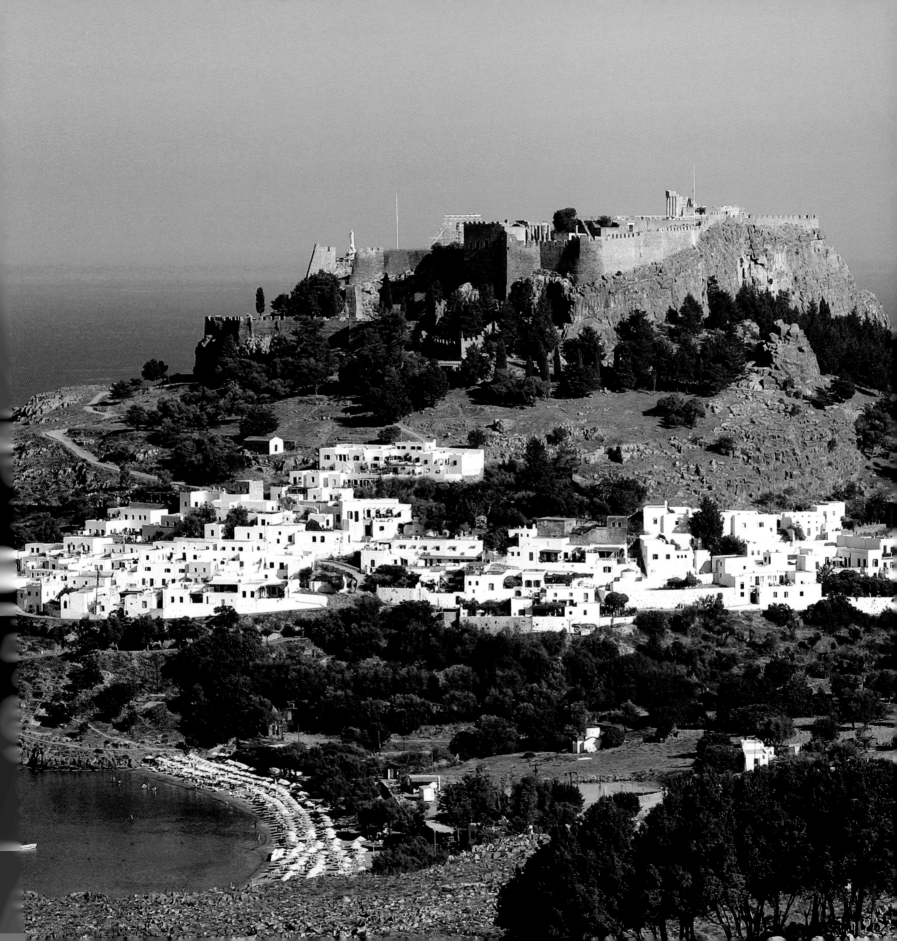

SANTORINI

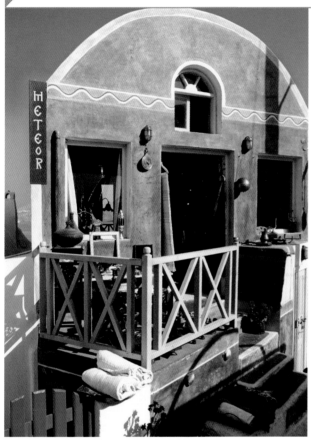

A place of memory, imagination, dream, and myth, Santorino—better known as Santorini, the name given to it by the Venetians to honor Saint Irene—is an archipelago of volcanic islands in the Aegean, part of the southern Cyclades. Having emerged from the ocean in the prehistoric period, it was then invaded by the tides following a seismic event sometime in the second millennium BC. It left behind a wide caldera, inside of which is a broad, elliptical-shaped bay, almost a half-moon, surrounded by volcanic isles characterized by red and black sands and indigo blue waters: Thera, the largest island and Santorini's capital, Therasia, Aspronisi, Nea Kameni, and Mikra Kameni.

Long ago, the island was inhabited by an advanced civilization, the Minoans, who mysteriously disappeared due to cataclysmic events—one of the theories is that Santorini is part of the Cyclades that belonged to the mythical Atlantis. Evidence of this flourishing period was uncovered with the discovery of a Minoan village on Thera that had been buried by a volcanic eruption 3,500 years ago.

To experience the island's magical atmosphere to the fullest, start with a walk through the main town on Thera, with its characteristic whitewashed homes, blue-domed Orthodox churches, and jewelry shops perched atop the island's highest ridge. From the old port, accessible by cable car or donkey ride on the narrow roads, small tour boats depart for Therasia, Palea Kameni, and Nea Kameni to let people experience the thrill of diving into hot springs. Before leaving, it's worth stopping at the village of Oia, where—in addition to the characteristic windmills—there are amazing sunsets on the Aegean. You can either enjoy the spectacle in silence from one of the caldera's several lookout points or from one of the oceanfront terraces at the many coffee bars.

Above: Shops and cafés occupy old warehouses once used by fishermen.
Below: Ruins of an ancient city on the main island of Thera.

Opposite: Panoramic view from the island's western coast showing traditional whitewashed houses.

Must See

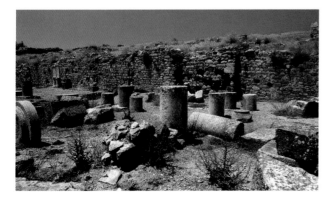

Red Beach is one of the most beautiful seaside spots. Close to Akrotiri, and not far from an ancient Minoan settlement, the beach gets its name from the reddish volcanic rock. It's a great place for those who love breathtaking views and peace and quiet. It's also the perfect jumping off point for excursions to the neighboring volcanic islands of **Nea Kameni** and **Palea Kameni**, as well as the beautiful white beaches. Those who stay at Red Beach can have an unforgettable dinner in the ancient village of Akrotiri, with its characteristic taverns tucked into alcoves. The menu is comprised of traditional fare and desserts are served with **vin santo**.

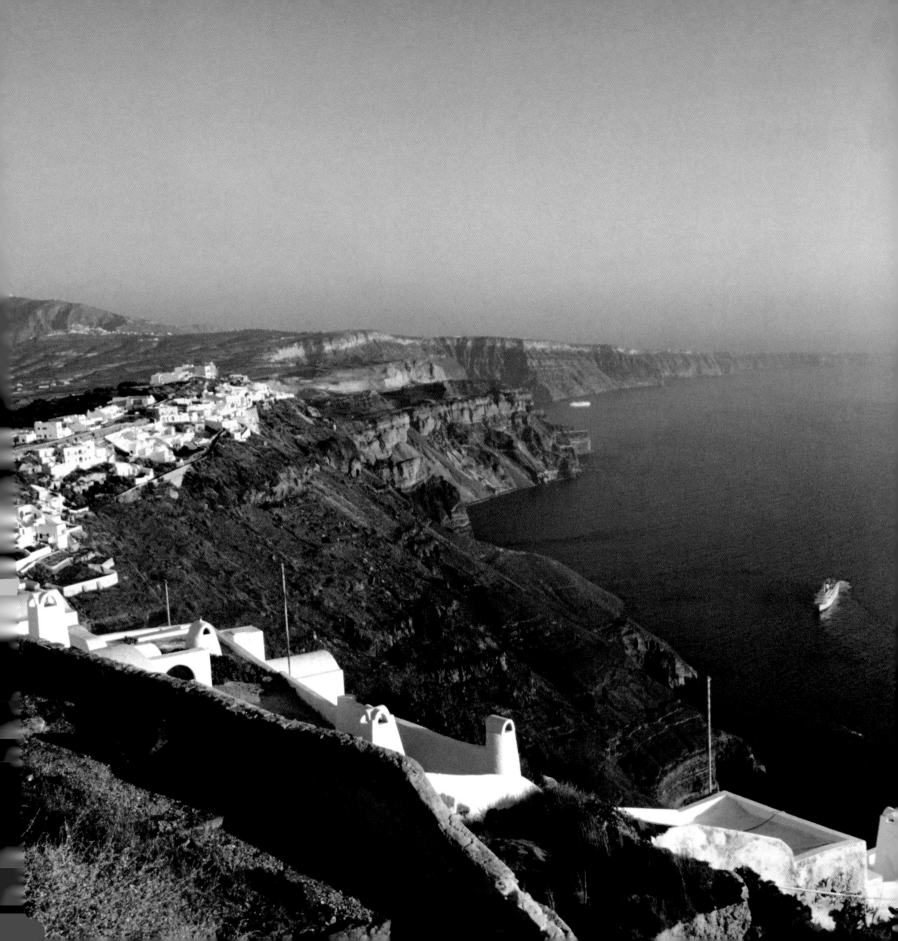

Above: The church of Santa Maria a Mare
on the island of San Nicola.
Below: San Nicola seen from Capraia.

Opposite: A cliff on Cretaccio seen from San Nicola.

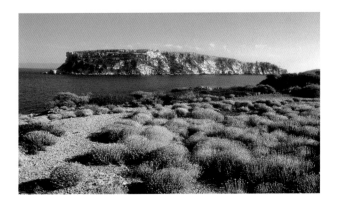

This unique archipelago has a way of holding visitors captive, both literally and figuratively. The Tremiti Islands were a penal colony for several centuries—from the 18th century, when King Ferdinand of Naples first sent prisoners there, to the mid-20th century, when the Facist regime sent political dissidents there. Today, however, the only prisoners are ones of a more poetic sort, as the Tremitis are still a place where mind, body, and spirit gladly fall captive to the islands' natural beauty. Here, the silence of the breezes and the scent of the sea have a spellbinding effect on whoever reaches this archipelago in the middle of the Adriatic, just north of the Gargano Peninsula.

The ferry to the Tremiti Islands takes you back in time. The dilapidated lighthouse on a high rocky reef, where decades ago monk seals used to play hide-and-seek, signals your arrival at San Domino, a green, tree-covered patch of earth that interrupts the flat horizon of the surrounding sea. The island is like a lost paradise that seems uninhabited and somehow manages to cloak every trace of cement in its vegetation. Then, as the boat veers gently to the left, a surreal vision appears. From a high sheer cliff, protected by imposing walls and thick bastions, you can see a fortified citadel glimmering in the sun's rays. High up, the blinding, golden stone facade of the church of Santa Maria a Mare dominates the landscape alongside a vision that reassures sailors today just as it did during the Crusades— the Acropolis of San Nicola, on the island that became Diomedes' shelter after the Trojan War.

Here, the connection between history and nature is remarkably evident, between the deep sea (the *mare profondo* of Lucio Dalla's popular song, inspired atop the Cala Matano) and the fruitful earth (olives and grapes have always been cultivated), the sacred (the quiet presence of a Benedictine monastery), and the profane (today's niche tourism).

Must See

All four Tremiti Islands are worth a visit: **Capraia**, an uninhabited cliff that emerges from the magical sea floor; **San Nicola**, which offers a fascinating look into the history of Mediterranean culture; **San Domino**, where— between hidden, nearly inaccessible coves— eateries serve fish with flavors that can't be found elsewhere; and the smaller **Cretaccio**, a tiny island made of marlstone eroded by the elements. Mingle with the locals (who've kept close ties to their Neapolitan origins), hear the playful calls of the seagulls in the sky, and experience the subtle pleasure of forgetting the car (automobile use is prohibited to anyone except residents), and savor getting back in touch with nature.

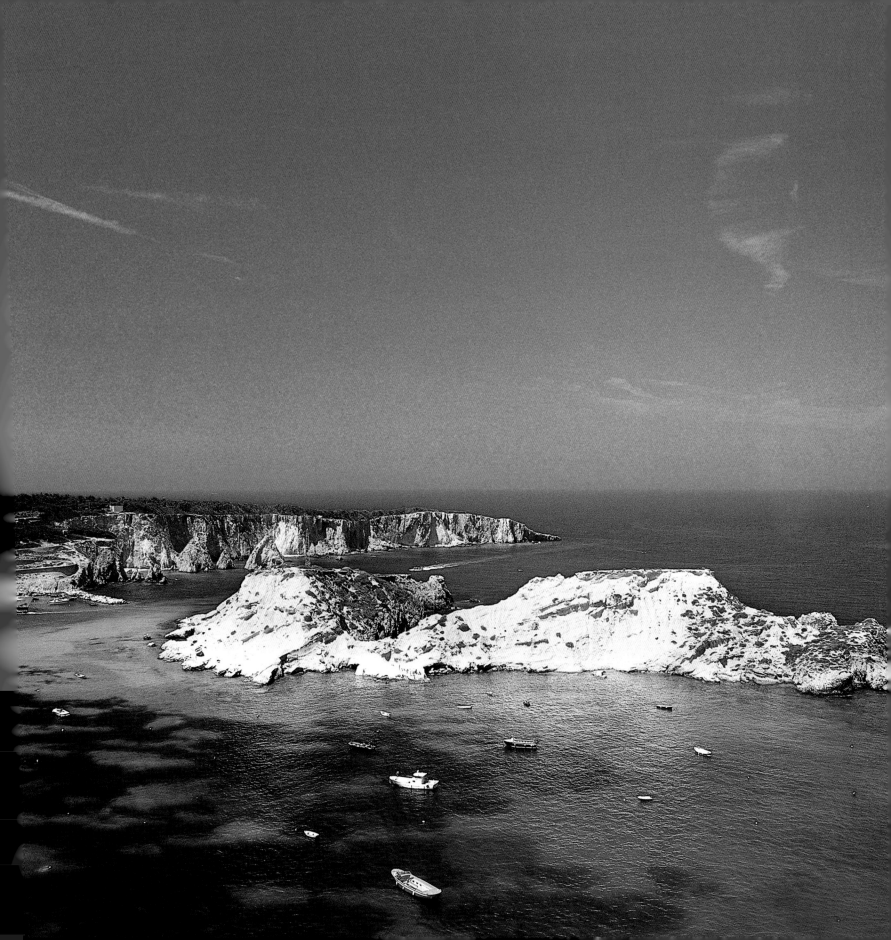

The rugged beauty of an island cast into crystalline waters, the sweetness of breezes that never tire of caressing the vegetation, sunny skies by day, and starry skies by night—no, this isn't a dream: these islands are nature's magic, and they captivate travelers. The sun-kissed faces of the indigenous people attest to the richness of ageless civilizations. Far from the noise of the city, things move at a slow pace, hunting and fishing are the main pursuits. Here, there's no need to use your imagination; these islands are Mother Nature's way of showing us that earthly paradises really do exist.

[Mauro Remondino]

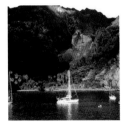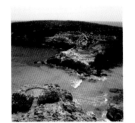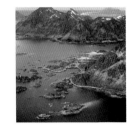
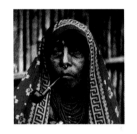
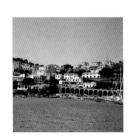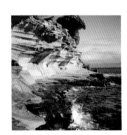

NATURAL
PARADISES

ANGUILLA

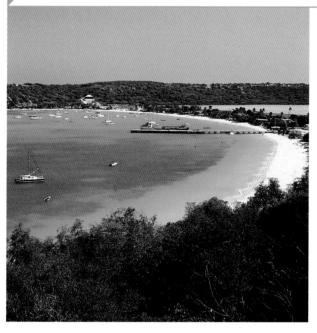

Above: The island's major attractions are white sand beaches and crystalline waters.
Below: A Baptist chapel.

Opposite: Sandy Ground, one of the busiest beaches.

According to local lore, this long and tapered strip of earth was named by Christopher Columbus to reflect the fact that its shape is similar to that of an eel. The island's pure white beaches and crystalline waters give way to a splash of green vegetation and bright spaces bathed by the sun. Anguilla, a British overseas territory in the Caribbean, with its capital known simply as The Valley, is decidedly different in culture and tradition from neighboring Saint Martin, which is just under an hour away by boat. The island's extreme simplicity is paired with luxurious hospitality. It entered the spotlight thanks to the presence of a select, rather elite public, who chose it for its untamed beauty, peace, and quiet—factors that invite you to spend the day at the beach from sunrise to sundown. And though there's no shortage of five-star hotels—some of the most highly regarded properties in the Lesser Antilles are here—the island still offers visitors the possibility of basking in the sun and enjoying long swims in absolute solitude.

The coastline is always caressed by a soft breeze, and the sandy beaches are beyond description. Then there are the pristine sand dunes between intense blue sky and the sea's transparent surface. Rendezvous Bay is an endless beach where you can walk undisturbed, the only audible sound being the waves. Shoal Bay West is the island's westernmost point, together with Barnes Bay and Mead's Bay. Coming back you'll find Sandy Ground, one of the liveliest spots where reggae bands often play. Spectacular Little Bay is where locals go to admire the sunset. On weekends, guests and residents mingle at the lively and cheerful Shoal Bay. Scilly Cay is a tiny islet not far from the mainland; it's accessible only by boat, and hosts a restaurant acclaimed for its lobster. Captain Bay, on the northeastern tip, definitely merits a visit for its unblemished coastline that's widely considered, according to regulars, the island's best beach.

Must See

Whether you're on the island for a day or for a lengthier vacation, a visit to **The Dune Preserve Restaurant** at Rendezvous Bay is mandatory. Just steps from the water, this eatery built on stilts in the sand is run by local musician Bankie Banx, an undeniably charming character who is an island legend famous for his Jamaican sound and distinctive rasta look. Those lucky enough will get the chance to hear him sing and play in person. He's also the organizer behind **Moonsplash**, an annual reggae music festival held in late March that is popular with both locals and out-of-towners. And for followers of jazz, the **Tranquility Festival** is not to be missed.

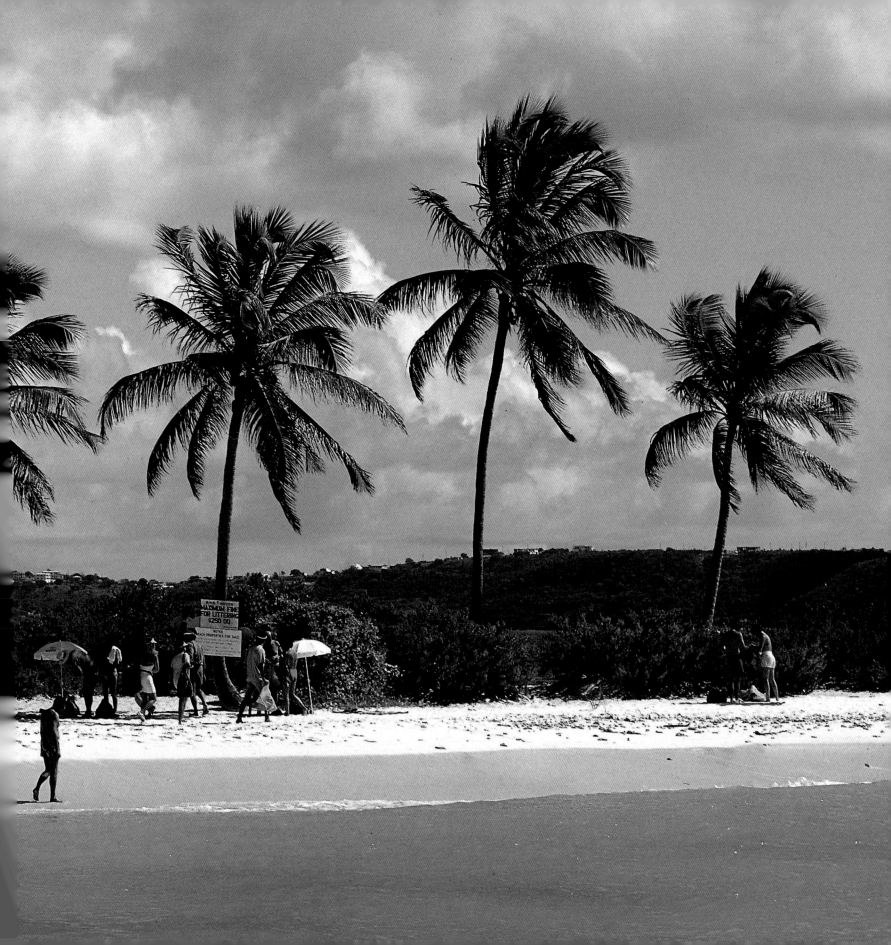

CAPE VERDE

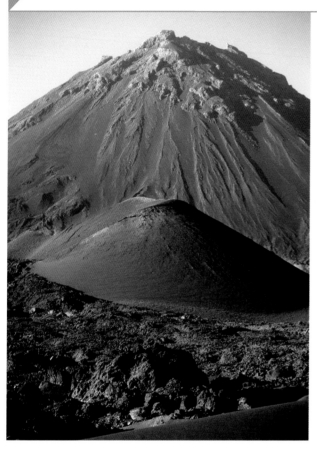

Above and Below: Two views of the Pico do Fogo volcano. The crater is 1,600 feet wide and 600 feet deep.

Opposite: São Filipe Beach, Fogo.

Halfway between the Tropic of Cancer and the equator, 750 miles south of the Canary Islands and 335 miles from Senegal, the Cape Verde archipelago includes 10 islands, none of which appear to be related. Fogo is dominated by the mighty Pico do Fogo, a nearly 10,000-foot-high volcano that requires significant exertion to conquer. Pitch-black ash dunes, jagged volcanic rock pinnacles, stone houses resembling blackened igloos, and wrinkled rock strata are the legacy of a series of eruptions—the last was in 1995—that repeatedly reshape the island's topography.

At dawn, amid a surreal silence, a pickup truck barrels through this Dantesque scenery and approaches Chã das Caldeiras, the starting point for those daring enough to brave the tough climb up the imposing Pico do Fogo, whose summit reaches 9,281 feet. The ascent is spectacular but demanding. From town to summit the elevation difference is 3,900 feet, and the steep gradients necessitate a hike of three to four hours. With each step hikers sink up to their knees in a soft bed of superfine volcanic ash. On the edge of the fuming crater, the air at the summit is pure and still, and there's a 360-degree view of the Atlantic. Standing on the peak of this perfect volcano, you are easily overcome by a sense of expectation.

Gliding down the soft slopes on the precipitous descent, the mountain many have called a "merciless lava cyclops" seems to take pity: exuberant shoots of a sparse yet unyielding, lush green vegetation courageously peer out from the inhospitable soil, and short rows of surprisingly rich crops cling to the slopes. Soon after visitors arrive at the Chã das Caldeiras cooperative everyone is offered a glass of Manecom, the famous volcanic red wine that is produced from grapes grown on Pico, while lively groups of local children—where they appear from nobody knows—proudly offer miniature homemade replicas of their modest lava stone houses.

Must See

The island's multicolored hinterland is a mosaic of agricultural fields fenced in by stone walls, terraced hillsides, scenic canyons, verdant conifers, perfumed eucalyptus, and small plantations of coffee, mango, and other tropical fruits. **São Filipe**, the island's capital, is an old village magically suspended above the sea cliffs and has a large, black pebble beach. Its sloping roads are lined with private residences (*sobrados*) that reflect Portuguese colonial architecture, with verandas and balconies painted in subtle pastel colors. There are also elegant municipal buildings, manicured gardens, and a lively covered market.

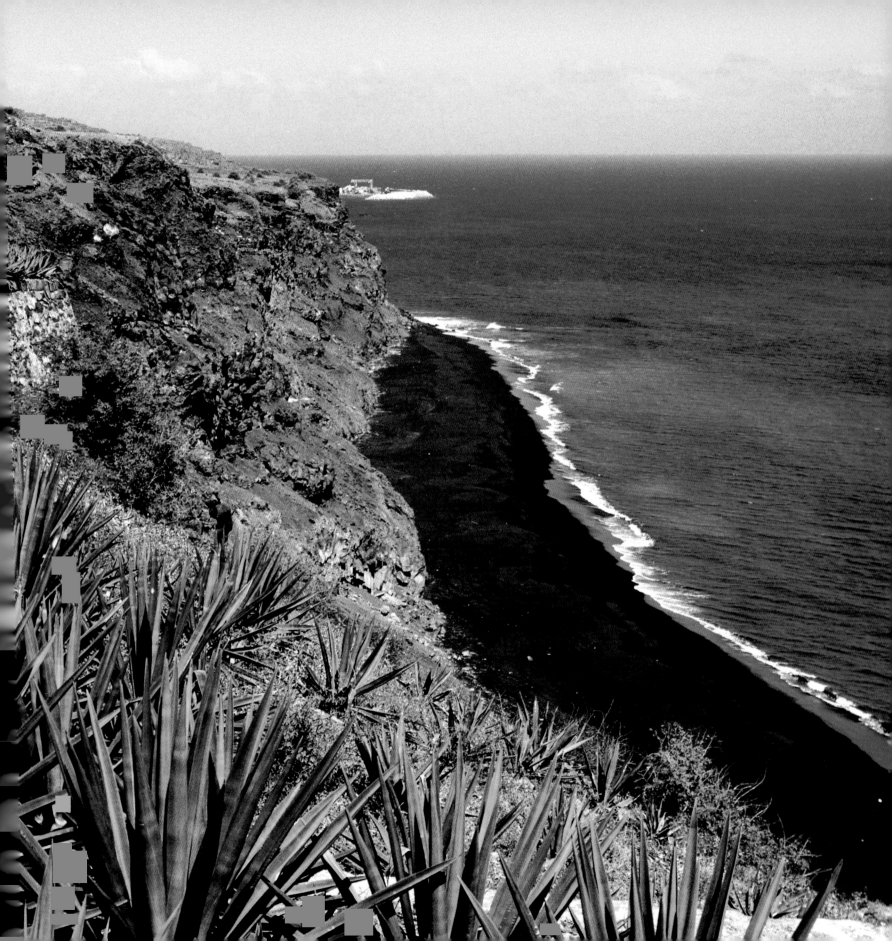

COMOROS

They look like four relics with strange yet elegant shapes, each slightly different and emanating a particular scent: ylang-ylang, cloves, cinnamon, and vanilla. The Comoros Islands—Grande Comore, Mayotte, Anjouan, and Mohéli—are suffused with something mysterious and ancient. The atmosphere is a mix of French, Arab, and African. Delicate perfumes hover amid the Arabic buildings, distinguished by their arches, balustrades, and elaborately carved wooden doors. Meanwhile, landscapes of black lava and fine white sand form the backdrop of the area's underwater universe. And it is underwater that the Comoros archipelago—a corner of paradise that spreads across the north end of the Mozambique Channel, between Africa and the northwest coast of Madagascar—stores its greatest treasures.

Grande Comore, the biggest island, is a vast green tropical forest with a great variety of colors, and the air is filled with the scent of coconut and vanilla. Its capital is Moroni, a traditional Arab city with the old town near the port. There the African market, two mosques, several large Moorish arches, and tiny winding streets lined with shops can all be found. Moroni's stone moorings make it a strategic location for watching the spectacular red-orange sunsets. Famous for its legendary queens, Mohéli is the smallest island, full of deep valleys, where rivers flow far below a high forest canopy. Anjouan's landscape contains white beaches and green mountains; it is also the most richly scented island. Its major city is Mutsamudu, a small citadel built in the 18th century. The easternmost island, Mayotte, is shaped like an upside-down sea horse crowned by an ancient volcano, surrounded by reefs, and interspersed with rough basalt peaks, valleys, and green forest. It is also the southernmost island, and extending around it is the world's largest coral lagoon.

Above: Moroni, Grande Comore, women in traditional dress.
Below: Fishermen at work on boats carved out of tree trunks.

Opposite: Dziancoundré Waterfall on Anjouan Island.

Must See

Sports enthusiasts can climb to the top of **Mount Karthala** (7,746 feet), the largest active volcano in the world, which looms over the southern part of Grande Comore. **Chindini** and **Chomoni** are two of the most beautiful beaches, with an unusual combination of black lava and white sand. **Foumbouni** is the third-largest town in Grande Comore and the least visited, but it has a brilliant white sand shoreline. A memorable experience can be had watching the **green tortoises** bury their eggs at night on Itsamia beach on the island of Mohéli. The **Dziancoundré Waterfall** is one of the major attractions on Anjouan, and you can easily walk there from the main city.

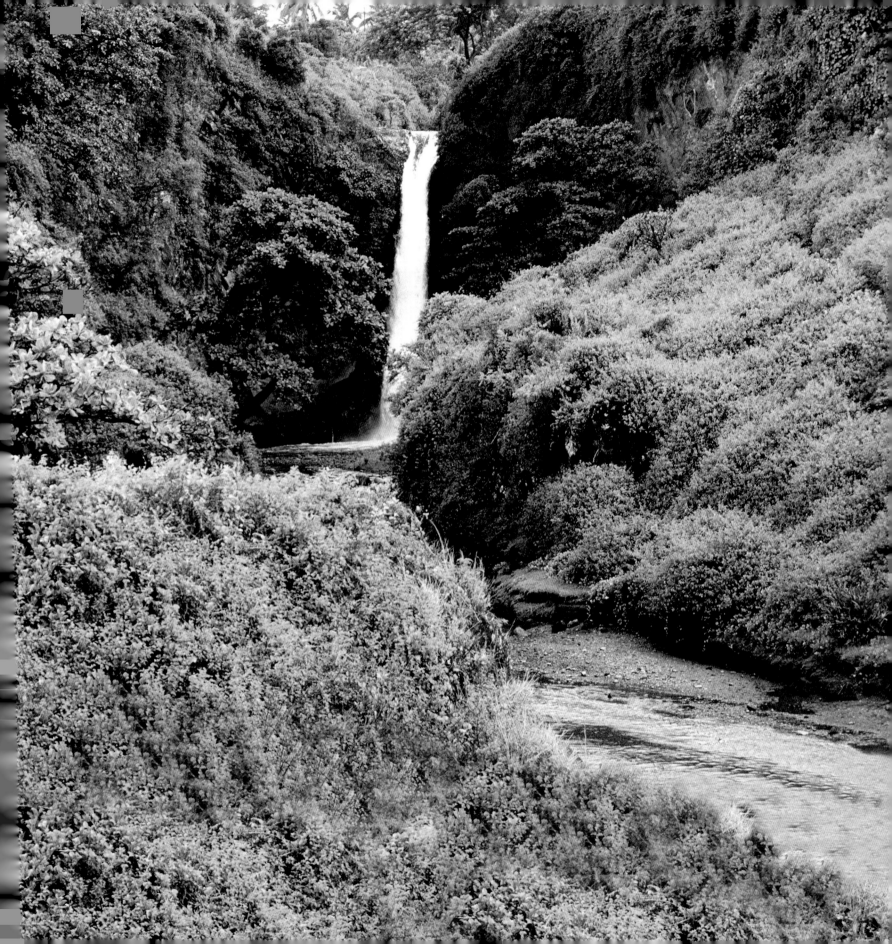

FRÉGATE ISLAND

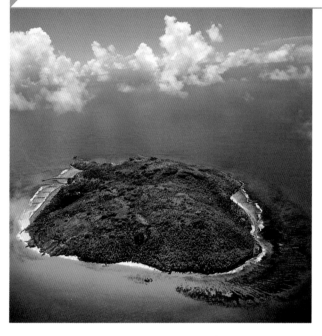

Above: Aerial view of the exclusive island that can host 40 guests at a time.
Below: The Rock, home to the island's spa.

Opposite: The white sand beach of Anse Macquereau.

Four degrees south of the Equator, Frégate Island, a granite block that sprung from the depths of the sea millennia ago, is only one square mile and is wrapped in a velvety blanket of lush vegetation that shows off a necklace of seven dazzling gems set within turquoise waters—seven superfine white sand beaches, one for each day of the week.

This provides an immediate answer for those who might be wondering how to pass their time on the island. Of the seven beaches, the prettiest is Anse Victorin, shaped like a half-moon. Its super-soft white sand and gently rustling palms are able to make even the least romantic of travelers lose themselves in ecstasy. A sojourn on Frégate also lets you discover rare species that, thanks to the environmental safeguards in place on this little paradise, are protected. From the 16 villas, with their private pools and lavish comforts, there are phenomenal ocean views that at sunset take on a golden hue, while the fairy terns, frigate birds, and magpie robins announce the end of yet another day. Touring the island from one beach to the next, you arrive at Signal Hill, the highest point, where the eye can wander endlessly along the horizon. Those lucky enough to visit Frégate today can seize on the memory of past adventurers who dared to cross the ocean in order to discover this enchanting place bringing spices, fruit, and exotic plants with them. Walking along the trails that run through the lush tropical vegetation, it's easy to bump into the giant Aldabra tortoises. Exploring the island also brings to mind the legend of a treasure of inestimable value supposedly hidden here by pirates centuries ago—author Ian Fleming, creator of the James Bond series, was convinced of its existence. And if the creator of the legendary 007 believed it, perhaps we can all dream that, apart from its natural beauty, Frégate could offer yet another unexpected surprise to those who fall under its spell.

Must See

Pampering and lots of relaxation for the body and mind are available at the **Rock Spa**, which dominates the island from rocky **Signal Hill** and where the products, many of which originate from Frégate's native vegetation, are strictly all natural. Or you can choose to have a relaxing treatment in the intimacy of your villa. From the **Yacht Club**, catamarans and boats depart for all-day deep sea fishing excursions to the tranquil Grand Bleu. For underwater enthusiasts, the sea floor, shallows, and surrounding reefs promise unforgettable dives. Finally, to end the day on a relaxing note, take a sunset walk and then enjoy a romantic candlelit dinner at **Anse Bambous** beach.

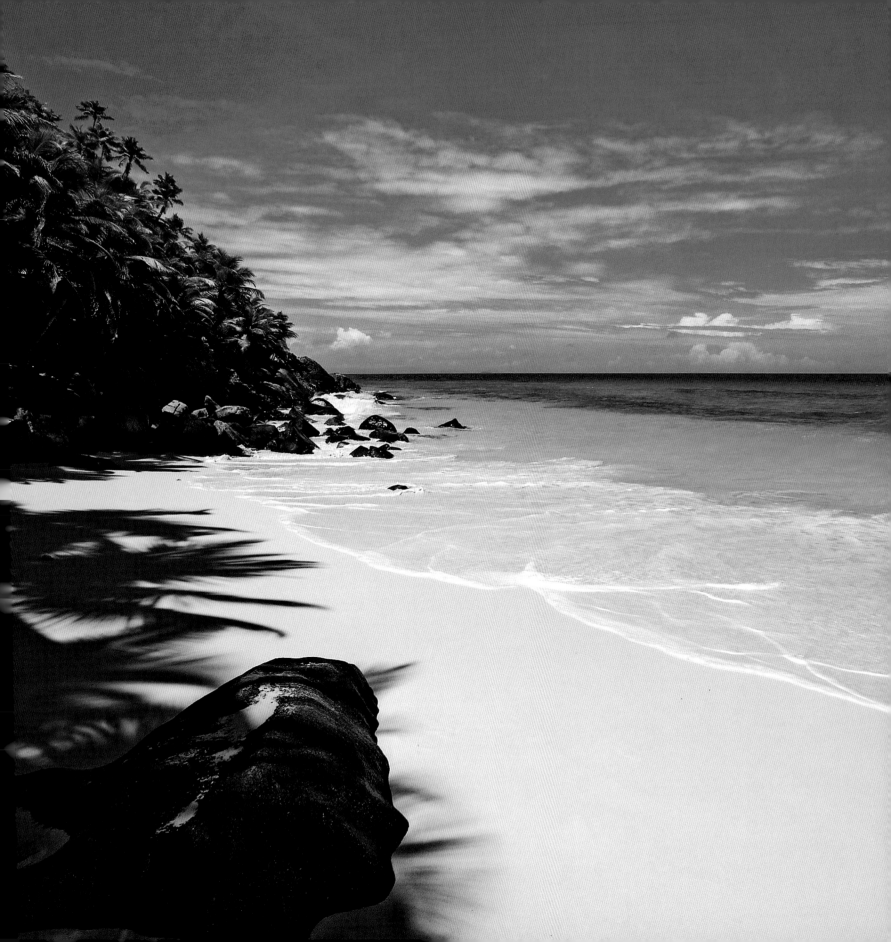

GALÁPAGOS

Between three and six million years ago, 600 miles off the coast of Ecuador, submarine volcanoes exploded in an infernal eruption.

A fury of lava flowed into the sea from craters as ash and boiling lava rained down everywhere. Nature's wrath was soon transformed into a miracle: the birth of the Galápagos Islands, magic offspring of fire. Smack dab in the middle of the Pacific, the volcanic archipelago's 13 islands, 42 islets, and 26 reefs are inhabited by 10,000 people—the remaining population consists of rock, waves, and wildlife on land and at sea. The winds and oceanic currents brought the first life forms here from the continent. Since then, nothing has remained quite the same, as all species have had to adapt to the environment. English naturalist Charles Darwin was well aware of this when, in 1835, he spent an entire month here observing the finches, iguanas, and giant tortoises— animals that would inspire his 1859 theory of evolution.

Discovered by chance in 1535 by Tomás de Berlanga, the Bishop of Panama, during a wayward voyage in the Pacific, the islands were scoured throughout the 1600s by pirates and buccaneers, who captured up to 300,000 Galápagos, the giant tortoises that gave the archipelago its name. These reptiles, able to reach a weight of 600 pounds, can survive up to a year without food or drink, and became an excellent source of fresh food for English and American whalers, who used them for their oil and meat on long voyages.

In 1959, the Galápagos Islands were declared a national park, and today only 100,000 tourists per year are allowed to enjoy the islands'

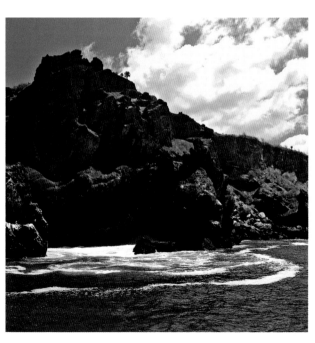

Above: Dark volcanic rocks and active craters are the archipelago's trademarks.

Right: The Galápagos Islands are home to colonies of marine iguanas that live in coastal areas.

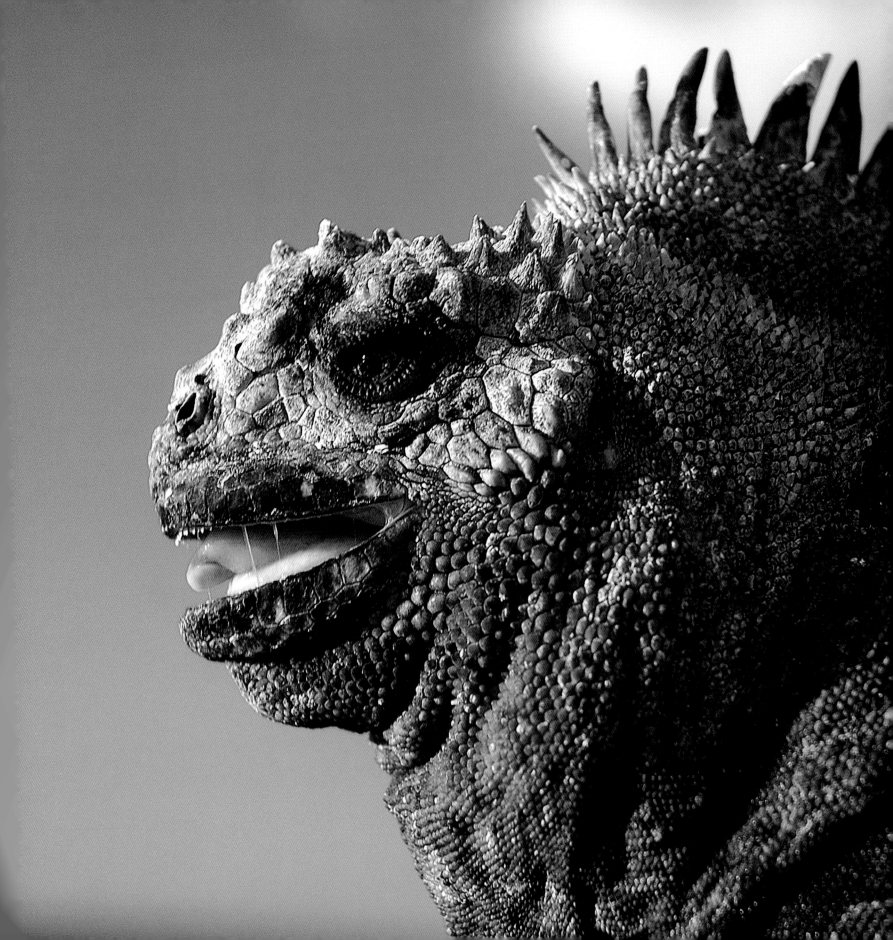

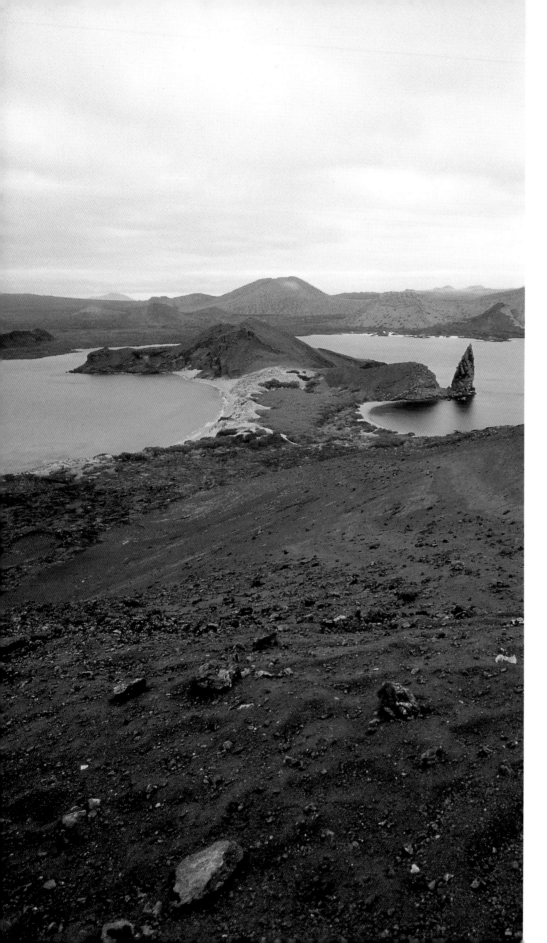

extraordinary natural beauty, of which 97.5 percent is closely protected. A sampling of the islands' native fauna includes 13 species of endemic finch, cormorants, giant tortoises, and marine iguanas. Its sea life also has a unique richness; over 300 species of fish are registered in the Galápagos, of which 50 are endemic. Fish, crustaceans, and tropical sea flora harmoniously flourish alongside cold-water marine life, a mix of opposites that somehow integrates perfectly. Here, the cold Humboldt current, which carries nutrient-rich waters from the southern tip of Chile, encounters the El Niño equatorial current descending from the Central American coast. They are accompanied by a third current, the Cromwell, that arrives from the central Pacific and brings cold water from the deep ocean. Such a mixture helps explain the contradictions of the Galápagos archipelago, surrounded by shark-infested waters and yet teeming with life, where sea lions frolic while the dramatic struggle for life unfolds. Whales, orcas, and penguins are seen swimming beside parrotfish, barracuda, green turtles, manta rays, and ocean sunfish, in a tribute to prehistory on the course toward modernity.

Must See

The **marine iguanas** are the only species of their kind that live in the water and feed on marine algae. They are found all over the archipelago, but those on Española Island have red markings on their backs. On tiny **North Seymour Island**, **blue-footed boobies**, **blackcaps**, and the biggest colony of **frigate birds** in the archipelago—the famous "sea pirates"—run wild. During mating season, male frigate birds puff out their red necks, spread their wings, and emit a sound akin to a drum, all in order to attract the fairer sex. On **Santa Cruz Island**, the Charles Darwin Research Station has a tour to let you see some of the 3,000 Galápagos tortoises, which have a life expectancy of 150 years, roam about in their habitat.

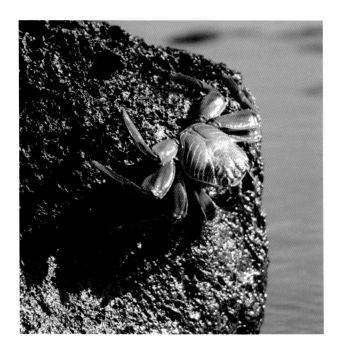

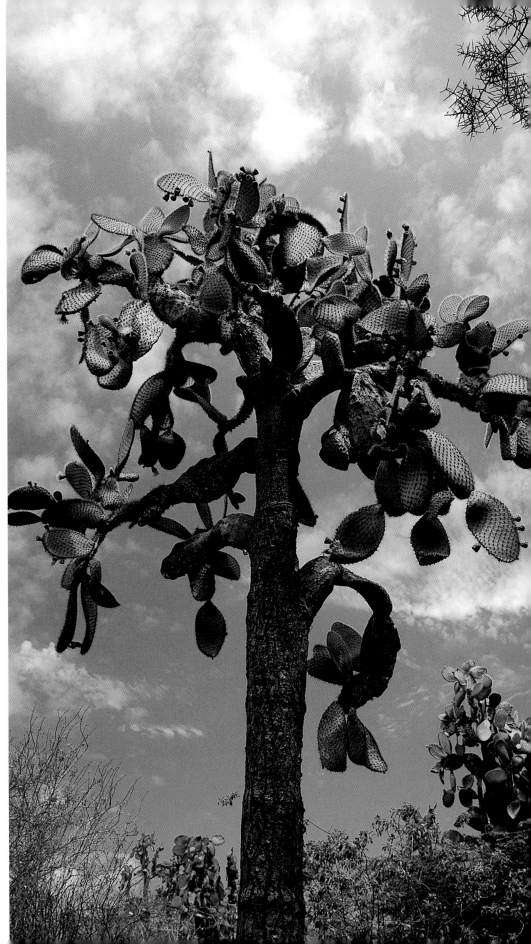

Above: A red crab.

Right: An Opuntia cactus (prickly pear), native to the Galápagos.

Opposite: Bartolomé Island, formed by volcanic activity.

Below: A giant tortoise, the islands' symbol.

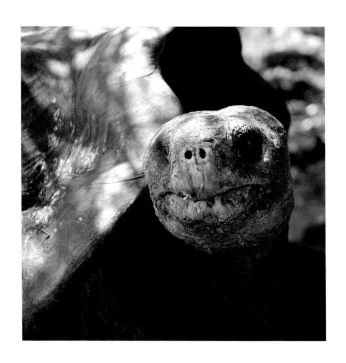

ISLA GRANDE

*Above: View of the Gulf of Ushuaia, Argentina.
Below: Gauchos near Porvenir, Chile.*

*Opposite: Elephant seals and cormorants live together
on the islands around the Beagle Channel.*

own at the bottom of South America, where people say the world comes to an end, lies Isla Grande. It's a borderland that wanted to prove its point by detaching itself from the continent, creating the 29th largest island in the world. Here, myth and reality combine, and both help blur the indistinguishable border dividing Chile and Argentina. And though many confuse this island with other Isla Grandes in the world, its having been named by Magellan when he discovered it in 1520 evokes legend and mystery. The great explorer also baptized the *Tierra del Fuego* ("Land of Fire"), and his name remains on the Strait of Magellan, separating the island from the continent. If you come to the island via Chile, you have to take a ferry from Punta Arenas, the capital of Chilean Patagonia, and navigate through the strait to the town of Porvenir. From Porvenir, which means *future* in Spanish, there's a dirt road, the only one that heads south. Along it you can see the pampas—a sea of grass, sunsets, and storms—as well as elephant seals, penguins, brisk winds, and solitude. The light contours the coastline like a razor cutting across a beach of shining rocks. The only crowds are made up of guanacos and sheep. Arriving from the Argentine side offers the same atmosphere and views. Either you fly to Rio Grande or Ushuaia, or you can cross the Chilean border by car, continuing to Punta Delgada, where you ferry across the Strait of Magellan to Puerto Progreso at the point where the two coasts are closest. While the Chilean part of the Isla Grande offers, apart from Porvenir, only sky and nature, the Argentine part has some villages as well as the towns of Rio Grande and Ushuaia.

The Ona Indians were the first to settle on the island 10,000 years ago. Enriqueta Gastelumendi was one of the Ona Indian's last representatives. In 2004, at age 91, Enriqueta passed away, leaving her island—which, as if under a spell, has kept the scents and memory of her people and their history unchanged.

Must See

Ushuaia is one of the world's southernmost towns, even if nearby **Puerto Williams** claims the title. Ushuaia is bathed by the sea as it flows through the Beagle Channel. Surrounded by the **Martial Mountains**, it offers a unique landscape. Originally called *Yamana* by the Indians who lived there, it was a penal colony for most of the 20th century. Besides the prison, the so-called **Museum of the End of the World**, the **Maritime Museum**, and the trains that convicts worked on to transport wood are all worth a visit. Take an excursion through the national park and enjoy a day of sailing on the Beagle Channel among islands inhabited by sea lions and cormorants.

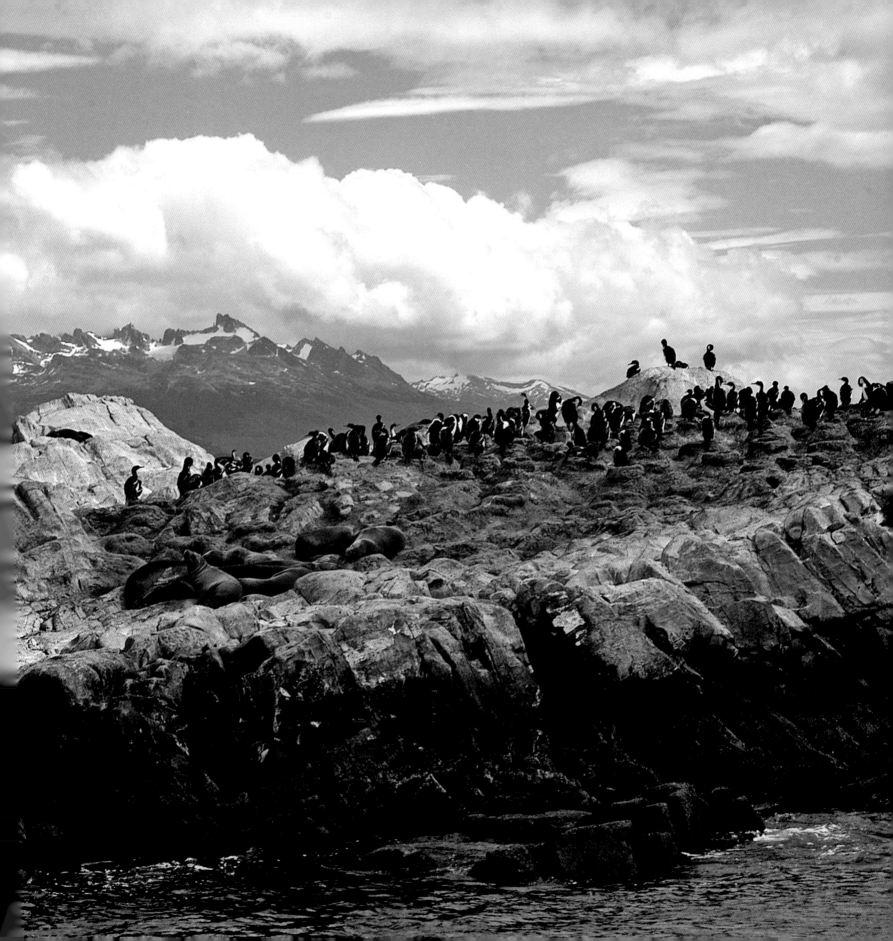

MARQUESAS ISLANDS

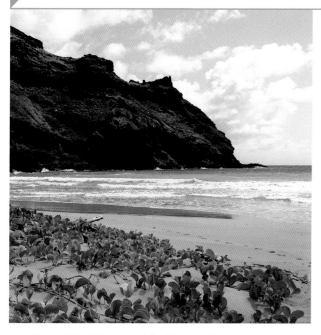

Above: The islands are full of beaches lush with vegetation.
Below: Horseback riding on Nuku Hiva Island.

Opposite: The green volcanic peaks of Nuku Hiva Island, the best known of the archipelago.

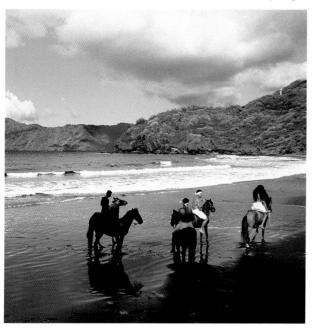

A handful of colored confetti strewn in the Pacific, the northernmost archipelago of French Polynesia is made up of dozens of islands where nature is untamed, yet at the same time still very inviting. *Soyez amoureuses et vous serez heureuses*—be in love and you will be happy: this is the message on the bas-relief of the Maison du Jouir, the home of Paul Gauguin, itself a work of art. Gauguin found his "kingdom of ecstasy, peace and art, far from the European struggle for money," in the Marquesas Islands. The adventurous sensation of discovering paradise in the *Te henua 'enana*, or "land of men," was shared by other artists and adventurers, including Jacques Brel, Herman Melville, and Robert Louis Stevenson. Anyone who breathes the scent of the waterfalls on Nuku Hiva, the best-known island, or walks through the little roads that wind through the blooming vegetation, where white horses have always lived in the wild, can relive this feeling of adventure.

The Marquesas are approximately 930 miles from Tahiti, in the northernmost part of French Polynesia. The landscape is dreamlike. The green peaks that thrust up from the ocean, decorated by corals, black pearls, and colorful sea life, have the allure of a natural cathedral imbued with a majestic and sensual simplicity. From a cultural perspective, the islands are extremely vibrant. Not only have these volcanic oases attracted great artists, they are also a hub for annual festivals and important international gatherings. Here, some travelers can't resist the temptation of returning home with a tattoo, one of the most popular local art forms. As an emblem of beauty and social belonging, it still has symbolic value. The young especially like to display a strong cultural identity on their skin. Once the exclusive privilege of nobles and priests, tattoos are now a requisite for conquering the hearts of local women.

Must See

A cruise aboard the **Aranui III**, a ship flying the French flag whose crew is composed mainly of friendly Marqueseans, allows one to admire these splendid volcanic islands from the sea and to visit the bays, beaches, and most charming coves of the archipelago. The Aranui III, which was recently equipped with the most luxurious comforts, was originally a cargo ship—a descendent of the boats on which passengers and goods used to travel. More adventurous visitors can explore the archipelago by boat, and among the places they can visit is **Hatiheu Bay**, the preferred retreat of writer Robert Louis Stevenson, as well as **Anaho Bay**, perhaps the most beautiful of all the Marquesas.

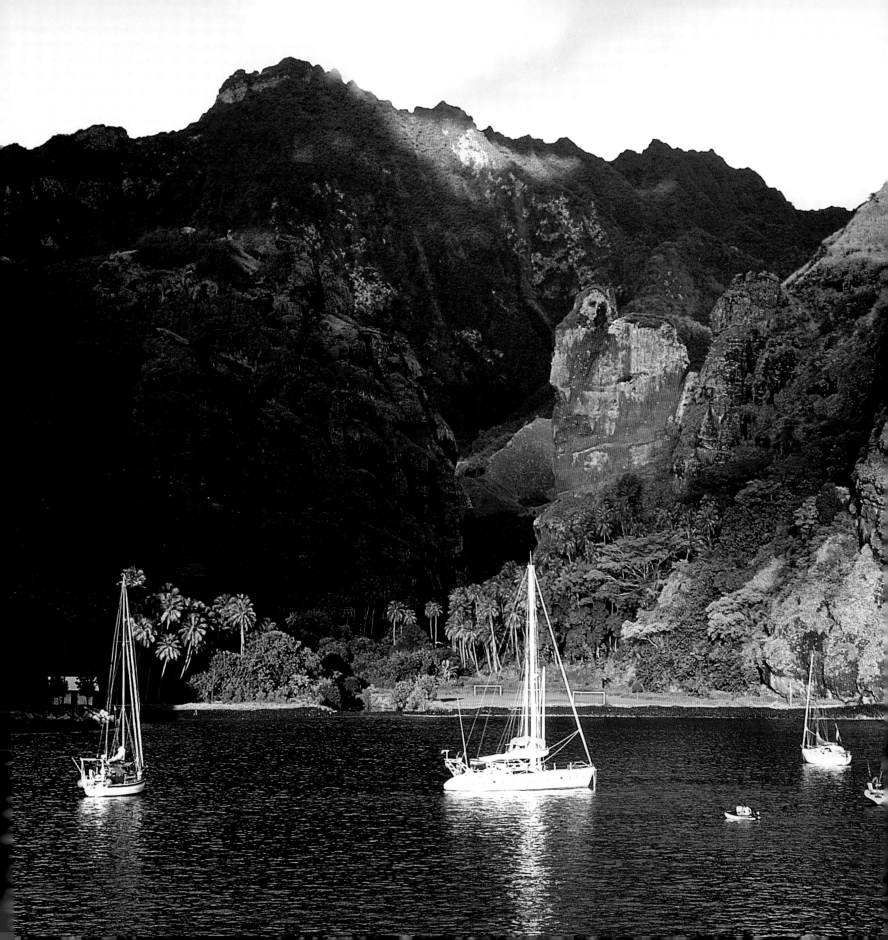

KANGAROO ISLAND

Kangaroo Island boasts a wide range of wildlife. The local species include the kangaroo (below), wallaby, sea lion (opposite), eagle, echidna, possum, and various species of bats and frogs.

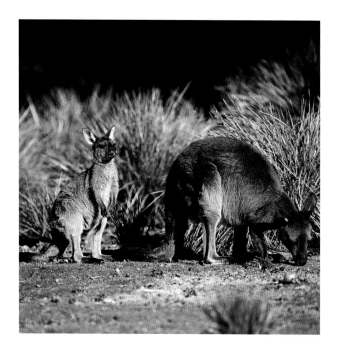

As the name suggests, the kangaroo is right at home on Kangaroo Island. But on this island swept by ocean winds only a half-hour flight from Adelaide, the capital of South Australia, you also find wallabies, possums, echidnas, goannas, and penguins—not to mention otters, eagles, dwarf emus, the elusive platypus, and many species of reptiles and birds. The island is also home to diverse species of sea dragons, as well as the loveable koala bear, by far visitors' favorite. Visitors can easily run into koalas, who sit serenely in the branches of eucalyptus trees for hours on end, moving with incredible slowness, and only when the tender leaves around them become scarce.

A third of Kangaroo Island's territory is designated as either a national park area or otherwise protected. It is fascinating not only for its extraordinary variety of fauna, but also for its diverse landscapes. You can find vast forests of eucalyptus, ash, and acacia trees, as well as green meadows full of sheep and cattle. There's even a "little Sahara" with dunes next to the ocean, and the so-called Remarkable Rocks, a formation of enormous granite blocks sculpted by winds in a panoramic setting atop a sheer cliff. The island's most precious jewel is Vivonne Bay, a long and enchanting half-moon of golden sand, often declared the most beautiful beach in Australia. Endless emotions await at Seal Bay, with its thriving colony of sea lions lazily sunbathing on the beach or diving into the waves, oblivious to any human presence—great material for photos and unique films. The most intense emotions occur at sunset on Penneshaw Bay, where every evening thousands of little penguins return to their burrows in single file after a day spent in the fish-filled waters.

Must See

Make a visit to the old **Cape Willoughby Lighthouse** and purchase some whiskey, soap, and eucalyptus candy at the **Emu Ridge Eucalyptus Distillery**. Another absolute must is making the climb up the 512 steps of **Prospect Hill**, just as the explorer Matthew Flinders did when he discovered Kangaroo Island in 1802. During a visit to **Flinders Chase National Park** you can admire the **Remarkable Rocks**, giant and strangely iridescent rock formations that balance precariously above a promontory lapped by the ocean waves. Finally, spend a night at the **Stranraer Homestead**, where Lyn and Graham Wheaton greet guests with a table fit for a king.

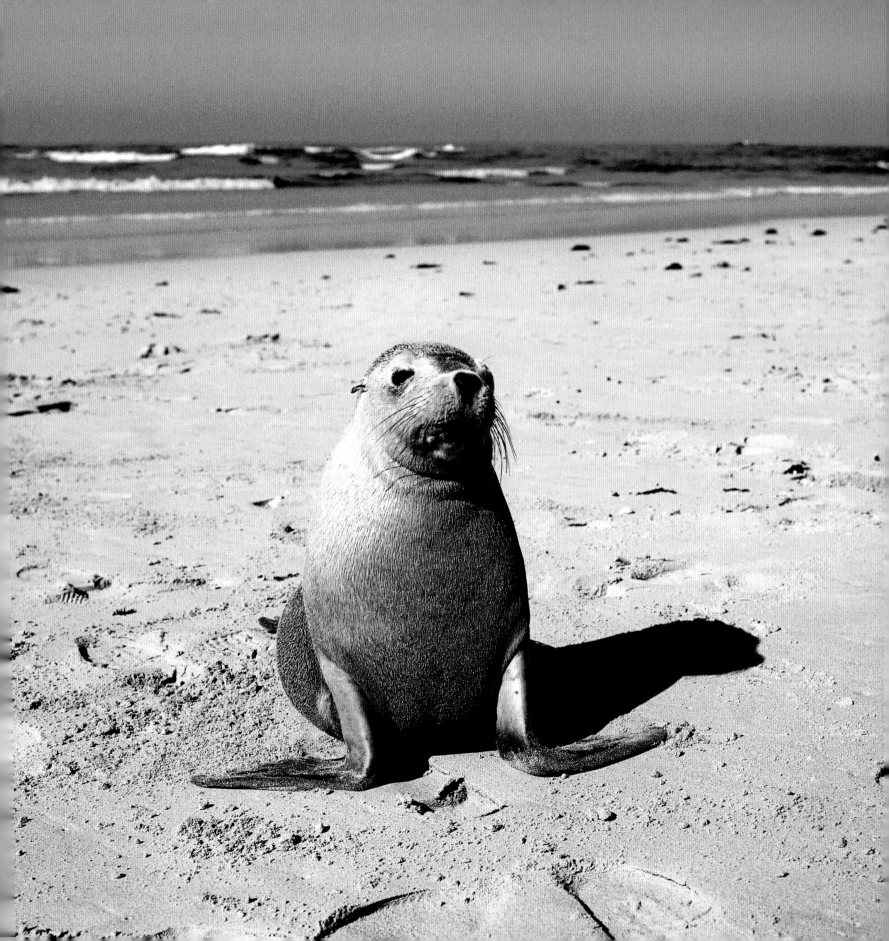

LAMPEDUSA

*Above: The small port of Lampedusa, home to fishing boats.
Below: Rocky cliffs on the eastern coast.*

Opposite: The Island of Rabbits, a natural reserve where loggerhead sea turtles lay their eggs.

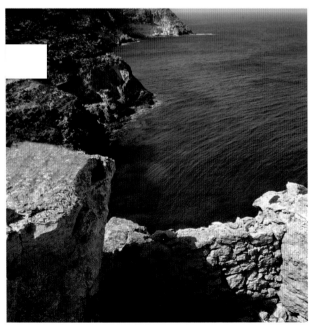

Lampedusa is a strip of Italian soil that surfaces close to the shores of North Africa. Geologically, it's a granite tabletop attached to the African continental shelf. It is also an island of turquoise waters and compelling cuisine, a place where you can lose yourself in the colors, melt away in the waves, or close your eyes and become intoxicated by the rich natural scents. The island generously offers impressions that can be sampled by all five senses. It starts with sight: the shades of the sky are painted as a reflection on the sea, and change depending on the time of day. In the morning, Lampedusa is tinged a delicate blue that gradually becomes infused with more saturated and decisive tones. It then makes way for orange and red sunsets that broaden the sky and are quite spectacular, especially when the sirocco blows and the air is saturated with the fragrances and heat of Africa, which act like a warming embrace. Here you can feel the wind's caresses and inhale an air rich with intangible emotions.

Be it the sea, with its unmistakable scent, or the bare landscape that hints at the allure of the desert, Lampedusa is a work of art laid gently upon the sea. It's one of the few islands that's been able to preserve intact the physiognomy of a tropical paradise, as well as the surrounding sea, populated by snapper, grouper, amberjack, lobster, turtles, dolphins, and parrotfish—the latter come from the Red Sea via the Suez Canal.

The lunar landscapes of the island's interior are part of an arid desert dotted with shrubs that have been debilitated by the scorching heat, a flat region where heat sketches out the contours of mirages, revealing nonexistent oases. Its virgin spaces are silent, and the wind blows slowly so as not to disturb the eternal calm. Here you can hear the island's heartbeat, which invariably leaves a lasting impression.

Must See

The major coves, grottos, and white sand beaches are amazing spots, saturated in light and archaic colors, that have remained unspoiled throughout the centuries. They include: **Cala Madonna**, **Cala Croce**, **Scoglio del Sacramento**, **Grotta Cattedrale**, **Cala Pulcino**, **Grotta del Bue Marino**, **Cala Stretta**, **Punta Sottile**, the famous **Cala Galera**, **Cala Maluk**, **Punta Cappellone**, and the **Grottaccia**, the most stunning of the island's grottos. When the tourists are absent in the off-season, it's worth spending an entire day on the **Island of Rabbits**, particularly the **Vallone dello Scoglio**, the island's broadest beach, which is surrounded by shallow sparkling waters.

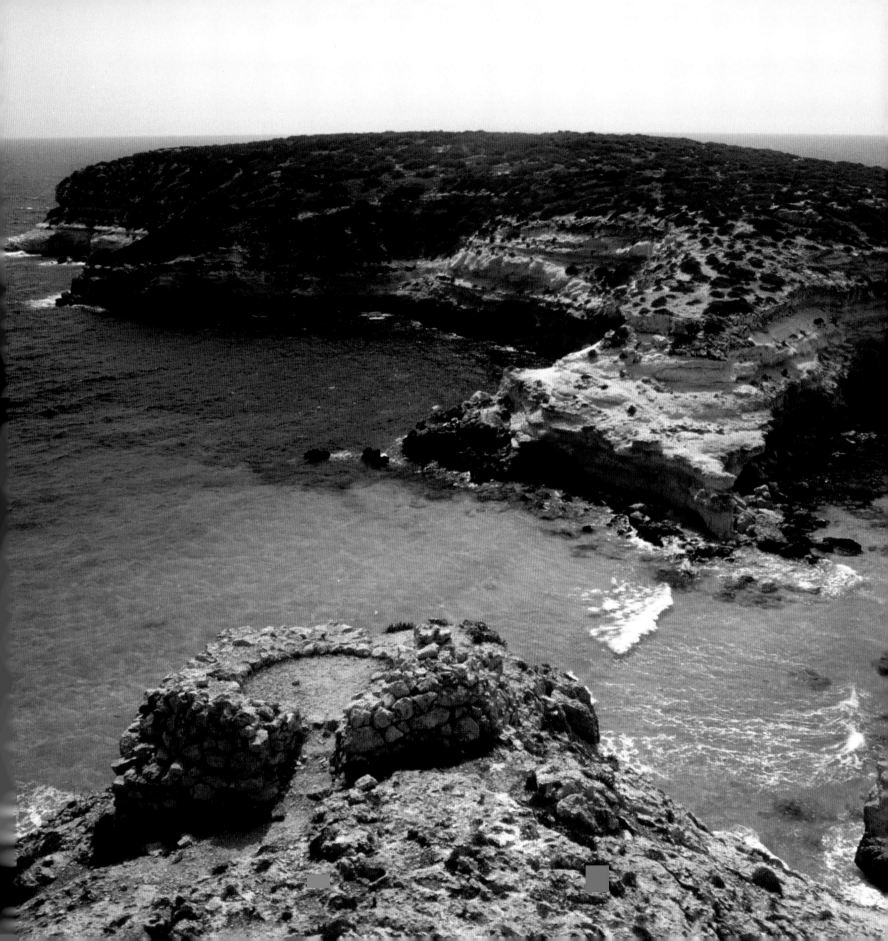

LOFOTEN

J ust off the northern coast of Norway, the Lofoten archipelago is one of Europe's most dramatic landscapes, and undoubtedly represents one of the last natural paradises of the Old World. Its jagged mountains with sharply, serrated edges rise up 4,000 feet from the ocean like vertical monuments. In the middle of verdant meadows a turquoise sea appears, along with idyllic fishing villages and beaches not unlike those found in the tropics. It's an enchanting place, to say the least—a masterpiece of nature. Seen from a distance, the rocky mass that makes up its five major islands—Austvågøy, Gimsøy, Vestvågøy, Flakstadøya, and Moskenesøya—resembles, irrespective of the direction from which one approaches, a continuous rampart that beckons and bewitches the visitor.

According to legend, the Lofoten Islands— whose etymological root comes from *lo* (lynx) and *fotr* (foot) in Old Norse—were created when God, still holding on to a small quantity of matter, threw it into the sea and proclaimed: "whatever becomes of it, becomes of it." The result was more than satisfactory. And despite its location in northwestern Scandinavia, the archipelago, which stretches over roughly 100 miles into the Atlantic waters between the Norwegian towns of Bodø and Narvik, has a remarkably mild climate due to a mix of warm currents from the Gulf Stream and cold blasts of air arriving from the Arctic. In fact, the weather here is anomalous as it's impossible to find a similar spot on the same latitude this far north of the Arctic Circle. Yet on the Lofoten Islands, everything seems different—the atmosphere, the light, the people. In particular, the local people are quite unique, as their faces are marked by a way of life

Above: Drying houses for cod in Svolvær.

Right: Aerial view of islets in the southern Lofoten archipelago.

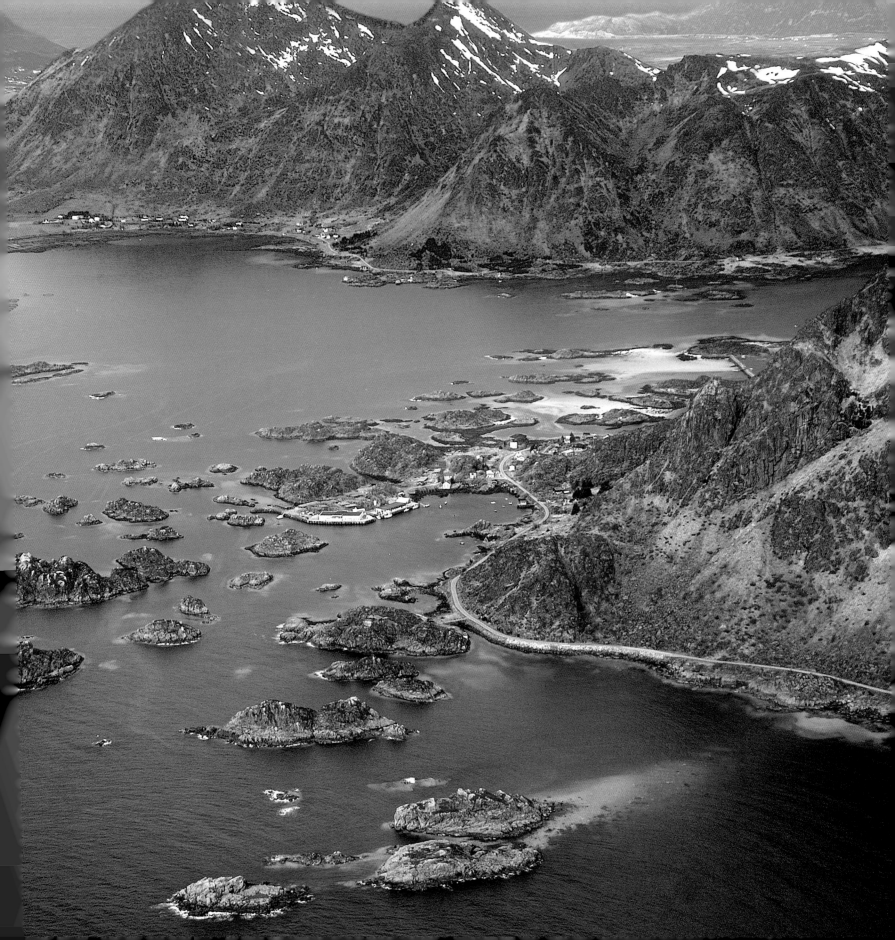

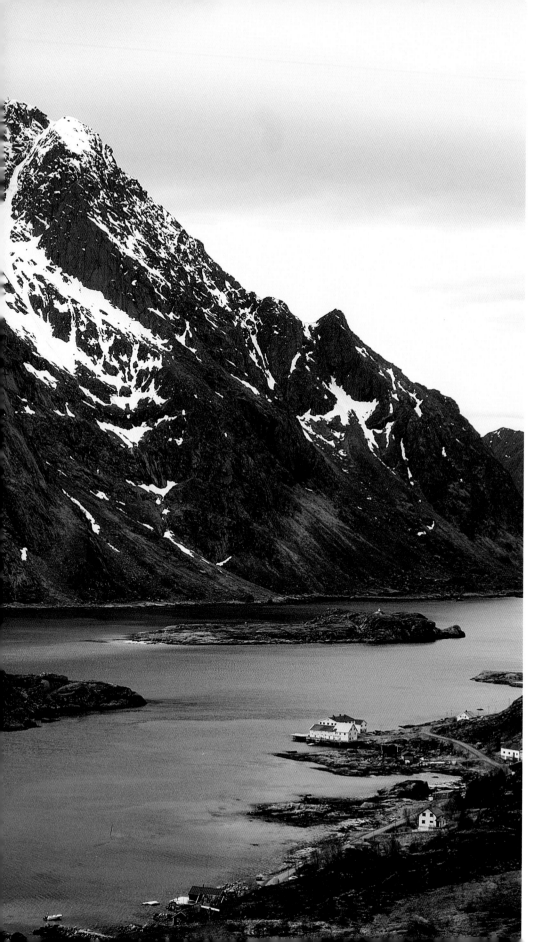

dictated by nature. Everything is written on their faces, which can be read like a map. Here, facial features vary like the scenery, both radiant and dark at once, weathered by time and the Atlantic winds; it's a lucid, sincere gaze that reflects the particular light on this stretch of coast.

The main source of income for the local population (25,000 inhabitants) is fishing and tourism, though the former has seen a decline in recent years related to overfishing of the North Sea. Thus tourism has become the major source of revenue for the islands, but it remains an activity that adheres to a pragmatic and sustainable approach, geared toward hiking, cycling, climbing, and sport fishing. In addition, these islands are known for their Viking heritage. Also noteworthy is the transition from the *Mørketid* (darkness) in winter to the midnight sun in summer, when from late May until the second week of July the sun never sets. This significantly influences the local way of life, not only for those who live here, but also for those who visit.

Svolvær, the capital of the Lofotens, is the archipelago's main base for fishermen. The town is also particularly attractive for artists, and is an artistic hub of northern Norway.

Must See

Take an excursion to **Trollfjord**, a marine inlet. This fjord, which has also been nicknamed the devil's canal, gets its name from Norse mythology (the *Trollen* were fairy-tale creatures) and it is without doubt one of the most spectacular fjords in all of northern Norway. The branch called **Raftsund** is 1.5 miles long, only 300 feet wide, and quite deep. It makes up part of the island's vertical rock wall that rises up to 4,000 feet. The Trollfjord was made famous for the eponymous battle that took place in 1890 between local fishermen and merchants over cod fishing rights. Other points of interest include the quaint town of **Digermulen** as well as **Svolvær**, capital of the Lofoten Islands.

Above: A typical seaside village.

Right: The village of Svolvær with its characteristic rorbu, wooden cabins used by fishermen.

Opposite: Fjord in the southern part of the archipelago.

Below: Eggum Beach on the Atlantic coast.

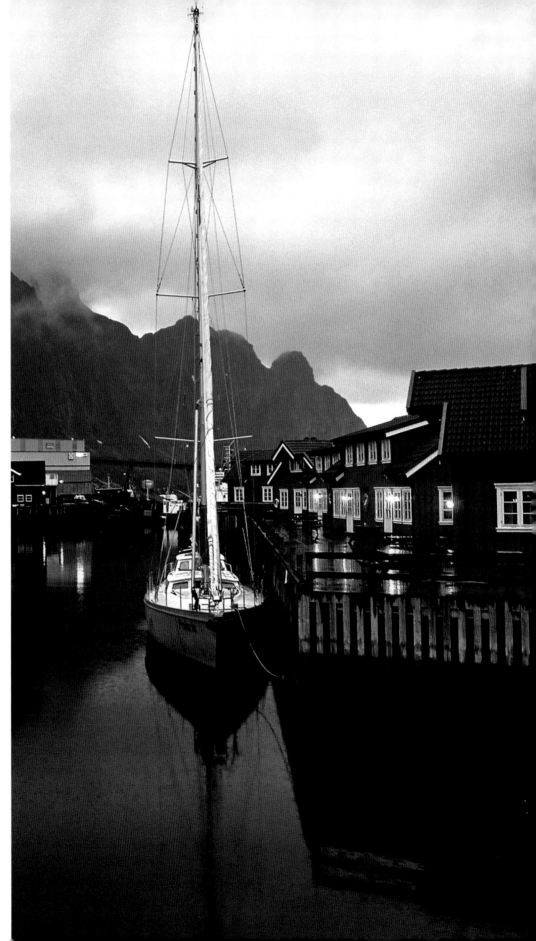

LUSSINO

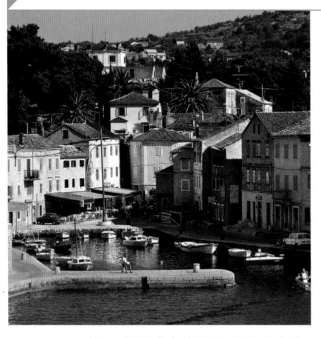

Above: Mali Lošinj, which despite its diminutive name is the biggest town on the island.
Below: Veli Lošinj, cozier and less crowded than its big sister.

Opposite: Lošinj Bay seen from above.

Lošinj—commonly Anglicized as Lussino—is a jewel in Croatia's Kvarner Gulf. This verdant island is suffused with the scent of sage and rosemary. It has two towns—Mali Lošinj and Veli Lošinj—full of vivid colors and pristine beaches just a short walk from the main square. Veli Lošinj, which translates as "Big Lussino," is, despite its name, smaller than Mali Lošinj, which translates as "Little Lussino." Situated on the northwest coast of the island Veli, Lošinj still looks like a typical fishing village, with pink, white, and ocher houses built one atop the other, closely huddled around the bay and the church of Saint Anthony. Behind them is an intense green backdrop of maritime pines, often bent by the wind that can be a pleasant breeze in the summer, while in the winter it turns into the incredibly strong Bora. There are a few hotels, found mostly in Mali Lošinj, on the northeast coast, where the white church of the Nativity of the Virgin stands out. Beside it is the famous Cikat Bay, with pebbles and sand, where the green seems to reach straight into the intense blue of the sea. Between the two towns, hidden among the rocks and pines, are several secluded churches and the ruins of ancient Roman villages, farmhouses, and Venetian towers.

Lošinj is an ideal destination for nature lovers. There is only one road, running lengthwise, on the entire island. The only connections are to the Island of Cres, via the bascule bridge over the Osor Canal, and to Pula and Zadar by ferry. To get around, you should use a bicycle to enjoy the silence, the salty sea air, the lookouts onto nearby islands, and the many hidden bays. There are no traffic worries, especially during the off-season—the island's population, across an area of 28 square miles, is less than 8,000.

If you go to the local tourism office, or simply ask a local fisherman, it's possible to organize an excursion to nearby Susak, an island of sand about 1.5 square miles in area, and Ilovik, a series of green hills that pop up from the sea.

Must See

The **Lošinj Dolphin Reserve** is the Adriatic's oldest and largest protected area dedicated to bottlenose dolphins. The nearly 200 square miles were declared a reserve in 2006, but it has already been monitored and researched for over two decades. The reserve is situated in the waters east of Cres and Lošinj, including the small islands of Cutin, Oruda, Orjule, Trstenik, and Ilovik. Dolphins thrive in this area, as do loggerhead turtles and blue sharks. So far, 112 different species of fish and 152 species of plants have been identified, showing a remarkable wealth of wildlife. Much to the delight of divers, there is even a shipwreck dating back to 1917.

MARETTIMO

*Above: Pizzo Capraro seen from nearby Monte Falcone.
Below: The lighthouse at Punta Libeccio in the south.*

*Opposite: It's best to visit the island's beautiful beaches
by boat, as many are hard to access on foot.*

Marettimo rises to a peak of 2,250 feet, a dolomite monolith projecting from the deep blue abyss toward the bright blue sky. The westernmost of the three Aegadian Islands, its profile can be seen from the two easterly islands, Favignana and Levanzo, only when the weather is good. Up until the 1980s, when there were rough seas the ferry would disembark passengers offshore, and rowboats would come out to pick people up. Renting a room from Cenza, a local widow who hung her wedding dress in a locked armoire, cost 10,000 lira a night. This was the custom in Marettimo: widows wore black for the remainder of their lives, and rented out their master bedrooms to visitors. The houses smell of Marseille soap, and the beds have white linen sheets that are hand-embroidered and give off the crisp scents of sun and sea.

Here, under an African sun, the entire world seems made up of a small town, a church, a piazza, a trattoria, a gelateria, and two harbors—one old, one new. From windows overlooking the old port, many locals fish for sardines, which quickly find their way into the frying pan. And though church bells often pierce the morning calm, the real wake-up call actually arrives at seven from the booming voices of fruit and vegetable vendors. Each day they make the rounds shouting "lovely peaches, tomatoes, eggplants." On Sundays, of course, everyone rests.

Homes here are decorated with a simple elegance. A few local motorboats head out to Cala Bianca, Punta Libeccio, and the multicolored grottos where divers visit corals, sea fans, and moonfish. From the depths of the Mediterranean, a magical world comes into view; the dreamlike Aegadian Islands are a world everyone may enjoy, as long as they respect it.

Must See

Known as Hiera in ancient times, Marettimo is a rugged, almost inaccessible island not suited for the lazy. Within its limited space, there's a lot to see: diving on the sea floor, countless grottos, sharply overhanging dolomite cliffs, delightful inlets, and high-altitude vistas of the sea while trekking. After the **Roman ruins**, pines, and lush meadows filled with flowers and herbs, you'll reach the summit of **Monte Falcone**, with its hawks, marine swifts, and seagulls that both hunt and are hunted. In the evening, the landscape is engulfed in the scents of mouth-watering Sicilian cuisine centered on fish. **Hiera**, the island's oldest restaurant, and **Trattoria il Timone** are the best dining spots.

Above: Ciutadella, the island's former capital, is now a hub of fashionable shops, cafés, and restaurants. Below: The bay at Cala Blanca.

Opposite: Cala en Turqueta.

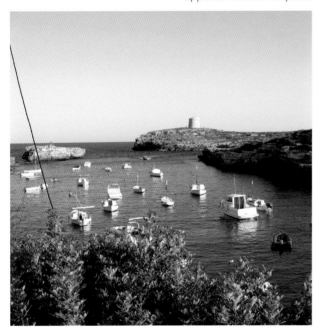

The heat, the sunshine, the sea: all these inspire a desire for relaxation, but also something more. Discovering Minorca is like falling in love. You're always in search of something special, be it the island's most enchanting feature or its most hidden locale, which becomes a gift to those who explore the island closely and follow their heart. It's a pity that these pages are deprived of sound, otherwise it would be possible to hear the undertow of the waves breaking on the reef, or catch the crunching sound of footsteps on wet sand as your eyes wander across the crystalline waters toward the horizon. An intense fragrance of pine trees wafts through the air, diluted by a even stronger scent emanating from the sea, as the island—the most northern and eastern of the Balearics—has a marine bouquet.

It stays this way until evening, when the blood-orange sky waits for the sun, which is in no hurry, to start fading into the horizon. The following day the sun again shines brightly and generously, and a refreshing air extends down the coast until it reaches the giant rocks at Pregonda and Pregondo. Due to their pebbly sand, these two bays seem to be protected from the boulders, which makes them a refuge on the rugged northern coast. Curiosity and a fervent spirit of adventure propels you forward to other breathtaking scenes: from the rugged northern reefs you can move on to admire the gorges in the south, which provoke rich emotions. Even the less sensitive visitors can't resist the island's mysterious power. Only by setting foot here can you truly understand the irresistible allure that takes hold of travelers, who become spellbound by the landscape, pristine beaches, red earth, clean waters, and contrasting colors. And when leaving, as you look back from a distance, the wind appears to blow the island farther out to sea. It resembles a raft, unique and eternally mysterious, ready to receive with open arms whoever wishes to experience a sweet giddiness.

Must See

L'Arenal de Son Saura, better known as **Son Parc**, is one of the few beaches in the northern part of the island that has fine white sand. **Cova de en Xoroi** is a natural cave located in the cliff face near **Cala en Porter**. On the walls, you can read about one of the legends of Minorca, the Arab Xoroi. After having sampled the lobster stew at **Fornells**, take a pleasant stroll along the waterfront. Not to be missed are the beaches of **Cala Macarella** and **Cala Macarelletta**, located on the trail between **Ciutadella** and **Sant Joan de Missa**. Surrounded by rich vegetation, they are prized for their translucent waters and turquoise colors.

84

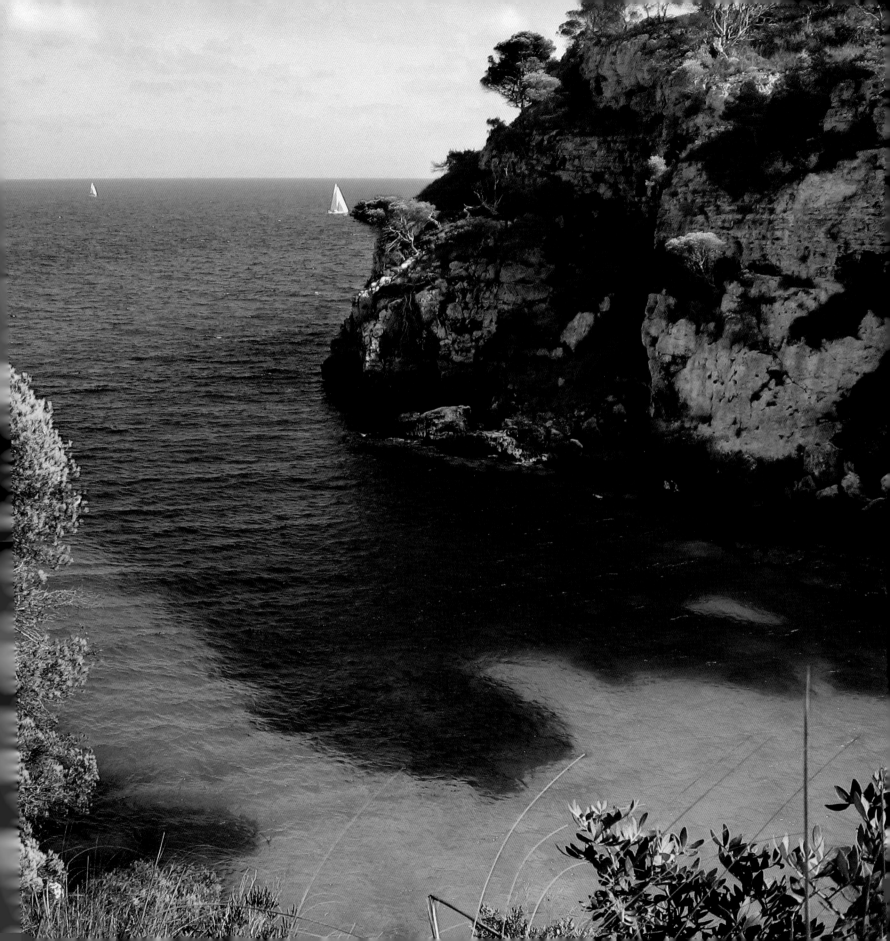

SAAREMAA

Above: Waterfall on the Lõve River in Valjala municipality.
Below: Canoeing on the Põduste River.

Opposite: Väike Canal, the stretch of water dividing Saaremaa and Muhu Island.

For the Vikings and other ancient peoples of Scandinavia, heaven supposedly corresponded more or less to present-day Saaremaa. One of the largest islands in the Baltic, it lies within Estonia's borders and its 1,000 square miles of territory are home to one of the least densely populated areas in Europe. It features beautiful green pastures, rolling hills, placid waters, and miles of white sand beaches. Saaremaa has everything you'd expect from a picturesque Nordic setting: tall grass rippling in the wind, cream-colored sheep, and windmills dotting the fields, with deer and elk crisscrossing roads undisturbed. There are endless forests, the scent of juniper, crisp colors only found at these latitudes, and clouds aligning in ways that only occur in these skies.

In centuries past, kings and emperors would spend relaxing moments here. Up until recently, Soviet bureaucrats visited, and today Tallinn's upper middle class—many of whom are Swedes and Finns—build colorful wooden cottages amid the trees. Somewhat paradoxically, the island's scenery has remained untouched thanks to the Soviet occupation—though the Estonian people's sacred respect for nature also plays a part. The entire area was once strictly off-limits, as the Red Army had built secret military installations for its navy and air force.

Meanwhile, the small island of Abruka, located in the bay in front of Kuressaare, the capital of Saaremaa, still lives according to a medieval decree that prohibits anyone—the island's 10 residents included—from moving any stone or branch that could in any way alter the landscape. Accessible by boat twice a day in the warmer months, the island still has a dense forest and surrounding sea that conjure up the distant past.

Must See

Kuressaare Castle is located in the island's capital. During the middle of summer, at midnight, this Viking castle—considered the most classic design within its category, thanks to its fortified walls, crenellated towers, moat, and draw-bridges—is bustling with young people. Just outside of town, the castle is close to a beach where endless games of volleyball are played in the soft light and crisp morning air. Inside the castle and its ramparts, there's an amphitheater immersed in green grass where rock concerts and festivals are held. Connected to Saaremaa via a causeway, tiny **Muhu Island** features quaint fishing villages like **Koguva**.

SAN BLAS

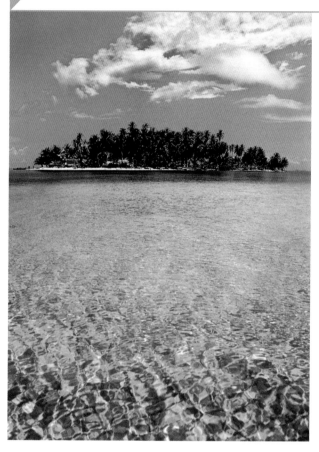

Above: View of Coco Blanco.
Below: Loading bananas at the port on Nalunega Island.

Opposite: Kuna woman in traditional dress.

A 12-seat turboprop flying from Panama City gets you to this small Central American territory in 50 minutes, where you'll pass over tangled forest before seeing hundreds of islets ringed by sand, palm trees, and turquoise waters. Close to the runway at Mamitupo Airport, which is little more than a hut and an asphalt strip, flat-bottomed boats welcome tourists on a journey to discover San Blas, the undisputed kingdom of the Kuna Indians and self-governing territory off Panama's Caribbean coast, not far from Colombia.

Authority here is entrusted to the *Saila*, a chief who is assisted by a council of elders; the shaman, known as *Nele*, conjures up forecasts and prophecies. While men here still move around in canoes, they also surf the Internet. And although they work in nearby Panama, where everything is state-of-the-art, their own huts don't even have telephones. Thus old customs intermix with the material things of the modern world. Women look after raising their children and weaving traditional *molas*, finely embroidered fabric that depicts animals and geometric patterns. These are worn with pride, and are the locals' most prized handicraft. Such outfits aren't sold cheaply, either, as prices vary between 20 and 40 dollars per piece. Rounding off the female wardrobe are the *canilleras*, rows of colorful twisted beads that wrap around arms and calves. A small, solid gold ring is also worn through the nose, and makeup is used—typically a wide, dark line—to emphasize the nasal septum. Dressed in such a way, the colorful Kuna women would seem perfect for a portrait, but they don't willingly let themselves be photographed. They claim the camera takes away their soul—although a payment of one dollar does help the soul run fewer risks. In the end, you can't deny that a few concessions have been made; but the Kuna's ancestral values, as a whole, continue to endure. It's an incredible balancing act that needs to be safeguarded.

Must See

Nobody's quite sure how many islands there are in this archipelago, perhaps 365, one for each day of the year. The untamed and unspoiled San Blas Islands are a spectacular string of coral labyrinths covered in coconut palms that are still relatively unknown on the international tourism circuit, and locals' efforts to protect the native culture remain strong. In the few lodges managed by the local Kuna, you'll only find spartan cabanas. The ones on **Achutupu** are spacious yet simple, with straw roofs, electricity running only until 10 o'clock at night, and private baths without hot water. Another must see is **Coco Bandero**, where the beach's beautiful white sands extend far offshore.

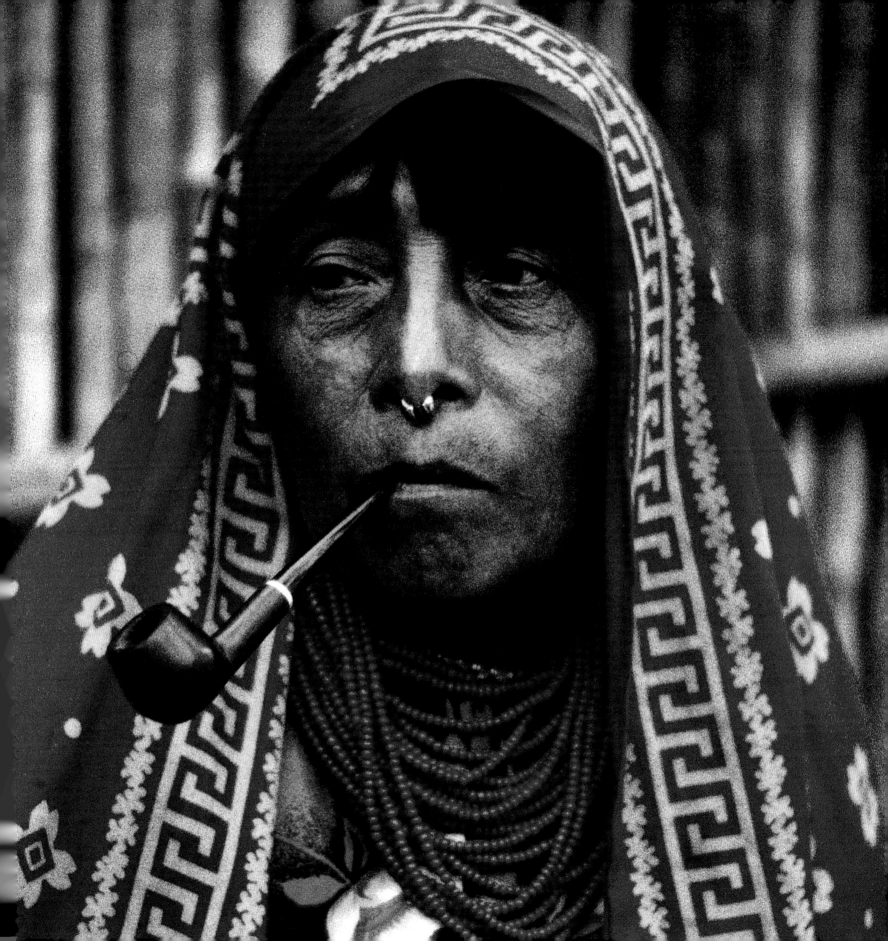

SVALBARD

Its mountains of rock are sculpted by the wind and laden with ice, a cornice suitable as a ring for the mythical Nibelungs. To consider this island a part of Europe is a bit of a stretch. In reality, it literally is the roof of the world. Svalbard lies just 600 miles from the North Pole, between 77 and 81 degrees north, on the last portion of floating earth inhabited by humans right next to an eternal ice cap. It's a place where sunlight is limited by the seasons: from October to March it's polar night, while spring and autumn are brief intervals (and the only time of the year when each period of 24 hours is divided between night and day); between June and late August there's the intense and vibrant arctic summer.

The Vikings were the first to arrive in this archipelago, baptizing the islands *Svalbard*, or "frozen coast." In 1596, the explorer William Barents christened them *Spitsbergen*, or "jagged peaks." Today, they go by their original name, while the later name refers solely to the largest island. The archipelago's history is one of cruel and indiscriminate exploitation of its natural resources. In the 17th century, Dutch, English, Basque, and Hanseatic whalers all hunted the Bowhead whale to near extinction. The following century saw the Russians inflict a similar fate on the reindeer and walrus. In the 19th century, the Norwegians went to work hunting the seal population. Ecological salvation arrived in 1899, when rich coal deposits diverted attention away from the animals and sparked a sort of mineral war among the great powers of the day. Norway scored a political victory in 1925 with the annexation of the archipelago, while the Soviets secured commercial rights. Thus, Svalbard still hosts Russian miners in addition to a handful of students,

Above: View of Magdalena Fjord.

Right: Polar bear staring at its reflection in the icy waters.

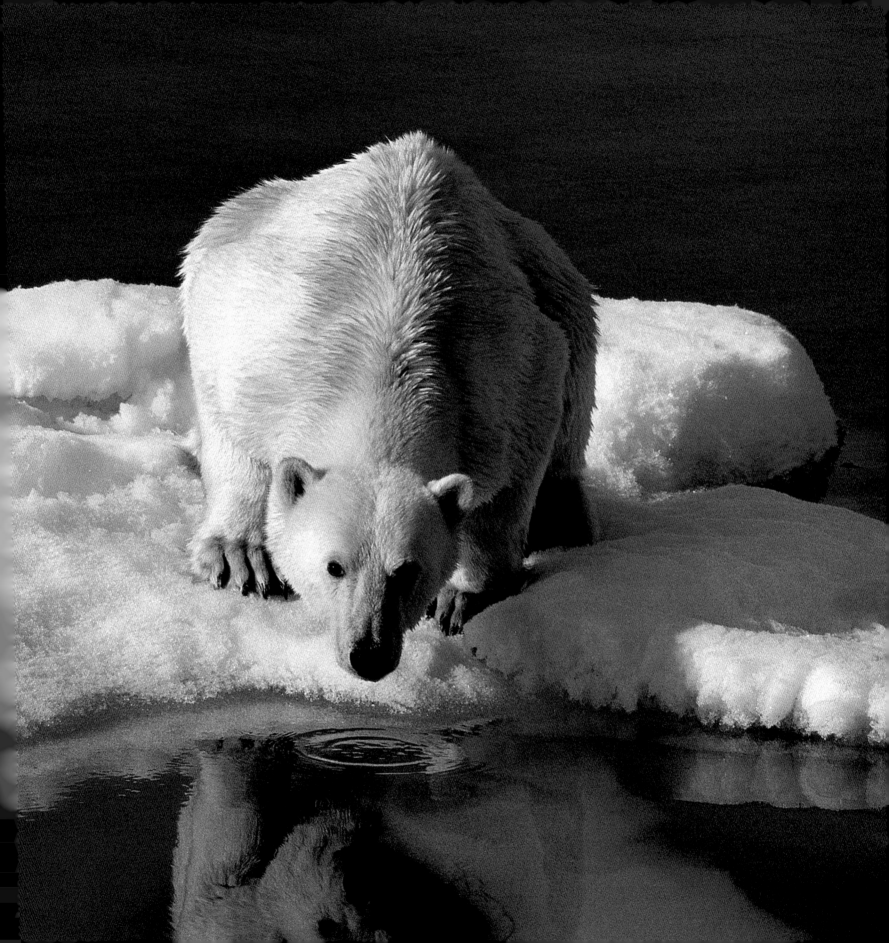

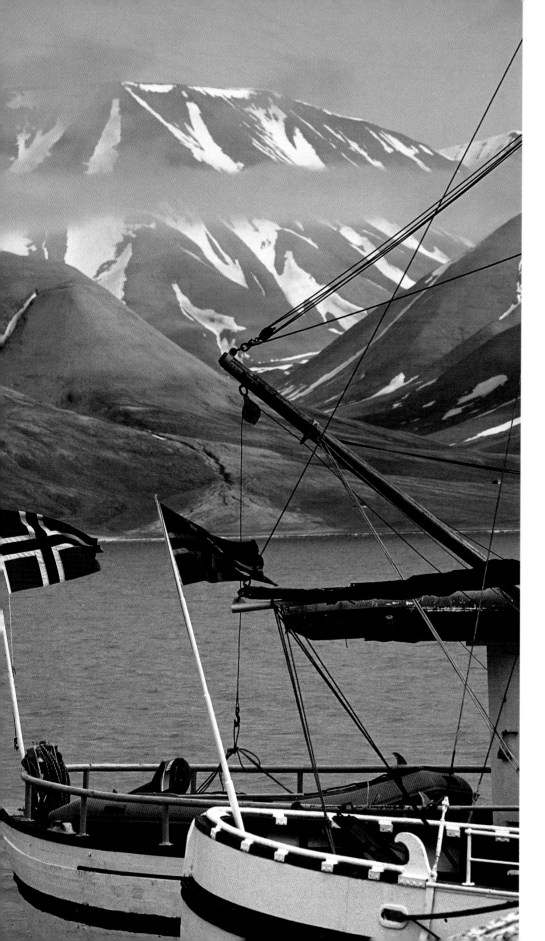

researchers, scientists, and tour operators: today, a total of 3,000 residents live on 23,000 square miles of land, though most are concentrated in two settlements, Longyearbyen, the capital, and Ny-Ålesund.

The stoic and fairly heterogeneous locals are drawn to Svalbard's informal and unfettered way of life. During the long polar winter, the only distraction is the aurora borealis, which animates the sky and makes for ideal astronomical observations. In good weather, the islands are more accessible, as the arctic landscape becomes a "land of light" and the environment offers all sorts of magical encounters: clear polar skies that almost blind the eyes, clouds of every shape and size punctured by the sun as it alights a circle on the surface of the sea, and the inevitable mirages that conjure up nonexistent islands and glaciers. This scenery incessantly reveals a natural paradise, which is protected with care and diligence. The only excursions available happen between July and August aboard oceanographic vessels. Located at the edge of the world and the boundaries of time, and protected by its extreme climate, the archipelago maintains the magical silence of ancient legends. Under its sky, heroism and tragedy unfolded as explorers such as Umberto Nobile and Roald Amundsen were won over by the land.

Must See

The Svalbard archipelago is one of the few spots where you can observe arctic **fauna** (whales, seals, walruses, reindeer, and a variety of birds) and arctic **flora** just as they were on the first day of creation. The unquestioned protagonist here is the **polar bear**, the main predator on the islands. They can be approached via rubber dinghy or on foot, but use extreme caution. Visiting the first **explorers' settlements** is a particularly touching reminder of the past. In the summer, Svalbard is without doubt a photographer's paradise thanks to its bright, blinding skies, untouched glaciers, and spectacular panoramas ranging from white to intense shades of blue. Before leaving, don't forget to sample the savory **reindeer stew**.

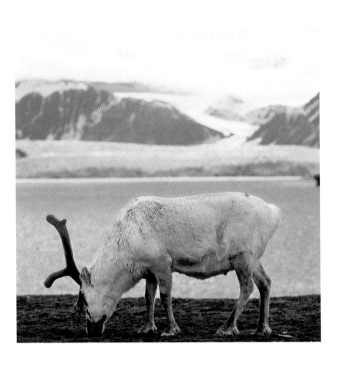

Above: In addition to reindeer, arctic wolves, polar bears, walruses, seals, whales, and a variety of birds all flourish here.

Right: Excursionists aboard a dinghy at Magdalena Fjord, one of the islands' most captivating sites.

Opposite: A view of the port at Longyearbyen.

Below: Commemorative bust of the explorer Roald Amundsen in Ny-Ålesund.

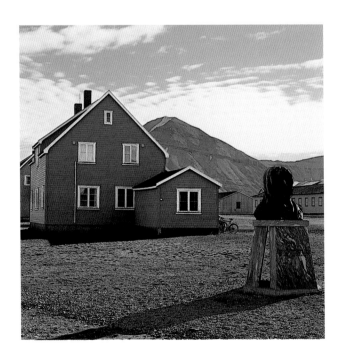

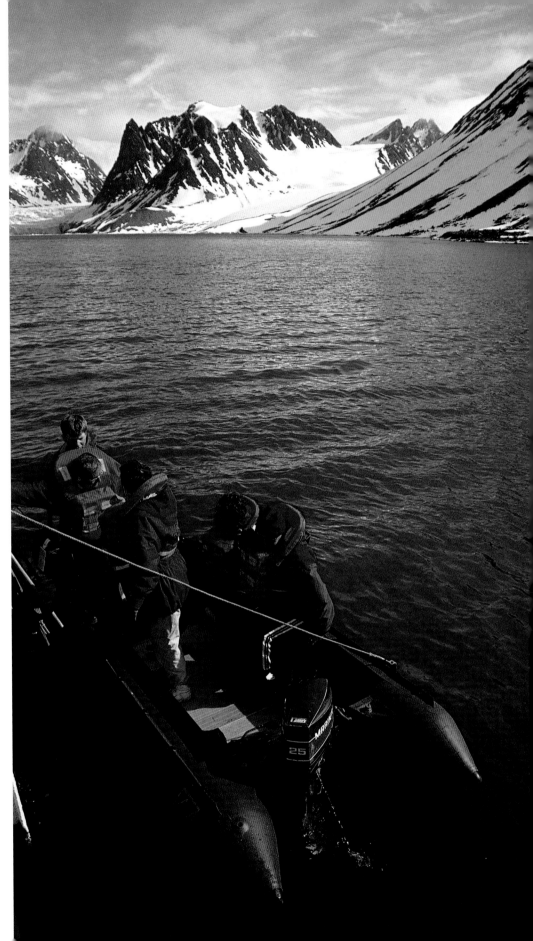

TASMANIA

Tahune AirWalk is located inside one of Tasmania's many forest reserves. Crossing this elevated walkway, suspended high above the trees on steel trusses, you can admire the foliage of the wet eucalyptus forest from a hundred feet in the air. From the undergrowth of lush ferns, plants rise straight up like spears pointing toward the sky. This one-of-a-kind experience offers an unusual vantage point from which you can appreciate its primordial nature, which reminds you just how much this island remains an unsullied paradise. Tasmania's natural environment is one of great value, having always been respected to the point that the recent construction of several dams was seen as a collective drama by the local population. The Tahune AirWalk is in the south of the island, not far from Geeveston, an hour's drive from the capital of Hobart. This latter city sits next to a spectacular bay, with two sides resembling a pair of welcoming arms opened wide. Each year this port greets sailors from one of the world's most famous regattas, the Sydney to Hobart Yacht Race that takes place in the rough seas of the Bass Strait, just south of Melbourne.

The island was discovered by Dutch explorer Abel Tasman, who christened it Van Diemen's Land—a name that remained until 1856—in honor of Governor Van Diemen. Tasmania has one of the highest concentrations of national parks in the world. Dominated by the barren ramparts of Mount Wellington, Tasmania is a succession of peaks, forests, and lakes. In November, the fields are colored pale pink by the broad bean flowers. Its English heritage is evident in the characteristic Georgian residences in picturesque hamlets, but also by what remains of the penal colonies, where His Majesty's government deported thousands of condemned men that, once free, became the island's first citizens. Port Arthur, on the Tasman Peninsula, is the most infamous penal colony, and held inmates as early as the 1830s.

Must See

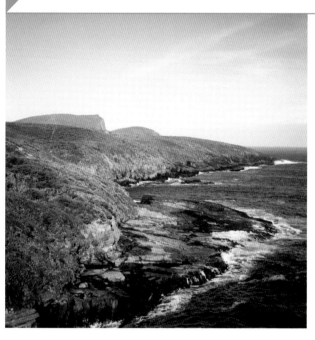

Above: A stretch of the island's southeastern coast.
Below: Tasmanian devils in the Bonorong Wildlife Center.

Opposite: Coastal view of Maria Island National Park.

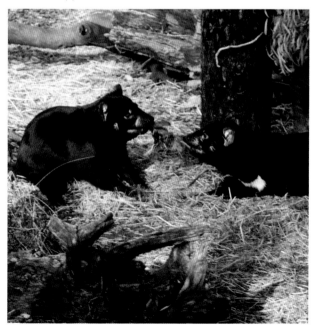

Not far from Tahune, the **Bonorong Wildlife Center** in Brighton (a half-hour drive from Hobart) is famous as the main wildlife reserve of the *Sarcophilus harrisii*, commonly known as the **Tasmanian devil**. Native to the island, the voracious little animal has achieved popular fame thanks to Taz, the animated cartoon character. The "little devil" sports black fur and a white stripe, and is noted for its powerful jaw, which helps it devour carrion. It's known to fight with other devils when feeding, but despite its irritable demeanor, the creature does have a goofy aspect to it. At Bonorong, visitors get to see these devils in their natural habitat.

94

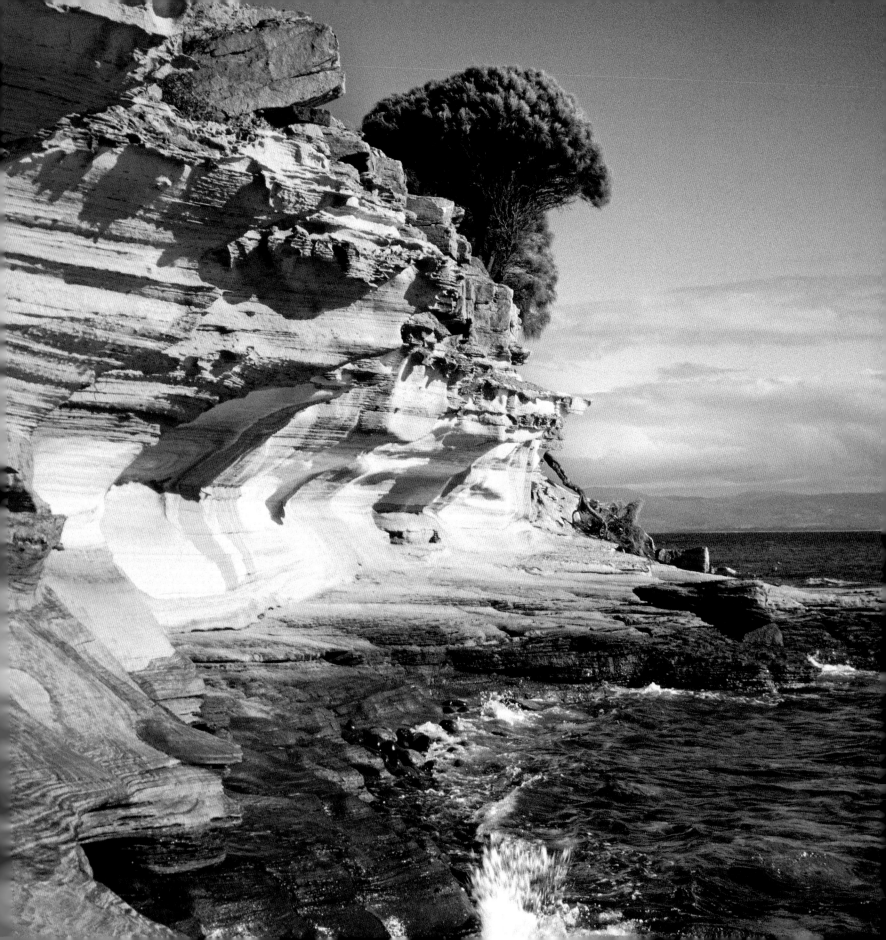

TOBAGO

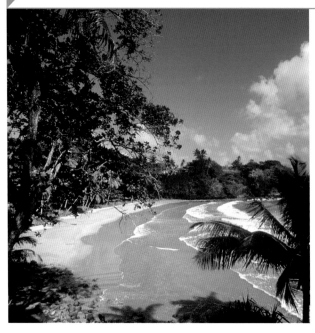

Above: Speyside Beach on the northeastern coast.
Below: A colorful and delicious fruit basket.

Opposite: Deserted beach on the eastern coast
that's an avian paradise.

Trinidad and Tobago are an odd couple. Despite the many differences between them, together the two make up a single Caribbean state. Twenty miles apart, they sit close to the Venezuelan coast in the southern Caribbean. The larger island, Trinidad, is densely populated, a bit chaotic, festive—its famous carnival is boisterous, to say the least—and at times seems overrun by tourists. Tobago, on the other hand, is relaxing, just as you'd imagine a Caribbean island to be. Just 115 square miles (Trinidad is over 1,800 square miles), Tobago is easygoing, and its elegant hotels are very discreet, just like the visitors who choose to vacation here.

Naturally, the beaches are just as they should be—incredibly stunning, white, and shaded by tall palms. As expected, Scarborough, the capital, moves at a very slow pace, but there is an international airport, as tourism is the main economic activity. Besides swimming and snorkeling—at Batteaux Bay, for example, manta rays, which are referred to as the taxis of Tobago, give rides to scuba divers—you can go for a walk amid the island's extraordinary natural beauty. There are forests considered to be some of the oldest on the planet; a pair of fishing villages, the pretty and characteristic Speyside and Charlotteville, that are well off the main tourist route; the six-foot-long leatherback turtles that weigh over 1,000 pounds; the intact coral reefs; the mangrove swamps; and the unpopulated isles of Little Tobago, Goat Island, and St. Giles, which have a rich avian wildlife made up of pelicans, ospreys, and frigate birds. In short, Tobago has everything you'd expect from an earthly paradise.

Must See

Idyllic **Pigeon Point** is home to the most stunning coral reef on the island. **Man O' War Bay** has a collection of spectacular beaches, while from the hills surrounding Scarborough, the capital, you have panoramas that look out over the beaches. **Fort King George** is the site of a famous battle between English and French forces. A perfect place for bird-watching is the **wildlife reserve** on the isle of Little Tobago. At **Tobago Forest Reserve**, you'll encounter a thick jungle that's said to be the oldest protected forest of its kind. The small, dark sand beach at **Buccoo Reef** is ideal for diving, and **Pirate's Bay**, once used by buccaneers, is now popular with snorkeling enthusiasts.

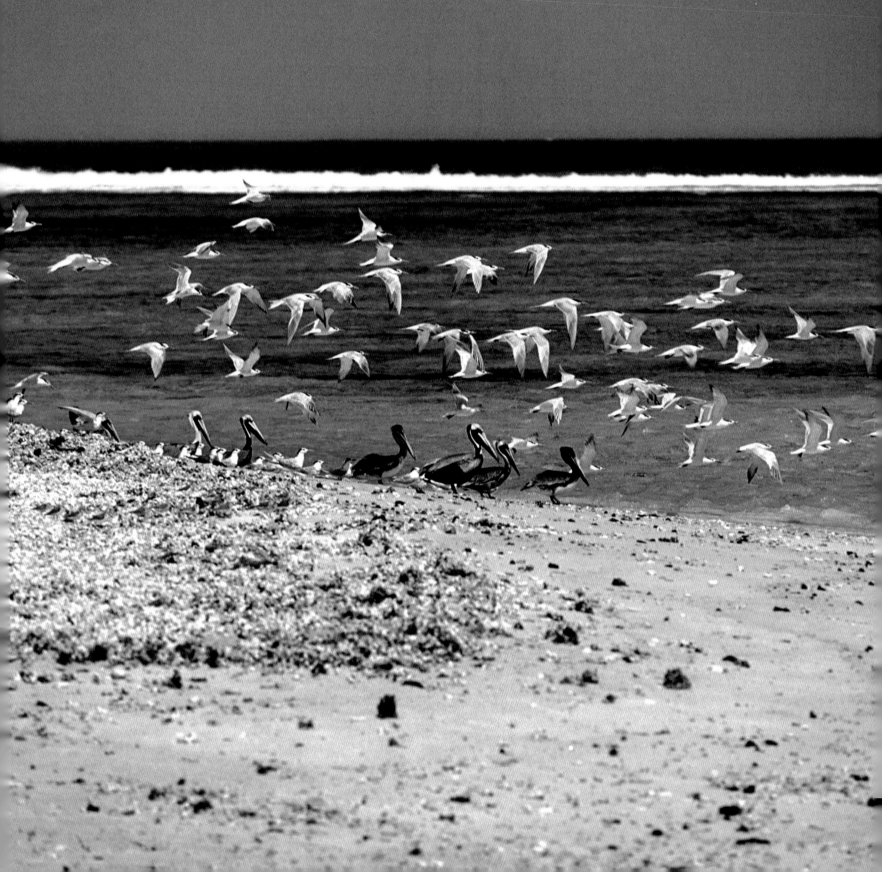

USTICA

It was already 1959 by the time Ustica finally shook off its role as a penal colony, where people were sent for "compulsory stays." It was up to the tourism board of the Palermo region to figure out a way to transform this beautiful and little-known island into an international destination.

Just 36 nautical miles north of Palermo, Ustica already had extraordinarily transparent waters, a rocky sea floor, easy access to the open sea, and caves that were ideal habitats for Mediterranean flora and fauna. The tourism board ended up listening to the "rock tribe": apparently naked men with black skin and shining hearts—an amphibious race scattered throughout the world—namely, scuba divers. They created the *Rassegna Internazionale delle Attività Subacquee*, a festival that every year since 1960 has awarded a solid gold trident set in a fragment of lava to distinguished scientists, technicians, and water-sport enthusiasts. This led to the creation of the *Accademia Internazionale delle Scienze e delle Tecniche Subacquee*, a school that established the first and only underwater archaeological tour, and turned the island into Italy's first marine reserve.

As a result, Ustica became the world's scuba diving capital. Today, groupers are photographed outside their dens, not harpooned. Divers can sway to the rhythm of a slow waltz with a school of salema porgies, sparkling and green as the algae they feed on. Or they can photograph the abstract paintings of red, yellow, orange, green, and blue that the sponges and corals embroider on the underwater reefs.

Ustica is also a destination for breathtaking sunsets, complete with dolphins leaping out of the water. You can see history and prehistory written into the rocks of the Neolithic village of Colombaia, upon the sea stacks, in the Greco-Roman tombs of Capo Falconiera, in the ruins of the pre-Christian necropolis, and in the 18th-century fortifications built by Charles III of Spain to keep the Barbary pirates at bay.

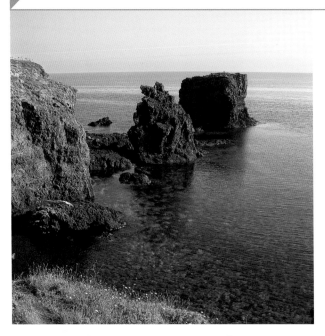

Above: The Colombaro sea stacks on the Tramontana coast.
Below: Artifacts a the Roman necropolis of Capo Falconiera.

Opposite: Cala Santa Maria, the main port for hydrofoils.

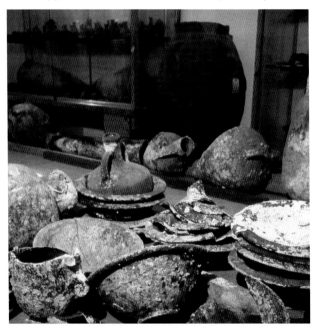

Must See

Visit the more evocative grottos, ideally by swimming there. There's **La Azzurra**, right under the hotel of the same name, **Grotta delle barche** and **Grotta dei Colombe**, as well as **Grotta Vede**, **Grotta della Patizza**, and **Grotta del'Oro**. Swim in the natural pool of **Punta Cavazzi**, carved out of black lava. Pros can dive into the **Grotta dei Gamberi**. Sample **spaghetti with sea urchins** or black cuttlefish ink, fish soup, and, above all, freshly harvested lentil soup. Accompany the meal with a glass of **Albanella**, a typical wine from an ancient local vineyard. Savor the figs at the beginning of the season and the prickly pears toward the end of summer.

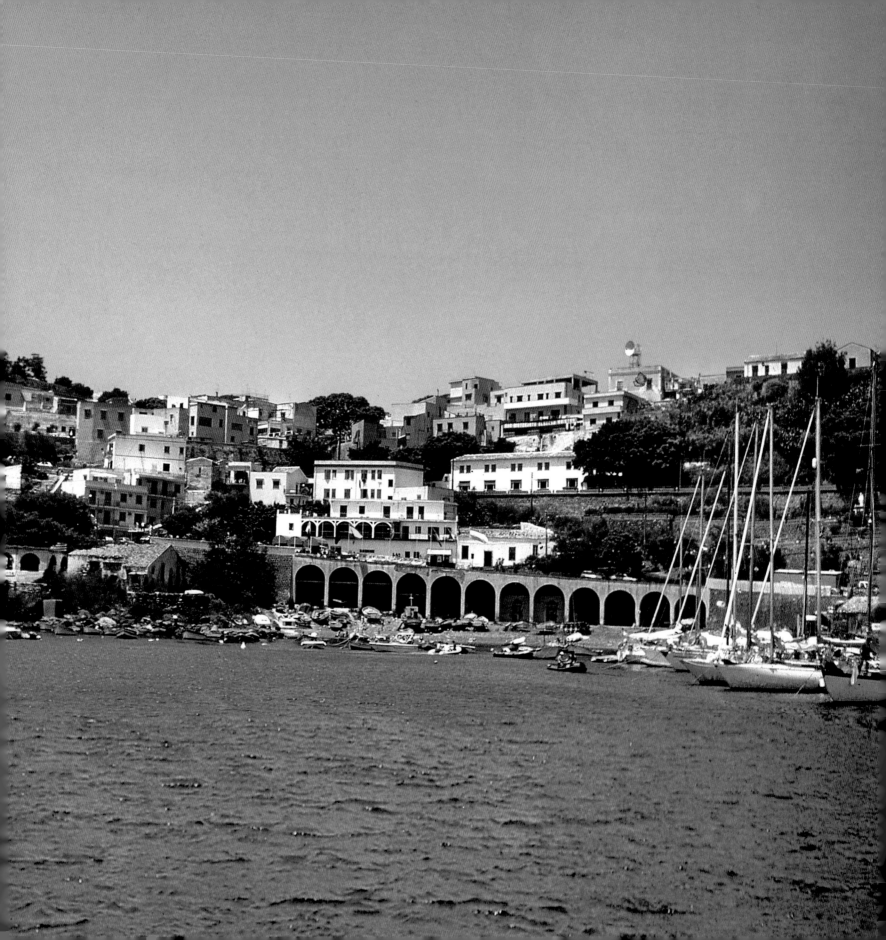

These colorful islands are full of charm and magic. The sun shines silently down on them—small, large, or boundless—creating a play of light on the surrounding sea. The very idea of an island, no matter where in the world, has a way of casting a spell on travelers, poets, adventurers, writers, musicians, and filmmakers. These unique spots have been sung about and recounted in stories from Homer's Odyssey to the novels of Hemingway and Dumas, from films like *Papillon* to Rossellini's *Stromboli* to Ian Fleming's James Bond series. Here, unforgettable islands become timeless legends.

[Luca Liguori]

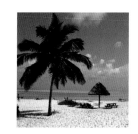
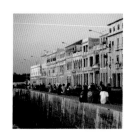
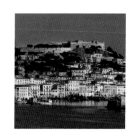
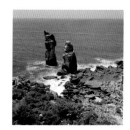

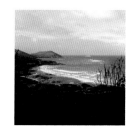

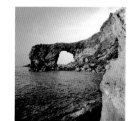

LEGENDARY ISLANDS

ALCATRAZ

Above: Poster of the 1979 film Escape from Alcatraz.
Below: Fisherman's Wharf in the port of San Francisco.

Opposite: View of Alcatraz penitentiary,
known also as "The Rock."

From a distance, the island of Alcatraz appears quite severe. Not far from the coast, this tiny isle doesn't have any beaches for sunbathing. Though it lacks sandy shores and likely isn't the ideal spot for a dream vacation, Alcatraz remains one of the most recognized islands in the world—thanks to, or perhaps because of, its penitentiary. Alcatraz housed many notorious criminals and also inspired classic films like *Birdman of Alcatraz* starring Burt Lancaster, *Escape from Alcatraz* with Clint Eastwood, and *Murder in the First* with Kevin Bacon.

Its name, in Spanish, means "gannet," a type of seabird, and like the bird, the island soars high in the popular imagination. It reminds you that you can always achieve your objectives, no matter what—but they often come at an enormous sacrifice. Known to Americans simply as "The Rock," it's little more than an outcrop in the middle of San Francisco Bay. Considered to be one of the most unsettling and intriguing places in the world, people first took notice of it during the Gold Rush in the middle of the 19th century. A major lighthouse was soon built to illuminate the new shipping lanes. At the beginning of the 20th century, it was decided that the small isle would be perfect for a prison as it was surrounded by treacherous currents.

Thus the island of Alcatraz became synonymous with the prison—a jail that was impossible to escape from, reserved for the most dangerous criminals. Between 1934 and 1963, its cells housed the likes of Al Capone and Robert Stroud, who was the inspiration for the film *Birdman of Alcatraz*. The penitentiary stands as an icon of repression for those rebellious detainees, and is more than just a place of atonement and rehabilitation. Today, as San Francisco discusses its future, Alcatraz remains a mandatory stop during a visit to the city.

Must See

The hallways inside the prison would make anyone want to try and break out—after all, **San Francisco** is right there. As the authorities like to point out, every attempt to escape from the penitentiary has failed. Perhaps it is this dramatic fact that draws two million visitors a year to the island. Upon leaving the prison, you are left with the feeling that someone could have pulled it off. Clint Eastwood's exploit in *Escape from Alcatraz* seems doable, and we feel as if we could take part. And yet the prison's imposing architecture tells us that the law is not something to toy with. It's best just to swallow your pride and take in the sights and sounds of nearby **Fisherman's Wharf**.

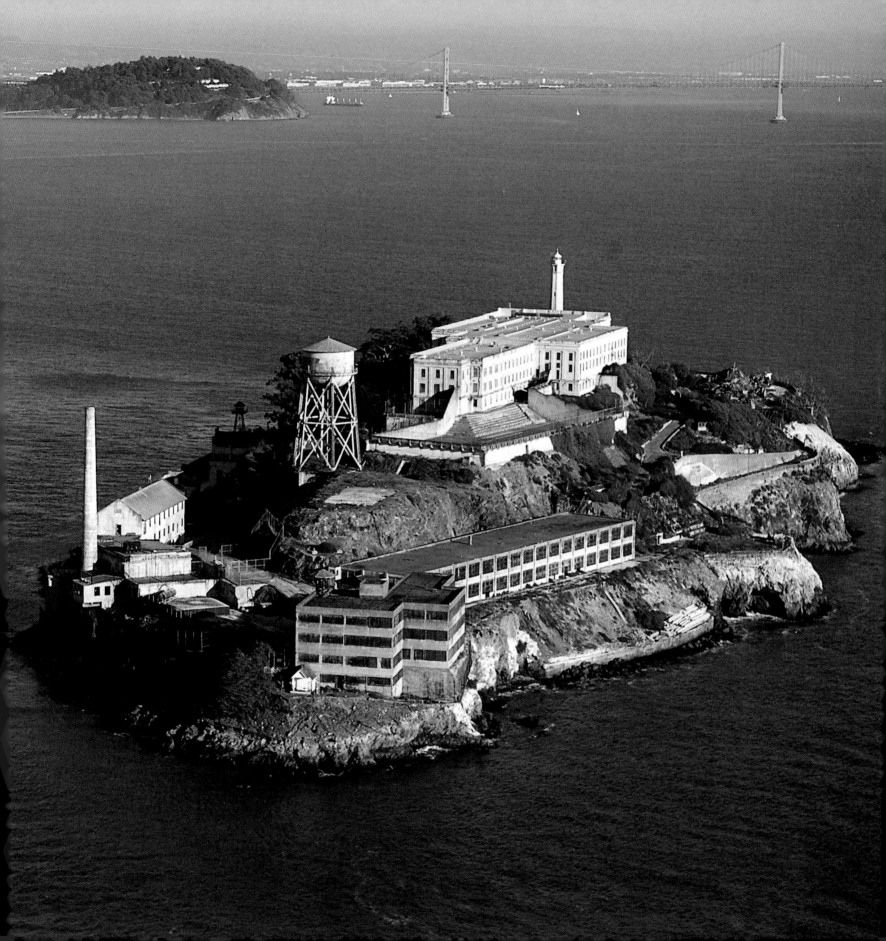

ARAN ISLANDS

Above: Bikes are the best mode of transport.
Below: One of the islands' few pubs.

Opposite: A typical residence surrounded
by stone walls.

The film *Man of Aran* recounts the hardships of life on these Irish islands, where nature shapes the inhabitants, the work is tiring, and destiny seems unavoidable. American director Robert Flaherty was the first to tell the memorable story of the Aran Islands and its people. He knew how to extract the essence out of these barren, rocky outcrops lined up in a row along Galway Bay like sentinels guarding Ireland. The film, which was honored at the Venice Film Festival in 1934, is a true classic. It's a bleak yet poetic documentary about the lives of a family of fishermen, the harshness and charms of the Aran Islands, and a land that is testament to nature's power. It features imposing stone forts (the Dúns), rocky shores, a large natural whirlpool known as the wormhole, Neolithic tombs, and the ruins of churches and convents such as Teampall Bheanáin, considered the world's smallest chapel. Its many forts, whose traces are still evident, served not only to defend the land, but also for the magic rituals performed by the druids.

All this is concentrated on Inishmore, the largest of the three Aran Islands, which measures eight miles in length. Here, the ancient Irish language is still spoken and old Irish traditions are jealously protected. Soft wool sweaters are still made using centuries-old techniques that each family passes down from one generation to the next. People move around on bicycles, riding on paths lined by stone walls. Most of the tourists who come to Inishmore arrive in the morning and are gone by nightfall, just enough time to visit the island. Ideally, you should stop over for a night in one of the simple bed-and-breakfasts dotted along the coast. It's the only way to experience the place's charm. The Aran Islands show Ireland at its most beautiful, evocative, and primitive—a remote, unsettling, and heart-rending place, a world outside of time, the perfect setting in which to appreciate nature's strength and the valor of humankind.

Must See

The prehistoric fort of **Dún Aonghasa** is located on the edge of a 300-foot cliff with spectacular views, and is comparable to the nearby Cliffs of Moher on the Irish mainland. According to medieval literature, it is named after a king of the Fir Bolg, one of the ancient Celtic tribes. Offering the most breathtaking views in the Aran Islands, it's best to visit either in the early morning or in the evening, when the only sounds are from the waves crashing against the rocks. To get around, it's best to rent a bike in **Kilronan**, the main town on **Inishmore**, where the few tourists that do arrive are deposited by the ferries from Rossaveal, Galway, and Doolin.

BAHAMAS

"**M**y name's Bond . . . James Bond." Smart, dashing, and seductive, Sean Connery, the original 007, didn't waste time in becoming one of the most recognized sex symbols on the planet. One accomplice in his rise to fame was the crystalline Commonwealth of the Bahamas, where in 1965 he shot *Thunderball*. It's not hard to imagine him behind the wheel of an Aston Martin DB5, driving down Blue Hill Road in Nassau or along West Bay, ready to jump out and sneak aboard the Disco Volante, the yacht anchored in Goodman's Bay, or trade blows with Spectre henchmen under the command of Emilio Largo, who is stubbornly defending two atomic bombs he's stolen from NATO.

Today, all the explosions that took place in the waters just off the coast of Florida, in one of the most alluring corners of the globe, are a distant memory. Visitors simply enjoy the many miles of fine sand that run up to Old Fort Bay, with its exclusive villas, on the north side of Paradise Island. New York is just under three hours away by plane. The only trace of activity is found at the Bacardi factory, which took refuge here after fleeing Cuba following Fidel Castro's rise to power. This multinational distillery, with its prominent bat logo, is the king of rum producers. On a sunny afternoon, one of Bacardi's veteran workers can sometimes be seen slowly rolling a barrique used to age the liquor. In the enormous square beside the factory, the silos reflect a magical light, the same sunshine that guided the pirates of Tortuga.

One of those buccaneers, Captain John Howard Graysmith, landed here with his crew some 300 years ago. His home still stands on West Hill Street, though now it houses a famous eatery and the

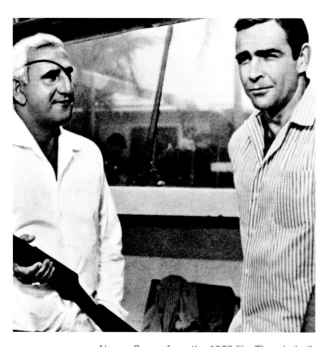

Above: Scene from the 1965 film Thunderball.

Right: Treasure Cay Beach on Abaco Island.

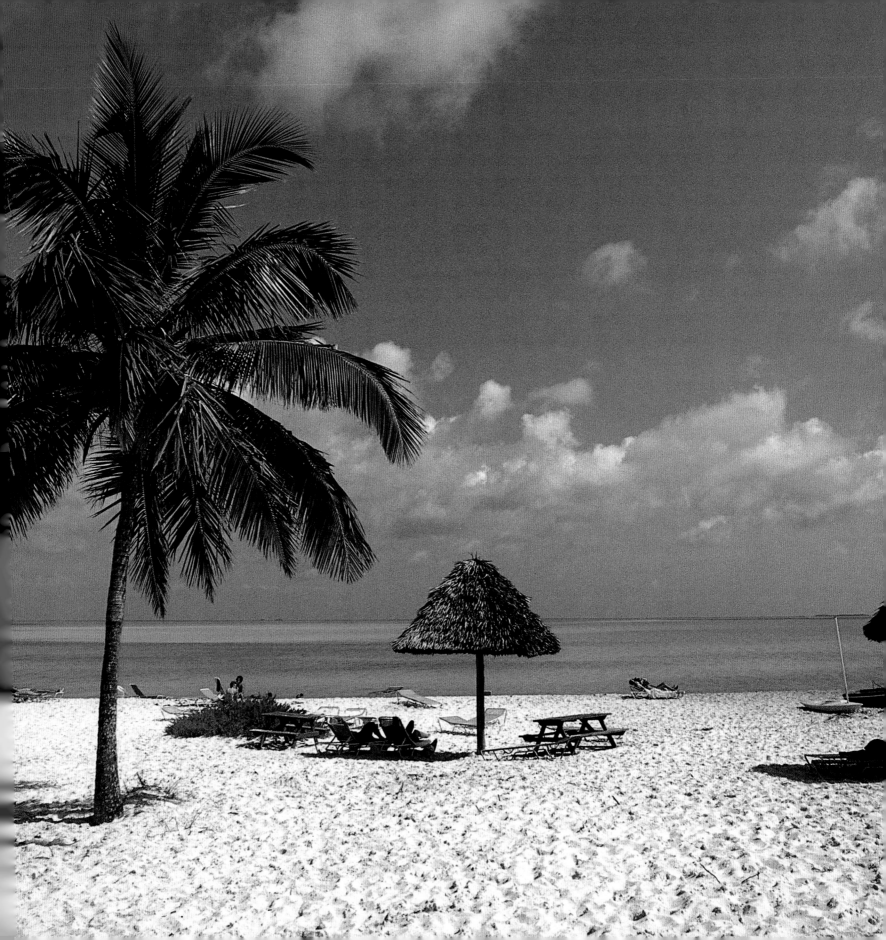

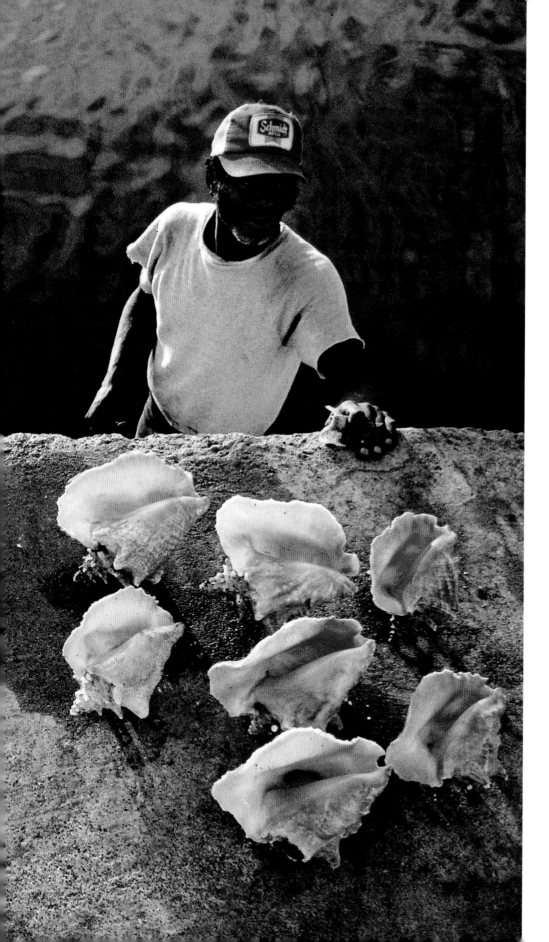

Graycliff Cigar Company, which makes high-quality Bahiba cigars. Many visitors spend hours observing the workers' hands as they roll tobacco leaves. This charming aspect is what makes New Providence and the other stretches of land in this archipelago inviting, and why author Ian Fleming made it the setting for one of his James Bond novels.

Along with the rum and cigars, there were a bevy of beautiful women at Bond's side in the Bahamas: Claudine Auger as Dominique "Domino" Derval, the female lead in *Thunderball*; Luciana Paluzzi as Fiona Volpe; and secondary roles played by Molly Peters and Martine Beswick. At the time of filming, the Atlantis casino, accessible from Nassau via bridge, hadn't yet been built. Together with the Ocean Club golf course, the concrete and glass Atlantis casino and aquarium, where giant manta rays swim, are now main attractions for the new moneyed classes. Comfortable ferries bring you to the beach, where the beautiful sunshine and soft breezes compete with each other. Snorkeling fans can't resist the fabulous tales recounted by a local boatman known as Captain Craig about the amazing sea floor and the barrier reef at Andros, the largest of the islands. To the east is the island of Eleuthera, while on Abaco—a two-hour boat ride from Nassau—it's possible to observe the elegant Bahama parrot. Yachters, meanwhile, have their own paradise amid the atolls of Exuma Cays.

Must See

Leaving **Nassau** behind, cross Eastern Bridge and head to the **Atlantis** casino with its 78 tables and 850 slot machines. Inside the gaming palace, you can dine at a **Nobu** restaurant and visit the aquarium. Not far away, on **Harbour Island**, lies the Ocean Club golf course. Find time for a stopover on the red sand beach of **Eleuthera** atoll, reachable by water taxi from **Paradise Island**, where the **Bahama Divers** will reveal their secrets and the best spots for snorkeling. Also not to be missed is a boat trip to fish for some **marlin**, the dramatic fish that Ernest Hemingway wrote about in *The Old Man and the Sea*. For shopping, Nassau's jewelry boutiques are quite popular.

Above: A local island girl.

Right: A woman making a hat on Eleuthera Island.

Opposite: A seashell vendor in the port of Nassau, New Providence.

Below: A policeman in Nassau.

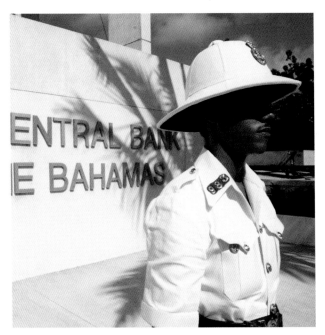

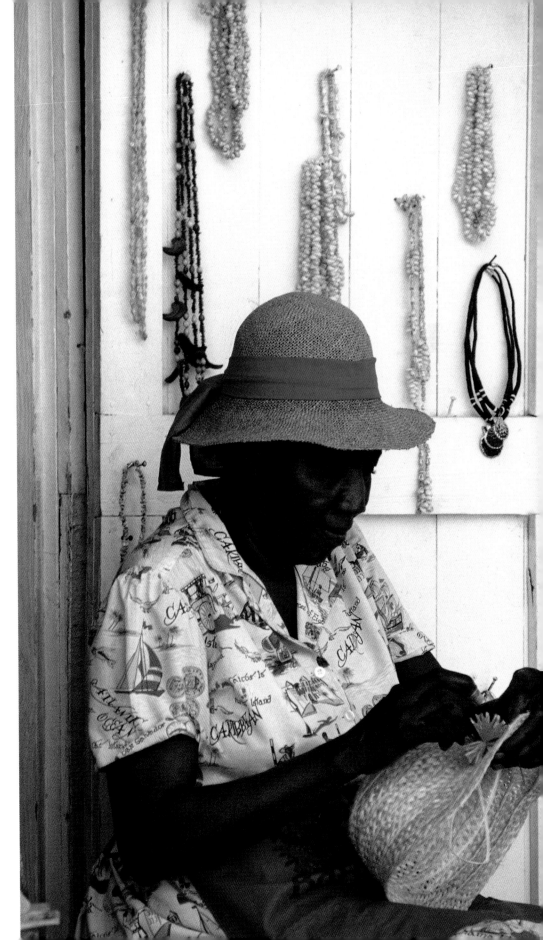

CUBA

"Life is what happens to you while you're busy making other plans." This quote by John Lennon is a motto Cuban director Fernando Pérez puts to perfect use in *La Vida es Silbar* ("Life is to Whistle"), his 1998 film about dreams, happiness, desires, freedom, and Cuba. This unmistakable island is the star of the film, and its scents, colors, languid sounds, and steamy tropical heat serve as the backdrop for the stories of its three main characters. There's Mariana, the fiery ballerina, who chooses chastity even as she rises to stardom; the musician Elpidio, who is unable to overcome the trauma of being abandoned by his mother, who is coincidentally also named Cuba; and Julia, a social worker incapable of confronting sex or even just talking about it. They move within a whirlwind of music, dance, and incredible stories under the extraordinary skies of Havana—a city that's both poor and stunningly beautiful, pleasant and somewhat bittersweet, like life itself, whose inhabitants are all in search of happiness.

Everyone who winds up in Cuba lets themselves be guided by the "whistling life," and becomes one with the spirit of this fiery and passionate land. They appreciate its countless charms, the lazy, passionate, and perennially smiling Havana that simultaneously stirs up new emotions and curiously familiar feelings in all its visitors. There's no traffic here, and the few brightly colored Buicks and aging Cadillacs have undoubtedly seen better days. Whatever the time of day, the streets swarm with people who have spent the hot tropical night under a spell as they chase dreams in vain. Walking through the streets of Old Havana, you might have easily bumped into Ernest Hemingway, perhaps at La

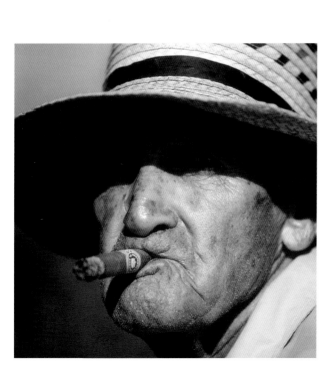

Above: Cigar smoker.

Right: Havana's Malecón promenade at sunset.

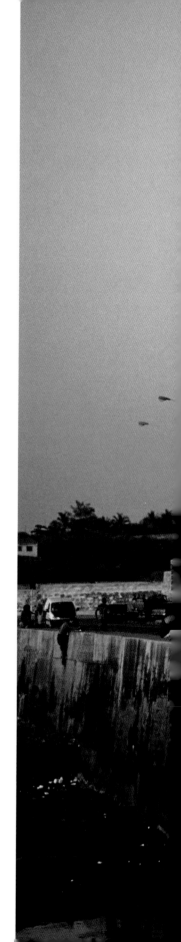

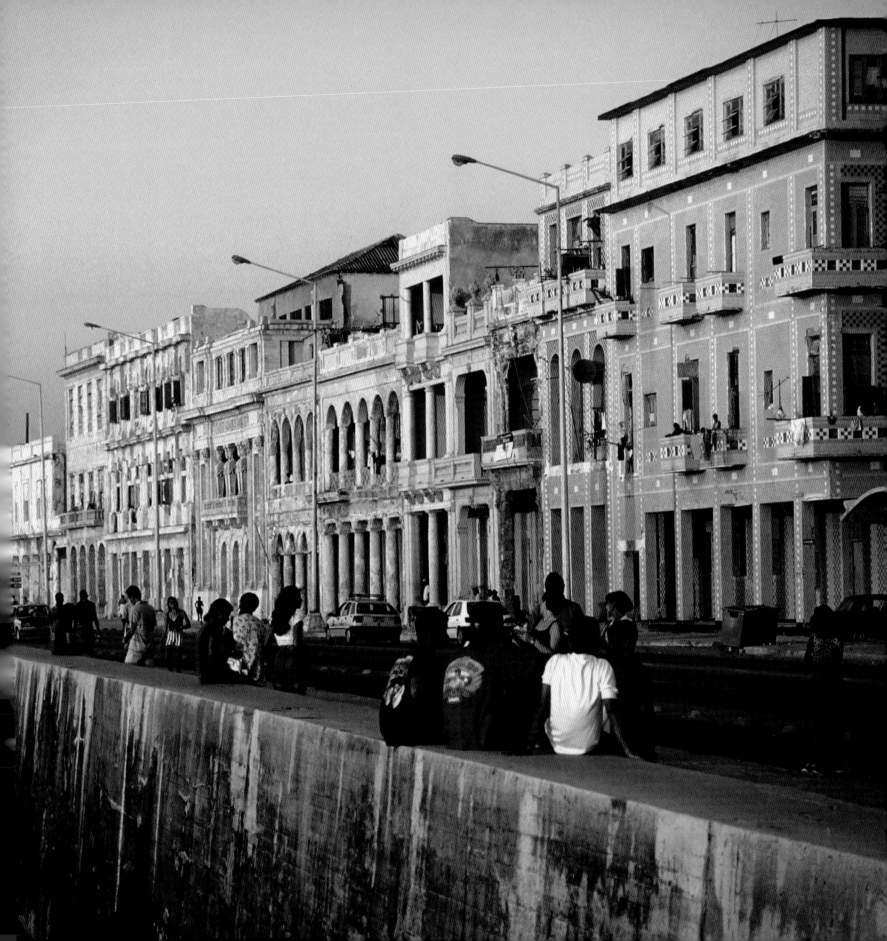

Bodeguita del Medio, the writer's favorite bar, which hasn't changed in spite of the inclement weather and waves of visitors that have passed through.

The Cubans—a mix of European, Native American, African, and Asian peoples—are representative of all humanity. Stopping on the corner of any city street is like finding yourself in the waiting area of a major international airport. You'll find women with amber-colored skin, black hair, and intense green eyes; little boys with blond hair and pitch-black pupils; blacks, whites, Chinese, Creoles, and mestizos. The Cubans, with their happy, open, and sociable temperament, don't hesitate to offer themselves as guides or invite you home for lunch, where they make you feel like an old family friend. Music is an integral part of life on the island. Everywhere, regardless of class or color, people dance merengue and conga for the sheer pleasure of abandoning themselves to the rhythm. All it takes is an empty can and a bamboo stick to improvise a new sound. And to find happiness? A bit of music, a smiling child, and a glass of mojito: rum, lime, sugarcane, mint, and ice, the perfect drink to ease one's daily anxieties. After such simple pleasures, everything else, like magic, turns into a dream—or, here in Cuba, perhaps it's real life.

Must See

Between the beach of **Varadero** and the open sea, where a fringe of white sand stands out next to the colorful and transparent sea, and where sunbathers worship a sun that doesn't heed the seasons, there's a natural pool of shallow, peaceful water that's as pure as a child. At dusk, you can sit down and soak yourself amid a whirlwind of blue fish that encircle you and dart about undisturbed. Here, you can sip a local cocktail and await the sunset in the company of friends. This oasis is one of the trendiest spots in all of Cuba, where you can bump into exceptional people such as ballerinas, poets, and philosophers, or just normal folks who truly understand the meaning of life.

Above: A group of demonstrators in Havana paying tribute to Fidel Castro.

Right: Santiago de Cuba, the island's second-largest city.

Opposite: The delightful Cayo Sabinal Beach.

Below: El Nicho Falls in the Sierra del Escambray.

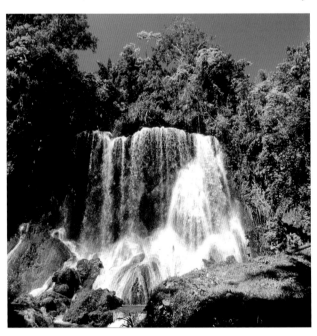

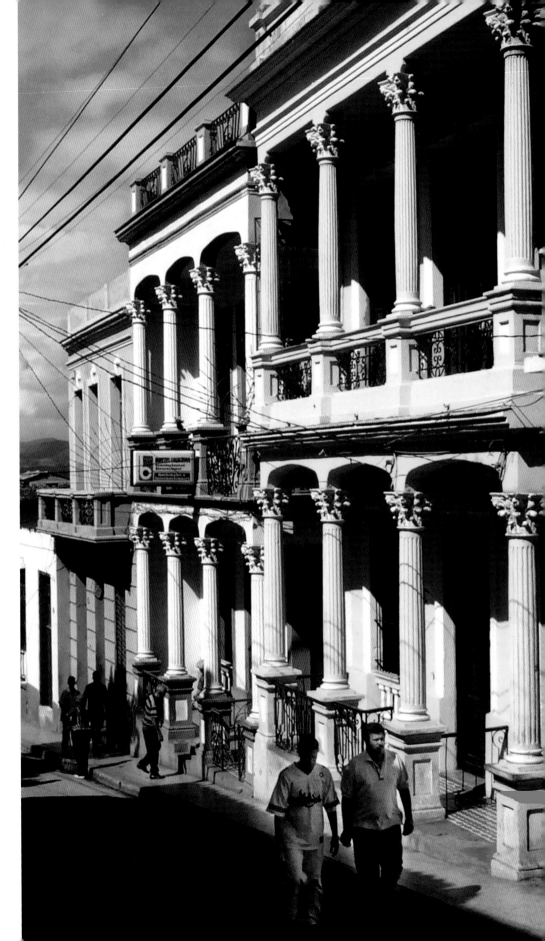

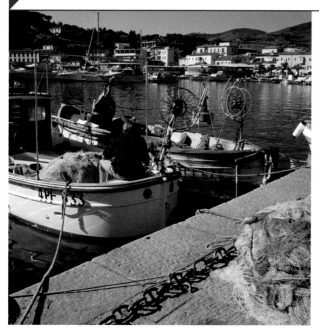

In May of 1814, Napoleon Bonaparte had just begun his exile on Elba, the result of defeats he suffered during his campaigns in Russia and Leipzig. Here, off the coast of Italy, he would spend 10 long months, and it was already hot when Napoleon appeared one morning in front of Villa San Martino, gazing out to sea and thinking back on his battles. Between his fingers he fidgeted with a button on the jacket that had accompanied him into battle. Napoleon couldn't have known that those tin buttons would break off in the cold, as described in the book *Napoleon's Buttons* by Penny LeCouteur and Jay Burreson. His soldiers had died because of a jacket that wouldn't button. Why hadn't he used iron, which was so plentiful on this island, instead? With this burden on his heart, and the memory of so many young men who had perished in the cold, Napoleon called for General Dalesme, the island's governor. He asked to be taken to the Rio Marina mine, which had laid idle for months because of a ban on exportation of the mineral. He soon got the mine up and running, and organized the workers and their carts. The extraction of iron, which Elba was full of, was a way for him to avenge those men who had not survived the cold winter.

For visitors arriving by sea today, the mine and the reddish stains left on the surrounding rock are quite visible. You can see a little bit of that ferrous red all along the coastline, which is best admired by boat. Then there is Porto Azzurro, dominated by the Spanish fort-turned-prison; Capoliveri, once known as Caput Liberum, which sits in a strategic position above the cliffs; Campo dell'Elba, which has a white sand beach; Marciana and Rio nell'Elba, the natural spring, which are exquisite spots; and Portoferraio with its impressive fortifications. In fact, in Portoferraio you can still visit the places where Napoleon passed his time in exile. Palazzina dei Mulini, located between Forte Falcone and Forte Stella, is a privileged spot that enabled him to monitor both the port and the town.

Above and Opposite: View of Portoferraio, the largest town and port on the island.

Below: Seagulls' Coast in Capoliveri, on the island's southeastern end.

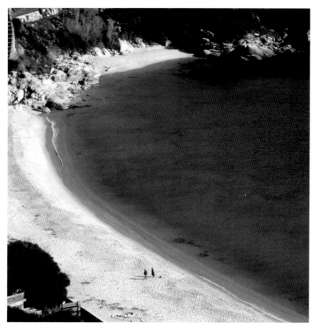

Must See

Docking in **Portoferraio** is like taking a jump back in time. Before Napoleon—whose summer house, **Villa San Martino**, is worth visiting for its Gothic portico, adorned with a statute of Galatea attributed to Canova—Cosimo de' Medici ruled the island. In 1548, he oversaw construction of the imposing forts of **Falcone**, **Stella**, and **Linguella**. After having crossed the so-called Porta di Terra along the harbor, the old town unfolds before you. Don't miss out on a glass of **Aleatico dell'Elba**, the local dessert wine. Moving to the other side of the island, you'll find the **Valle del Pomonte**, an ideal stop for those with an interest in archaeology.

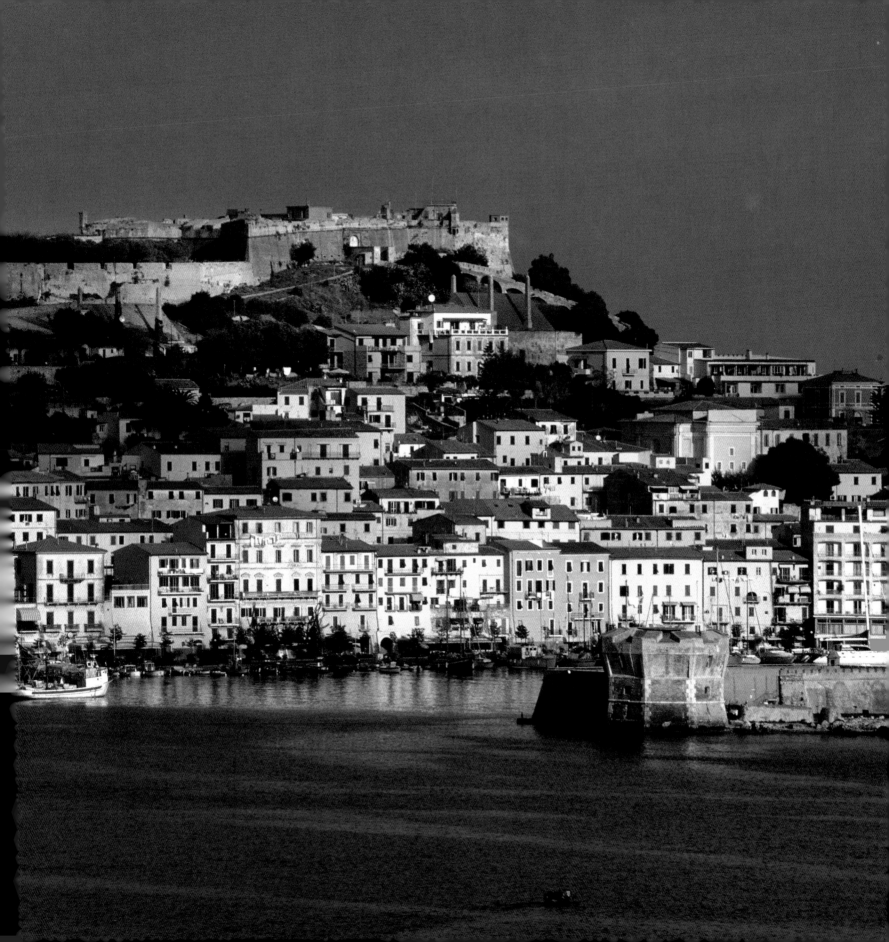

SAN PIETRO

On the main island of Sardinia, people still converse in the ancient Sardinian language. But on San Pietro Island, off Sardinia's southwestern coast, local children are sung to sleep with lullabies in the Ligurian dialect. While most Sardinians eat *malloreddus* pasta and *porceddu*, a type of roast suckling pig, the residents of San Pietro enjoy *farinata*, a chickpea flatbread, and couscous. On mainland Sardinia, economic development is often rather disjointed and irrational, leading to the construction of "cathedrals in the deserts," as development efforts in nearby Portoresme are known. On San Pietro, they've stuck to hunting tuna ever since the time of the Phoenicians. Indeed, this unique island, with its sole town of Carloforte, shares the same sea, winds, Peregrine falcons, colors, minerals, and tranquility of the Sardinian mainland. Despite all that, they don't share a common language.

The Romans referred to San Pietro as *Accipitrum Insula*, or "Sparrowhawk Island." Today's inhabitants are descendants of sailors from Liguria that for generations had settled in Tabarka, a tiny island off the Tunisian coast, rich in coral reefs and sea sponges. Once the red coral there had been exhausted, the residents of Tabarka needed to find another means of support. Yet they were in a hostile land, far from the familiar Liguria they had left behind, so in stepped Charles Emmanuel III of Savoy. He granted them a substitute home on the agreeable island of San Pietro, which was fairly well off in terms of potable water, and featured forests of Aleppo pines and a crystal clear sea. To give thanks they named the village where they settled *Carloforte*, which in Italian can also be read as "Charles the strong."

Above: Pensioners in Carloforte congregate in the square.

Right: The Columns of Carloforte, two sea stacks on the coast facing nearby Sant'Antioco.

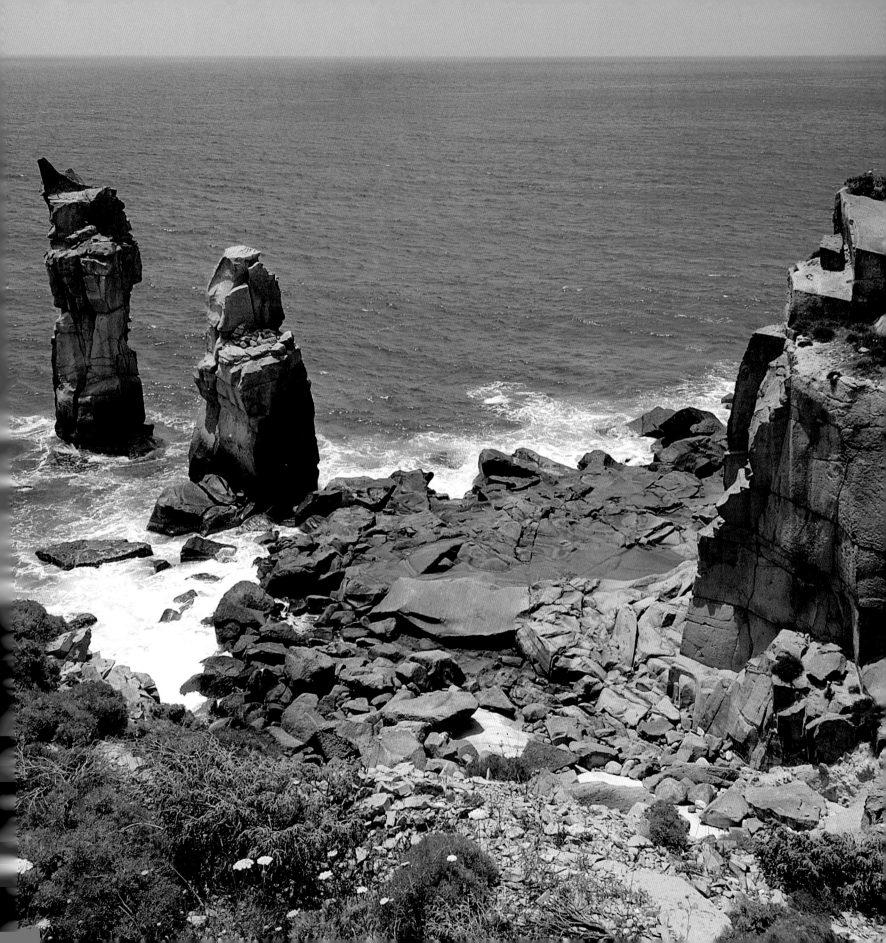

The inhabitants' Ligurian heritage is still evident in the town's urban planning. There are narrow alleys and arcades, as well as elegant 18th- and 19th-century townhouses facing the Battellieri boardwalk. But the world knows San Pietro for its traditional tuna hunt, one of the oldest in the Mediterranean, which brings in an enormous catch. The ritual is carried out each May, bringing in 4,000 tons of adult tuna that have come from the Atlantic to reproduce. Fattened up, they deposit their eggs in springtime, swimming in schools along the coast. Here, the fishing nets of the large black-hulled boats wait for them. The nets direct the tuna toward the surface for the bloody slaughter known as the *mattanza*, which some foolhardy types prefer to watch from below the waterline. It's a somewhat macabre proceeding, steeped in ancient rituals overseen by the *rais*, the person in charge of the hunt.

Today, a big part of the tuna hunt is geared toward tourists, but despite these efforts it still hasn't stopped the gradual decline of this kind of tuna fishing. After the fish are caught, tuna is taken to the warehouse, where the eggs are harvested and turned into cured fish roe, the heart is preserved and served as an appetizer, and the fillet is dried and salted. The most prized sections of the tuna, meanwhile, are delivered to a waiting plane that will swiftly deliver the meat to the top sushi restaurants in Italy and Japan.

Must See

Not far from the island's solar and wind energy plant, **Nasca** is a fairy-tale place covered in luxuriant Mediterranean underbrush. Have a swim in the waters of the suggestive natural swimming pool known as **Troggiu**, which is accessible from a trail. Troggiu gets its name from the basins used for collecting grapes, as clean waters turn dark and turbulent during the frequent storms brought by the mistral winds. The 400-foot cliffs overlooking the sea at a nearby bird sanctuary host about 100 pairs of **Eleonora falcons** each summer. Known also as the queen's falcon, the birds arrive from Madagascar, where they spend the winter, in order to make their summertime nests on San Pietro.

Above: Carloforte's defensive walls.

Right: Children of Carloforte in traditional dress.

Opposite: Capo Sandalo, the rockiest area on the island.

Below: Port of La Caletta.

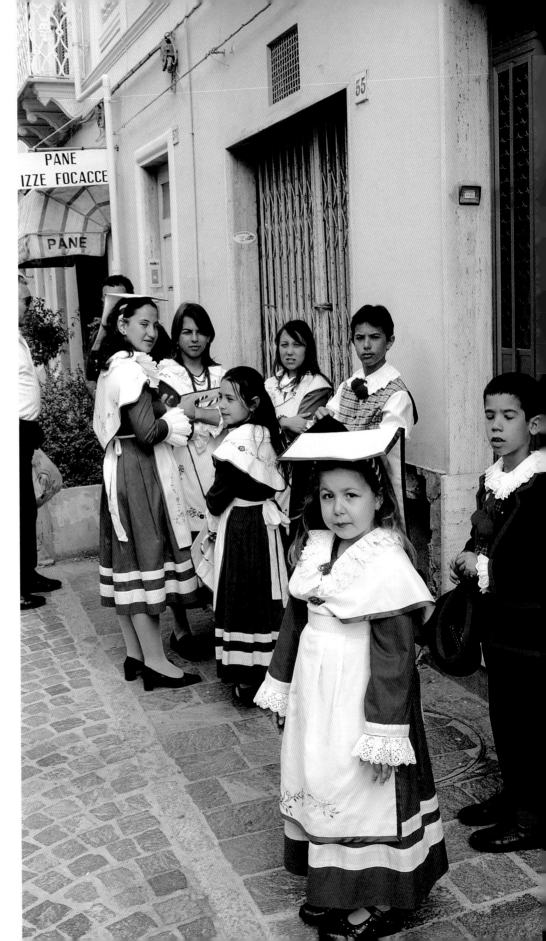

ISLE OF WIGHT

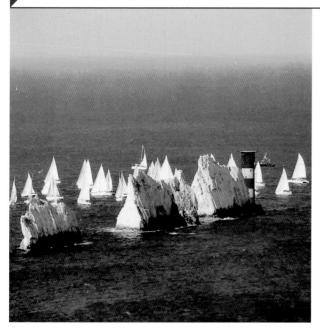

Above: The famous Cowes Week regatta, a prestigious yacht race founded in 1826.
Below: A typical English cottage.

Opposite: Thatched-roof homes in the village of Shanklin.

For those who came of age in 1968, the Isle of Wight immediately brings to mind the famous festival of 1970, when The Doors, The Who, and the virtuoso guitar playing of Jimi Hendrix livened up the summer on this northern island. Often that's all people seem to know about the place. But, of course, it has much more to offer. Just a few miles from the southern coast of England, facing South Hampshire and Portsmouth, it is separated from the mainland by the Solent. The southern part of the Isle of Wight faces the English Channel. It has a population of 140,000 and receives almost 3,000,000 tourists per year, which means 21 tourists for every resident. When they step off the ferry or hovercraft at Ryde Pier, there are no longer any hippies to greet them; rather, they are immersed in a remarkably traditional British atmosphere, with a little train waiting by the pier in a tiny station, home of the smallest railway company in Great Britain—it runs barely eight miles from the pier to Shanklin, on the eastern part of the island. The climate, thanks to the sea, is relatively mild. The landscape is green, soft, and relaxing. Even Queen Victoria appreciated it; she would vacation here at her Palladian residence, where she died in 1901. There are few cars in the capital of Newport, and people mainly get around in carriages. Elsewhere you can see views from the cliffs at Alum Bay, on the western part of the island. The nights are spent drinking beer in pubs scattered here and there. Hikers enjoy the well-marked walking paths along the coast. There are also jazz concerts, and even an Isle of Wight music festival that harks back to the legendary concerts of the late 1960s and early 1970s, evoking the myth of the island "with the blue of youth in its eyes."

Must See

In **Newport**, the capital, there are many hotels, restaurants, and pubs. The 11th-century **Carisbrooke Castle** is where King Charles I was imprisoned. Cowes, at the mouth of the Medina River, plays host to a famous regatta during **Cowes Week** in August. Not far from there is **Osborne House**, the one-time residence of Queen Victoria. **The Needles** are impressive limestone stacks that rise out of the sea. The villages of **Yarmouth** and **Godshill** feature thatched-roof houses. The lively town of **Sandown** has the best beach on the Isle of Wight. **Ryde** is the biggest town on the island, with stately Victorian and Georgian buildings and a golden six-mile-long beach.

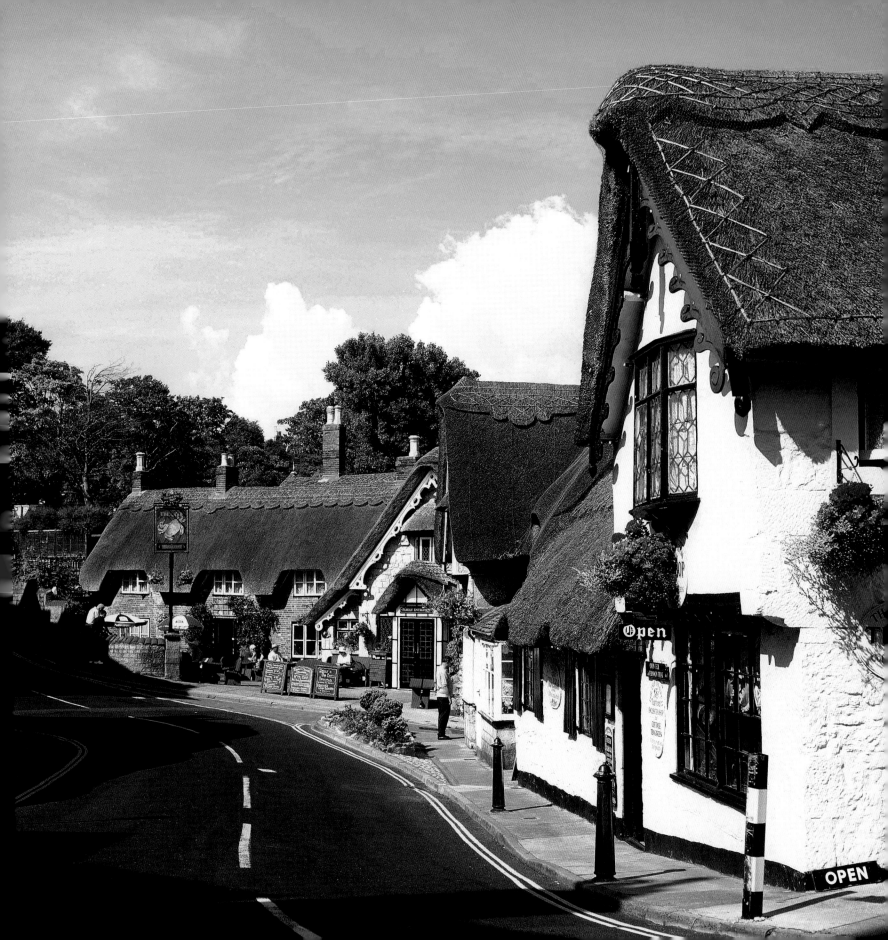

OPEN

CAYENNE

I t's fascinating that the final scene of one of Hollywood's most unforgettable films, starring Dustin Hoffmann and Steve McQueen, takes place in Cayenne. Moviegoers will likely recall the incredible attempt at escape made by Henri Charrière, inmate number 51367, who was sentenced to life in jail for murder and went by the nickname "Papillon" because of the butterfly he had tattooed on his chest. For Papillon, it was the last in a series of failed getaways and subsequent recaptures from the living hell of the penal colony where France had deported 90,000 forced laborers over the course of a century. Napoleon III had opened it in 1852 in order to rid France of the "unrepentant dregs of society," but the prison was closed by order of General de Gaulle after the colony was promoted to the status of a French overseas region.

Welcome to French Guiana, in South America, a strange and fascinating land that includes Cayenne—the region's capital—Saint Laurent, and Kourou, the site of a strategic European spaceport where satellites are launched into orbit and one of the last outposts of the legendary French Foreign Legion still stands. In short, it's a French enclave some 4,300 miles from Paris, right in the middle of a South American rain forest. This area includes more than 35,000 square miles of lush green Amazonian flora crossed by two large rivers: the Maroni River, which delineates the northwest border with Suriname (former Dutch Guiana); and the Oyapok River to the southeast, which marks the boundary with Brazil.

Just a few miles from this natural paradise in the emerald waters of the Caribbean, the dark silhouettes of the Îles du Salut (or Salvation Islands) stand out. Papillon, in his eponymous memoir, described in

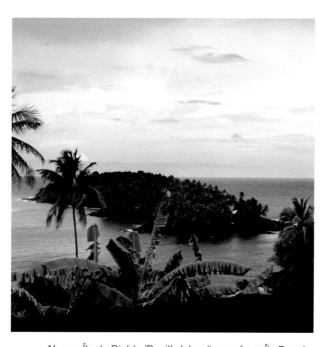

Above: Île du Diable (Devil's Island) seen from Île Royale.

Right: Scene from the 1973 film Papillon.

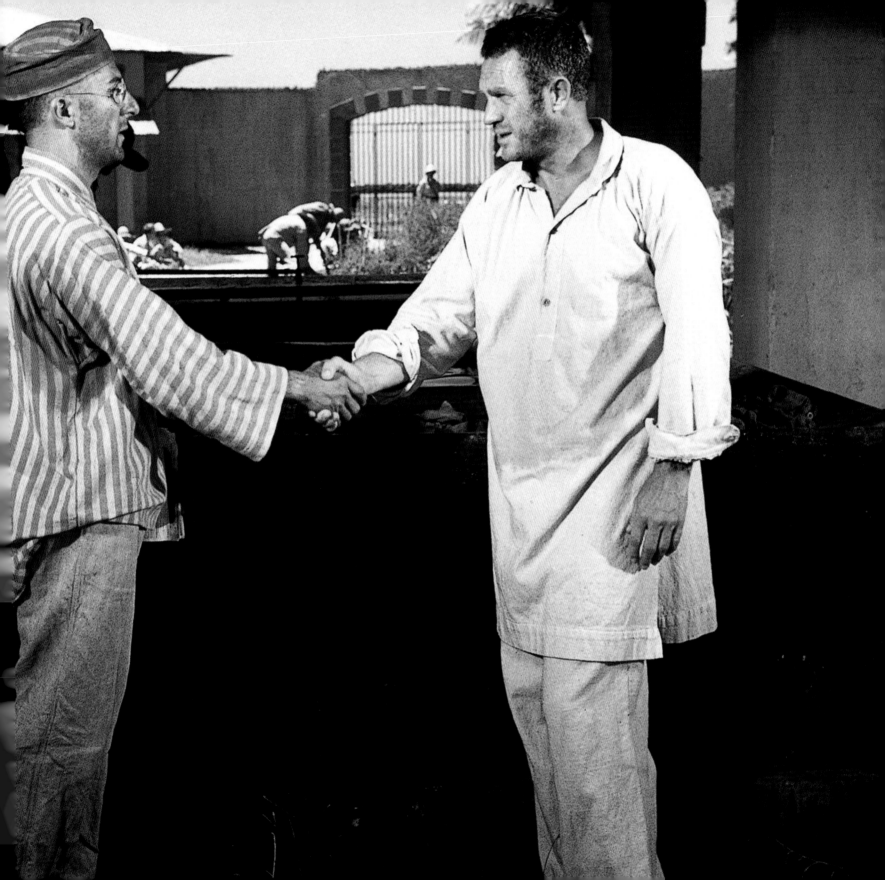

GUYANE FRANÇAISE RÉPUBLIQUE FRANÇAISE INSTRUCTION
LIBERTÉ. — ÉGALITÉ. — FRATERNITÉ. du 8 juillet 1841.
MODÈLE MODIFIÉ.

MINISTÈRE DES COLONIES

ADMINISTRATION PÉNITENTIAIRE

FEUILLE SIGNALÉTIQUE

du nommé *Charrière, Henri, Antoine, dit "Papillon"*

évadé le *Cinq* à *4ᵉ 30* du mois de *Septembre* 1934

de *l'Hôpital de St Laurent*

où il était détenu sous le numéro *51.367*, *1ᵉ catégorie*, ____ section

detail the infernal former penal colony and its legacy of horror and death. Made up of three tiny islands, the smallest is Île du Diable (Devil's Island), once reserved for political prisoners who were kept in solitary confinement. Here, French army officer Alfred Dreyfus, who had been wrongly convicted of treason, looked out, alone and in despair, toward his ungrateful country far off beyond the horizon (perhaps as a way to redress the injustice he endured, a white lighthouse was constructed on the coast of Kourou that bears his name). Île Saint-Joseph, meanwhile, was meant for those inmates who were considered unrepentant criminals (men like Papillon). They were locked up in the so-called man-eating cells, windowless cement blocks with a thick grating on the ceiling that only permitted a faint light to filter through.

Finally, there's Île Royale, where the most common prisoners were deported and which housed the main prison complex. The most impressive island of this tiny archipelago, today the prison on Île Royale has been immaculately restored and opened to tourists. Included in the tour is Papillon's former cell, number 47, where you can still admire the butterfly, his good-luck charm, that the condemned man scratched into the wall with a nail.

Must See

At **Crique Gabrielle**, under a canopy of lianas and mangroves among cocoa plantations and rosewood forests, you'll find the **Morpho**, a beautiful butterfly with large wings colored in metallic shades of blue that flutters about while locals' flat dugout canoes silently glide across the water. **Voltaire Falls**, with its 50-foot downpour, is a spectacular sight. Located in the middle of the Amazonian forest, its water shower provides a relaxing massage. **Les Hattes** is one of the most enchanting and picturesque beaches in French Guiana. **Sea turtles** weighing up to 1,500 pounds come here to lay their eggs.

Above: Entrance to the cell block where "Papillon" was imprisoned for many years.

Right: Document registering the arrival of a prisoner at the penal colony.

Opposite: Statement detailing the escape of Henri Charrière, a.k.a. "Papillon," on September 5, 1932, at 4:30 a.m.

Below: A wing of the cell block.

LANZAROTE

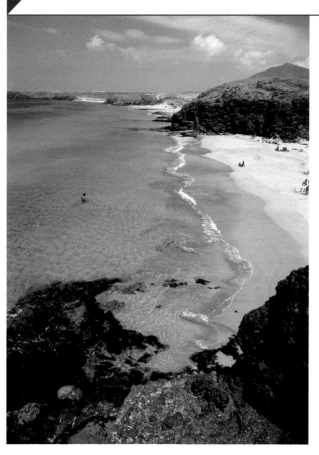

Above: The stunning Papagayo Beach, situated at the southern tip of the island.
Below: Timanfaya National Park.

Opposite: La Geria, with its vineyards growing in volcanic soil.

Visitors should be prepared for a rough voyage through a harsh, wild, lunar landscape made of lava and volcanic ash as they venture into the heart of the Montañas del Fuego on Lanzarote, the easternmost of the Canary Islands. In this protected area of the Timanfaya National Park (the entire island is a UNESCO Biosphere Reserve) there is a concentration of more than 100 volcanoes and 300 craters. It is a majestic landscape, with a solidified sea of lava and spectacular geysers, transformed into one of seven centers for culture and tourism built between 1964 and the early 1990s by César Manrique (1919–1992), the artist and architect who pioneered sustainable architecture and had total respect for his island. At La Cueva de Los Verses—the evocative itinerary Manrique eked out of the "arteries of the earth," caverns that are over 150 feet deep—you can walk underground in the ancient pirate caves amid layers of lava, tunnels, and mazes. It's a walk through the earth's core in a whirl of colors that range from magnesium black to iron oxide red. There are no recognizable life forms here, but the rocks have solidified into bizarre animal forms, like the incredible 20-foot-long lizard. The dialogue between man and nature evoked by Manrique's poetic architecture is crystallized in Los Jameos del Agua, a multifunctional space with an auditorium, restaurant, and nightclub molded into the lava with a small salt-water lake full of *jameitos*: small, blind, albino crabs that seem to have come from another planet. Then there's the Jardin de Cactus in Guatiza, a magnificent example of recovering formerly degraded land; built where there was once a volcanic ash extraction plant, it is now home to 10,000 cacti, among which are the rare pachydermic *Ferocactus wislizenii*. A land straight out of Dante's poems and a perfect synthesis of architecture integrated with nature, Lanzarote is a voyage back in time, as well as a relaxing island full of beaches—an unspoiled place with primordial charm.

Must See

Go for a walk in **Los Hervideros**, which is part of the **Timanfaya National Park**. There's a panoramic sightseeing tour designed by César Manrique that is carved out of the cliff. You'll find it filled with lookouts in the volcanic rock that open onto the Atlantic. Lashed by trade winds and surrounded by a severe landscape, you will be enchanted by the vastness of the sea and the beauty of the waves that smash against the cliffs. **La Geria**, the area inland where wine is produced, offers a unique spectacle. In an ample stretch of lava, you can see vines of Malvasia and Moscato growing from inside rock funnels more than six feet deep.

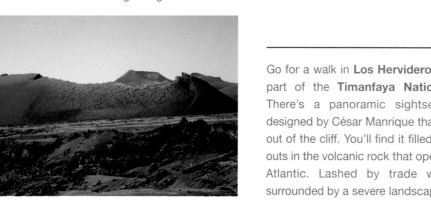

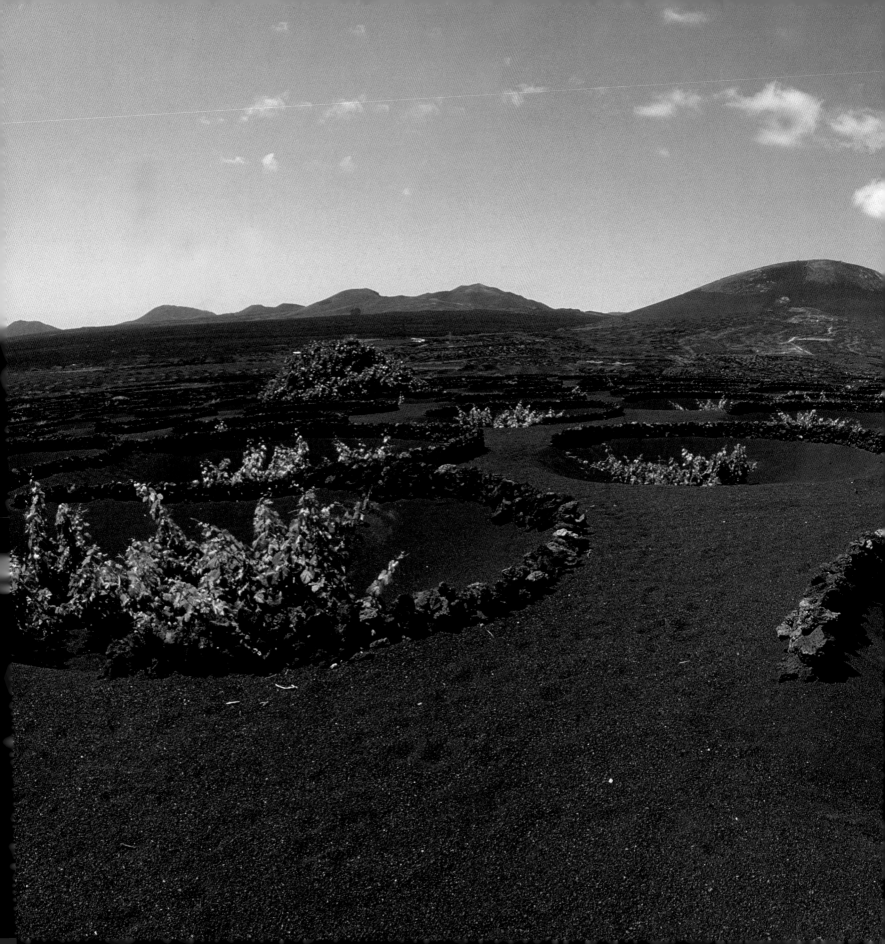

MONTECRISTO

Above and Below: Two views of the remote island, a nature reserve since 1971.

Opposite: Cala Maestra and the 19th-century Villa Reale.

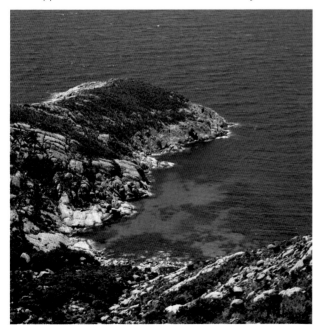

Best known as a fictional setting for the novel *The Count of Monte Cristo* by Alexandre Dumas, the most mysterious of the seven islands in the Tuscan Archipelago appears as a monolithic silhouette on the blue waters of the Tyrrhenian. The island's real treasure is its harsh, wild landscape, which has been kept pristine thanks to diligent conservation.

Imagine a granite cone emerging from the Mediterranean without warning, devoid of human life, and with only a few tiny coves to make landfall. Solitary and inaccessible, Montecristo is clearly not a very hospitable island, yet it has always emanated a mysterious charm. Over time, peoples ranging from the Etruscans, Phoenicians, Romans, Carthaginians, ascetics, corsairs, monastic orders, the odd nobleman, and even a king have attempted to conquer it, but its prickly landscape has always rebelled. Since 1971 it's been a nature preserve, the first initiative aimed at protecting the naturalistic patrimony of the Tuscan Archipelago, and all approved visits are under strict supervision.

The steep coastline, inland area of peaks and small valleys, and rocks forged by water and wind all reveal glimpses of strange creatures straight out of some fabled bestiary. The monk seals have vanished, leaving the wild goats to divide up the island among themselves. Lacking natural predators, the goats, which resemble the ibex, have adapted perfectly to the rough and rocky terrain. There are also many winged species, including the rare Corsican seagull, the shearwater, the Peregrine falcon, and many migratory birds that, when tired, choose Montecristo as a stopover along the route between Europe and Africa. Among the 300 botanical species here, rockrose, strawflower, heather, and rosemary predominate, while higher up, on Colle dei Lecci, several dozen centuries-old specimens continue to thrive. Exotic and decorative species—such as palms, agave, oleander, eucalyptus, and domestic and Aleppo pines—were introduced in the vicinity of the former royal villa, the island's sole building, constructed by King Victor Emmanuel III.

Must See

The **Villa Reale** at **Cala Maestra** opens onto a tree-studded valley and the granite slopes of **Monte della Fortezza**, covered in shrubs that rise up to 2,100 feet, where there are sweeping views of the entire island. Along the trail you'll encounter the **Grotta del Santo**, the 5th-century refuge of the hermitic Saint Mamiliano, filled with religious offerings left by mariners and a spring with supposedly miraculous properties. Continuing on, you'll reach the ruins of the 15th-century **San Salvatore and San Mamiliano Monastery**, destroyed in 1553 by Saracen pirates following the orders of Ottoman admiral Dragut. Hidden away here is the treasure that inspired Alexandre Dumas' *The Count of Monte Cristo*.

MUSTIQUE

Above and Opposite: Deserted fine sand beaches and turquoise waters make Mustique the pearl of the Grenadines.
Below: Patio of a luxurious rental villa decorated with Caribbean motifs.

Mustique doesn't feel at all like the Caribbean, at least not the Caribbean overrun by tourists. Here, everything gives off a feeling of serenity, understatement, and orderliness. Mustique is a garden, and its well-manicured vegetation is found both inside private properties as well as outside. Joggers greet people with a nod, and young women in smart outfits ride horseback at sunset on the beach at Macaroni Bay. Small, eco-friendly electric cars known as "mules" run along roads that rise and fall over the gentle hills.

The history of this quaint island, which measures a mere two square miles, began in 1960, when Princess Margaret of England received a plot of land here as a wedding gift just before the island's owners, the Mustique Company, got the go-ahead to build a tourist development. Since then, princesses and rock stars enjoying a winter escape here have found themselves in the pages of the gossip magazines. Situated in the eastern Grenadines, Mustique is seen in the collective imagination as one of the ideal places for exclusive getaways.

Over the years, much has changed. Built on a former plantation, the charming Cotton House Resort has more than 100 villas that are now rented out on a seasonal basis. Nevertheless, the big mansions of the rich and famous hold sway over the island. Only Basil's Bar has remained intact. Stretching out along Britannia Bay, the sunset brings the island to life. At Basil's, cocktails are served at a circular bar, a dinner of the best Caribbean delicacies can be enjoyed on the large wooden veranda, and a few evenings a week there's a big buffet with the local steel drum band, whose music resonates across the entire bay and invites people to let loose on the dance floor.

Far from the noise, colors, and pleasant chaos that characterizes most Caribbean islands, Mustique invites you to relax and enjoy its many fine sand beaches and shaded palms.

Must See

Island hopping is the best way to enjoy the Grenadines. Take a cruise and hop from one island to the next, starting with the forts on **Saint Vincent** and ending with **Tobago Cays**, where inside a horseshoe-shaped coral reef you'll discover four uninhabited isles. Stop in **Bequia** for its colorful produce market, picturesque beaches, and lively nightlife; **Canouan**, where sea turtles lay their eggs on **Mahault Beach**; **Palm Island** for the beach at **Cashuarina**; **Mayreau** for its enchanting Saltwhistle Bay; and **Petit Saint Vincent**, with its 22 bungalows scattered along the northeastern coast, hidden from view by the tropical vegetation.

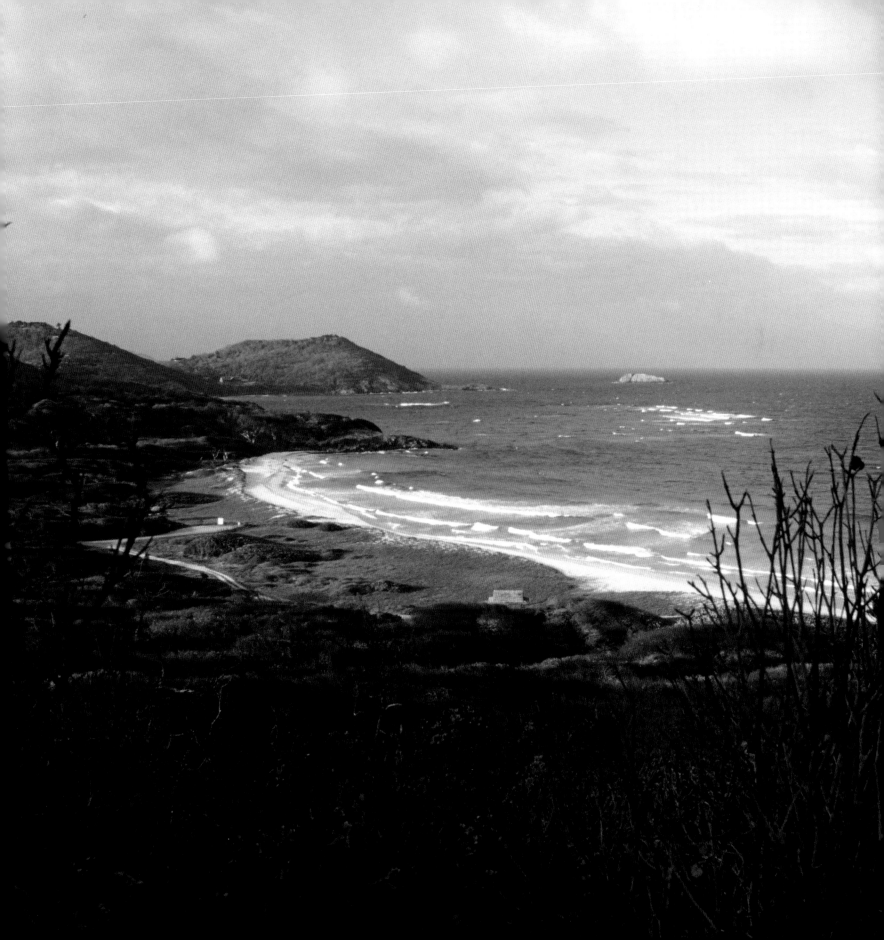

OUESSANT

I n northwest France, in the Finistère region, known as "the ends of the earth," on clear days when the mistral wind blows, you can see the isle of Ouessant—often Anglicized as Ushant—off the Atlantic coast. Once known as Enez Eusa, from the local Breton dialect, Ouessant is an island that offers its share of powerful emotions. This wild island of extraordinary beauty lies just 12 miles from the continent, but if you arrive on a day when the sea is rough, the crossing from the port of Le Conquet seems especially long, and gives you time to admire the forest of lighthouses that rise up from every corner of the island.

Ouessant is made up of lighthouses, reefs, deserted shorelines, and inquisitive sheep. Most of all, however, it's a windswept and lonely place. Stepping onto land in a narrow bay, you soon come across the village of Lampaul, where nearly all of the island's 932 residents live. A bike is all you'll need to begin your exploration of this last lookout across the ocean. Simply choose one of the five lighthouses on the horizon, follow the white, twisting roads that lead there, and you'll uncover the secrets of this place. If you're lucky enough to be invited into the home of a local, you'll understand just how the sea has dominated the lives of residents. Many homes' interiors resemble a ship's hull, with rooms divided by simple wooden planks and furnished with extremely functional furniture. One day is not much, but it will be enough for you to treasure all that your senses are able to take in. On the return boat, you will realize just how much Ouessant has given you, and—like many of its visitors—you may even start to miss it just a little.

Above: Stone houses and walls are typical of the island's architecture.

Below: Museum in Lampaul.

Opposite: Nividic lighthouse off the southwestern coast.

Must See

The **Creac'h lighthouse** rises up on the western tip of Ouessant. One of the world's most powerful lighthouses, its beam is visible up to 33 miles away. At its base, in the abandoned electricity station, there's a quirky museum of lighthouses and buoys. Other lighthouses not to be missed are **Stiff** and **Nividic**, which is halfway out to sea. In two colorful houses in the village of **Lampaul** there's a museum that tells a concise history of the island. Lastly, don't forget to sample *ragoût de mouton*. This traditional dish is made from a simple recipe and tastes delicious. The tender lamb is slowly cooked for five hours under a layer of vegetables.

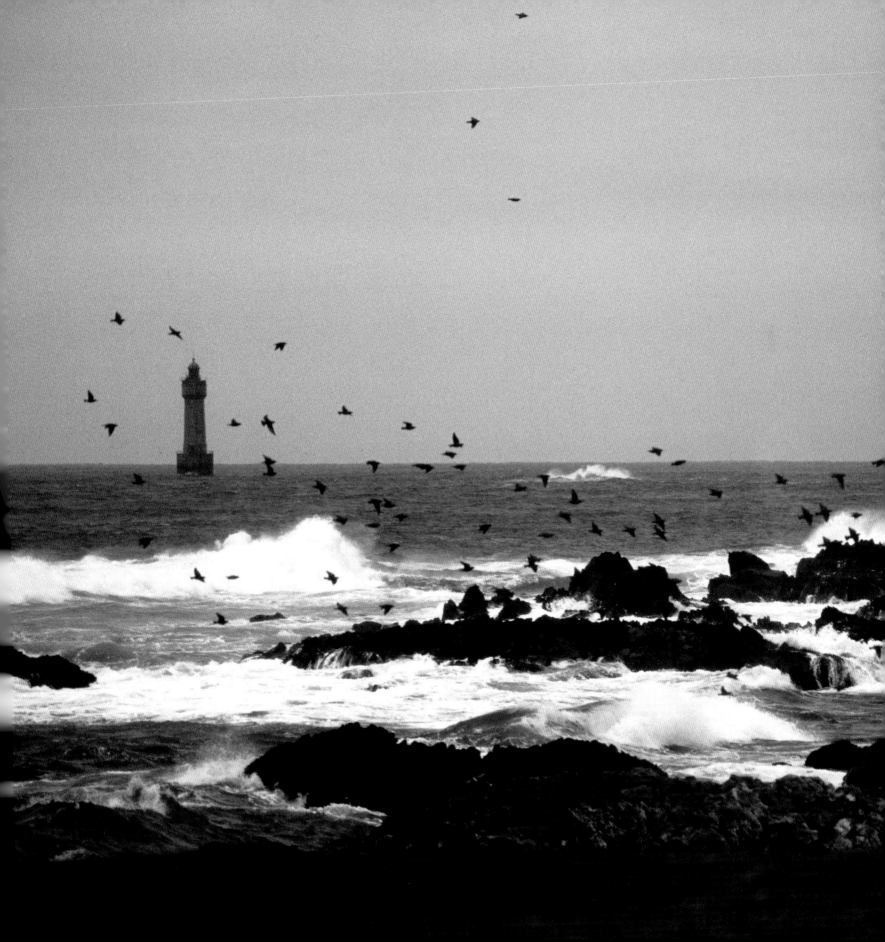

Above: Robben Island seen from Table Mountain.
Below: The jail where Nelson Mandela was imprisoned.

Opposite: Mural in the Nelson Mandela Museum.

Rising up before the vastness of South Africa, Robben Island comes across as rather miniscule. Set just off the coast of Cape Town, this pancake-flat island is barely two miles long. From the air, it stands out on the water as a small mass of metamorphic rock dotted with vegetation. You arrive here from the Victoria and Albert Waterfront, the South African port and eponymous shopping mall, stuffed with boutiques that are always crammed with tourists.

The journey is short, just seven miles across the waters of Table Bay. Yet as soon as you step ashore, it's impossible not to be struck by the abrupt change of scenery. Here, there aren't any hyped-up tourist attractions, nor are there sandy beaches or guides offering photography safaris or trips to the savannah. Between the rocks there is a small penguin colony, and in the middle of the island the only thing that stands out is the old prison, with its gray walls still looking quite menacing. For years, during the apartheid era, this was the maximum-security prison where "inconvenient" political prisoners were locked away—men like Walter Sisulu, Govan Mbeki, and, of course, Nelson Mandela, who was held here for nearly 20 years and deprived of all freedoms.

Mandela's tiny, dingy cell remains intact, and it's hard not to be moved by the chipped bars and single window looking onto the courtyard. The jail's perimeter walls are so high that they don't allow you to see the horizon or the surrounding landscape. Thus, the only contact with the outside world is a strip of sky. Accompanying visitors in this almost ghostly setting are the "survivors"—former detainees or, at times, their children, who recount the physical hardships and unprecedented psychological pain. Nearby, you can also visit a rock quarry where prisoners were forced to do hard labor for the entire day. The only reminder of their toil is a small pile of pebbles, a silent monument that is also a hymn to South African democracy. It was, after all, right here that free spirits like Nelson Mandela began to conceive a brighter future for their country.

Must See

Make the ascent in the cable car to the summit of **Table Mountain**, with its distinctive tabletop peak overlooking Cape Town from a height of 3,563 feet. Up here, on clear days, you can clearly make out the silhouette of Robben Island, as well as the **Dutch fortress** and the **Waterfront**, a fabulous marina built in 1990 around the old port area. Toward evening you can witness the spectacular sunset. Just a few dozen miles separates Cape Town from the **Cape of Good Hope**, with its small lighthouse. Continuing onward to the southeast, you'll come across the rocky beach at **Cape Agulhas**, the point where the Atlantic and Indian oceans converge.

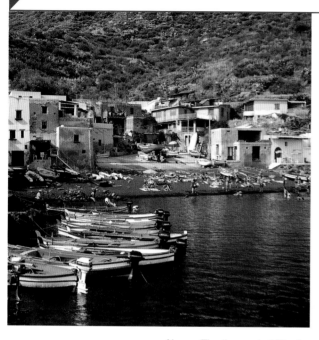

Above: The tiny port of Rinella.
Below: Scene from the 1994 film Il Postino.

Opposite: The Punta Perciato arch at Pollara Bay.

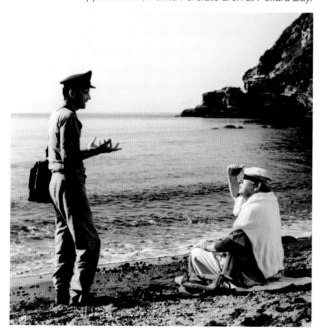

A new version of the *dolce vita* is found on Salina, an island with a unique mix of nature, climate, culture, and food. There are its bold, authentic flavors, the relaxed atmosphere and discreet charm of its new spa hotels, and many villas with pleasant terraces—all done in varying architectural styles, ranging from the traditional to the contemporary to the downright rustic. Salina has its very own way of life. With respect to the more famous Aeolian islands, such as festive Lipari or trendy Panarea, Salina is a completely different world. The three major farming towns—Leni, Santa Marina, and Malfa—each have a distinct identity. Not only does the island have abundant vegetation, its greenery also offers a lot of variety. Agriculture and viniculture play a big role here. Local capers and the caper fruit have an unforgettable flavor. Fifteen wineries, some open to the public, produce 80,000 bottles of Malvasia, a sweet, honey-yellow dessert wine typical of the volcanic Aeolian Islands. Several new hotels are also associated with the winemaking business. Particularly attractive is the Malvasia Capofaro Resort.

But Salina's charm is not only associated with hospitality. Day after day, one bend in the road after another, from one small cove to the next, the island gradually reveals itself. Because the land is so rich, the sea is almost optional here. While local life revolves around daily routine, vacationers often opt for the prolonged, blissful idleness of good cuisine and contemplative pursuits. Like elsewhere in the Aeolian Archipelago, the sea is out of this world, but it's best enjoyed by boat. Not to be missed is Punta Scario for its incredibly transparent waters, though its pebble beach isn't suited for sunbathing. Yet Salina is best known for Pollara Bay, a rugged place of primordial beauty, with small hideaways carved out of the volcanic rock by fishermen, which are unfortunately eroding due to the unrelenting sea. Just above, among the Mediterranean, is the famous house used during the filming of *Il Postino*.

Must See

Whether it's restaurants with a touch of class or spartan eateries, you'll eat well thanks to the island's flavorful and authentic dishes, even in the places you'd least expect. In the village of **Lingua**, the no-frills cuisine has made a name for itself—be sure to enjoy the many delicacies offered at its outdoor restaurants. There's the ***pane cunzato***, a type of focaccia with rich Mediterranean flavors, and the semi-frozen ***granita*** dessert. You should also try the **spaghetti with olives and capers**, baked ***linguine al cartoccio***, breaded **squid**, and the well-known ***caponata***. Before leaving the island, don't miss out on a glass of sweet **Malvasia**, a wine ideally suited to local growing conditions.

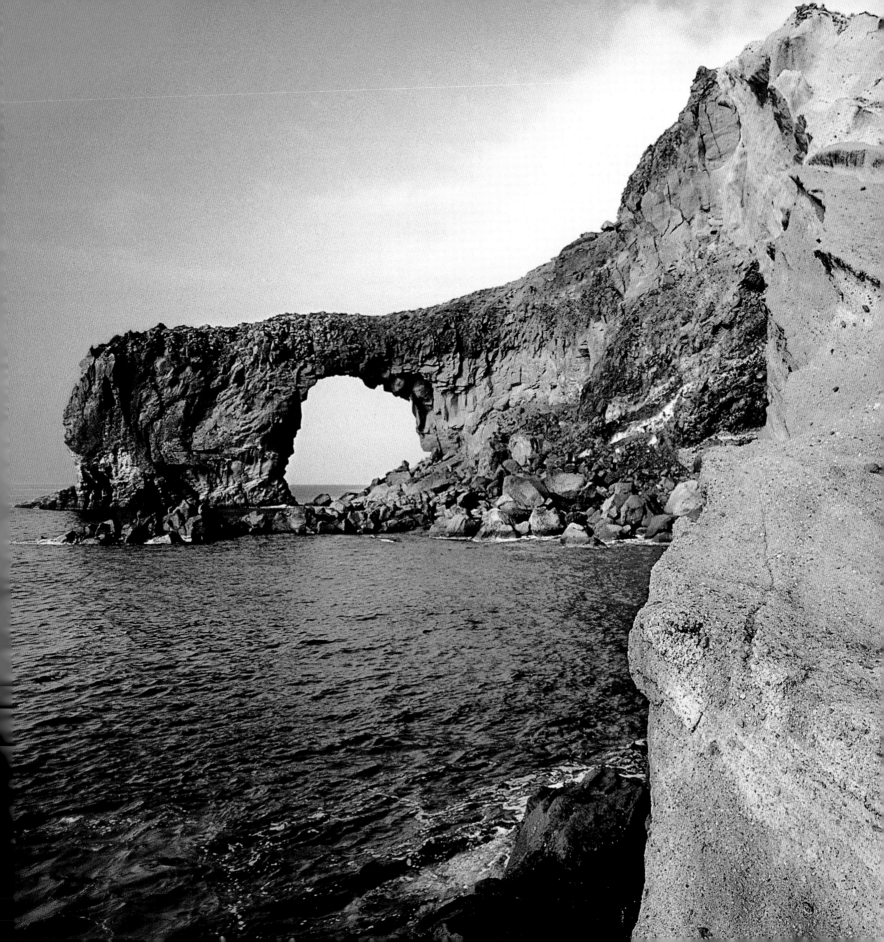

STROMBOLI

Y ou have to admit: volcanoes are the most intriguing mountains on the planet. And if you're talking about one of the most active volcanoes in Europe, and if it's on an island, then the fascination doubles. Whoever has a soft spot for islands can't miss Stromboli, the pearl of the Aeolian archipelago—named after the Greek god of wind, who appears to have carved out the islands' curvaceous forms. In Sicilian, the island is called *Strumbulu*, meaning "top." The inhabitants respect and fear it so much that they call it *Iddu* ("He"). And "He" does not pass unobserved, seeing as how almost every hour he makes his presence known with gurgling sounds and micro-eruptions.

The rediscovery of the island is owed to Roberto Rossellini, who in 1949 filmed *Stromboli* here. The movie tells the story of a Lithuanian refugee (played by Ingrid Bergman) who, in order to obtain Italian citizenship, marries a local who works as guard and fisherman. The film offered such beautiful views of the island that it began to attract visitors. This was at the dawn of the mass tourism phenomenon, and up until the 1970s the island was a destination only for true nature lovers looking for an unspoiled atmosphere that lacked the usual comforts. There is still a generation of people on the island who remember the film and saw many of the inhabitants appear as extras—just like Iddu himself, who started erupting during the shooting.

On the island you can find hotels, pensions, and houses to rent, in which the owners add beds on top of beds, transforming the houses into camp sites. They come to get you at the port in little three-wheel motor rickshaws, the vehicle that has become the island's signature taxi. This, too, accounts for Stromboli's charm, a place where electricity is at times optional, the ATMs have a lantern on top, and cell phones simply give up. The ride back on the hydrofoil is generally very melancholy, and the last image that remains imprinted in your memory is the silhouette of Iddu, who emerges so majestically from the sea.

Above: The house where Roberto Rossellini and Ingrid Bergman stayed in 1949.
Below: View of Stromboli from nearby Panarea.
Opposite: A spectacular cove with the tiny island of Strombolicchio in the background.

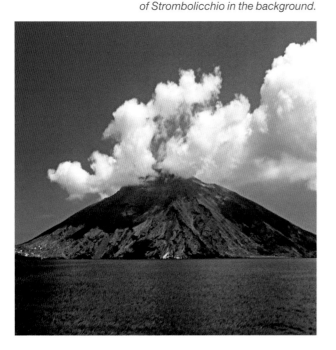

Must See

Don't miss the black sand beach of **Ficogrande**; a swim to **Strombolicchio**; the trip to **Ginostra**, the smallest port in the Mediterranean; a rendezvous in the piazza at the **Da Ingrid** bar for a granita; and a swim under the **Sciara del fuoco**, the sheer rock face where lava flows down into the sea. The water is warm, the sea floor is pitch-black, and the landscape is straight out of Dante. But the most unforgettable experience is the steep **climb to the crater**, which should be done with a guide. You hike up in the late afternoon, so you arrive when it's dark, in order to admire the active craters, exploding rocks, and lava that rolls down the mountain and fizzles out in the sea.

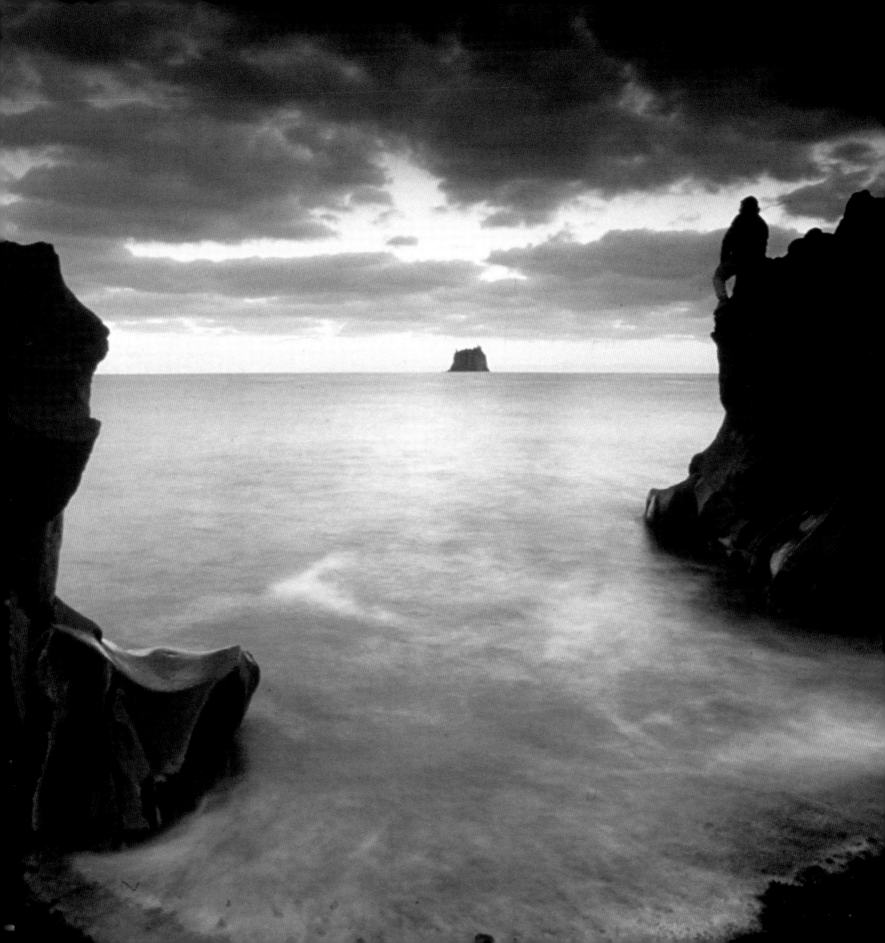

ZAKYNTHOS

Above and Opposite: Sea stacks on the Keri coast.

Below: Navagio Beach, also known as Shipwreck Bay, is only accessible from the sea. Shut in by high rock walls, it is hidden from view virtually until you arrive on the shore.

Zakynthos is the island of poetry, of beaches with crystalline waters, and of verdant Mediterranean underbrush. Ugo Foscolo, an Italian poet born here in 1778, cited the island, which often goes by the name Zante, in his poem "To Zakynthos." It is also the homeland of the renowned Greek poet Dionisios Solomos, an orator of freedom whose statue stands in the middle of Solomos Square, the island's most important and prettiest plaza.

The "flower of the Levant," as the Venetians called it, Zakynthos is one of the largest Greek islands in the Ionian Sea. It has a fairly variegated coastline, with sandy shores on its eastern part, while the western half is more rugged and has sea caves of exceptional beauty, like the Blue Grotto. To visit the Blue Grotto, which is located on the northern part of the island near the port of Skinari, take a boat from Agios Nikolaos. The magical atmosphere of the bizarrely shaped rocks and transparent waters reflecting blue-green colors will quickly overwhelm you. It's a perfect location for diving, as well as for snapping memorable photos. But Zakynthos is not only known for beautiful beaches. There's also the National Marine Park where loggerhead turtles, a protected species, can be seen laying their eggs along the beach at Laganas Bay, chosen by the animals for its unspoiled environment. Far off the main tourism circuit, the island's tiny mountain villages are worth a look. Among these is Bochali, known for its Venetian fortress and spectacular panoramas. From here, take in the view of the city of Zakynthos.

Not to be missed is dinner in a Greek tavern where, if you're lucky, you can listen to *kantades*, traditional songs of Venetian origin. Also worth seeing is Gyri, the highest settlement on Zakynthos, where locals have successfully preserved traditional farming methods. Its antique threshing machines, run-down windmills, and villagers' firsthand accounts make the trip a truly unique experience.

Must See

Navagio Beach is a narrow strip of white sand at the base of sheer limestone cliffs. Sometimes referred to as **Shipwreck Bay**, images of this incredible beach have been used by the Greeks to promote the country's tourism industry. In the 1970s, a cargo ship ran aground here and was never salvaged, so bathers will still find the wreck today, right in the middle of the beach. To reach its shores, take a boat from **Ormos Vromi** or the Zakynthos-Saint Nikolas ferry. If you want to get some memorable photos of the beach, you'll have to venture out to the sides of the small cove. From there, you can capture the place in all its splendor.

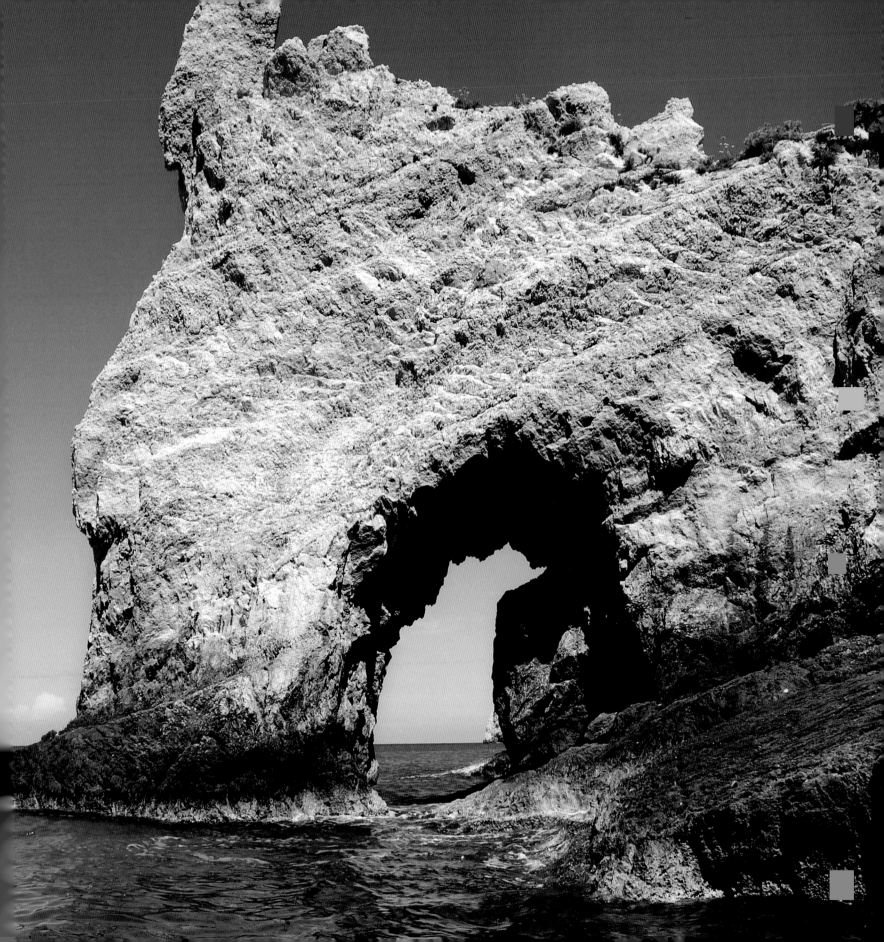

These diamonds in the rough have abandoned themselves to an aqueous embrace—be it the oceans, seas, or lakes, it makes little difference. They are enveloped by the caresses of an indomitable lover, yet no one, not even Poseidon, can force these rocks to yield. Visitors can't help but unlock the mystery of these places—islands you can explore but can never conquer, territories whose borders are mapped but whose soul remains uncharted. Despite their physical boundaries, their spirits remain limitless. You might wonder if that's even possible, but here, an island is an island—a splinter of the infinite.

[Manuela Soressi]

 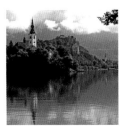 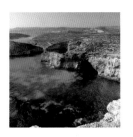 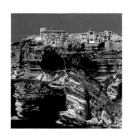

 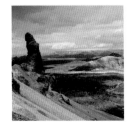 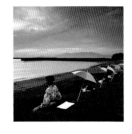 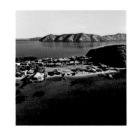

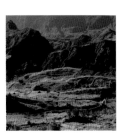 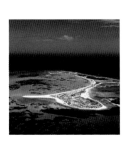

DESTINATIONS
TO EXPLORE

ALDERNEY

icture an island three miles long and one and one-half miles wide where the 2,000-odd residents are ready to greet you with open arms. This is Alderney, or Aurigny, depending on whether you bump into an English speaker or a French one. While its larger sister islands are well-known, picturesque, and offshore tax havens, Alderney, the third-largest of the Channel Islands, is just known for being a haven. Its temperate climate, rugged scenery, and welcoming, down-to-earth residents make it the perfect spot to recapture that inner peace we so often fear we've lost. Here, the jet-set lifestyle and flashiness are foreign concepts.

Once you've arrived by boat or small plane, the best way to get around is on foot or by renting a bike. No place is too far or hard to reach. Visiting Alderney means discovering an isle filled with magnificent beaches, rocky cliffs, and a curious mix of wildlife and vegetation. It's a place where peacefulness and relaxation are full-time pursuits. In addition to being a restful refuge, Alderney is also steeped in history. Its earliest records may have been lost with the passing millennia, but three forts found here convey the story of recent events, as the horrors of conflict and deportations that occurred during World War II have left their mark.

If nature, in all its most varied forms, interests you, then contact the Alderney Wildlife Trust. They can organize excursions and, more importantly, boats for partaking in an enthusiastic day of birdwatching. But the real pearl of Alderney is the railroad, which cuts across the countryside for two miles between the port of Braye to Mannez Quarry, and passes the nearby Mannez lighthouse. Though it's not very tall, the lighthouse is one of the oldest in the world; it was inaugurated in 1847 by Queen Victoria and Prince Albert. If your day hasn't been too exhausting, there's always time for an evening out in one of the many welcoming pubs on the island, spent in the company of a good pint of beer.

Above: A stationmaster of the Alderney Railway, one of the oldest railroads in the world.
Below: Saint Anne, the capital.

Opposite: Fort Albert, a Victorian-era fortress.

Must See

Though the **Alderney Railway** operates trains on holidays and weekends during the summer, you are better off experiencing life on the island by walking or pedaling down the more than 40 miles of lanes that criss-cross Alderney between camp sites, beaches, and farmhouses. Some paths come abruptly to a dead end at the edge of cliffs, from which you can admire spectacular views and sunsets. There's also the charming landscape, with its country lanes, pubs, and homes decorated with flowers. Take a trip back in time and visit the island's three major forts: **Houmet Herbe, Quesnard,** and **Les Homeaux Florains**, all of which are situated next to the sea.

BLED

Above: A ferryboat station chief.
Below: The island as seen from Bled Castle.

Opposite: View of the island with the church of the Assumption of the Virgin.

Bled is the only island in Slovenia, and it is not situated on the Adriatic Sea. In the middle of a deep blue lake, Bled formed during the last Ice Age. It is a typical Slovenian tourist destination, but is also a religious center because of its Marian sanctuary, mentioned for the first time in 1185. Today, what was once a small chapel has been transformed into a baroque-style building dating back to 1698, where you can still admire graves from the eighth century and a series of frescoes inspired by the *Biblia Pauperum*: the Annunciation, the story of Joachim and Anne, the Virgin in the temple, and an evocative Eucharistic Christ surrounded by angels and terrifying instruments of torture—images that are at once splendid and disturbing.

But the church dedicated to the Virgin Mary isn't the only treasure here. The island, which appears to have been inhabited as early as the Neolithic era, reveals a majestic entrance, a big staircase in gray stone that leads first to a square and then to the sanctuary. At the side of the church is a hermitage, which, having welcomed traveling hermits who came in search of peace for over 200 years, is now a hostel for pilgrims. Then there is the house of the provost, which accommodated the sacristans. Also worth visiting are the chapel of the Madonna of Lourdes, the statue of Mary Magdalene, and, of course, the beacon.

Many visitors also go to Bled for the beautiful views that can be admired from the shore. It offers a privileged lookout point onto the castle of Bled, which clings to the surrounding rock as if it were carved from it. If you are a nature lover, you should pay attention to the mountains: you can see up to Triglav, the "three-headed" mountain that is the symbol of Slovenia, as well as up to the Planinski Vrh, the Jerebikovec mountains, and the Mali and Veliki Draski Vrh peaks. On clear days, the mountains are beautifully reflected in the lake's surface.

Must See

A romantic legend says that a widow once lived in the **Castle of Bled**. To commemorate her beloved husband, she commissioned a bell made out of gold and silver for the island's chapel. During the lake crossing, a violent storm caused the bell to sink, together with the crew and the boat that was being used to transport it. The bell has never been found. Desperate, the woman then sold all her belongings, donated the money for the new church on the island, and entered a Roman convent. The bell supposedly still rings today from the depths of the lake on luminous nights. As with every beautiful legend, the wishes of whoever hears it will come true.

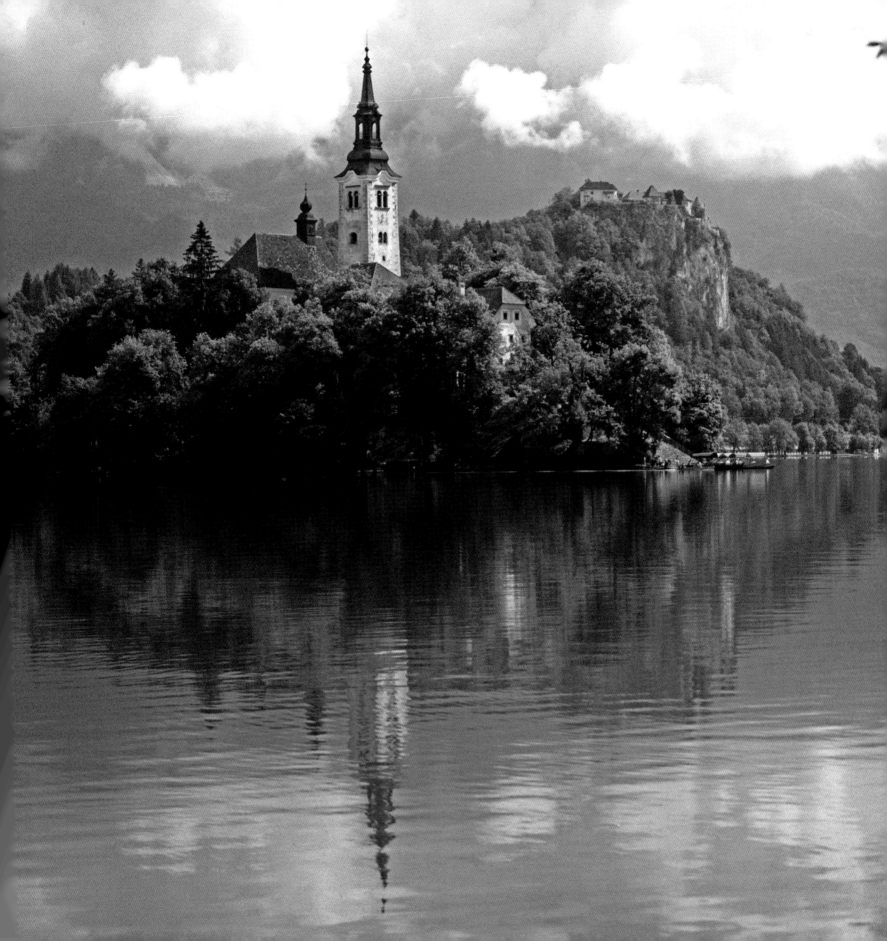

BORNHOLM

A land of striking contrasts, the majestic Danish island of Bornholm is anchored in the Baltic Sea between Sweden and Poland. Rønne, with its prominent natural harbor, is set between two reefs of rock from several geological periods, which slope down into the lapping waters of the surrounding sea. From the harsh shore bursts forth vegetation similar to Mediterranean shrubs. Then there's a view that's worth the climb up the 108 steps to the top of a rocky gorge. From here, local religious leader Jons Munk used to preach to Bornholm's Protestant villagers. The view looks out on the western coast and the Hammeren, a granite massif rising 270 feet above sea level and separated from the rest of the island by a broad valley in which Lake Hammersø lies.

An island of fishermen, Bornholm has its share of quaint villages, including Sandvig, Allinge, and Gudhjem, which is located on a small natural bay. Fishing here dates back to medieval times. Today, the town is also known for its glassware and ceramics. From Gudhjem a ferry departs daily to the island of Christiansø, with its old fortress linking to the isle of Frederiksø via a rope footbridge. Nearby, there's the rocky island of Græsholm, a seabird sanctuary not open to the public. In both Gudhjem and Svaneke, warm plates of smoked herring are served. Prepared in wall-mounted ovens that burn birch wood and open like drawers, the herring and salmon are hung on grills by their tails. They emerge with crispy skins and an appetizing gold color.

At the center of the island is Almindingen Forest, a dense collection of centuries-old trees with earth-splitting roots that form impressive sculptures. There are also small lakes for bird watchers. The scenery abruptly changes toward southern Bornholm. In the area around Dueodde, there's a beach with powdery chalk-white sand stretching as far as the eye can see that is frequented by ducks and shorebirds.

Above: Fisherman in the port of Svaneke.
Below: Typical wooden houses painted in beautifully bright colors.

Opposite: The village of Svaneke.

Must See

The Aa Kirke, in **Aakirkeby**, is the largest church on the island and was built in the 12th century. In **Nexø**, there is the **Museum of Navigation**, as well as a pretty park that is home to countless butterflies. The quaint village of **Snogebæk** is well known for its chocolate factory and for its local delicacies. At the **Bornholm Museum** in Rønne, you'll find artifacts that date back many centuries. Of particular interest are the embossed gold foil plaques containing figurines known as *Guldgubber*, whose origins are said to go back as far as the Iron Age.

CHILOÉ

Above: A grandmother and granddaughter in Ancud.
Below: Fishermen in the small port of Quemchi.

Opposite: Typical wooden houses of fishermen
in Castro, the island's capital.

If you visit Chiloé, do it after you've read the work of Francisco Coloane, the island's native son. If you've read his novels but don't know about Chiloé Island, you'll want to get to know it. "Coloane is our maestro," explains fellow Chilean writer Luis Sepúlveda as he wanders among the stalls of smoked shellfish in Puerto Montt. "Every Chilean that reads Francisco finds in his stories of the *brujo* (the sorcerer) the origins of his Native American past, of the Spanish explorers, or both if that's what destiny has decided." The lucky few who Coloane welcomed into his home in a quiet Santiago neighborhood were attracted by the magnetism and lucidity of the elderly man with striking white hair and the face of an old sea dog.

To reach Chiloé, you board a ferry at Parqua, a small port 750 miles south of Santiago. A half-hour later, you dock at Chacoa. You've finally made it to Chiloé, an island once populated by pirates and whalers, where today many fishing boats tie up next to the fisherman's stilt houses. Leaving Chacoa behind, the first city you encounter is Ancud, the former capital, with its traditional wood homes and a fascinating museum chronicling the island's turbulent past, its natural history, and its legends. Heading south you come to a pretty inlet and Castro, the island's capital. The impressive cathedral of San Francisco, made entirely of wood and painted in shades of orange and violet, is the main attraction, along with the *palafitos*, dwellings built on stilts. Moving further south, there's lush vegetation on higher elevations all the way to Chonchi. From here you can easily wander off to discover the island on your own. Not to be missed is the natural park that runs along the western coast, with its deserted beaches, gold prospectors, and salt collectors. As you leave Chiloé behind, you pass the same coastline surveyed by Charles Darwin, an astute observer of its precious secrets. Be sure to pay close attention, because in this unique realm your imagination is more alive than ever.

Must See

On the small islands in the gulf next to Castro, the only means of transport is walking or riding on horseback. **Quehui Island** is even more rugged. Though reachable by ferry from Castro like the other isles, be sure to double-check the schedule, as sailing times vary. **Curanto** is a unique local way of cooking both fish and shellfish. Prepared in a hole in the ground, a fire is lit and the bottom is covered with stones from the river. Fish, potatoes, and cabbage are placed inside and then covered over with stones and a damp burlap cloth. After waiting about three hours, it is ready to eat. The taste of this delicacy is hard to describe, as it has a flavor all its own.

COMINO

Above: View of Comino.
Below: Saint Mary's Tower, built in 1618 by the Knights Hospitaller of Malta as a lookout post and defense against invaders.

Opposite: View of the sea from Saint Mary's Tower.

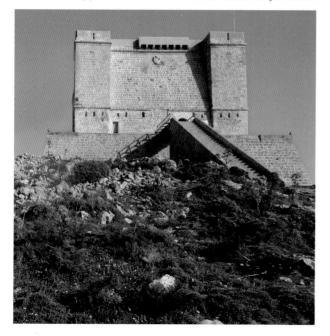

Rocky, rugged, and small—it's barely one square mile in size— Comino bursts forth from the waters of the Mediterranean halfway between Malta and Gozo. It's barren, yes, but strewn with wild fennel and cumin—*kemmuna* in Maltese, *comino* in Italian—from which it gets its name, as well as its intoxicating scent, as the cumin combines with other plants, resembling handfuls of confetti strewn by a distracted giant. The ground is coralline limestone, and the island's 10 or so inhabitants have to put up with salty winds. What little agriculture they do manage to grow is thanks to sheer will-power. During Roman times, the island was deserted, but with the arrival of the Knights of Malta the island found its role: it soon became a bulwark for the Maltese Archipelago, as its location made it ideal for thwarting pirate incursions.

All sense of time changes on Comino, conditioned by an arcane combination of natural rhythms and the changing of the seasons. Visitors are struck by the intensity of its colors, which arouse the senses and emotions. Nothing is taken for granted—there are no cars, and the absence of noise ampli-fies the echo of the sea which, depending on how the wind blows, laps or crash-es against the shore in a sensual rhythm. Its crystalline waters—a palette of hues that froths into turquoise, aquamarine, and emerald waves—open up into an underwater labyrinth, making it the undisputed Mecca of scuba diving— especially Ras l-Irqieqa and Saint Mary Bay, on the southwest and northeast coasts, respectively. But the ultimate experience is found on the western side of Comino, together with the tiny uninhabited isle of Cominotto—just over 300 feet long—creating a small canal that forms the Blue Lagoon. It's a bright blue color that gradually becomes transparent as you approach the shore, and underwater it's possible to admire natural arabesques in the rocks lit by the sun's rays.

Must See

At the southeastern tip of Comino, you'll find **Saint Mary's Tower** rising up more than 250 feet. Constructed in 1618 by Alof de Wigna-court, the Grand Master of the Knights Hospitaller of Malta, according to architect-ural plans by Vittorio Cassar, it is the center of a series of defensive structures and lookout towers. Along the path that leads to the tower, the view looks out on the **Blue Lagoon** and **Cominotto**, a neighboring island hemmed by a ribbon of sand and surrounded by cliffs. Comino's only house of worship is situated on the coast at **Saint Mary Bay**, shaded by carob trees. It's a small church with a simple facade and a 17th-century chapel dedicated to the Annunciation inside.

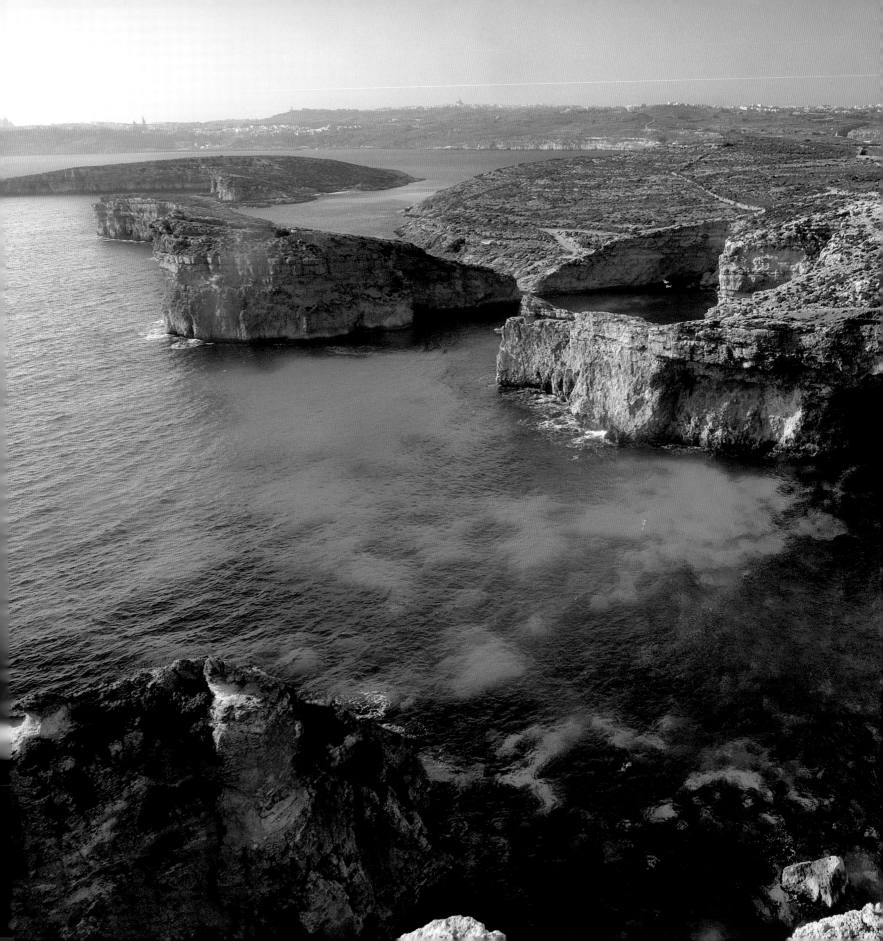

CORSICA

Here, the smell of absinthe, carried in on the mistral wind, the same wind that bolsters Corsica's countless seagulls, assails the senses. And the lighthouse of the Iles Sanguinaires ("Bloodthirsty Islands"), which sits within earshot of the Gulf of Ajaccio, seems to reign over everything: the red rocks, the wind, the colorful shrubs, the eagle in search of shelter. Ravines shadow roads that no one takes for granted—they are always full of surprises. While Tour de la Parata may seem like the end of the earth, it's not. Arriving at the first café, the elderly gentlemen do nothing to contradict the stereotype that they're inactive and lazy. They are prisoners in an island game that shuns those in a hurry. Under the pergola they play endless card games, stopping only to relight a pipe or sip pastis.

In Napoleon's hometown of Ajaccio, there are signs of a gathering storm. His former residence, now a museum, is tucked away in a narrow lane that leads to Place Foch, where a statue of him as First Consul recalls the despair and grandeur of a life that's become part of world history. Here, the sea is always blue and foaming. Moving onward, the D111 road takes you to the Gulf of Valinco. Here, the story of Corsica begins with the prehistoric sites of Fontanaccia, Filitosa, and Palaggiu. The latter boasts 258 *menhir* (stone monoliths) and is the most impressive megalithic site on the island.

Moving inland, the houses of Sartène are divided by narrow roads. Above a promontory, there are panoramic views westward toward Campomoro. The rugged coast, with many inlets and dramatically pointed rocks, is a spectacular place to take a dip after sampling the local crêpes and pommes frites.

Above: Beaches near Cargèse.

Right: View of Bonifacio, a town perched above limestone cliffs on the southeastern tip of the island.

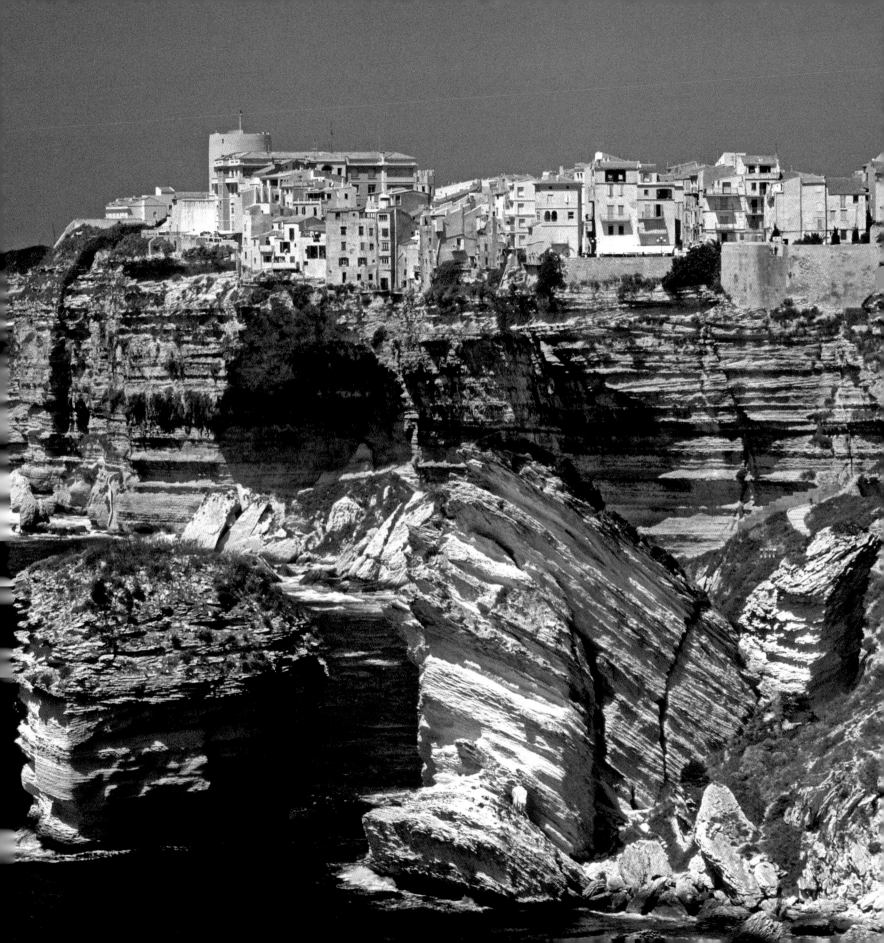

But the island's real wonders lie underwater. Dive down and admire red coral and lobster just 15 minutes from the coast by boat. Before reaching Bonifacio, you encounter Roccapina Bay. On Route 196, once you reach a 1,100-foot-high mountain pass, leave the car and walk to Lion's Rock, a dramatic lookout over the sea where you'll see a string of breathtaking inlets, home to windsurfers and yachtsmen. Bonifacio's cliffs signal the start of the Lavezzi Islands Marine Reserve, one of the most beautiful spots in the Mediterranean, with emerald green waters, calcareous rock, Piantarella's fine blond sand, and an incredible sea floor.

Corsica's charming contradictions don't end here, however. Returning north, near Porto-Vecchio, there are beaches of unparalleled beauty: Cala Rossa, Palombaggia, and Tamaricciu. And the scent of oak, fern, and maritime pines wafts down from the Ospedale Forest. A change of scenery takes you to the summit of Vacca Morta (4,300 feet), offering unrivaled views of the coast and mountains. From here, descend toward Golfe de Porto and one of the planet's most spectacular natural attractions: here, in red rocks sculpted by the wind and eroded by water, nature has drawn the outline of animals, architectural forms, and odd figures. In his novel *Une Vie*, Guy de Maupassant eloquently described the awe and splendor of the place.

Must See

Be sure to retrace the footsteps of Napoleon Bonaparte. In **Ajaccio**, the city remembers its famous native son at every turn. There's the **Bonaparte House National Museum** on Rue Saint Charles, where Napoleon was born; the Napoleon room at city hall; the 16th-century cathedral where the future ruler was baptized; and his country residence at **Les Milelli**. Other spots worth visiting include: the **Iles Sanguinaires**; the **Scandola** and **Girolata** nature reserves; the inlets and beaches of **Roccapina**; and the **Lavezzi Islands Marine Reserve**, a windsurfer's paradise. Sample the **bouillabaisse** at the **Aux Bon Amis** restaurant in Calvi. Also try **brocciu**, a cheese made from goat's milk.

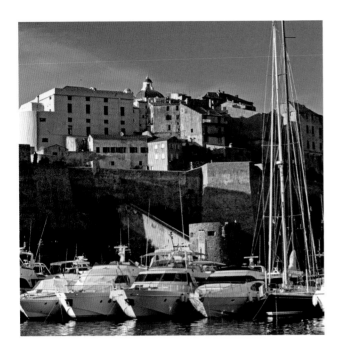

Above: View of the port of Calvi.

Right: The Girolata Nature Reserve.

Opposite: The menhir of Palaggiu.
This site includes 258 stone monoliths.

Below: Lavezzi Islands Marine Reserve.

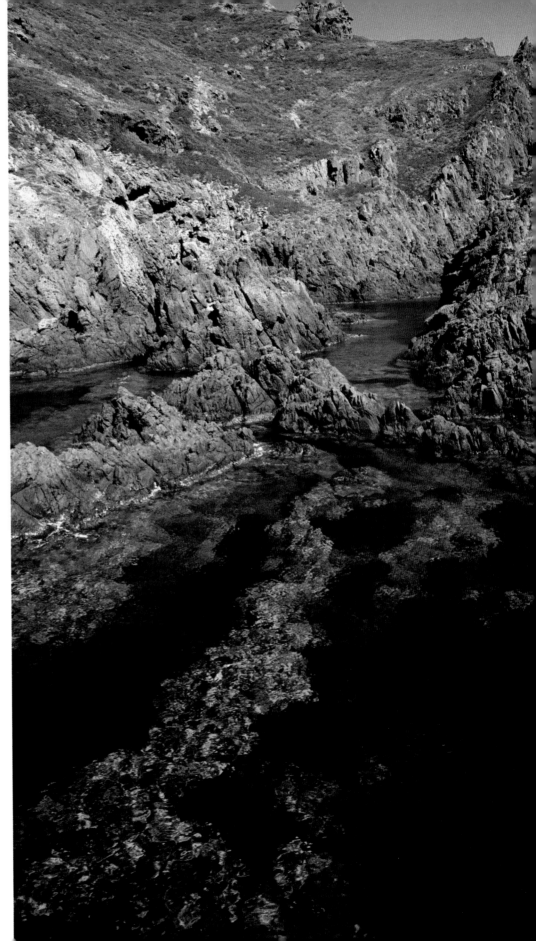

Above: Sunset on Pajaros Island, or "Bird Island," frequented by 150 species of migratory birds.
Below: Fishermen with a captured shark.

Opposite: A typical residence.

The island of Holbox is a delightful discovery, a magical place where no sooner have you arrived than the silence, serenity, colors, and nature's lovely fragrances start to make an impression on you. Its peacefulness is due to the fact that there are no cars—transport is provided by electric golf carts that move slowly down the island's paved roads. Things are never rushed, and time is never a concern. The peacefulness you encounter here, especially for those who are caught off guard or unaware that they have arrived in a special place, triggers a sense of awe and wonder. Exploring Holbox requires visitors to respect the local lifestyle, which is quite different from what the popular imagination may associate it with, and has none of the hustle and bustle of most tourist destinations.

There are lots of adjectives to describe Holbox, but perhaps the most appropriate is *romantic*. People can't resist capturing on film its fiery red sunsets and the calm pace of island life. Harmless whale sharks swim around you, bright emerald and turquoise waters surround you, and Holbox's powdery sand tempts you to stroll its shores. Indeed, this paradise seems tailor-made for lovers, and is adorned with beautiful seashells offered up by the sea by the thousands, each exquisite and unique. Locals decorate their homes with them and sell them to visitors as souvenirs. You're free to collect them, but you're only allowed to take a handful with you—a sign that mass tourism still hasn't set roots down here, even if Holbox is just an hour by boat from Chiquila, right on the Gulf of Mexico, and a mere 100 miles from Cancun. To arrive, you need to cross through small towns, the jungle, and unpaved roads. Seemingly close but in reality light years away from Cancun's bustling crowds, Holbox is the ideal destination for those looking to enjoy nature in peace and quiet.

Must See

Holbox is one and one-half miles wide and about 25 miles long, and is part of the **Yum Balam** biosphere, a nature reserve made up of many islands. For moving around the nature reserve, a kayak is the recommended means of transport. From mid-May to late September, harmless whale sharks, the most common sight in these waters, spend their days around Holbox feeding on the rich fields of plankton. It's the only time of year when excursions are organized to see the sharks. Other islands worth visiting are **Cabo Catoche** for its many bird species, including the pink flamingo, and **Yalahan**, for its freshwater spring that was once used by the Maya.

ICELAND

Above: Reykjavík, the capital, viewed from Hallgrímskirkja church.

Right: Rock formations in the Landmannalaugar region.

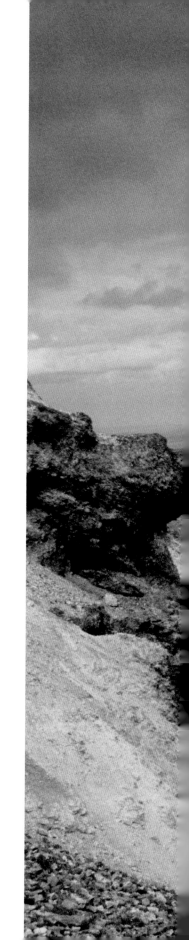

J ust as it was 30,000 years ago—when, legend has it, Iceland was the home of an arctic tribe said to be the progenitors of all humanity—you can walk along the coast, but the island's core remains impenetrable. Yet amid the shore's infinite hairpin bends you eventually come across the remarkable Ring Road. Bereft of guardrails, the route climbs up steep promontories and covers great distances that never seem to end. The road is part of the modern age. Previously, people moved around on horseback, with all of their belongings and animals in tow. Save for geologists, expert trekkers, and the odd adventurer in search of unexplored lands, few venture into the highlands. Today's adventurers are seen as the direct descendants of legendary outlaws such as Fjalla, Iceland's Robin Hood, who sought refuge in places considered inhospitable even for trolls.

Indeed, large swaths of this island, which covers 40,000 square miles and dangles just below the Arctic Circle, don't seem fit for man. Desolate plateaus cover 52 percent of its territory; there are meandering rivers that reach boiling temperatures; its steppes rival those of Tibet and Mongolia; and its center has moon-like craters. Lava fields cover 11 percent of the surface, while 12 percent is blanketed in ice. The remaining 20 percent is deemed "habitable" and used for cultivation.

The forces of nature, often dormant for long periods, manifest themselves here in spectacular fashion. The scarce population—300,000 inhabitants, of which 170,000 live in the capital, Reykjavík—translates into majestic landscapes full of solitude. You are constantly immersed in the ancient myths of Old Norse legends that trace their literary

and anthropological origins to this land. At the dawn of time, choristers and mystics composed sagas where reality and fantasy intertwined to form a literary collection of 60 texts whose authors remain anonymous. There's even something mythical about the country's naming system; children take their father's first name and add a suffix to form their last name—women place "dottir" after it, men "son."

As you might imagine, nature here is spectacular, magical, and restless. It makes its presence known through more than 200 volcanoes, 250 geothermal zones, 780 hot springs (where temperatures average 170 degrees Fahrenheit), and 30,000 waterfalls. The island's natural masterpieces, forged by fire and ice, include: Gullfoss waterfall, located in a majestic canyon bordered by green slopes; Geysir, with its celebrated spout of hot water rising more than 100 feet in the air; the Vatnajökull glacier, which conceals volcanoes below its ice; the glacial lake of Jökulsárlón, where icebergs float in deep blue water; the primordial beauty of Lake M´yvatn, with its many steam vents; the roaring Dettifoss, Europe's largest waterfall in terms of volume; the western fjords, set between crystal lakes and sheer cliffs; and Mount Snæfellsjökull, where the protagonists of Jules Verne's *Journey to the Center of the Earth* confronted the abyss. Everywhere you turn a feeling of awe awaits, as you explore this land governed by secret prehistoric laws.

Must See

Visit the sites where the earth boils over with unnerving force. Around **Lake M´yvatn**, take long walks that will carry you back to the dawn of creation. Then there's the magical light, which changes with each passing cloud and warms everything—the waterfalls, snow-capped peaks, multicolored homes, birdlife, horses, volcanoes, steppes, boiling mud pools, black sand beaches, laundry flapping in the wind, and children with strikingly blond hair. There are rocks molded by storms, fumaroles, stones of every imaginable color, sunsets ablaze in apocalyptic reds, the blue hues of the sea and the sky, and countless blue-eyed women. It's an island that captures your heart, and every one of its attractions warrants a visit.

Above: A typical glacier landscape.

Right: View of the village of Höfn.

Opposite: A hot spring in the Landmannalaugar region.

Below: Skógafoss Falls in southern Iceland. The waterfall is 80 feet wide with a vertical drop of 200 feet.

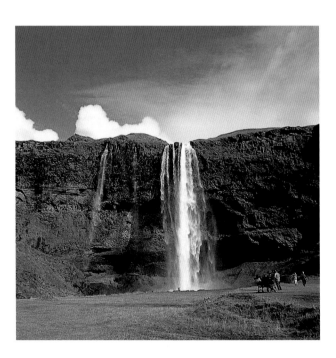

KYUSHU

*Above: Tiny Aoshima Island in Miyazaki Prefecture is linked to the mainland by a stone bridge.
Below: Kagoshima Castle.*

Opposite: A sand bath at sunset on Kagoshima Beach.

Kyushu is an island of volcanic activity and hot springs that emit a vibrant energy. Here, one of life's essential elements—water—runs, gushes, and splashes around, invigorating the lives of the Japanese. The coastline's abstract beauty provides the backdrop for aquatic rituals that suggest sacredness and a natural world imbued with *kami*, or spirits, within an organic totality that lives in harmony with the sea, sky, rocks, and wind.

The fury of the waves and the wind carve little cavities into the rocky, sheer cliffs where Shinto spirits are said to dwell. The allure of these rituals is accompanied by a deep silence, and is reflected in the bathing ritual. The waterfall bath, performed here during summer pilgrimages to volcanic shrines, provides you with a unique set of emotions.

Viewed from above, the island resembles a geographic embroidery that's been transformed into evocative scenes. You can lose yourself in the waves of Hokusai and its floating mist and metaphysical vegetation, as well as in the ancient land of Yamato, located in the extreme south of the island. From here, ancient Chinese and Korean cultures spread throughout the archipelago and gave rise to Japanese civilization. In Fukuoka, the Buddhist priest Eisai founded the Shofukuji Temple, introducing Zen Buddhism and green tea to Japan. Kublai Khan's fleet was wiped out in these waters by a typhoon said to be the mythical *kamikaze*, the divine wind.

Cho-cho-san's statue in Nagasaki Bay commemorates the protagonist of Puccini's opera *Madame Butterfly*, which was set here. Between Nagasaki, whose port was kept open during the Tokugama shogunate, and Kumamoto, there's an impressive landscape that weaves through the Shimabara Peninsula and the 70 isles of the Amakusa district. A significant group of volcanoes is found in Unzen-Amakusa National Park, with peaks pushing 5,000 feet, and in Aso-Kuju National Park, where Mount Aso (5,223 feet) towers with its five peaks.

Must See

Beppu is noted for its 3,000 thermal springs, as well as for its eight *jigoku*, or boiling hot springs and mud pools. **Yakushima** is an ancient volcanic island and a protected UNESCO World Heritage site; covered in centuries-old cedars and cypress, it features a vast ecosystem that includes rare species of rhododendrons. The *yunohana-goya* is a straw-roofed hut where locals grow sulfur "flowers," a crystalline powder produced from the vapor of the hot springs. Be sure to book a stay at one of the traditional **ryokan** inns and indulge in one of their **onsen**, the outdoor hot springs. At **Ibusuki**, situated on Kagoshima Bay, try the naturally heated **black-sand spas** and curative baths.

164

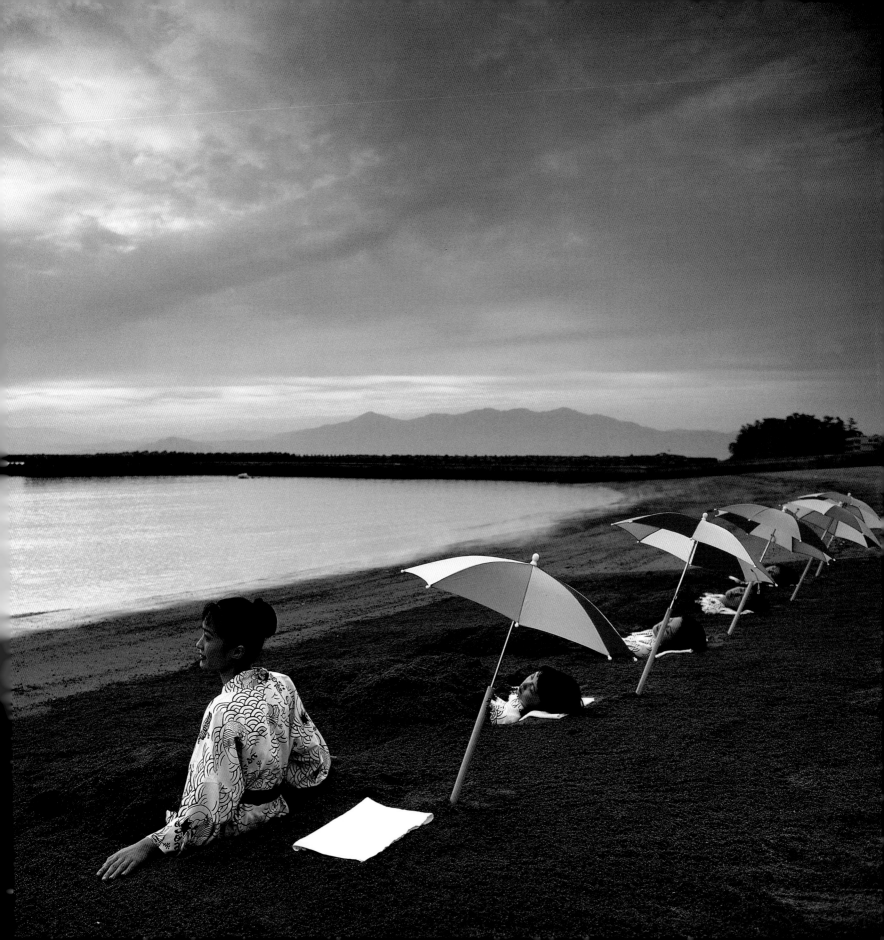

MOCHIMA

Above: An isolated beach in the Borrachas archipelago.
Below: Aerial view of the archipelago.

Opposite: Fishermen's village on Chimanas Island.

Mochima is a collection of islands, 34 to be exact, that only nature's unbridled imagination could have dreamt up and assembled as this heterogeneous grouping of secluded beaches, stunning reefs, and tangled jungle, all united by a sea floor of exquisite beauty. The archipelago is so stunning that it's now protected as a national park, and is only the second marine reserve to be created in Venezuela. The Mochima National Park spreads along the northeastern coast between Puerto La Cruz and Cumaná. The islands that make up Mochima are an inseparable bunch. In fact, there isn't one island that plays a prominent role in terms of hosting tourist accommodations or a village of particular importance; each offers those fortunate enough to visit something exclusive and unforgettable.

It goes without saying that a boat is absolutely essential when planning a visit. However, things are made easy by the fact that small rental agencies line the coast from Puerto La Cruz to Cumaná and are happy to accompany you on a discovery of this marvelous paradise. Mono Island, the Chimanas, and Borracha Island are the most well-known due to their size and to the fact that they are the only ones equipped with facilities to accommodate visitors. Given the lodgings, booking here requires people to be flexible, but after check-in be sure to sit down for a seafood lunch that features a plate of lobster. This delicacy is caught in large numbers by local fishermen who live in tiny villages situated on the sandy beaches and rocky outcrops.

These tiny conglomerations are usually made up of no more than four or five colorful wooden cabanas with sheet metal roofing. Walking past the boats you'll see locals tending to their nets or the pots used for capturing lobsters and crab. Accustomed as they are to a solitary lifestyle, the locals will watch you with a certain shyness, but they never hesitate to smile or offer a friendly wave.

Must See

If you get the chance, don't miss out on an aerial tour of the archipelago aboard a **helicopter**. Barcelona, Puerto La Cruz, and Cumaná are the three cities from which you can arrange flights. From above, the islands will appear even more enchanting. The whiteness of the beaches, the tiny secluded fishing villages, and the color of the sea will be etched into your memory forever. If you're lucky, you might even see a school of **dolphins** leaping out of the water as if they were in a vast natural swimming pool. But don't forget that the fate of this unspoiled archipelago depends on conservation efforts and the respectful behavior of all its visitors.

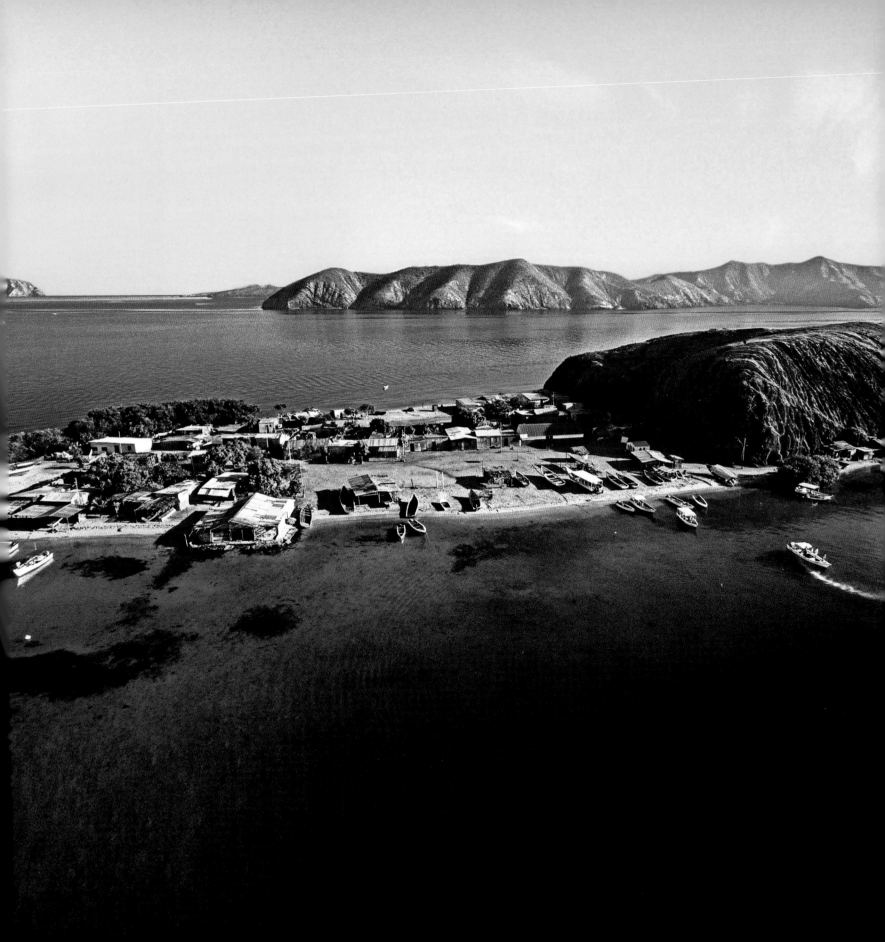

EASTER ISLAND

F ar from the South American mainland, Easter Island is isolated like no other place on earth. What also makes it unique is the open-air archaeological museum found here. Scattered about this Polynesian island are the remnants of hundreds of villages, cemeteries, and places of worship that conceal the mystery of how the ancient islanders built and transported their gigantic *Moai*, the unmistakable figures with anthropomorphic features we're all familiar with. The elaborate ceremonies, superstitions, and rituals that bound residents to their ancestral gods make Easter Island an absolute must for lovers of history and archaeology. Here, using hieroglyphics carved onto wooden tablets, locals created the only written form of the Polynesian language. Myths and legends were transformed into extremely complex rituals, and cults flourished. The cult of the "birdman" was one of the most important, and each year it organized a dangerous competition among male contestants who first descended the steep slope of the Rano Kau crater, and then swam to the nearby isles to collect the first eggs laid by the seabirds. The winner was proclaimed "birdman," and for the ensuing year received the best foods and a bevy of young virgins. Men would also quarry rock and carve the *Moai*, which are still considered among the most incredible archaeological discoveries on the planet. Visiting the quarry where they were made stirs up strong emotions, as does the sight of the sacred sites known as *Ahu* at Anakena, Tongariki, and Akivi, where the statues were mounted onto stone platforms. They are similar to those seen at Stonehenge, Machu Picchu, the pyramids of Giza, and the Roman Coliseum.

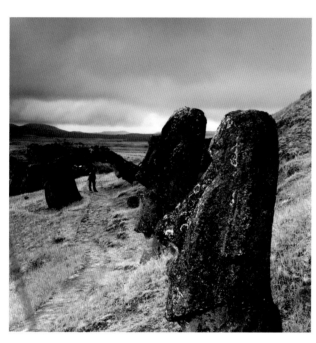

Above: Rano Raraku, where stone was quarried for the Moai *sculptures.*

Right: Crater of the Rano Kau volcano.

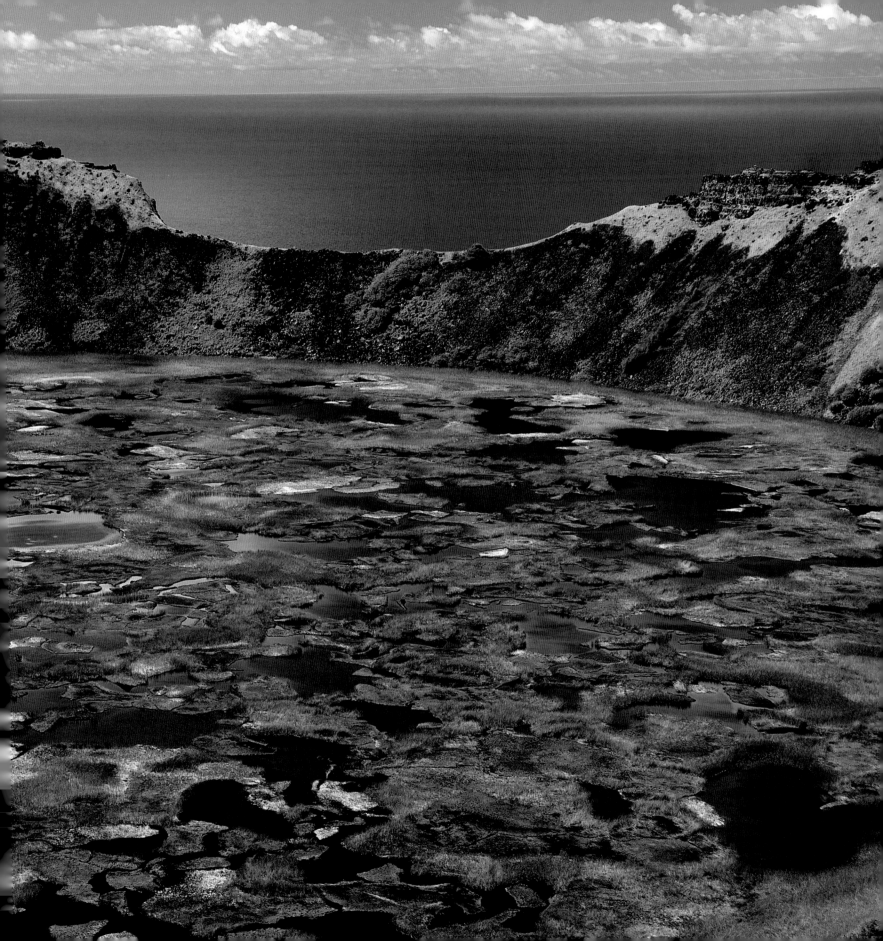

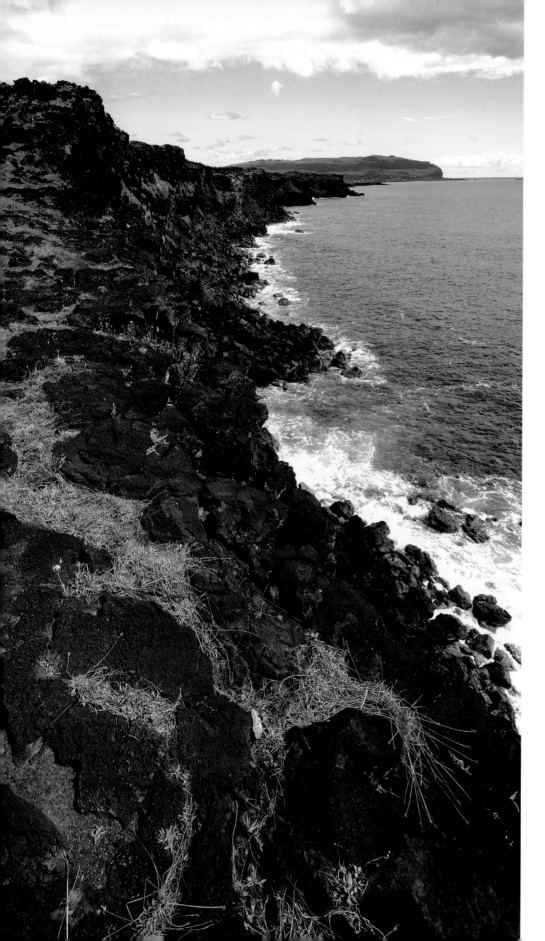

Easter Island also offers incredible excursions on foot or on horseback through a distinctive volcanic landscape. Its crystal-clear waters abound with sea life, and its giant waves beckon experienced surfers. For less sporty visitors, there are beaches and rocky coastlines, the erosion of which serves as a warning of the dangers our civilization is facing. That's because when the Polynesians, who arrived on large outrigger canoes, first explored the island, they found it uninhabited and overflowing with natural resources, so much so that for several decades the new arrivals enjoyed great prosperity. However, over the span of a few generations, the island became overpopulated. Soon the dense forest covering was gone, the fertile earth was lost to soil erosion, and numerous plant and animal species became extinct. Overfishing depleted the food supply in the sea, and soon after the inhabitants began to fight among themselves. When food became scarce, residents started to kill one another just to survive. The same thing, on a much larger scale, could very well happen to us if we don't take the necessary steps to avoid it. Indeed, Easter Island also teaches us that it's possible to reverse the process, repair the damage, and not repeat the same mistakes. By visiting this haunting yet enchanting place, we can learn how to avoid a similar fate.

Must See

The **Father Sebastian Englert Anthropological Museum** offers a comprehensive look at the island's history. Catch the sunrise at **Ahu Tongariki** and then swim in the crystal-clear waters along **Anakena Beach**. For scuba diving, head to the tiny isles of **Motu Kau Kau**, **Motu Iti**, and **Motu Nu**. Also worth a look is the archaeological site at **Orongo**. The volcanic stone used to create the *Moai* statues is found at the **Rano Raraku** crater. There are also deep-sea fishing expeditions and two-day horseback excursions where you get to sleep inside caves once used by the islanders. Be sure to visit archaeological sites in the presence of a guide. For lunch, sample an *empanada* or tuna *ceviche* at one of the many restaurants in **Hanga Roa**.

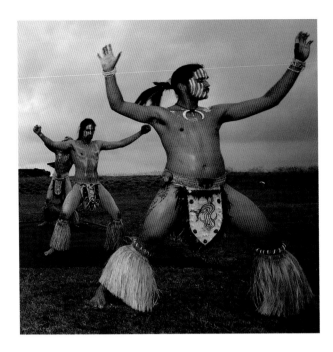

Above: Traditional dance performed at Ahu Ko Te Riku.

Right: The white coral sands of Ovahe Beach.

Opposite: The rocky western coastline.

Below: Giant Moai sculptures. The monolithic figures were carved from a single block of volcanic tuff.

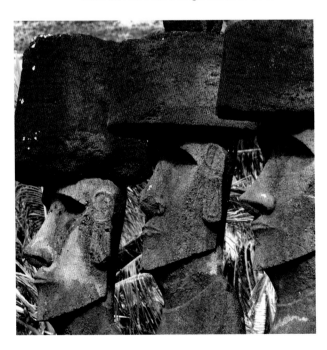

RÉUNION

Above: Cliffs along the coast between Saint-Benoît and Saint-Philippe.
Below: A market in the capital, Saint-Denis.

Opposite: The inland region of Salazie.

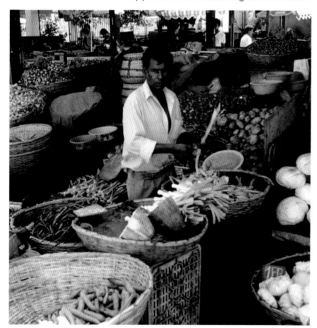

Situated in the middle of the Indian Ocean, Réunion offers much more than the average tropical paradise. Born three million years ago from a violent union between sea and fire, it offers sensations you can't experience elsewhere, with more than 125 miles of coastline, half of which is sandy, and mountain ranges that surpass 10,000 feet above sea level and harbor an active volcano. And it has yet another advantage: it belongs to the European Union and uses the euro as its currency. The island is an overseas region of France, with a multiethnic population (European, Indian, Malagasy, African, Chinese, Arab, and Creole) and a fascinating mix of cultures, customs, and religions.

The refined atmosphere you find in restaurants, hotels, and shops is decidedly French. Along with the beautiful palm-lined beaches, mild year-round climate, exquisite variety of Creole cuisine, and exotic fruits (including the petite and delicious "Victoria" pineapple), the island offers a host of emotions that are hard to experience all at once. Before all else, visitors are struck by the incomparable vistas of the interior: mountains covered by lush forests, spectacular peaks, steep cliffs and ravines, countless waterfalls, and high plains dotted with tiny villages and farmlands (there are even vineyards at 5,000 feet). There are immense craters forming a veritable moonscape near the temperamental volcano surrounded by a mountainous rampart and small, surreally pointed volcanic cones. There are breathtaking views along the coastline and on the three cirques—the immense calderas of the older and now inactive volcanoes of Cilaos, Mafate, and Salazie—as well as from the grandiose and still active crater of Piton de la Fournaise, which "built" the southeastern end of the island and continues to extend it.

Must See

Explore the island for a little adventure in a 4x4, on foot, on horseback, or on a mountain bike over the more than 600 miles of trails that cross the high plains and forests, passing through amazing panoramas. Fly over the island in a helicopter, an exciting experience straight out of a scene from *Indiana Jones*, with a vertiginous flight through narrow ravines, misty waterfalls, steep peaks, and the otherworldly terrain around the volcanoes. A visit to Saint-Denis, the capital, reveals the city's **Tamil Indian temples** as well as the Christian cathedral of **Notre Dame des Laves** and the **church of Saint Anne**, reflecting the island's rich mix of races and cultures.

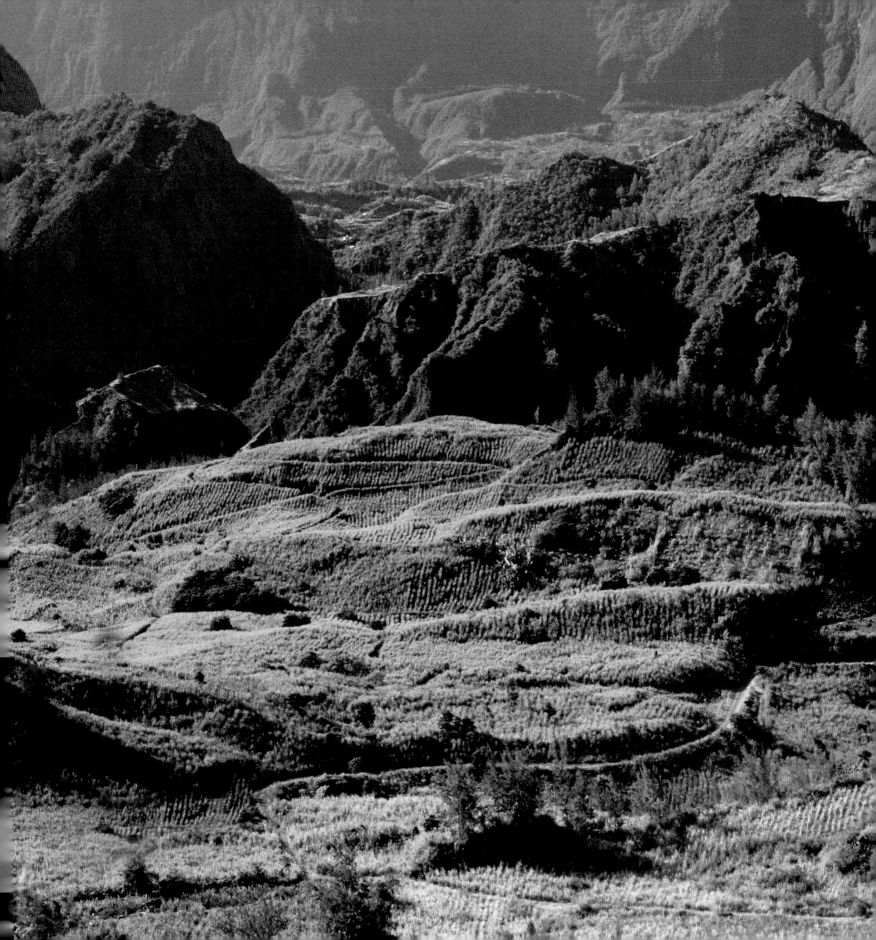

TORTUGUILLA

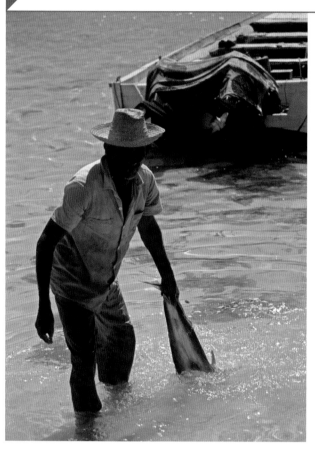

La Tortuga Island, in the Colombian Caribbean, is 60 miles from the coast of Puerto La Cruz and 50 miles from Margarita Island. Its unspoiled scenery, which in the popular imagination is populated by bloodthirsty pirates and tales of treasure, is just over 60 square miles in size. Notwithstanding its uniqueness and the incredible sea around it, there are actually three tiny uninhabited islands that keep it company; one of these goes by the name of Tortuguilla. Lacking any easy transport options, this extraordinary locale is nearly impossible to reach.

For those unable to procure a boat to make the crossing, there is one other option available: head to the main square in Puerto La Cruz and ask for a man named Paolo the Genoese. Someone will introduce you to him as he sits puffing away on a cigar and sways in a worn-out hammock. Tell him you want to go to Tortuguilla and, with a bit of luck—plus a few hundred dollars for fuel—a few minutes later you'll be aboard his single-engine airplane flying a northwesterly route toward the island.

While Paolo may seem a bit of an eccentric, don't be fooled by appearances, he's a good pilot. After 20 minutes in the air an irregular strip of land suddenly appears below. Its blindingly white beaches seem to slide into an emerald and cobalt blue sea dotted by fishing boats anchored offshore. There's not a single tree, bush, or landing strip in sight, but after two tight turns the Cessna comes to a jolting stop on a stretch of sand. Look around, take a deep breath, and inhale the sea air. Wherever you turn, the water reflects the sun just a few feet below. Not far away, on the islet's miniature isthmus, a few fishing skiffs out for the lobster hunt are beached. After two or three hours, however, you must resign yourself to the fact that it's time to go, and try to free yourself from the grip of the Stendhal syndrome that overcomes most visitors. Time flies, but upon returning to the mainland you'll feel as if you've awakened from an extraordinary dream.

Above: Fishermen are the only people you're likely to run into on the island.
Below: The beaches have white sands and turquoise waters.

Opposite: Aerial view showing the irregular outline of Tortuguilla.

Must See

It might seem obvious, but make sure you take full advantage of the time allocated to you during your stay on Tortuguilla. Familiar emotions inevitably surface, and will make you conscious of the fact that this strip of land ringed by a fabulous sea is a metaphor for solitude—a constructive solitude that allows you to be at peace with yourself and those close to you. Even the gentlest wave in this silence will have a voice, as will the faintest breeze. If it's **lobster** season, you might be able to purchase a few fine specimens from the local fishermen. And finally, don't forget to pack a sun hat and powerful sunblock for your skin.

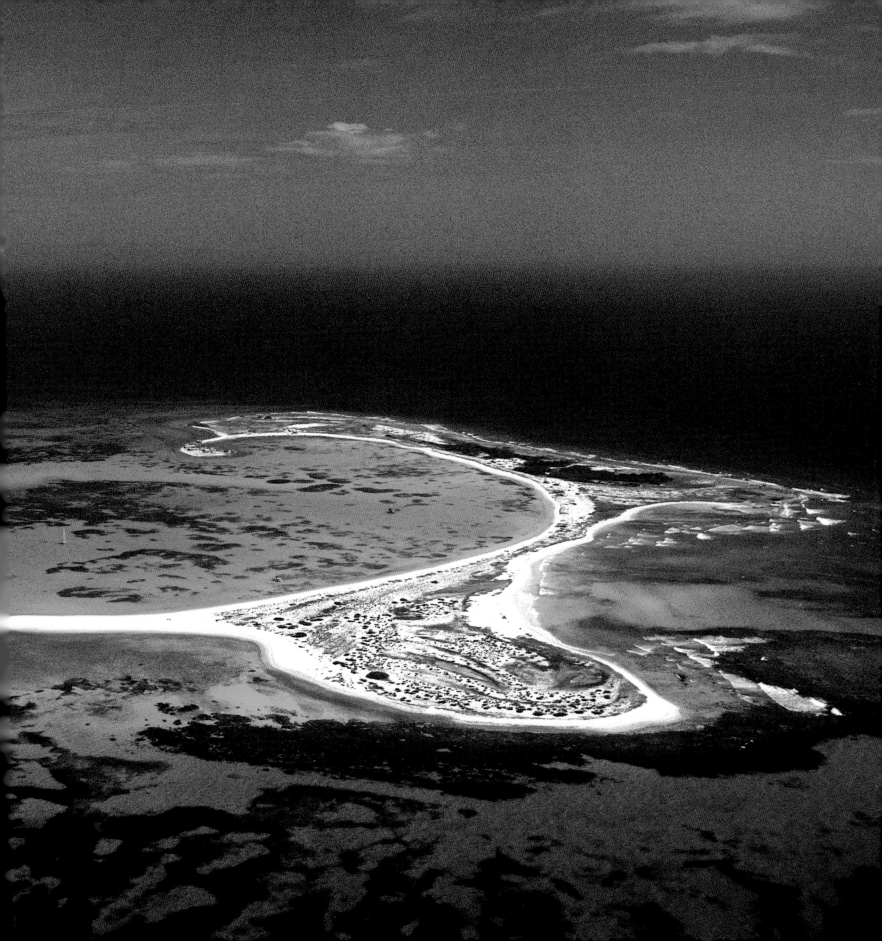

WAKATOBI

A t its southern tip, the large island of Sulawesi in Indonesia breaks into fragments of coral, then disappears into the Banda Sea. There are 13 islands east of the island of Buton, in the middle of an endless sea that descends to depths of over 3,000 feet. From these remote, crystalline waters emerges the Wakatobi Archipelago, also known as the Tukangbesi Islands. Recently declared a marine park by the Indonesian government, it brings together a handful of islands that are full of palms and agriculture centered on the tropical forests. Villages full of huts built on stilts by the formerly nomadic Bajau people blend in with the colors of the sand, and appear to float on the water with the arrival of the tide. In Kaledupa, the Kampung Bajo is one of the best examples of a community of *Orang Laut* ("sea people"). Originating in the island-dotted seas around Sulu, in the Philippines, and from the southern coast of Borneo, this ethnic group gradually spread all the way to the Maluku Islands and Sulawesi. Moving in fleets of sailboats known as *perahu*, they set up villages—some seasonal, others permanent. Today, the former nomads use the rich coral reefs on these islands—where they live as subsistence fishermen—to set up their villages on stilts, which seem like a labyrinth of makeshift architecture.

There are other, virtually invisible Wakatobi islands, which are a nightmare for anyone trying to navigate these waters—anyone except, perhaps, the *perahu* captains from Makassar, who were the first to explore the routes toward the Maluku, and who colonized the archipelago before the Dutch arrived. These ghost islands are called *karang*, coral rings that peer out from the sea at low tide. Then, when high tide comes in, they disappear. Karang Kaledupa and Karang Kapota extend for 45 miles and spread out along a 100-mile perimeter. These two atolls are also the closest to the archipelago's four main inhabited islands: Pulau Binongko, Pulau Tomia, Pulau Kaledupa, and Pulau Wangi Wangi.

Above: Fish market on Kaledupa Island.
Below: Face painting during a traditional ceremony on Kaledupa.
Opposite: A strip of coral sand protrudes out into the Banda Sea, where the Indian and Pacific oceans meet.

Must See

A visit to the **stilt village** built by the **Bajau tribe** on the coral reef of **Kaledupa Island** is worthwhile. Here, you can discover the lifestyle of the local "sea gypsies" and admire their crafts, such as the *keris*, a dagger made of local metal. There is the eco-friendly **Wakatobi Dive Resort**, on **Tolandono Island** near Pulau Tomia, considered one of the world's best spots for scuba diving. Then there is the coralline lagoon and beach in **Pulau Ndaa**, plus diving off the reefs of the **Karang Koromaha atoll**. Traditional fishing catamarans, known as *bagan*, are anchored in the Pulau Tomia lagoon. And then, of course, there are the welcoming people with their bright smiles, who never intrude and are always friendly.

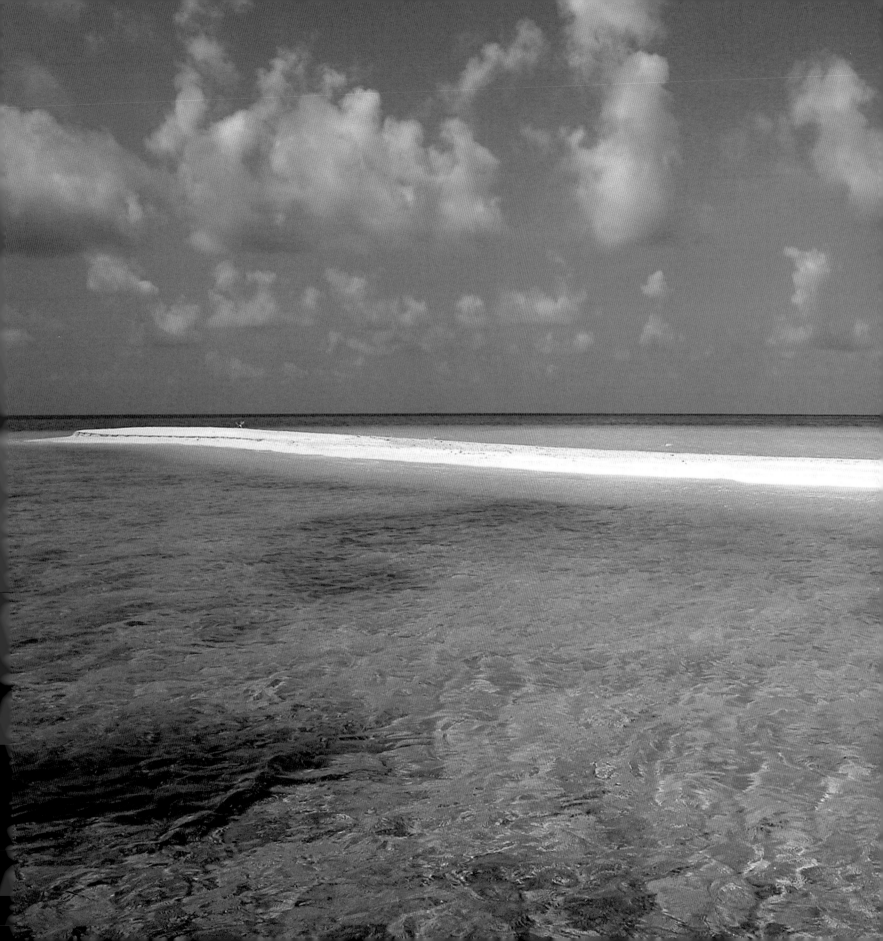

These are ancient lands of commerce and trade, tracts of earth that have welcomed new cultures and crops over countless centuries. They harmoniously blend the two like a cook playing with spices and exotic ingredients, pairing contrasting elements to create entirely new flavors. From the Mediterranean to the Caribbean, by way of the Indian Ocean, each island has developed its own culinary repertoire and turned itself into an archipelago of aromas that make for a truly unique experience. Here you'll find appetizing adventures on both land and sea.

[Vittorio Castellani aka Chef Kumalé]

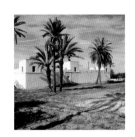

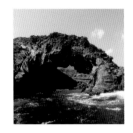

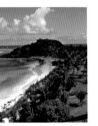
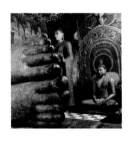

ISLANDS
OF TASTE

ANTIGUA

The sun's rays caress the willowy coconut palms and slip between the towering bamboo; their warming touch skims over the orchids and the hibiscus. And then, when you tire of the bright, clear sky, and the fine white sand that borders the bays and coastline like a lace hem, you simply dive into a sea of sapphire and lapis lazuli. There's all the magic of the Caribbean in Antigua, the jewel of the Lesser Antilles. Included among its many delights is the local cuisine, which wins over fans with its intense and enticing flavors thanks to Creole influences that play up the aroma of spices and tropical fruit. Freshly caught lobster, barracuda, and grilled king fish, served with a superb spicy condiment (like chutney), a side dish of Creole rice with spices, a classic pepper pot (a meat and vegetable soup), mango mousse, and *ducana* (sweet potato and coconut) reflect the island's history as a melting pot and tell its story better than any travel guide.

Antigua has also been blessed by Mother Nature for another reason. Thanks to the presence of the trade winds, the island doesn't have a rainy season. This added bonus means people enjoy its 365 beaches year-round, with their silky, blindingly white sands that open onto the extinct craters of ancient volcanoes and the many reefs that line the western coast, as well as the many reefs on the jagged eastern side that provide shelter from the waves. From Boggy Peak (1,300 feet), the island's highest point, accessible by 4x4 via a winding dirt road that leads you through pineapple groves, you have sweeping panoramas of the Caribbean Sea. Here time feels like it has come to a standstill. Below, you can almost make out the great sailing ships of the 17th and 18th centuries that once plied these waters

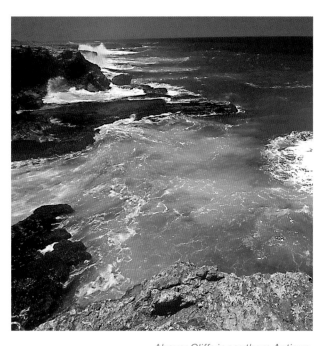

Above: Cliffs in southern Antigua.

Right: A resident of Saint John's.

in search of fabulous riches—on the hunt for, or hunted by, daring adventurers and unscrupulous seafarers. If you direct your gaze toward the rolling landscape and sweeping plains of the interior, the silhouettes of old stone windmills emerge like ghosts from the past; these structures dot the abandoned sugarcane fields and render Antigua even more magical. This enigmatic charm pervades the entire island, creating a place that is at once cheerful and seductive.

International yachtsmen, especially those from Europe, have a prestigious outpost on the island in the form of the Saint James's Club, founded by Peter de Savary. Nostalgics, meanwhile, can search for traces of the island's maritime past at Nelson's Dockyard, the 18th-century British naval base. The historic arsenal, which has recently been restored, is dedicated to Horatio Nelson, who spent the early part of his naval career here. The charming old brick buildings have now been transformed into lodgings, and it's a great location even for those who are not up on their nautical terms yet love the sea and the stories of Jules Verne.

Must See

At **Deep Bay**, visit the century-old wreck of the Andes, a merchant ship that sailed from Trinidad with a cargo of pitch resin and ended up catching fire and sinking here. Pull on a mask and fins and explore the wreck. **Betty's Hope** was a sugarcane plantation started by an Englishman in 1651 and is an important piece of Antigua's economic history. Its windmills and distilleries preserve the memory of this adventurous period. **Half Moon Bay** is Antigua's most spectacular beach, and is also the island's bodysurfing capital. At **Dickenson Bay**, there's a lengthy stretch of beach with fine sand and turquoise waters lined with a string of bars and resorts with live music and an active nightlife.

Above: Rum distillery in Saint John's.

Right: Coco Bay.

Opposite: Carlisle Bay.

Below: Fruit and vegetable market in Saint John's.

AZORES

T he force of lava shooting up from the depths of the ocean over time has led to the formation of this archipelago in the middle of the Atlantic. Halfway between Europe and America, the Azores are a borderland far from both continents, and as a result those who travel around the world aboard sailboats seek out its harbors. Here, the steep basalt cliffs and sea stacks battered by the waves drop away, and gentle slopes and plains hosting quaint towns with tessellated sidewalks and baroque churches come into view. In many of the local restaurants that dot the landscape, fresh fish is grilled and savored with ice-cold beer and local wines such as Verdelho do Pico. Visitors who venture inland along dugout trails come across crater lakes of various sizes, reflecting emerald hues and waterfalls encircled by blooming hydrangeas and lush vegetation; in some places the greenery turns into a wild and tangled mess, while in others verdant pastures similar to the Irish countryside appear.

From these shores, the surrounding sea seems infinite; it gives off a salty scent that mixes with fragrances from the humid native forest studded with tamarisk, laurel, and juniper. While it's not unusual to come upon deserted beaches, the most evocative sight is offered by the island's active volcanoes. The only sign of the powerful forces under foot here is the hot sulfuric steam that rises slowly to the surface. Invisible to the eye, it seeps through cracks and fissures in the earth or emerges with the same violent energy that gives rise to the nearby caldera and fumaroles. These natural "ovens" of steam are used by islanders to cook *cozido*, a meat and vegetable stew prepared in an airtight pot that's buried in the earth. This delicacy is part of a tradition that encapsulates the character of these islands, which are like no other in the entire world.

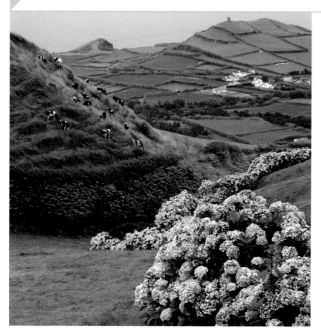

Above: Fences made out of hydrangeas are a common sight.
Below: Trekking on Faial Island.

Opposite: View of São Miguel, the most populated island in the archipelago.

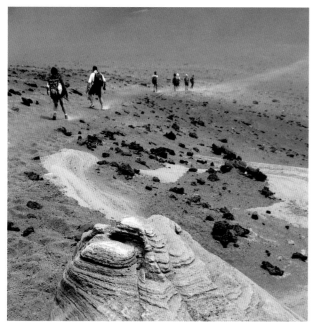

Must See

A trek to the peak of **Mount Pico** (7,700 feet) is not to be missed. From atop this volcano's summit, you can admire the curve of the horizon where the sky and ocean meet. At **Capelinhos**, a young strip of land on **Faial Island** that emerged from the sea following a volcanic eruption in 1957, there's barren earth, sheer cliffs, and a lighthouse. At the port of **Horta** you'll come across sailors' **graffiti** and refreshing pints of beer at **Peter Café Sport**, where travelers from all over the world leave behind messages and mementos. From Pico Island, fascinating photography safaris offer **whale watching** as well as a chance to see dolphins swimming in the Atlantic Ocean.

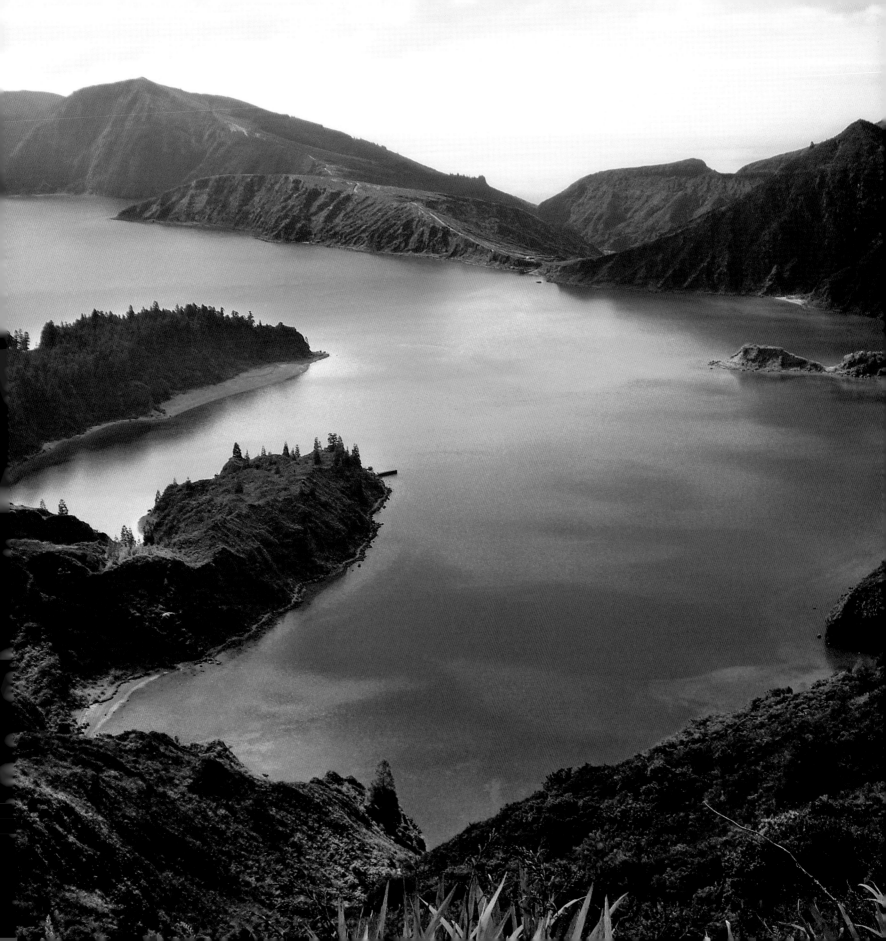

CAPRERA

Above: Built in 1856, Giuseppe Garibaldi's home is now a museum.
Below: Porceddu, *a traditional local dish.*

Opposite: View of Cala Coticcio.

Have you ever heard of the Maldives? Well, you'll find them at the northern tip of Sardinia under another name: the archipelago of La Maddalena. Here, on Caprera, one of the most beautiful islands in the archipelago, you can visit Shipwreck Beach, where the first few feet of sea is blindingly white, like the sand underneath it, before turning turquoise and then a stunning shade of cobalt blue. Cala Coticcio, another cove, has been nicknamed Tahiti to highlight the fact that Italy also enjoys transparent waters like those found in the tropics. The beaches here are easily accessible on foot via trails that cut between smooth granite, unforgettable sea views, and mysterious rock formations shaped by erosion, shrubs, and ruins of the former military base.

Caprera's cuisine relies on simple ingredients that derive from the local pastoral tradition and are handed down from generation to generation. Pecorino, the best-known of Sardinia's cheeses, is worth sampling, as is the ricotta that's used in hundreds of recipes. To reach Caprera, board a ferry at Palau, and after a 20-minute journey you'll disembark at the small port on La Maddalena, the main island. Once you've reached the Passo della Moneta Strait, which separates La Maddalena and Caprera, you'll notice the 10-foot-deep sea floor has been filled in with rocks to create a narrow causeway where traffic only moves in one direction at a time.

A paradise for boatmen, Caprera is home to one of the most famous sailing schools in the world. There's also a shade-providing pine forest, which was planted by the Italian Navy during two reforestation efforts in 1906 and 1950. All over the island you can feel the presence of Giuseppe Garibaldi, the Italian patriot and national hero who spent 26 years on Caprera. Here, you'll find his burial site and former home, which still houses his furniture, portraits, and writings.

Must See

You must try **Malloreddus**, which is a sea-shell-shaped pasta prepared with a fresh tomato sauce, sausage, and a generous portion of grated pecorino cheese. **Culurgionis** is ravioli stuffed with ricotta and chard. **Pane frattau** is made using soaked carasau flat-bread served with tomato sauce and a poached egg covered in pecorino. Then there's the classic **porceddu**, a roast suckling pig served on a wooden tray with myrtle leaves, and **pecora in cappotto**, a lamb dish with boiled potatoes and onions. Desserts to sample include **tiricche, papassini, sospiri, seadas, mostaccioli, pardulas,** and, of course, the local **honey**, which comes in strawberry, thistle, chestnut, and asphodel varieties.

CAPRI

The wine of Capri, produced on terraced hillsides sloping toward the sea, has been prized since antiquity. It's been written that Roman Emperor Tiberius, who in 38 AD elected to make the island his summer residence, was a connoisseur of the local grape. Capri's so-called nectar of Bacchus is made up of the ruby-red Piedirosso and the straw-yellow Falanghina and Greco grape varieties. But they aren't the only reason to visit Capri, which is part of an enchanted group of places that one shouldn't speak about too much, for fear of ruining the magical atmosphere that surrounds them.

The ideal season to appreciate the island's charm is winter. Like a beautiful woman who falls asleep in the arms of her beloved after a night of lovemaking, the island, exhausted after the fashionable summer season, reveals its secret places in the peaceful serenity of the cooler months. Walk along Via Krupp, which connects to Marina Piccola, and you are bound to run into some interesting characters, possibly even celebrities, among the locals. To get into the spirit of things, it's best if you partake in a few of the local rituals. These include: sampling the famous *torta caprese* dessert, a mixture of almonds and dark chocolate that's prepared with a dash of liquor and no flour whatsoever; sipping a glass of the local white wine, the traditional muse of poets and writers; dining at the restaurant in the shadow of the Faraglioni, reachable by boat from Punta Tragara, where you are gently caressed by the lapping waves and bathed in the blue light of the unrivaled Caprese moon; making the rounds at the historic Gran Caffè in Piazza Umberto I, known the world over as "La piazzetta"; browsing the boutiques in Via Camerelle; getting sandals made at Canfora by the master cobbler, who decorates his shoes with gold and precious stones to give them a regal dignity; and finally, paying a visit to Villa Jovis, the sumptuous residence of Emperor Tiberius.

Above: Piazza Umberto I, better known as "La piazzetta."

Below: One of the many artisan workshops that make bespoke sandals.

Opposite: View of the Faraglioni.

Must See

Villa San Michele in **Anacapri** is the extraordinary creation of Axel Munthe, the Swedish physician, writer, and philanthropist who at the end of the 19th century built a house on top of the ruins of a church dedicated to Saint Michael. Munthe wanted a home that, "like a Greek temple, was open to the sun, wind, and light of the sea."

On the villa's highest terrace, above all life's worries, there's a **sphinx**, a vigilant guardian of the island and its stunning beauty. Nobody knows who brought the statue there, but it is undeniably magical. Those who pet it forget their everyday troubles and leave convinced that, sooner or later, they'll return to Capri.

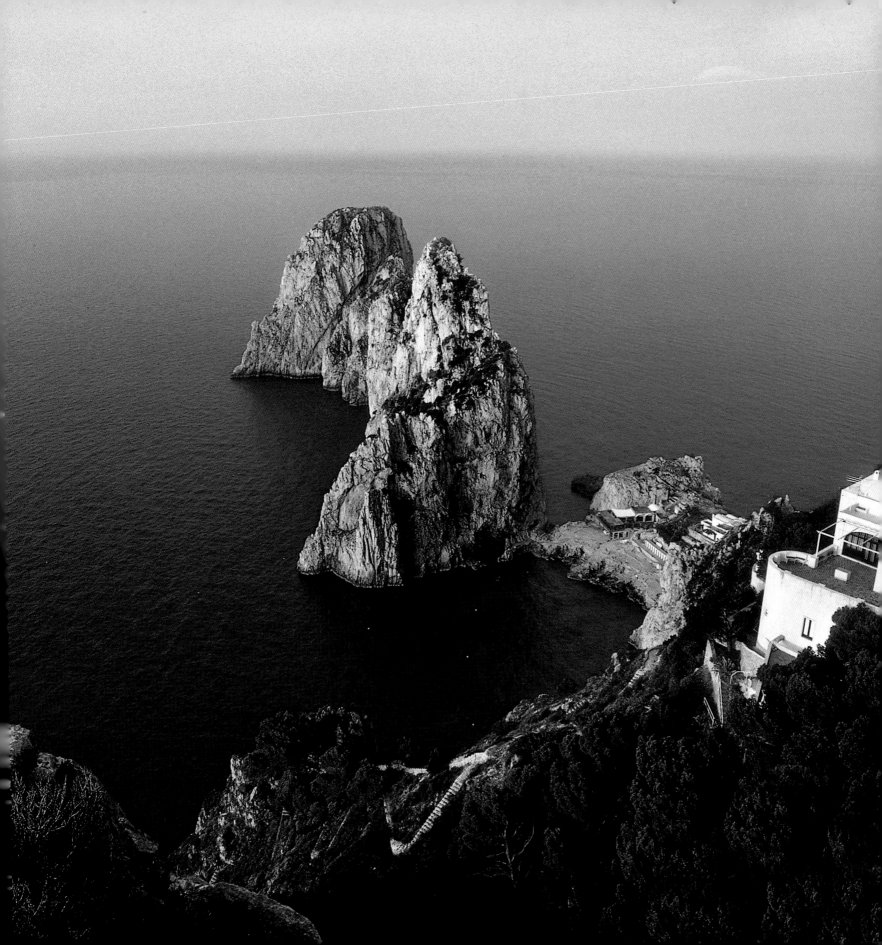

DJERBA

Above and Below: Spices and rugs at a city market in Houmt Souk.

Opposite: Arabian-style villa on the outskirts of Guellala.

D escending the stairs from the airplane, you suddenly feel as if you've walked into an oven. At first you might think the jet's engines are overheating, but you soon realize they've got nothing to do with it— it's simply the sweltering embrace of Djerba. The heat wraps around you like a sweat cloth and the sun's rays cut through the air like a scimitar, blurring the outline of the palms at the edge of the runway. A glance at the thermometer—which easily tops 100 degrees Fahrenheit in the shade, and even 120 degrees in August—reminds you that this is Africa. But you soon get accustomed to it, thanks to a surprising wind that whips up dry breezes to gently cool you both day and night.

Known as the land of the *Lotophagi*, who were said to have bewitched Ulysses, Djerba is a flat island just off Tunisia's eastern coast. Linked to the mainland by an ancient Roman bridge that is battered by waves, there are over a million palms here, as well as 600,000 olive, orange, cactus, and agave plants, all surrounded by stunning white beaches. It's a verdant oasis that has been ruled by the Carthaginians, Romans, Vandals, Sicilians, Aragonese, Spanish, and Turks. Each has left their mark on the island's architecture, religious customs, culture, language, and cuisine.

Towns such as Houmt Souk, Midoun, and Guellala are home to ancient caravanserai inns and souks where people bargain over everything from caftans (the ones here are described as *climatisé* for their ability to keep the body cool) to scarves made of camel hair. In narrow alleyways, scents from local kitchens waft through the air to create an ethnic melting pot of Mediterranean, Turkish, Jewish, and Berber cuisines. Couscous is the staple food, but many other delicacies are worth sampling: *brick* is a delicate pastry fried in oil and filled with lamb's meat or egg; the super spicy *merguez* sausages are made from roast mutton; *harissa* is a hot chili pepper sauce; and of course the exquisite mint tea with pine nuts is the perfect end to each meal. And don't forget *thibarine*, a liquor made from dates, and *boukha*, a local spirit produced from soft figs.

Must See

Djerba is home to many mosques, which are painted white and distinguished by a linear architecture of the utmost simplicity. But along the road to El-Kantara, Islam has left space for other religions. **El Ghriba** is one of the oldest synagogues in the Arab world. On the 36th day after Passover, Jews from all over the Maghreb arrive at the synagogue in order to participate in the well-known annual pilgrimage. Police discreetly keep watch over the procession from towers in order to protect the pilgrims, and there haven't been any problems of late. It's a peaceful corner of the sun-kissed island where even the camels have the air of ancient sages.

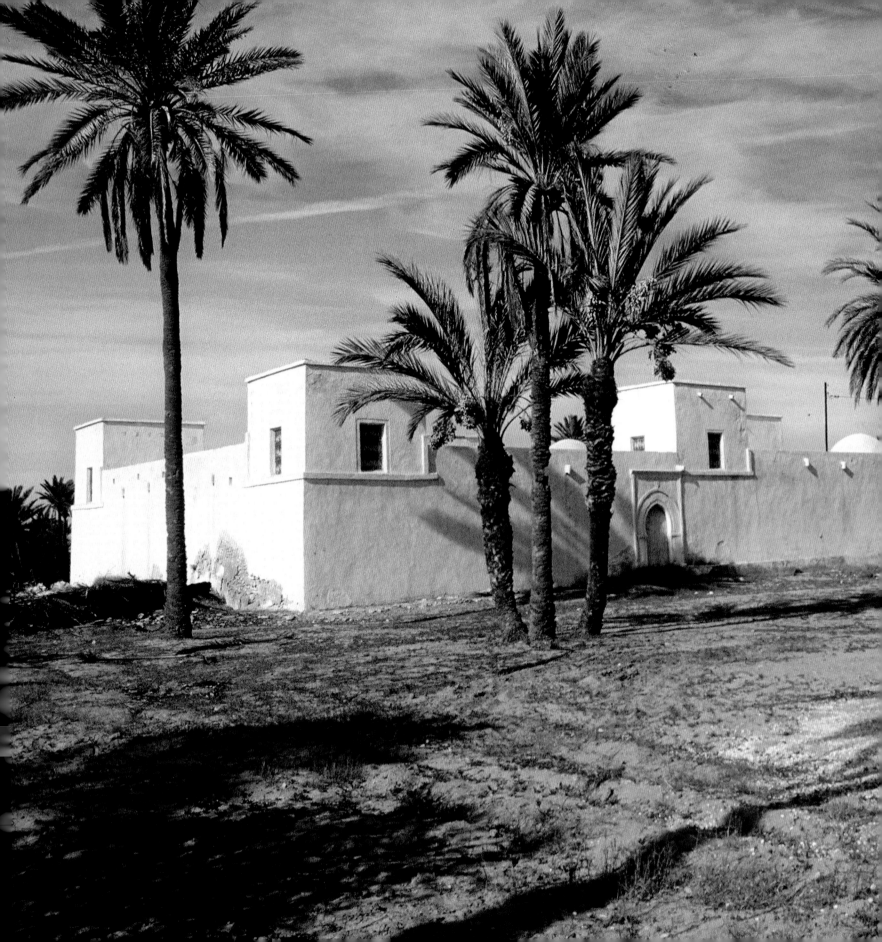

JAMAICA

If the pulsating rhythms of reggae music embody the soul of Jamaica, then the national dish, jerk, will make even your palate want to dance. For visiting musicologists, reggae is the ideal sustenance. And herein lies all the complexity of the Caribbean island's flavors: everywhere the air is permeated by the scent of the many spices (21 of them, many kept secret) with which jerk is prepared. Its roots go back to Africa, the ancestral motherland of most Jamaicans, and to the history of the slaves, who after a rebellion against the English around the end of the 17th century took refuge in the remote mountainous areas. The fugitives hunted wild pigs, then smoked the meat to preserve it; but first the meat was marinated with local berries, green pimento, Jamaican pepper, chili peppers, nutmeg, thyme, and cinnamon. Now even Hollywood stars (Errol Flynn was among the first) love to try pork or chicken in jerk sauce, especially at Boston Bay, east of Port Antonio, where you find one stand after another on the beach. Before indulging in this popular food and its complex combination of pungent and sweet flavors—which create mysteriously spicy nuances on the tongue—you can watch it cook in a long and slow ritual on makeshift oil-drum grills over coals and aromatic pimento branches.

And then there are the wild Blue Mountains—which literally are blue thanks to the intense color of the pines—that give their name to the most expensive coffee in the world. The beans' aroma comes from the pure mountain air, suffused with the scent of conifer resin and volcanic soil, which give it a less acidic, more full-bodied flavor. The sun, which at this high altitude is often veiled, caresses the plants without burning them. For this reason, authentic Blue Mountain coffee conveys a delicate flavor, often brought out by wet processing, which is preferable to dry roasting, and its aftertaste has a pleasantly sharp bite.

Above: Blue Lagoon, the famous beach that lent its name to the eponymous film.
Below: Dunn's River, where you can practice waterfall climbing.

Opposite: The town of Port Antonio, on the eastern shore.

Must See

Climbing **Dunn's River Falls** in Ocho Rios is still the most memorable experience Jamaica offers. It's not every day that you find yourself in a lush rain forest climbing 600 feet up the limestone cliffs and magnificent waterfalls along this remarkable river. Despite the occasional crowds, an outing here is unforgettable, and afterward you can go for a swim in the pristine sea below. Here you can taste what many have described as the most unique and delicious breakfast in the Caribbean: **ackee** and **saltfish**. This curious fruit, poisonous when not ripe, has a pulp that, when cooked, looks like scrambled eggs, and pairs well with cod, a selection of fried Johnny cakes, and bananas.

192

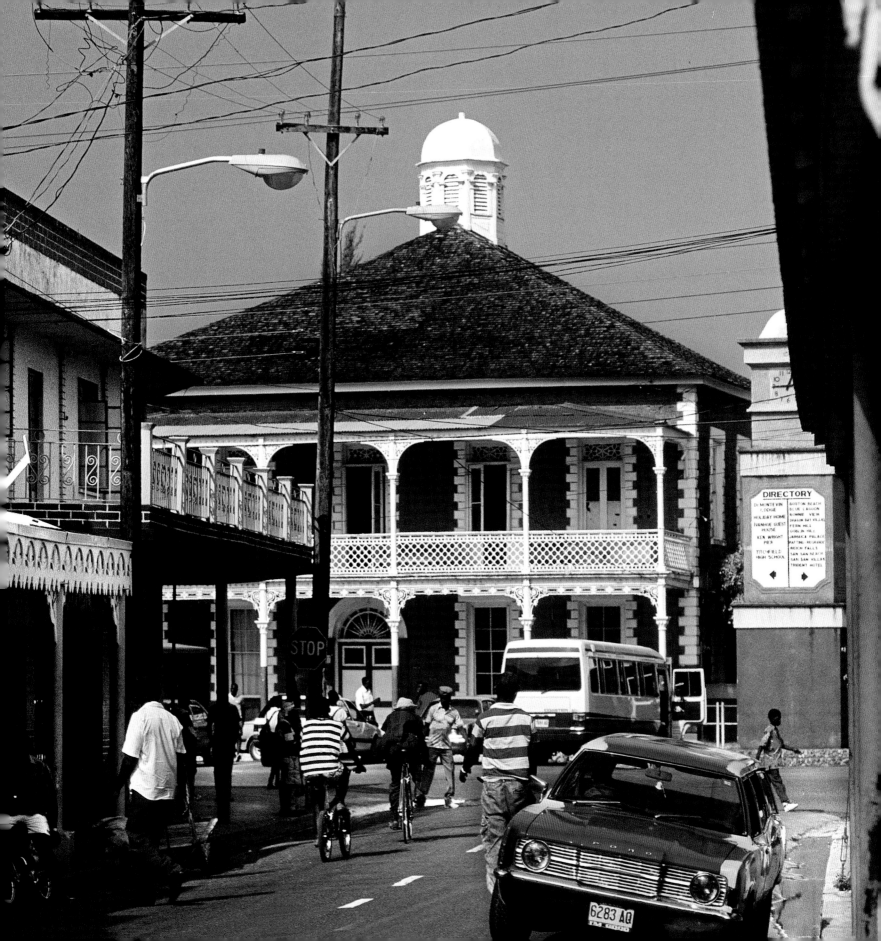

JAVA

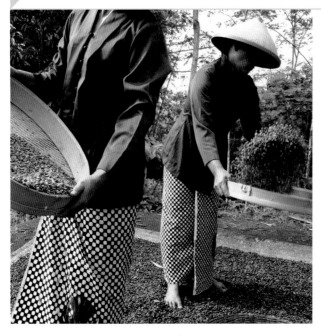

Above: Women on a plantation sift green coffee.
Below: Street vendor in Jakarta.

Opposite: The Borobudur Buddhist temple
dates back to 800 AD.

Of the 17,000 islands of the Indonesian Archipelago that are scattered more than 3,000 miles along the equator, Java has always been considered one of the most interesting. It is known for making excellent coffee, as well as for the rituals of drinking it that have developed over the past three centuries as a result of the blend of different cultures on the island: Hindu-Buddhist, Muslim, and European. The *Coffea arabica* plant was brought to Java by the Dutch in 1706, and by the middle of the 18th century the Mocha Java blend was considered one of the best in the world.

The Javanese like to sip their intensely flavored coffee at all hours and in ways quite different from Westerners. The street—with its numerous and colorful food stands, known variously as *warung*, *leshan*, and *kios*—is where locals prefer to eat a meal or sip a cup of coffee at any time of the day or night. Here, all sorts of food and drink are served by the *kaki lima*—the ambulant vendors and their carriages—which are often found near the markets and stations. From dawn's first light, the streets start teeming with people who crowd the tables of the *kopi warung* to have breakfast on the street, resting their food on banana leaves that serve as both trays and tablecloths. Each kiosk boasts its own specialty and exhibits it in plain view or advertises it by writing the dish's name in colorful block letters.

Among the many curiosities of Indonesian coffee culture is the story of the *kopi luvak,* which elicits significant interest and curiosity among visitors to the archipelago. There exists a very precious coffee that goes for nearly 700 dollars per pound; it comes from coffee beans that have been ingested and then "deposited" on the ground after having been processed by the digestive tracts of a tender little animal. Word of this unique beverage has spread around the world, and has set many visitors out in search of its incomparable flavor.

Must See

The Buddhist temple of **Borobudur**, recognized by UNESCO as a World Heritage Site, is in the central part of the island, about 25 miles from Yogyakarta. You should visit the many **food markets** in the early morning, when the stands exhibit all kinds of produce and tropical fruits. A trip to **Losari Coffee Plantation Resort & Spa**, an enchanting resort in the middle of a coffee plantation where there are 32 traditional houses in the local *limasan* and *joglo* styles, is a great place to treat yourself to regenerative therapies such as massages and purgative infusions based on coffee. At **Ijen**, hikers can enjoy the view of a magnificent turquoise-colored sulfur lake.

MADEIRA

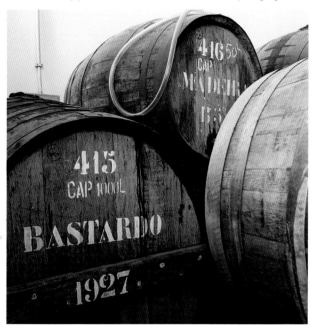

Mention Madeira and people immediately think of the wine. History tells us that Henry the Navigator, the Portuguese prince who pioneered the country's maritime explorations, ordered the first colonists to plant vines on the island. Grapes for Madeira acclimated quite easily thanks to the volcanic soil, and thus a distinct and robust fortified wine was born. The island itself is just as remarkable. You might imagine it as a tourist destination with grand hotels, but instead you arrive to find a tree-covered island emerging like a mirage from the Atlantic. While Funchal, its capital, is certainly a vacation getaway dotted with hotels, there are also many Portuguese colonial baroque buildings, white limestone houses, and farms tucked away in the landscape. Of course, there are also a few historic hotels with famous guests—such as the legendary Reid's Palace, where Elisabeth of Bavaria sojourned, Winston Churchill took his afternoon tea on the terrace, and George Bernard Shaw learned to dance tango.

Beyond Funchal, Madeira is a verdant island in perennial bloom, featuring a laurel rain forest dating back to the Pliocene era that covers 37,000 acres and includes ferns and *vinháticos*. A UNESCO World Heritage Site, it is part of a national park that extends over two-thirds of the island. As a result, Madeira is a destination for ecotourism that offers pristine landscapes, cliffs plunging dramatically into the Atlantic, tiny villages immersed in green, terraced vineyards, and stunning mountains. Discovering Madeira's peaks is a thrilling adventure. You pass hydrangeas, heather, and rhododendrons as you head up Pico do Arieiro. From here, continue on foot along a spectacular trail that leads to Pico Ruivo, the island's highest peak. Hike along the *levadas*, a network of 200 irrigation canals nestled among ferns and wild orchids dating back to the 16th century. Enjoy riding the cable car up to Monte, and then return to Funchal on a wooden sled. Afterward, swim in the natural pool at Porto Moniz, and take pictures of the traditional A-frame bungalows of Santana.

Must See

Try the legendary **vinho da Madeira**, the drink Napoleon took with him into exile on Saint Helena and Thomas Jefferson used to toast the Declaration of Independence on July 4, 1776. Madeira may be blended or sourced from a single vintage. It's divided into four grape varieties: the dry, amber-colored **Sercial**; the semi-dry **Verdelho**; the medium-sweet **Bual**; and **Malvasia**. Taste and purchase wine at **Adegas São Francisco**, Funchal's oldest winery, housed in a baroque building that also contains a wine museum. A chilled glass of Sercial is the perfect aperitif as you watch the sun set over the ocean and wait for the stars to illuminate the night sky.

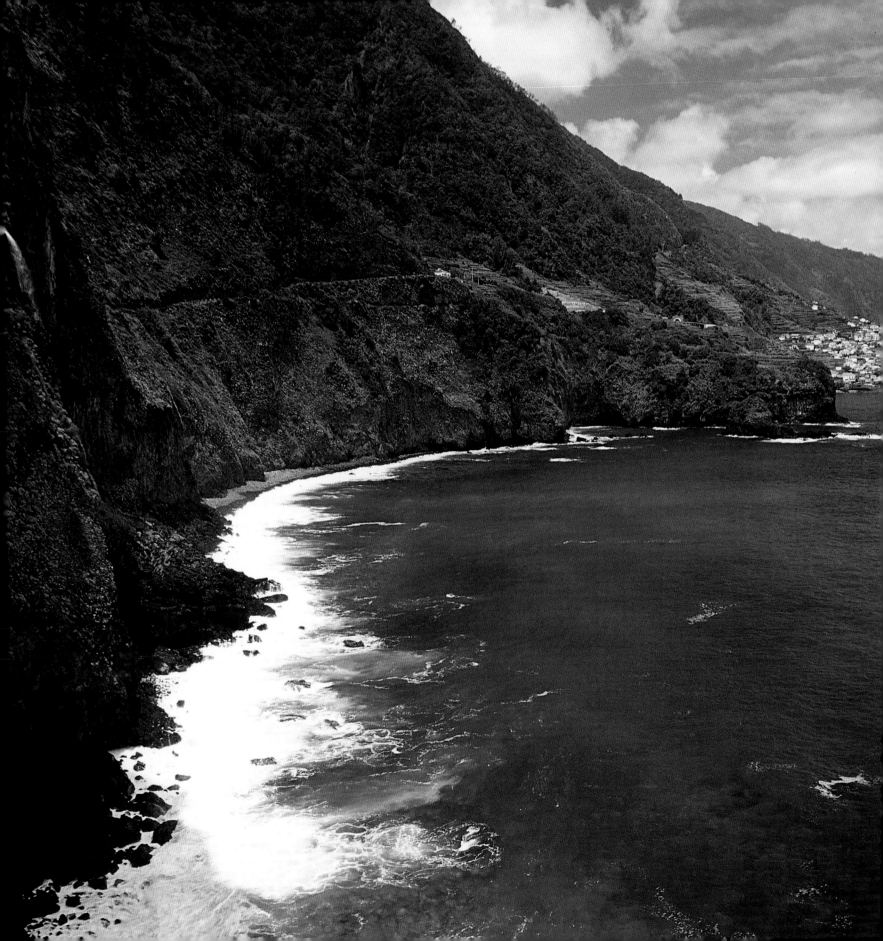

MAURITIUS

The island of Mauritius was already known to Arab sailors in the 10th century, but it wasn't until 1598 that the Dutch took to this emerald green paradise, which was still uninhabited at the time, set in the turquoise waters of the Indian Ocean. They named it Mauritius in honor of a Dutch prince, and from that moment on the archipelago was used as an important stopover for ships sailing to India. The French occupied the island later on, and re-baptized it Île de France. Colonists then brought over hundreds of African slaves and Indian workers to the island to begin cultivating sugarcane, and soon after Chinese merchants began to arrive. Over the centuries, the diverse languages, religions, and races of the local population have helped to enrich local life, and today each has been carefully preserved. Analogously, Mauritian cuisine, easily the richest and most refined cooking in the Indian Ocean region, has skillfully blended the diverse culinary cultures that have crossed paths here. For example, the Indian art of combining spices has been fused with the secrets and techniques of Cantonese cooking. It has also been blessed by the refined contributions of French cuisine, and more recent influences from Italy.

Of course, good cooking calls for quality ingredients. Simply visit one of the many food markets here to see what man and nature have brought to the island. Each day, when the market opens at dawn, you'll find all the aromatic herbs (coriander, curry, and ginger) that are used in Creole cooking to give dishes their unmistakable flavoring. In addition, there's an excellent selection of colorful fish, mollusks, and shellfish that populate the coral reefs surrounding the island. And let's not forget the dozens of tropical

Above: The colorful berries of the coffee plant.

Right: Beach and wild vegetation on Île aux Cerfs.

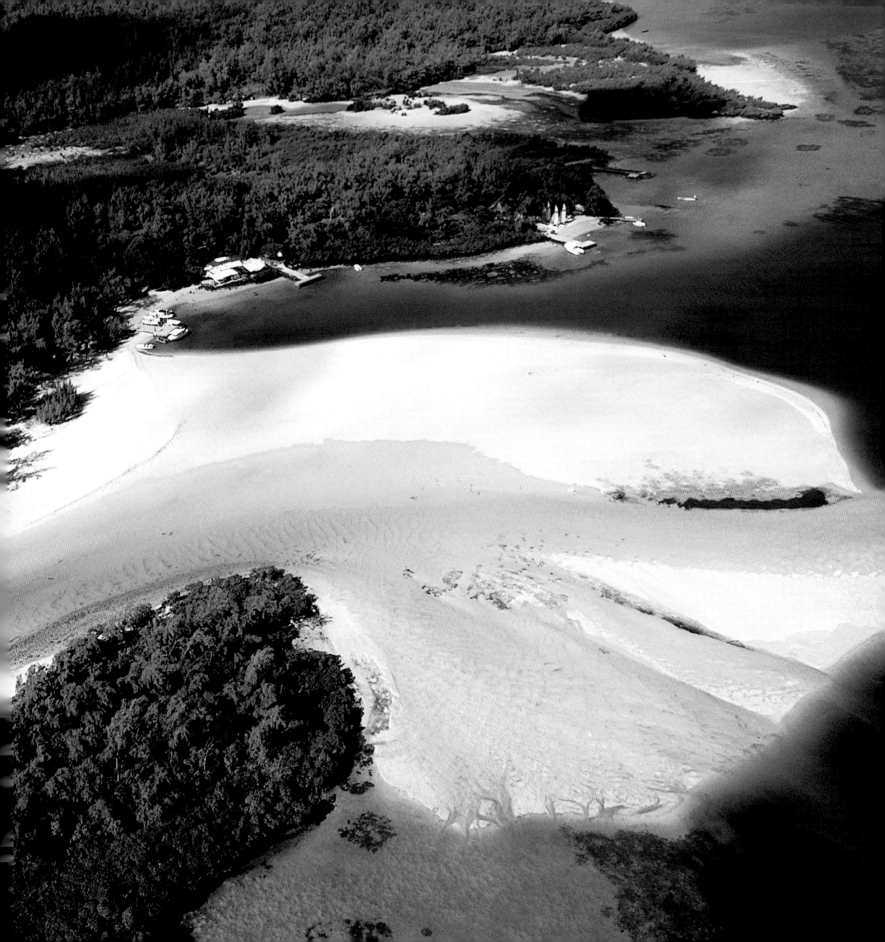

fruits, including papayas, mangos, and guavas. Then there are local delicacies—like palm hearts, the local deer meat that is used to make a superb curry, and baby lobster. Coming into contact with the flavors of Mauritian cuisine starts on the street. Here, you can sample a wide selection of food from vendors. Try the *gateaux piment* (vegetable meatballs), candy apples, stuffed meat, vegetable pastries, and deep-fried vegetable *pakora* cooked right before your eyes at roadside stands that open in the early hours of the morning. From here, pass over to the bold creative cooking that's on offer at the top restaurants and exclusive resort properties that are spread around the island. It's no coincidence that Dominique Loiseau of Relais & Châteaux and her staff chose Mauritius as the place to commemorate Bernard Loiseau, the celebrated three-star Michelin chef who passed away in 2003, with an international event. The Bernard Loiseau Culinary Festival is hosted by the Constance Belle Mare Plage Hotel, where the late cook enjoyed spending his free time.

Must See

Take an early morning walking tour of the **Port Louis food market**. Also stroll through the capital's **Chinatown** and go on a guided tour of the **Pamplemousses Botanical Garden**. There are also tea plantations and the **Bois Chéri** teahouse to visit, plus natural parks and waterfalls in the island's interior. Sample some sugarcane at the **Aventure du Sucre Museum** and the classy cuisine of Jacqueline Dalais at **La Clef des Champs**. For Creole dishes try **Belle Kreole** in Mahebourg, while Stefano Fontanesi offers a fancy Italian-Mauritian menu at **Dinarobin**. There's the Bernard Loiseau Culinary Festival and the **Deer Hunter** restaurant at Belle Mare Plage. For a lesson in Mauritian cooking, try **Le Prince Maurice**.

Above: Beach on Île aux Cerfs.

Right: Hindu temple in Port Louis.

Opposite: The colorful hillsides of Chamarel, a natural phenomenon caused by volcanic activity.

Below: An elderly woman in charge of selecting coffee beans.

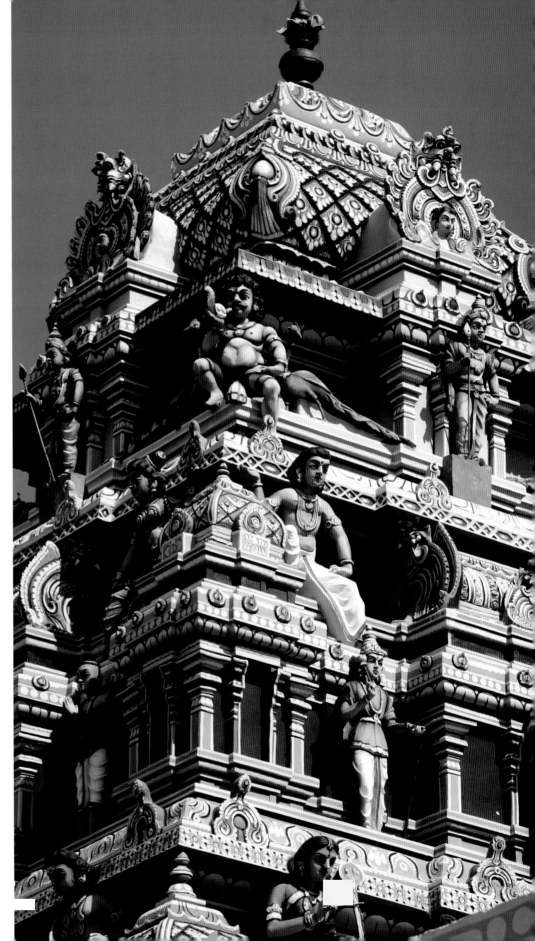

I taly's fifth-largest island, Pantelleria is closer to Africa than to Continental Europe. The island fascinates and amazes visitors because of its uniquely contrasting and varied landscape, made up of old lava flows, coves, and promontories.

It's an island for free spirits who are a little wild—it's not well-suited to beach lovers. Pantelleria truly deserves its nickname, Daughter of the Wind, given to her by the Arabs to underscore the constant presence of the wind god Aeolus' children, capable even today of imprisoning this land in a windswept grip. The sea around Pantelleria never loses its intense blue, and is most spectacular when the mistral blows. Under the bright sun its white foam turns into golden glints that transform the choppy surface into a giant piece of lapis lazuli.

Blue is one of the three fundamental colors of the island, together with green and the black of the volcanic rocks—which can also turn red, yellow, or gray. In the center of Pantelleria is Montagna Grande (2,742 feet), which towers over its surroundings. From up there you can clearly see the island's volcanic history and make out the volcanic vents that locals, more farmers than fishermen, have had to rework into rocky terraces in order to grow the local delicacy, sweet Zibibbo grapes. There are also capers, round flowering bushes, and prickly pears, with their thorns and bright red summer fruit—all in a land where trees have trouble growing. Pantelleria's rich colors, sensations, and fragrances remain in the hearts of its visitors. And their suitcases are often filled with Moscato wine, figs, and capers to remember their vacation in the heart of the Mediterranean, on an island whose sunsets regale those who patiently await their unique viridescent light, one of the most ineffable phenomena that the sea and sun have to offer.

Above: Prickly pears flowering in Gadir.
Below: Capers and Zibibbo grapes are typical products of the island.
Opposite: Punta dell'Arco with its Arco dell'Elefante ("Elephant's Arch").

Must See

The climb up **Montagna Grande** leads up a well-maintained asphalt road, passing through a pine forest whose scents overtake those of the surrounding Mediterranean brush. If it's not a cloudy day, you should be able to see across the great crater at the base of Montagna Grande to **Monte Gibele**, whose crater was once occupied by a lake, as well as the ancient secondary conical craters known as *cuddie*. The **Salto della Vecchia** has a breathtaking view from atop a 1,000-foot sheer cliff full of nests from a variety of sea birds. The tiny **Nikà Port**, built into a volcanic ravine, has cliffs dotted with thermal springs.

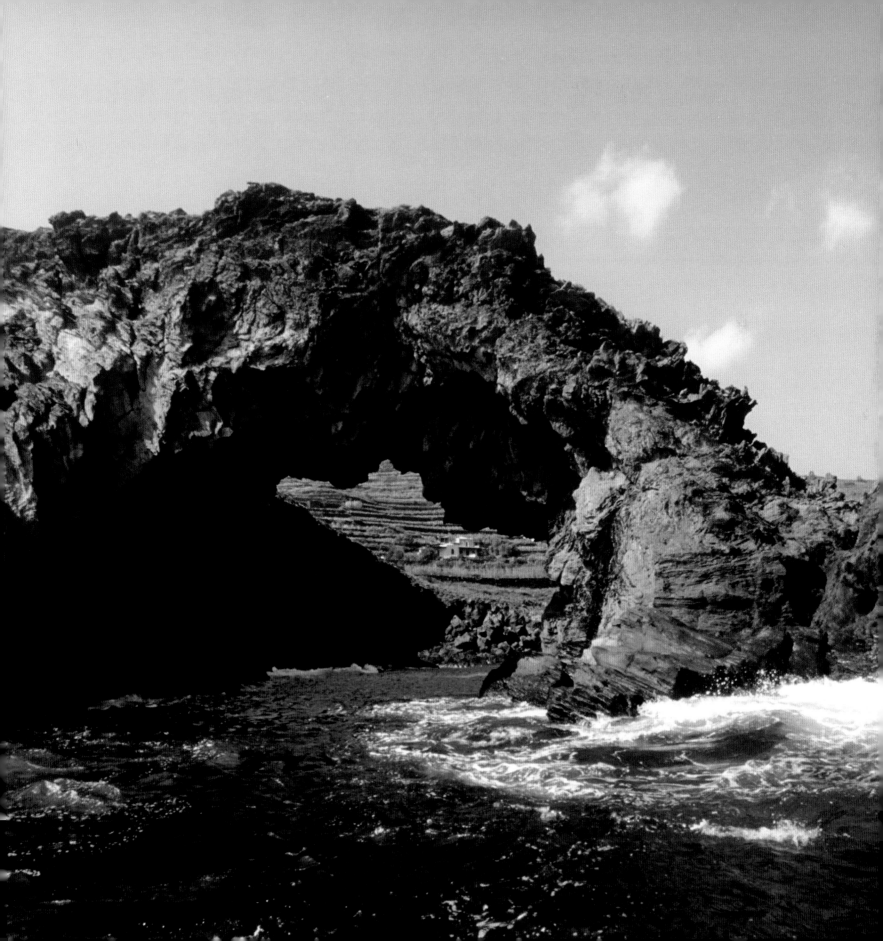

PIANOSA

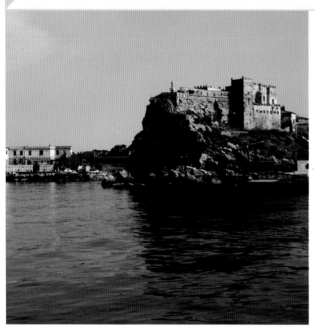

Above: Forte Teglia, a Napoleon-era fortress
that overlooks the old port.
Below: The island's tiny harbor.

Opposite: Punta del Marchese and La Scarpa Island.

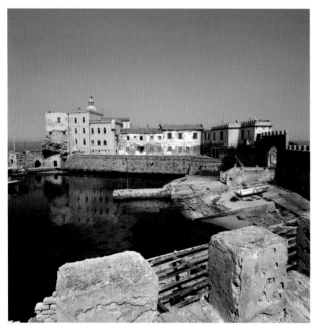

Everything on this timeless island has a strong flavor, and at times is even a little bitter, like the local lemon marmalade. Most people associate Pianosa, which is part of the Tuscan Archipelago, with the former penitentiary housed here.

Its harsh landscape is marked by catacombs carved out of volcanic rock, Napoleon's fortress that kept watch over the land, and the Roman and villa baths of Agrippa facing Cala Giovanna, the only sandy strip of coastline.

Even the colors of this flat oasis are bold. Rocks that link Punta del Marchese to Punta di Libeccio range from ivory to ocher yellow, and within their veins lie hidden marine fossils. Birds, meanwhile, have brilliant plumage, and the myriad colors seen on the sea floor are difficult to find elsewhere. Then there are the black cherries, mulberries, and fox grapes used throughout the archipelago to make preserves, as well as the scent of rosemary that was cultivated in vegetable plots by the inmates. Even the bread here has a strong taste of figs. And the same goes for the codfish dishes, which are derived from Spanish recipes, and the anchovies, sardines, and stuffed squid.

Just as powerful is the island's grim past as a prison. The layout was shaped by Napoleon's mix of medieval décor and Renaissance elements, but town planning revolved around the needs of the penal colony. There's the 19th-century warden's office, guards' residences, and work yard, where prisoners tilled the soil and cultivated the rich flavors of the island. Today, even though the prison complex has been shut down, there are still a few dozen people living here. Nonetheless, the place feels isolated and cut off from the outside world. They don't take hotel bookings, and visits are limited to 100 people per day, who must then make the return trip by ferry to Elba or Piombino.

Must See

A glance at the sea floor reveals more than a few surprises. The area is particularly colorful and rich with life. All you need is a mask and a desire to go snorkeling at **Cala Giovanna**, the only stretch of beach where swimming is allowed. You'll come across red coral where **mullet**, **grouper**, and **sea bass** look for shelter in an expanse of sea-grass that serves as the Mediterranean's lungs and enlivens the waters around this island, which has remained unspoiled for a century and a half thanks to its inclusion in the National Park of the Tuscan Archipelago. One advantage of swimming here is that the sea floor gently slopes downward as you move away from shore.

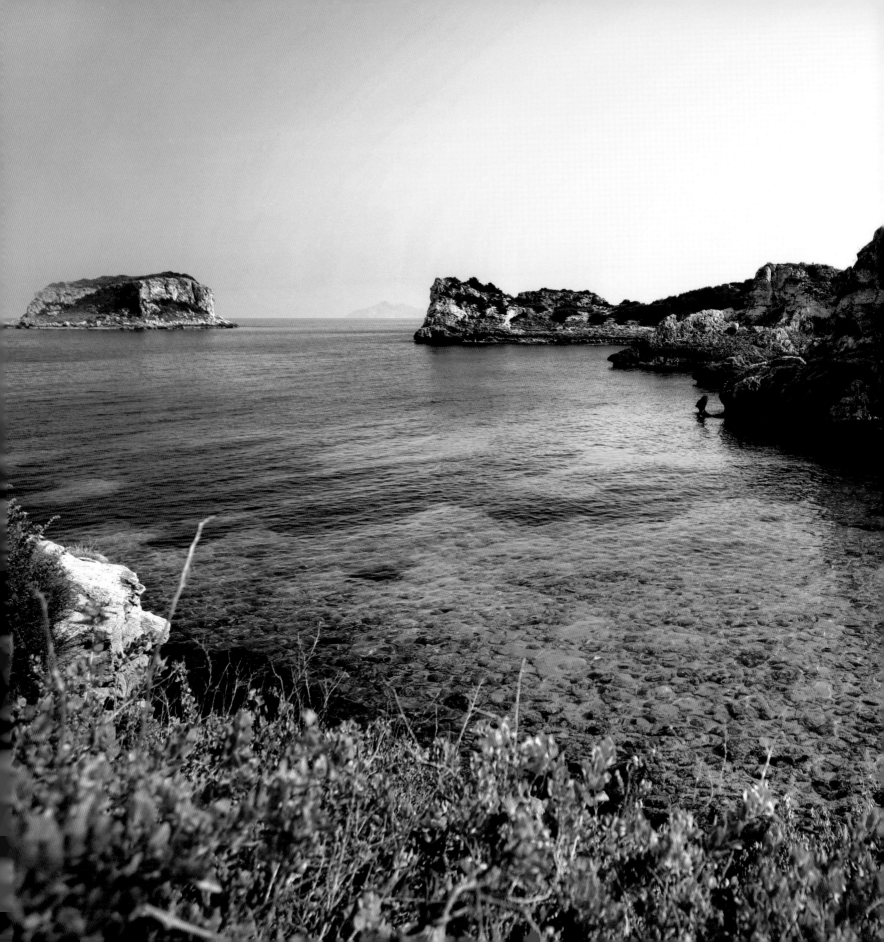

SAINT MARTIN

Above: Fruit vendors in Marigot, the main town on the French side of Saint Martin.

Below: One of the many tourist bars in Marigot.

Opposite: View of the seaside near Marigot.

If Saint Barts is the most exclusive spot in the Caribbean and Anguilla the most English, Saint Martin is without doubt the most fun and lively destination you'll come across. Over its 36 square miles the Creole, French, and Dutch cultures of this tropical island mix together in the Caribbean's sweet idleness with a vibrant, cosmopolitan lifestyle. To soak up its atmosphere, simply sit on the beach at sunset with a glass of Guadeloupean rum in your hand and lose yourself in the improvised notes coming from a local band.

As soon as you touch down at the airport in Philipsburg, you can't help but notice its unique atmosphere. Since the mid-17th century the island has been divided into two halves, one French, the other Dutch. The latter, more frenetic and chaotic, is nonetheless quite fun, and is frequented by travelers who come ashore from cruise ships and crowd the waterfront in the vain hope of finding discounts at the duty-free stores. It goes without saying that the much calmer French part of the island is where people go to spend their vacations.

To get into the spirit of things on Saint Martin, it's best if you leave behind the image of immaculate resorts and immerse yourself in the spontaneity and warmth of the place. To take advantage of the surrounding sea, simply hire one of the many boats that are on offer in each harbor and venture along the coast. Saint Martin is the heart of a whole collection of islands, each different from the other and small enough to explore in a day. Aboard a catamaran with favorable trade winds, you can sail toward Tintamarre, an uninhabited island that's reachable in an hour. From there continue on to Anguilla, that flat strip of land with sparkling sands. Diving fans will want to head to Sabe, while Prickly Pear is the preferred spot for snorkeling enthusiasts. Finally, there's Saint Barts, a three-hour sail away. There, you'll find all the luxury, seductiveness, and calm you'll ever need.

Must See

In the Caribbean version of Saint-Tropez, don't miss out on the sparkling **Baie Orientale**, where beaches are lined with *lolo*, colorful wooden bungalows offering drinks, the freshest tuna sushi, and live music night and day. **Pinel Island** is a stretch of fine white sand where famous people from all over the world show up at noon to sample lobster and rum cocktails prepared at **Karibuni Restaurant**. The former fishing village of **Grand Case** is the hub of the island's nightlife, and is lined with eateries, art galleries, and bands playing improvised music. **Oyster Pond** has a unique oyster-shaped bay that marks the border between the French and Dutch territories.

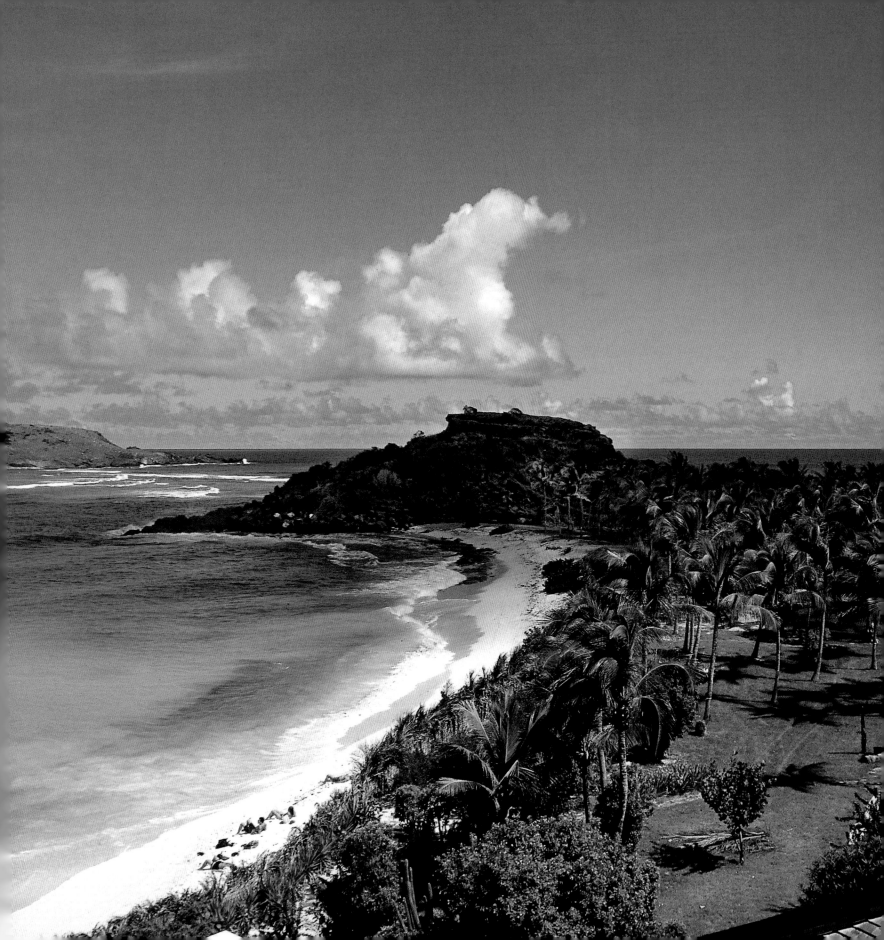

SRI LANKA

S ri Lanka includes seven UNESCO World Heritage Sites. They range from ancient sites steeped in history to sacred cities, places that feature unique artwork, and unspoiled natural hideaways that are home to the island's famous wild elephants. This land captures your soul with ancient emotions that you cannot escape from; the religious intimacy of its sites and people extends everywhere. You feel like a spectator in a world that's imbued with a peculiar atmosphere; the strong scent of incense and the bright orange and violet colors will trigger your imagination. Here, the locals possess the innate charm of people from the East, and welcome visitors with a generous hospitality and a serene calm.

On this magical island, bathed by the waters of the Indian Ocean, you breathe a different air. It starts with the mosaic of customs that make Sri Lanka a country full of surprises, a place that's able to steer clear of the typical clichés. Here, there are numerous religious festivities that fill the cities and countryside with joy, celebrations that cover all the professed faiths—Hindu, Muslim, Buddhist, and Christian. Each is celebrated with genuine enthusiasm, and affirms the warmth and kindness of the people. In fact, it's during the religious festivals that you most often come into contact with the locals and their culture.

First and foremost is Sri Lanka's cuisine, which relies on spices. The staple food is curry rice with peppers, an unmistakable flavor that invites you to experiment with decidedly more unusual dishes, such as the traditional pairing of pineapple with peppers, considered a local delicacy, or chicken with peanuts and mango salsa. Also not to be missed

Above: Girl in the village of Kinniya.

Right: Cave of the Divine King inside the Golden Temple of Dambulla. The temple dates back to the 1st century BC and is made up of five caves converted into reliquaries.

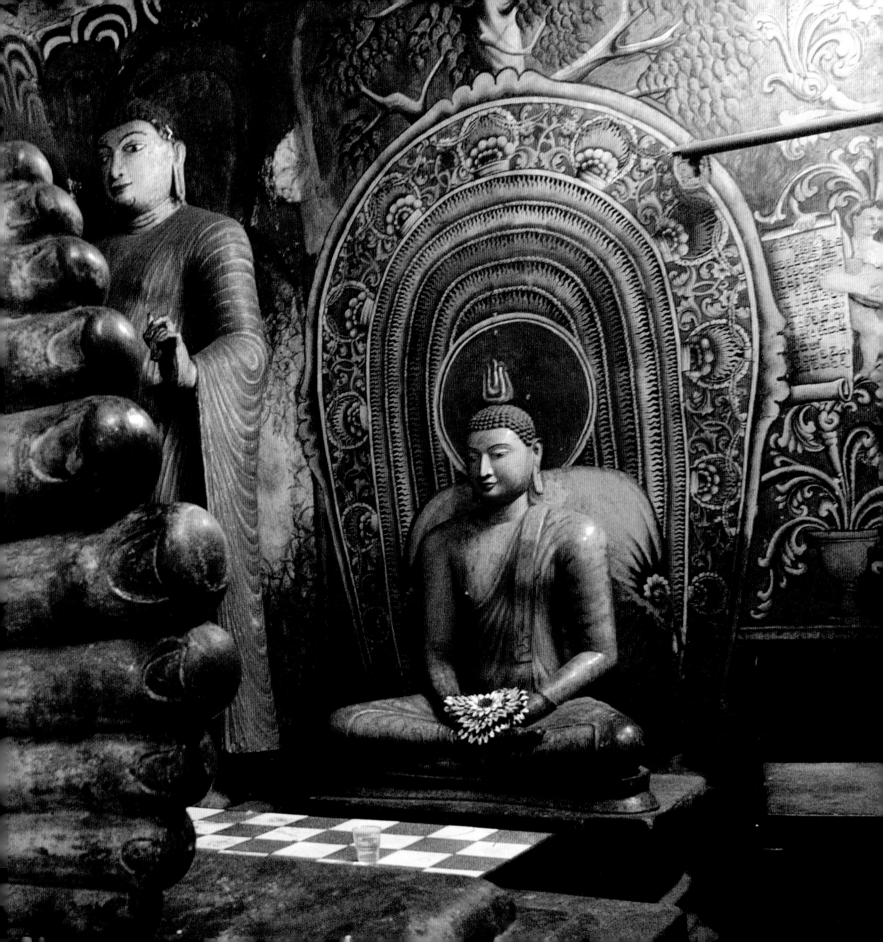

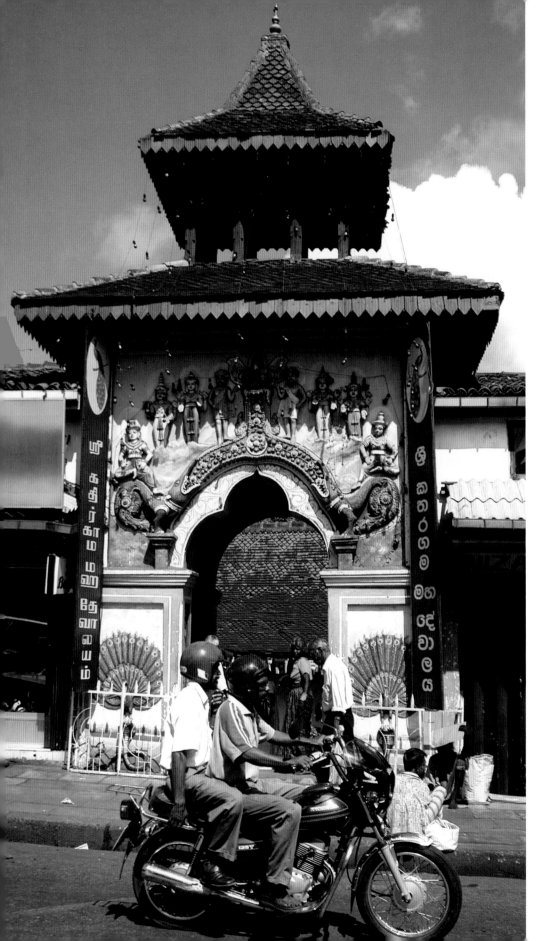

at the dinner table is fresh fish and a rich variety of tropical fruits.

Sri Lanka is also a land of tea, and its vast tea plantations are considered one of the country's main riches. Considered the national drink, people typically enjoy it with milk or lemon. The national liquor is *arrack*, made from the sap of coconut palms. As far as desserts go, the *hopper*, a mixture of egg fritters, honey, and yogurt, is sure to win over visitors' palates. It also makes an ideal snack for those with a sweet tooth, especially after having climbed up the rock of Sigiriya, the most-visited site in the entire country. Erected in 473 AD, the remnants of this fortress tell the story of its builder, King Kassapa, usurper to the throne who killed his father and sought protection here against attacks from the legitimate king. On top of the rock a self-sufficient settlement was built that served as the capital for 20 years. To arrive at the summit, you need to walk up a long and torturous stone staircase, as well as a suspension footbridge. The final portion involves a brief climb up the rock face—obviously, it's not a place for those leery of heights. The ascent is tiring, but you're paid back with an amazing view of the jungle and tiny surrounding villages where families live in perfect harmony with nature. Standing up on the rock, you feel the wonderful sensation of being in paradise.

Must See

The city of **Kandy** features the **Dalada Maligawa Temple**, which houses the so-called Tooth of Buddha, one of the most revered relics of Buddhism. Equally moving is a visit to **Polonnaruwa**, the former capital, that was originally built in the 10th century. Here the **Gal Vihara** are conserved, a collection of sculptures carved from an enormous granite wall that shows a 45-foot-long reclining Buddha and a standing statue over 25 feet tall. Other religious sites include **Dambulla**, where you can view cave art inside five spectacular grottos. According to legend, the temples here were constructed some time in the 1st century BC. The 150 representations of Buddha—the largest in Asia and the oldest anywhere in the world—are well worth the trip.

Above: A woman cultivating tea in the highlands above the town of Nuwara Eliya.

Right: Beach in Trincomalee, on the eastern side of the island.

Opposite: View of Kandy, the island's cultural capital.

Below: Fishermen in Weligama use an unusual technique whereby they stand on poles to catch their prey.

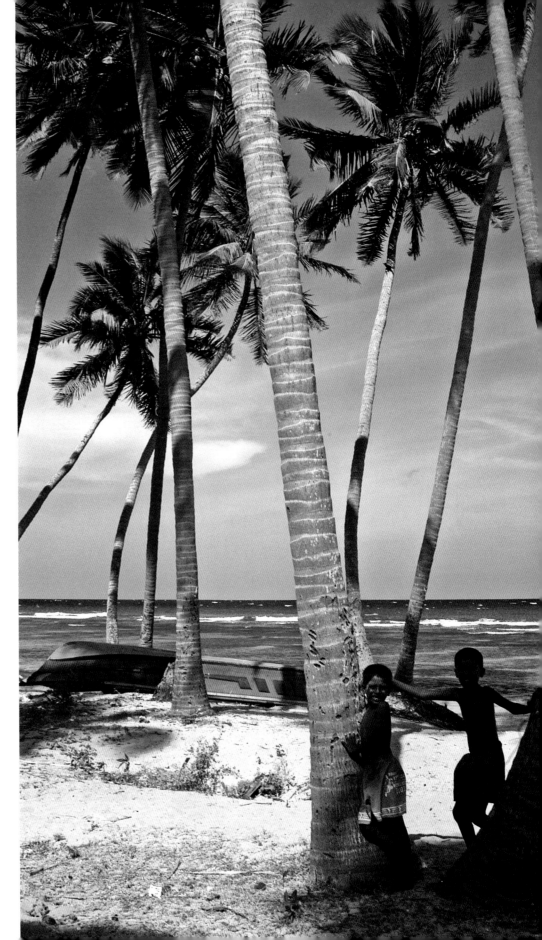

ZANZIBAR

Above: The Zanzibar red colobus monkey
is native to the island.
Below: Maasai tribesmen in traditional dress.

Opposite: View of Kiwengwa Beach.

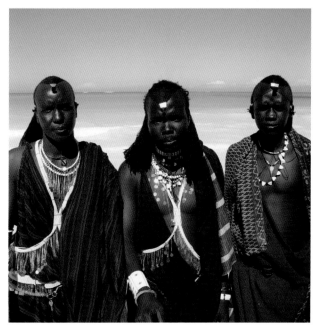

Like a celebrity, this island in the Indian Ocean goes by two names: its real one, Unguja, and its stage name, Zanzibar, which also designates the entire archipelago off Tanzania's coast, whose capital is also called Zanzibar.

All the quintessential impressions of Africa—the ones that get under your skin—are present here. They include the spicy scents (it's a leading producer of cloves, pepper, and cinnamon); the mix of vegetation (from clusters of bananas and coconut palms to the red berries of the coffee plant, mangos, and majestic baobab trees whose branches are lined with colorful birds); and the manicured gardens that alternate with swaths of forests. Jozani Forest is one such place; it's the only spot you can see the spirited red colobus monkey up close. The island's fine white sands reflect millions of invisible crystals and tiny seashells, and it's easy to find half shells of every size, unblemished or speckled, on the shore or sold on the beach by kids on bicycles. In the same lagoon where snorkeling gives you the chance to discover unusual fish, the ebb and flow of the tide reveals a coral reef you can wade across. The rhythmic ripple of the waves lapping gently against the reef is the sound that rocks you to sleep each night and eases your awakening in the morning. The days seem too short here to do all the things the island has to offer: a swim with the dolphins, shopping in the bazaar, a visit to the fishing villages, lunch on the beach, and dinner befitting a gourmand, with exotic fruits and local fish delicacies.

In 1964, the Zanzibar Archipelago united with Tanganyika to form modern-day Tanzania. Historically linked to the Assyrians, Portuguese, and the Sultan of Oman, it was a logistical base for many historical expeditions, such as the one led by David Livingstone in search of the source of the Nile. Zanzibar was part of the Sultanate of Oman (from 1832 to 1962), even if for the last 70 of these years it was recognized as an English protectorate. Even today, the island is adorned with many of its historic palaces and mosques.

Must See

The many traces of Arab-African culture can be admired by walking through **Stone Town**, the old part of Zanzibar's capital, full of stone houses with ornately carved wooden doors. Along the waterfront, there's the Arabian **Old Fort**, built on the site of a Portuguese chapel, and the **House of Wonders**, equipped with the first eleva-tor in East Africa. It was constructed in 1883 for Barghash bin Said, who built another palace nearby to house his 99 concubines. The sultan's private apartments are open to the public at the **Beit el Sahil** residence. Also worth a visit is **Pemba Island**, 30 miles from Zanzibar. It offers some of the best diving in the archipelago.

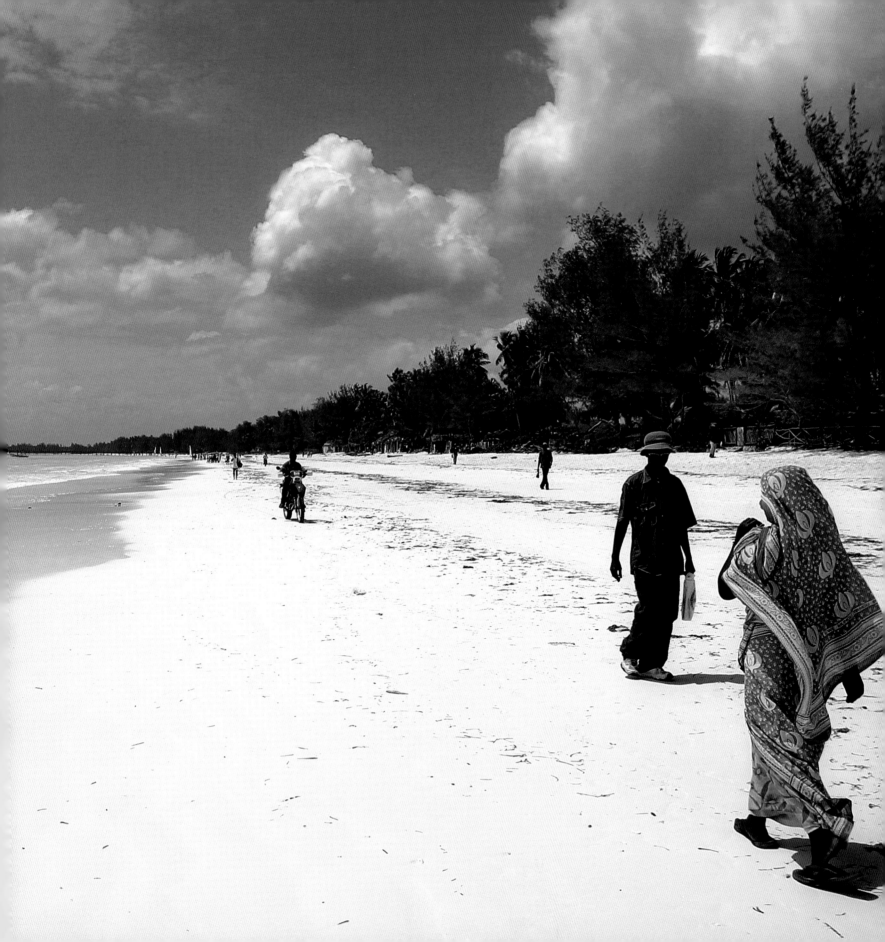

Every so often you need to unplug from the mainland and head for an island, a tiny microcosm closed off by the surrounding sea. This escape helps prepare us to enter another realm, a world where emotions are more intense. Whether our destination lies in the lower latitudes of the Caribbean, in the sparkling blue Maldives, or in the azure waters of the Indian Ocean, arriving on one of these islands allows you to leave behind the daily grind and dive into another world—one so rich with different lights, colors, and sounds that it's almost surreal, just like a dream.

[Ada Mascheroni]

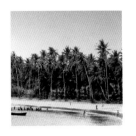

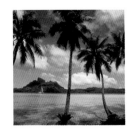
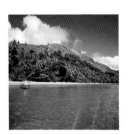

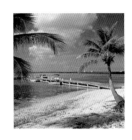

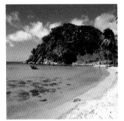
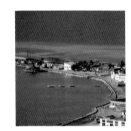
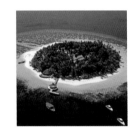

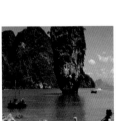

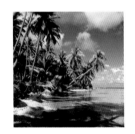
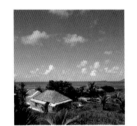
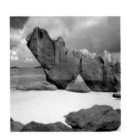
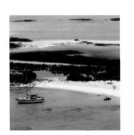

DREAM
DESTINATIONS

ANDAMAN ISLANDS

Above and Below: Two views of Port Blair, the capital, located on South Andaman.

Opposite: Fishermen's beach in the Nicobar Islands.

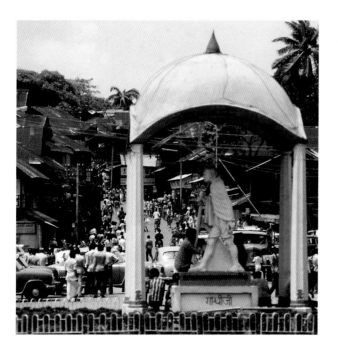

Lost in the transparent green, blue, and indigo waters of the Bay of Bengal, the Andaman Islands are an archipelago that has a rhythm all its own. Marvelously preserved, their primitive charm comes from the forests, centuries-old trees, and the many exotic fruits and flowers. Under a sky streaked with pure white clouds, immaculate fine-sand beaches lead you to a crystal-clear sea, with coral reefs swarming with tropical fish. East of India, its 239 islands, both large and small, extend latitudinally for hundreds of miles. This chain of islands forms a barrier that continues to the south, past the Ten Degree Channel, all the way to the Nicobar Islands, an archipelago not open to tourism.

The coasts of North, South, and Middle Andaman host settlements of people of different faiths and ethnicities who arrived from India over many decades. Port Blair, the capital, is a lively commercial hub that owes its name to Archibald Blair, the English lieutenant who at the end of the 18th century explored the archipelago and was responsible for setting up an outpost to provide aid for ships in distress. Port Blair is also the site of the so-called Cellular Jail, or *Kala Pali*, a massive prison complex built to hold common criminals as well as activists fighting for India's independence. Filled with powerful memories, it has now become the setting for theatrical sound and light shows that retell key moments in India's history—a history tied to the relatively recent English occupation. These ancient lands, which are remarkable from a naturalist's point of view, owe their conservation to their primordial appearance and mysterious aura; for centuries they were avoided by passing ships because of a legend about hostile natives. Those widely feared inhabitants, who arrived from Africa thousands of years ago, still live on small isles that remain completely inaccessible to outsiders.

Must See

Take in the view from **Mount Harriet**, the highest point on South Andaman. It's suitable for trekking as well as for birdwatching —the area has 246 species of birds. On **Ross Island**, which was once a British possession, the ruins of a church and theater built by the English provide a romantic backdrop. You can also take a boat tour in the placid, narrow canals that meander through the many islands full of majestic old trees, lush mangroves, ferns, and exotic flowers. Be sure to organize an excursion to **Five Islands**, in the middle of the Duncan Passage, where a series of uninhabited isles are connected to each other by a marvelous strip of sand.

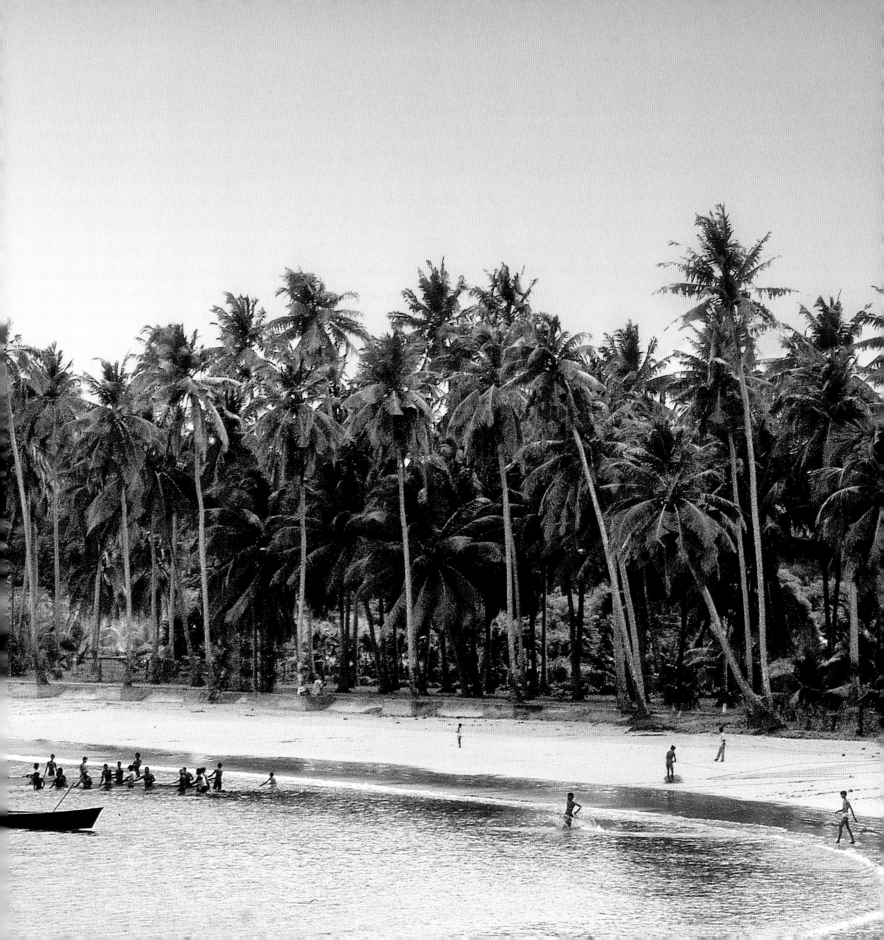

FILICUDI

Above: A view of the island's unspoiled landscape.
Below: The Canna sea stack emerges from the transparent waters.
Opposite: A spectacular sunset seen from the sea. Filicudi is reachable only by hydrofoil or ferryboat.

Escape. It's a word with many connotations: the thrill of freedom, the absence of restrictions, the end of everyday life. With its remote location and natural simplicity, Filicudi is a magical outpost, fit for explorers who want to escape from it all and be reborn. Shaped by the wind and no fewer than eight volcanoes, the island is a celebration of unspoiled nature.

Its rocky coastline is lapped not by tropical seas, but by the deep cobalt waters of the Mediterranean. The fifth-largest of the seven Aeolian Islands, Filicudi sits at the western end of the archipelago between Salina, to the east, and Alicudi, the westernmost isle. Planes don't fly here, so the boat journey allows you to experience a gradual separation from life on the mainland, which slips away on the horizon just as the sea's energy encourages your body and mind to relax. It's an almost imaginary island set in a parallel world, a place where electricity only arrived in the 1980s. Riding along its lone road on a scooter from the port toward Pecorini, passing Capo Graziano on the way, awakens senses that were in deep hibernation. The sun's dazzling light reflects off the many prickly pear cactus plants and paints a natural wall of emerald green along the route.

Heading toward Pecorini Mare, the earthly scents of Mediterranean *maquis* waft through the air, mixing with other fragrances that call to mind the island's culinary traditions. Since this is still Sicily, allow yourself the pleasure of sampling fried rice croquettes with meat sauce, eggplant, vegetable *caponata*, and Aeolian salad sprinkled with the capers that grow everywhere here. Go barefoot, enjoy a cold beer sitting on the low wall behind the tiny beach at Pecorini Mare, wander the trails, and swim in crystal-clear waters at sunset while admiring Canna, the towering sea stack rising 280 feet out of the water that points to the Bue Marino Grotto, the mythical lair of monstrous sea creatures. These are just a few of the pure, simple pleasures of Filicudi.

Must See

Amazing views on this three and one-half-square-mile island are found along the lone road connecting the seaside towns of **Filicudi Porto** and **Pecorini Mare**. Use the extensive network of trails and discover the island on foot. You'll come across Mediterranean fan palms growing at the base of the Mount **Fossa Felci** volcano. The small Aeolian Museum in the port town of **Macine** and the Neolithic village of **Capo Graziano** all offer traces of the island's past. Walks in **Stimpagnato** come with spectacular sunsets, views of the Canna sea stacks, and neighboring **Alicudi**. The clear waters around Canna and the Bue Marino Grotto invite you to dive in with your mask and fins on.

BORA BORA

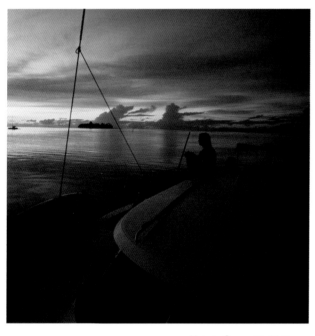

Above: Sunset in Vaitape.

Right: Mount Otemanu seen from the Motu Toopua lagoon.

The sharp, jagged landscape and the lush green forests of Bora Bora make it a natural marvel. From the airplane, it resembles an emerald dipped in a turquoise sea surrounded by a necklace of shiny pearls. The vertical walls of its extinct volcano, its inner bays, its pure white sand beaches framed by sprawling palms, its little natural alcoves, the surrounding islets, and vibrant sea floor—everything in Bora Bora takes your breath away. Among the many islands of French Polynesia, it's without doubt the most famous, but is also the one that best tells the story of the geological evolution of this remote Pacific region. These islands, which were formed by massive volcanic eruptions, are slowly sinking—at a pace of a few millimeters per year—down into the coral reef barriers that surround them.

Blessed year-round by a phenomenal climate, free of monsoons and cyclones, Bora Bora is a destination for all seasons. The sun shines constantly, interrupted only occasionally by brief rain showers. The landscape is covered by a thick botanical garden in perennial bloom. In the interior, you'll find the ruins of *Marae*, the ancient temples the local population built, with large stone altars that also served as cemeteries and ceremonial sites. Unfortunately, missionaries later destroyed most of these. There are also remnants of the World War II military base used by American soldiers.

Visit the island's many sights on horseback or with a local guide, who will help explain the unique civilization of the people who first reached Bora Bora aboard their flat-bottomed *sai* boats. With a mask and flippers, you can swim for hours in the calm, transparent waters of Point Matira in the company of

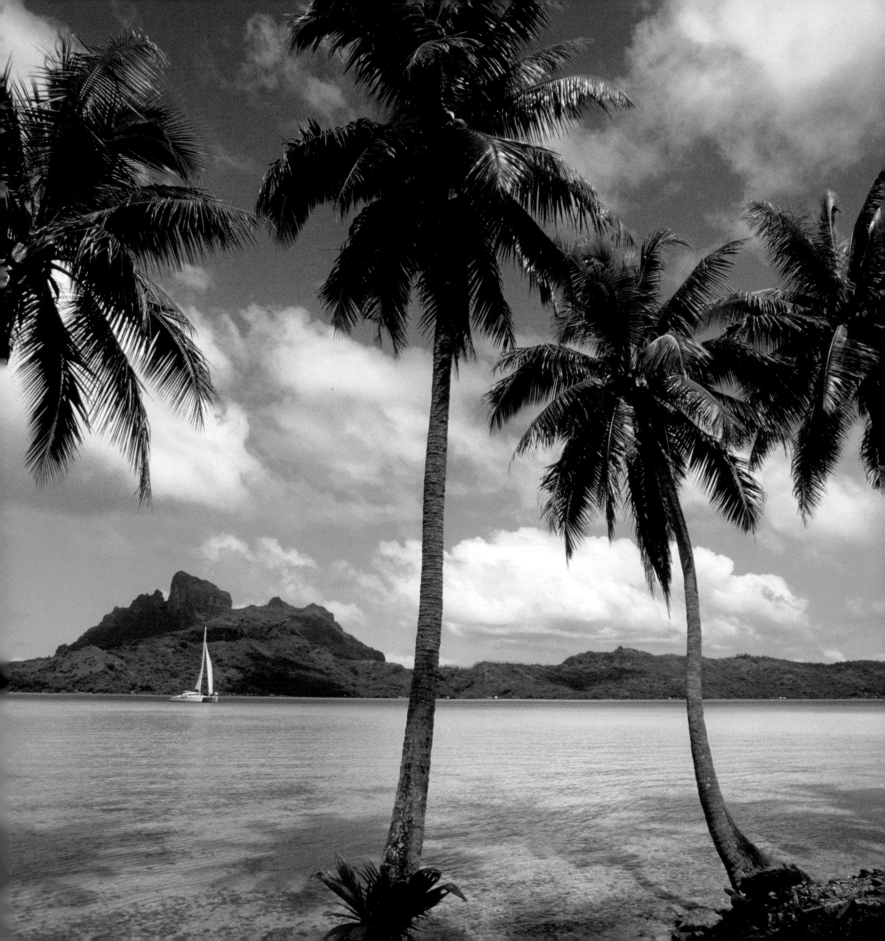

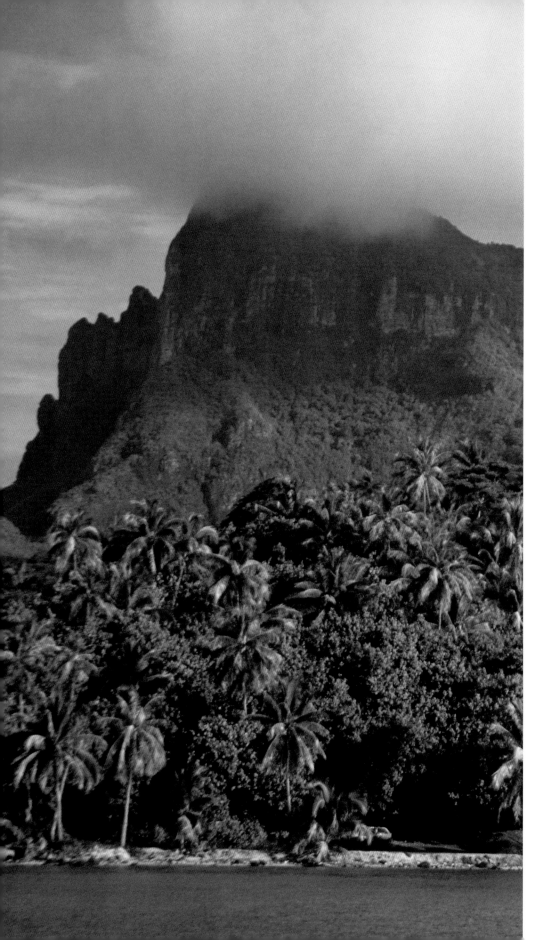

manta rays. In the southeastern corner of the island, explore the underwater Coral Garden nature park and its colorful coral reefs surrounded by equally colorful schools of fish. At the entrance channel to the atoll, sharks and barracuda can be seen partaking in a never-ending dance.

As you sail or paddle through the serene waters between the island and the outer ring of the atoll, you'll be overwhelmed by the idyllic spots that pop up on the horizon, one after another. Seemingly out of nowhere, hotel bungalows appear, hovering over the water here and there, offering accommodations where luxury and the best creature comforts are standard, and honeymooners feel like they're experiencing a fairy-tale dream come true. From sunrise to sunset, you are pampered in every imaginable way, with incredible menus that feature fish as the staple food, and the attention to detail and genuine friendliness of the locals is amazing. Once you've set foot here, you will be immediately hit by a wave of indescribable emotions. In such a paradise, perhaps it's better to just remain in a silent state of bliss and immerse yourself wholeheartedly in the island's natural magic.

Must See

Have a barbecue of fresh fish on one of the tiny islets, known as *motu*, that are covered in palms. Be sure to visit the **Lagoonarium** to observe up close the many species of fish kept temporarily in large pools. The tanks connect to the open water, allowing the fish the possibility to swim in and out as they please. Take a **boat tour** of the atoll and stop at various points so you can admire its barrier reef. Make arrangements to go **scuba diving** in the channel at the entrance to the atoll, where countless fish take advantage of the sea currents to feed. At the spas inside the best hotels on the island, choose from a vast array of **massage treatments** for immediate physical and mental rejuvenation.

Above: Beach at Motu Piti Aau.

Right: White coral in Faanui Bay.

Opposite: Mount Otemanu seen from Povai Bay.

Below: Point Matira on the southern part of the island.

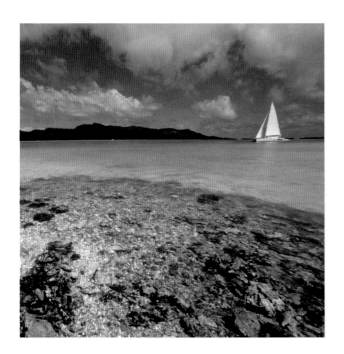

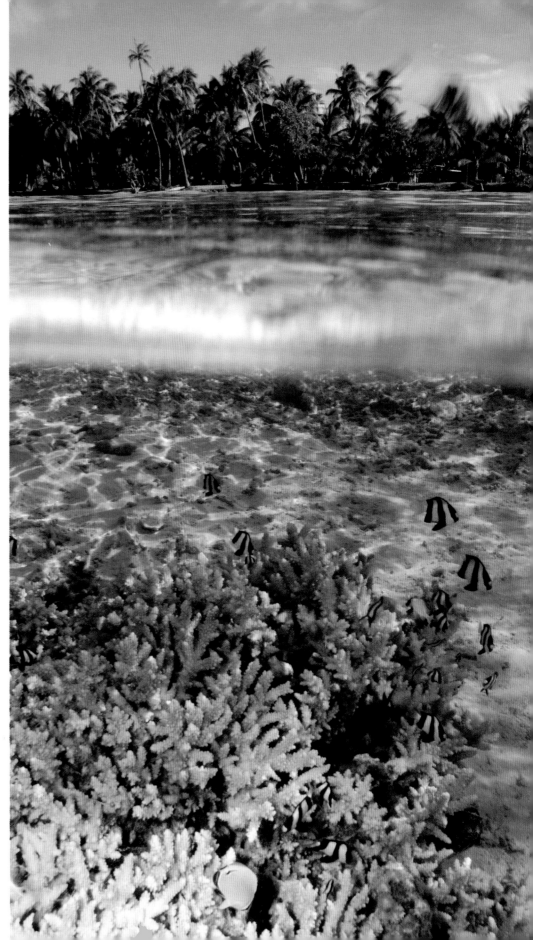

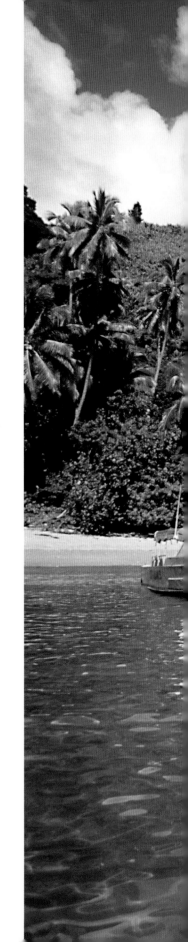

FIJI

The volcanic, rocky islands in the northern part of Fiji are immersed in green and surrounded by a deep blue. Mysterious and enchanting, they are quite different from the coral reefs and sunny backdrop of the better-known Yasawa Islands in the western part. Taveuni and Qamea, in Fiji's northern region, are remote paradises where a small number of tourists—facilities are quite limited here—are welcomed by native Fijians, who up until the early 20th century were practitioners of cannibalism.

Several years ago, Italian novelist Umberto Eco spent several months here in order to write his novel *The Island of the Day Before*. The author set his story on Taveuni, where his protagonist, Roberto de la Grive, is marooned aboard a ship in the south seas. For the first time in his life, the character encounters a sky, water, birds, plants, fish, and coral that he cannot put a name to. Unable to swim, he passes the time reminiscing, and waits for a chance to make landfall on an island that is not only far off in the distance, but also far off in time. Notwithstanding this fantasy-inspired literature, deep down there's a grain of truth to it. Those who decide to visit Taveuni and Qamea will encounter islands that seem to be suspended in time.

Often covered in clouds, which are drawn to the height of Taveuni's volcano, this place is a refuge, and Qamea's Naivivi Bay also serves as a natural shelter from Pacific storms. You can arrive on Taveuni from the city of Nadi aboard a six-seater airplane, which lands on a strip of paved runway cut out of the middle of the jungle. Today, these islands in Fiji's northern region are a scuba diver's paradise. But you must not forget that, besides the natural wonders

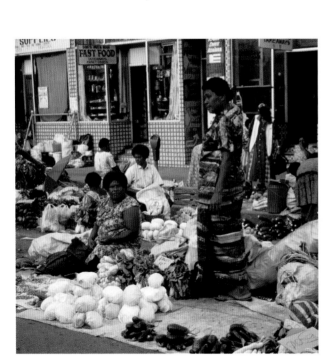

Above: Street market in Nadi on Viti Levu Island.

Right: One of Fiji's amazing beaches.

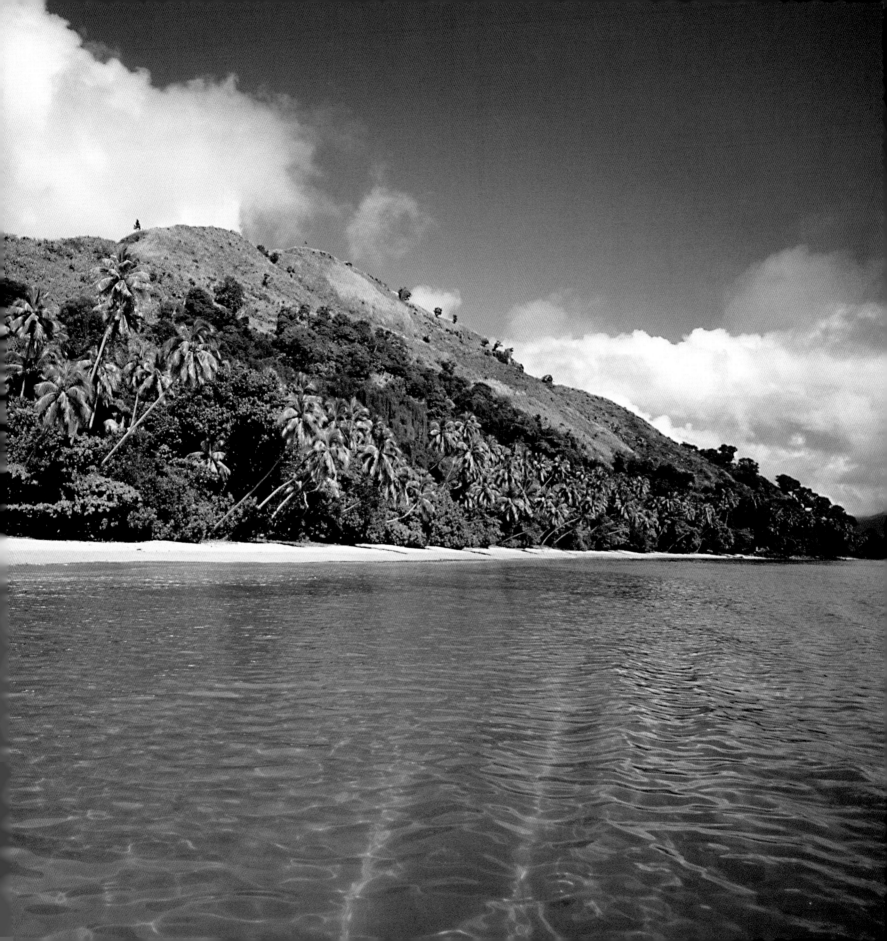

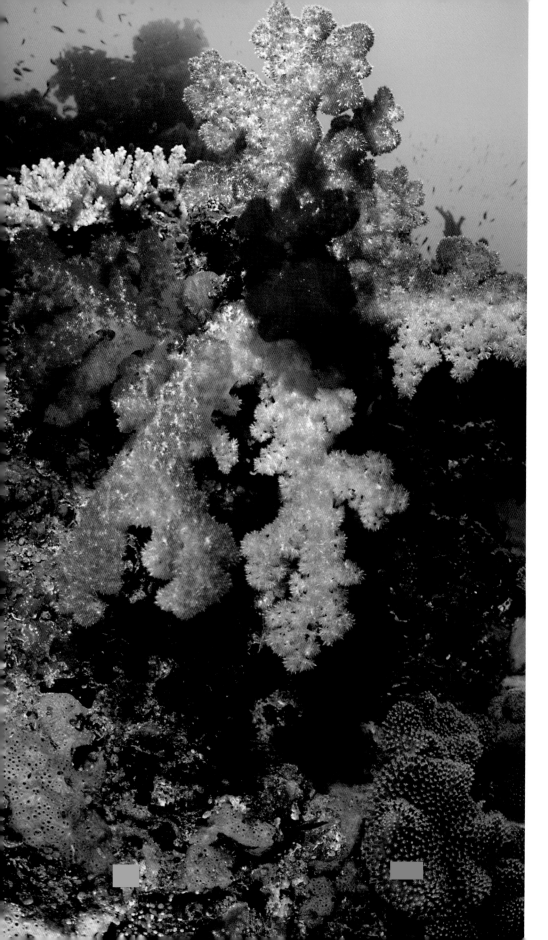

that make this place unique, there's also a cultural component that enriches the islands. Fiji is home to remarkable writers and playwrights such as Joseph Veramu, Jo Nacola, and Marjorie Crocombe.

Organized throughout the year, the archipelago's many festivals are full of life and quite unique. The Hibiscus Festival is held in August in Suva; the Bula Festival takes place each July in Nadi; the Sugar Festival occurs in September in Lautoka; and the Diwali Festival is celebrated in October and November in various towns. Despite the strong influence of Western culture, Fiji's inhabitants still practice traditional arts and crafts, including dance, an ancient art form handed down over the years, which marks the key passages in the life of each local. It's an expression of the body, and traditional beliefs maintain that it is able to summon the spirits of the afterlife.

Today, visitors usually think of Fiji as a festive island nation in the central Pacific bathed in sunlight. Yet these lands were once known as "Islands of the Cannibals," and the local population was seen as cruel and hostile. In fact, Fiji boasts a truly unique history in the Pacific, as it's composed of an interesting mix of Melanesian, Polynesian, Micronesian, Indian, Chinese, and European races. For almost 50 years, until the military coup in 1987, the indigenous people of Fiji were actually an ethnic minority in their own country.

Must See

The enchanting **Taveuni Island** captured the attention of novelist Umberto Eco, who wrote *The Island of the Day Before* while visiting here. The book's title was inspired by Taveuni's unusual predicament—it's famous for being crossed by the 180th meridian, also known as the International Date Line. Go on an excursion to the **Mamanuca Islands**, an archipelago of unspoiled atolls encircled by warm, crystalline waters. Try a glass of **kava**, the local drink with which chiefs and prominent elders welcome guests, which is also consumed on special occasions such as births, marriages, and funerals. Take a tour of the colorful **Suva Municipal Market** and its stands filled with local delicacies.

Above: Taveuni Island in the Somosomo Strait, one of the most famous diving spots.

Right: Local residents on Viti Levu Island.

Opposite: The vivid colors of a coral reef.

Below: An islander weaves palm branches to make floor mats.

Above: Kahakuloa Bay on Maui.
Below: Girls wearing the traditional lei.

Opposite: Kilauea, one of the planet's most active volcanoes.

The Hawaiian archipelago is famous for its islands of fire. One of many "ultimate paradises" for tropical daydreamers, it's a picturesque Eden made up of sun, sea, and stunningly beautiful people. This remote and innocent world is perhaps a bit artificial, but in a way that nevertheless intrigues our collective imagination. And yet this breathtaking frontier of the United States is something more: in the open book that is our planet, Hawaii forms a chapter that is perhaps more riveting than the "Ring of Fire," a menacing series of volcanoes identified by geologists that stretch from the Andes to Asia and encircle the Pacific Ocean.

Today, the most active Hawaiian volcanoes are Mauna Loa (13,681 feet) and Kilauea (4,091 feet), both found on the big island of Hawaii. Both are shield volcanoes, characterized by a wide base, gently-sloping sides, and eruptions occurring along large fissure vents that run all the way down to the sea floor far below. It is along such fractures, also known as rifts or "lines of weakness," that Hawaii's volcanoes erupt. They emit spectacular and terrifying fountains of lava that may rise hundreds of feet into the air, though most are lower, given the lava's fluidity and temperature, which ranges between 2,000 and 3,000 degrees Fahrenheit. The lava takes on the appearance of a constant, undulating flow with an almost ropy surface that Hawaiians call *pahoehoe*. Mauna Loa, with its enormous profile, is the symbol of this archipelago. On its slopes, man's first attempt to alter the natural course of a lava flow took place; after a violent eruption in 1935, an aerial bombardment tried to divert lava threatening the city of Hilo. Indeed, the volcanic history of this splendid hideaway in the Pacific has been important to science precisely because of the unique nature of eruptions here, including lava fountains, an almost total absence of explosive activity, the lengthy duration of eruptions, and the vast area covered by new lava.

Must See

Take a 10-hour tour of the island of Hawaii, also known as the "Big Island," which is the largest in the archipelago and now back in the spotlight as a tropical paradise seen in many television shows. Several possible excursions allow you to take in the incredible sights, which range from the lush rain forest to the **Kilauea** summit caldera. During the trip, there are many stopovers where you can better appreciate the island's beauty. In **Honolulu**, the pristine capital on Oahu, you can visit the **Queen Emma Summer Palace**, with its prized collection of Hawaiian furnishings, and admire the distinctive **State Capitol**.

CAYMAN ISLANDS

Above: George Town, the island's capital, is characterized by colonial English architecture.
Below: The sea floor off Little Cayman hides a scuba diver's treasure of corals and sea sponges.
Opposite: A beach on Little Cayman's southeastern coast.

The Cayman Islands rise up like blossoms in the middle of the Caribbean Sea, between Cuba and Jamaica. And yet Grand Cayman has little in common with these two neighboring islands that are considered the homeland of music and boisterous fun. Especially quiet, Grand Cayman is a paradise for scuba diving and birdwatching enthusiasts. It is also known for its well-manicured English-style lawns (the Caymans are a British protectorate) and is considered quite chic for its bright, uniformly white colonial architecture alternating with the facades of villas and large buildings, marking quite a difference from the pastel colors on most ordinary houses. While Grand Cayman may be staidly traditional, it is also incredibly beautiful. This island is the biggest in the archipelago, which also includes two other smaller islands, Cayman Brac and Little Cayman. The islands were discovered in 1503 by Christopher Columbus and called "Las Tortugas" because of the many sea turtles that can be found in its waters. Over the centuries, it became a refuge for pirates and a paradise for fishermen, scuba divers, tourists, and investment bankers.

Whether you call them the Tortugas, the Caymans, or simply an offshore tax haven (for which they've become famous), the islands conjure up images of white sand beaches fringed by green palms bordering a crystalline sea. The locals you encounter here are quite varied, from businessmen with briefcases to scuba divers in fluorescent suits, Englishmen watching cricket as they sip gin and tonics and smoke Cuban cigars, to blacks walking down the street to a reggae beat. In Grand Cayman you can find the Seven Mile Beach, one of the most spectacular in the Caribbean, literally seven miles of white sand. The Cayman Islands are renowned as a scuba diver's paradise—there are at least 400 marked diving places—and offer a marvelous underwater world complete with coral barriers, shipwrecks, and an infinite variety of tropical fish.

Must See

Absolutely not to be missed is the **Cayman Wall**, which drops down into the ocean's abyss for hundreds of feet, and is interrupted only by a few grottos and sea canyons. And then, of course, there's **Sting Ray City**, where scuba divers and snorkeling enthusiasts can play alongside hundreds of enormous stingrays.

Attracted by bits of fish that are thrown into the water here by fishermen as they clean their nets, the stingrays have begun to arrive in this area in greater numbers. This rather serene relationship with man continues today, so much so that the stingrays take food directly from the hands of scuba divers.

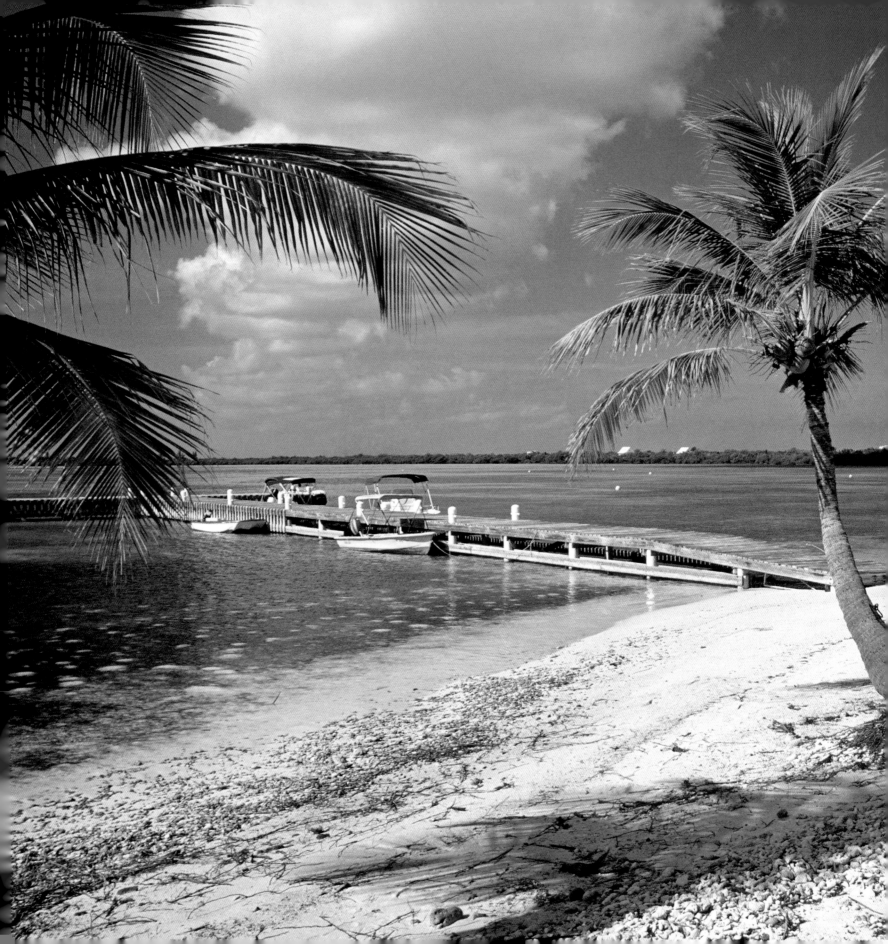

ROSARIO ISLANDS

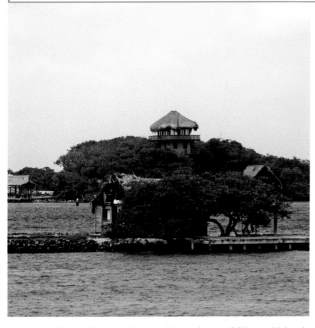

The Rosario Islands archipelago is a natural paradise made up of 27 coral islands, some just barely large enough to host a few cabanas. Located 25 miles off the Colombian coast, they are not far from Cartagena, the colonial Spanish city and fortress known as the "Pearl of the Caribbean." The archipelago also includes the National Park of the Rosario Islands. There are centuries-old palm trees and white sandbars surrounded by crystalline waters, all protected by a magnificent coral reef barrier stretching for 35 miles underwater, making it an ideal destination for snorkeling and scuba-diving enthusiasts.

You can explore this gift from Mother Nature in total freedom. In fact, the ease of movement from one island to the next spares visitors the usual monotony of having to stay put on the same island. Each atoll has a different attraction, ranging from the hugely popular aquarium on San Martin de Pajarales Island to the colorful bird species collected in an oasis by research biologists. The list of attractions also includes indigenous villages where people living in the wild abide by the laws of the jungle. The adventure continues aboard a canoe that caresses the turquoise waters. Let yourself be gently carried away by the current, and soon enough you'll find yourself among a thicket of lianas next to a freshwater lagoon. Here, take a moment to admire the mangroves that, thanks to an unusual reaction with the water, grow by crisscrossing between each other to resemble a puzzle of pick-up sticks.

In the evening, the excitement continues at the dinner table. Seafood reigns supreme with rich offerings ranging from aphrodisiacal oysters to exquisite lobster. Everything, of course, is enjoyed by candlelight on the seashore under a starlit night sky.

Above: The archipelago is made up of 27 coral islands situated 25 miles off the coast of Cartagena.
Below: Egrets and a brown pelican.
Opposite: San Martin de Pajarales Island hosts the Oceanario, a museum dedicated to marine life.

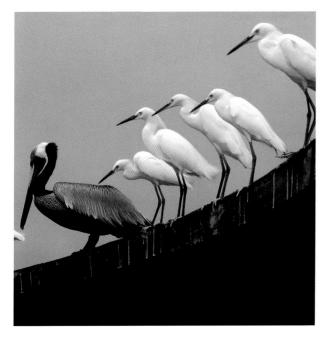

Must See

The president's house can be visited on **Isla Tesoro**. **Isla del Pirata**, which hosts a hotel, **Matamba**, and **La Fama** are the first islands you can see when arriving by boat from Cartagena. Your journey starts by leaving the tourist port and passing through Boca Chica. You will pass the outline of **Isla de Baru**, which together with **Isla Tortuga** and **Isla Periquito**, makes up a group of smaller islands sporting powdery white beaches encircled by an emerald sea. The two largest islands, Isla Grande and Isla del Rosario, are filled with picturesque lagoons. On the smallest isle, **San Martin de Pajarales**, the **Oceanario** houses sharks, dolphins, and other amazing sea life.

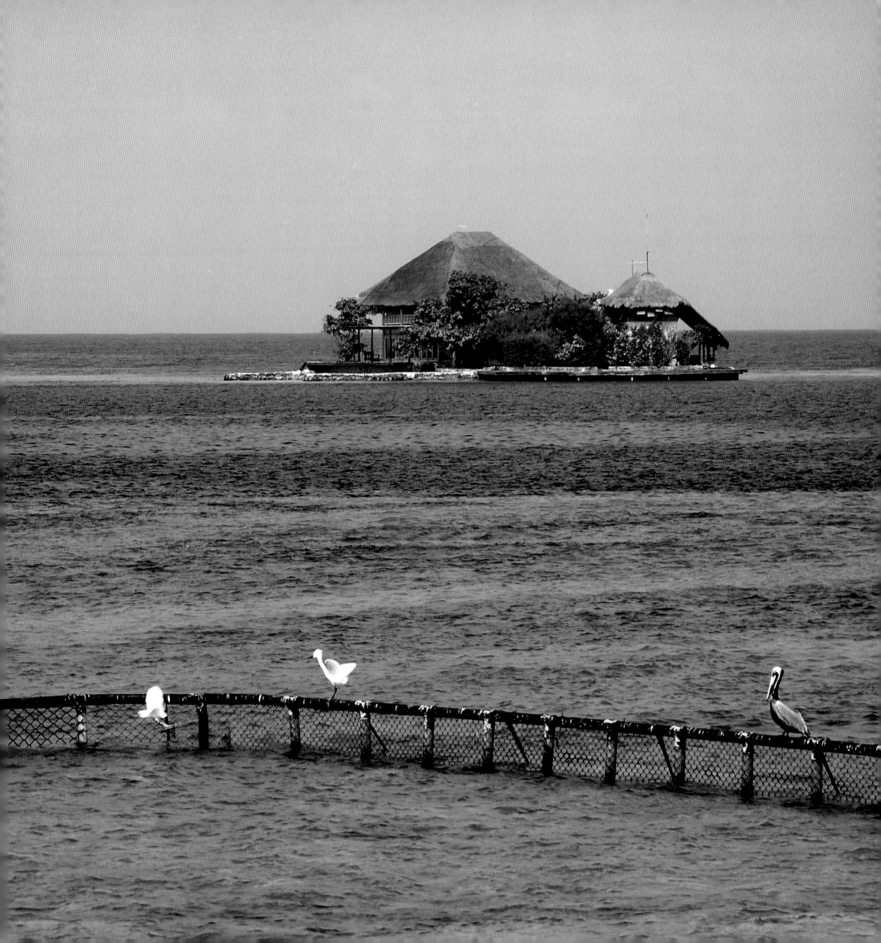

LAKSHADWEEP

Although the Sanskrit word *Lakshadweepa* means "100,000 islands," the actual Lakshadweep archipelago consists of just 36 emerald drops scattered in the dark blue Arabian Sea off India's southwestern coast. People can be found on 10 of the islands; the rest are oases of unspoiled nature and the harmony of the waves. Palms are the only thing stretching skyward, as hundreds of branches burst forth like silent green fireworks. Life is present in every corner of these islands and on the ground new shoots search for daylight from under fallen coconuts. Between the intense green palms and the transparent waters, the blindingly white coral sand stands out, shining bright as snow in the sunlight. You walk as if in a dream amid the breezes, and spot seashells carried about by hermit crabs, which live along the shore in the powdery sand. Strolling here feels like walking across sparkling sugar that dissolves in a soft caress whenever it comes into contact with the warmth of your skin. At low tide, the sand becomes a silvery blanket stretched out toward the sea. Like a mirror, it reflects the blue sky and the whiteness of the passing clouds. Your feet sink slowly into the water, and you can hear the rhythmic sound of waves break against the offshore reef. There's nothing here but beauty, faint breezes, a profound silence, and warm and inviting waters. There aren't any boats, and you don't hear the noise of planes overhead. The sea, together with creatures like the giant sea turtle, reigns supreme.

Watching the sea turtles' courtship among the waves is touching. They express a perfect harmony, a primeval force that invokes the irresistible call to procreate. It's possible to observe them from a boat at sunset just as the sun puts on a magnificent show. Come nightfall, the females exit the water and dig holes in the sand to deposit their eggs.

Above and Opposite: Two views of Suheli, a private island that's the jewel of the Lakshadweep.

Below: A shoot from the coconut plant.

Must See

Between May and July, you might be able to watch baby sea turtles at dawn on the beaches of **Parali I**, **Parali II**, and **Tinnakara** as they break out of their shells and begin their perilous journey toward the sea. Don't miss the private island of **Suheli**, a truly amazing jewel of perfection and light. The complete silence and colors of the island will leave you with lasting memories. A jubilee of vivid colors can be admired in the coral reef at **Bangaram**, which descends 400 feet into the deep and is populated by groupers, dolphins, stingrays, sea anemones, clownfish, sponges, and barracuda.

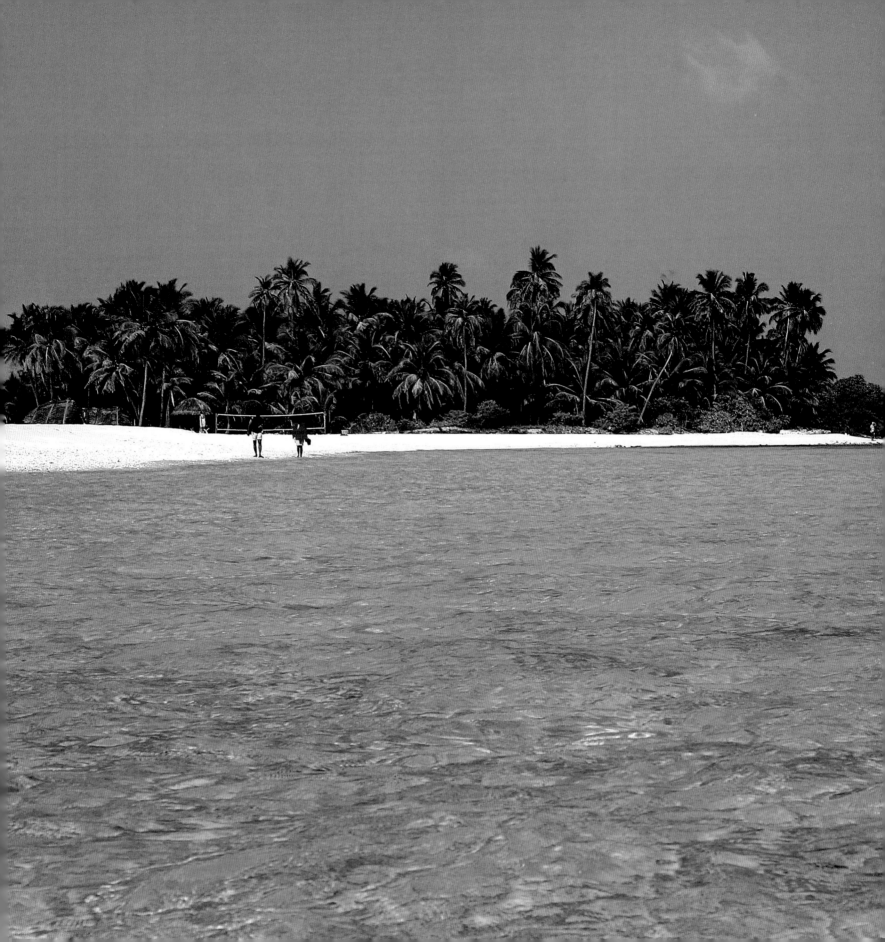

LES SAINTS

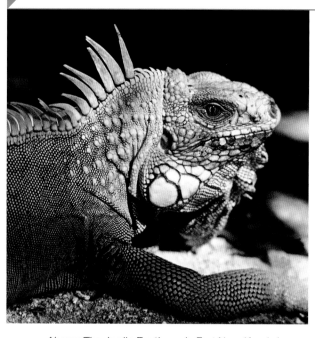

Discovered by Christopher Columbus and colonized in the 17th century by Breton sailors (although some might call them pirates), Les Saints has long been off the radar, a haven far from the beaten path.

A few hours before sunset, when the large catamarans take excursionists back to Pointe-à-Pitre, the main island of Terre-de-Haut empties and the village of Bourg des Saints is left to the few tourists booked here at one of the local hotels or who have arrived from boats anchored at Anse du Bourg. Terre-de-Haut and Terre-de-Bas are the only inhabited islands.

The ideal day here ends with a cocktail—the sunset *punch planteur* is a must—and a stroll through village streets lined by colorful little wooden homes that house all sorts of shops and eateries. The beaches of Terre-de-Haut are reachable by scooter or minibus, but a boat allows you to explore beaches even farther away. In just a few days it's possible to visit the prettiest ones, like the golden sands of Pompierre Beach, protected by the surrounding rocks, or the pinkish sands next to Sugar Loaf, a mass of basalt rock 170 feet high covered in cactus, next to which you'll find a coral reef hidden just below on the sea floor. Even on the tiny Îlet à Cabrit, where the archipelago's many goats often disturb visitors' picnics, or the Grande Anse Beach on Terre-de-Bas, it's possible to enjoy a pleasurable swim and do some scuba diving.

Like a sliver of France left behind in the tropics, this small archipelago just south of Guadeloupe is full of colors that light up the sea and the local homes. Its intense mix of fragrances are derived from Creole cuisine and local flora, beckoning to anyone who comes to the Caribbean in search of an authentic experience.

Above: The Jardin Exotique du Fort Napoléon is known for its iguanas.
Below: Local fishermen use santoises *boats.*
Opposite: Anse du Bourg Bay with Sugar Loaf in the background.

Must See

Don't miss **Fort Napoléon**, dedicated to the French emperor. It is located on **Pointe de l'Eau**, which offers a view of all the islands in the archipelago. A small **naval museum** here documents the French victory over the English fleet in 1782. Behind it, there's the **Jardin Exotique**, one of the most fascinating botanical gardens in the Antilles. It's filled with large tropical plants, big cacti, and iguanas who crawl around undisturbed. Also worth a visit is **La Maison de l'Artisanat** in Grande Anse, a workshop where you can still purchase the hard-to-find *Salakos*, the typical hat used by local fishermen since the 19th century.

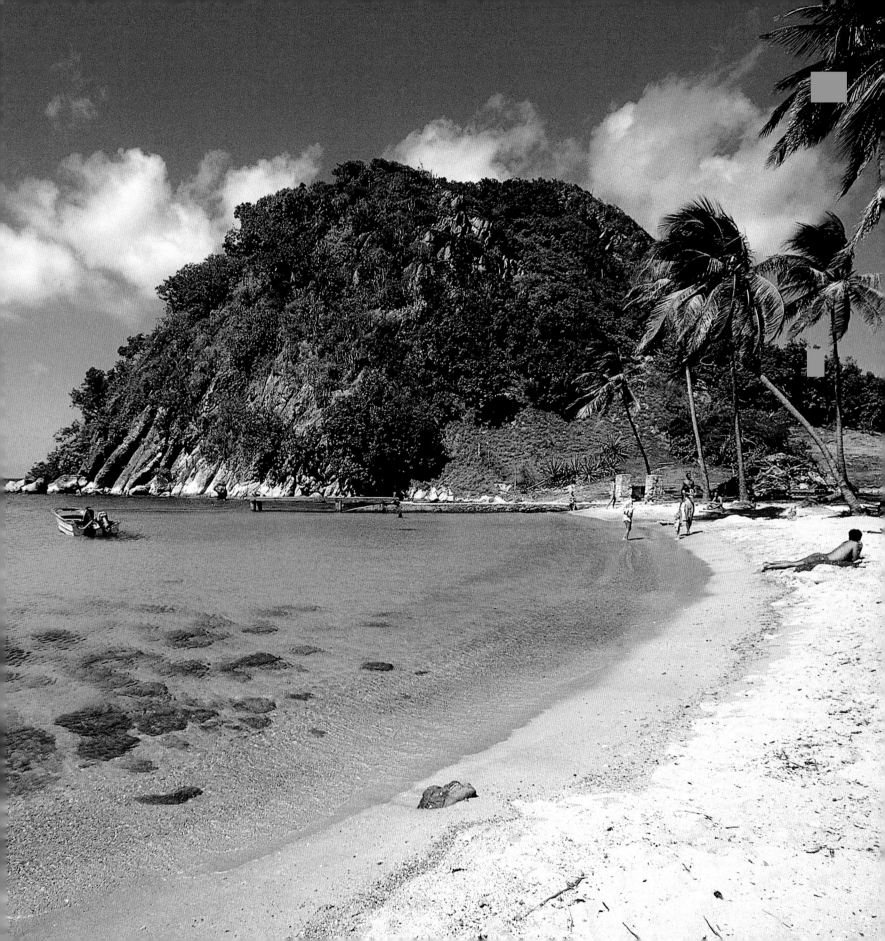

LOS ROQUES

I n Los Roques, the sea's color shifts from cobalt to turquoise, and from indigo to emerald. The ever-so-soft, white, powdery sand stretches out until it slips into the water. A silence reigns over everything and makes you feel as if you're in another universe. Los Roques, an archipelago of 350 coral islands north of Venezuela, is one of the largest natural reserves in the world, a place where the only sounds are the blowing trade winds and the songs of seabirds, and where the largest group of inhabitants are the sea turtles who keep the fish and the 1,500 people here company.

Most residents live on Grand Roque, the capital. Barely a mile wide and two miles long, there are small lodgings known as *posadas*, many of which are run by Italians who've successfully combined the Mediterranean lifestyle with a Caribbean ambiance, keeping things elegant and sober in a place that's refreshingly primitive. Grand Roque is 30 minutes by plane from Caracas, and you land on an asphalt strip that is generously referred to as "the airport." The town's center has sandy streets, colorful little houses, and friendly locals. It's a base from which you can take day trips aboard boats that the *posada* owners make available to guests and which allow you to reach the many exotically named islands of the archipelago: Cayo Grande, Cayo de Norte, Crasquí, Noronquí, Francisquí, Tres Palmeras, Cayo Muerte, Cayo de Agua, Dos Mosquises, and Los Canquises. Each island has a unique element that makes it stand out: the only two palm trees in the entire archipelago, a pelican colony, a lagoon, coral gardens, seashells, mangroves, the remains of a shipwrecked galleon, pink flamingos, and pre-Columbian ruins. What they all have in common are pristine beaches and a colorful sea that makes for an unforgettable visit in a natural paradise.

Above: Pelicans sun themselves on Grand Roque.
Below: The colorful posadas, or small inns that are often run by Italians.

Opposite: A view of Grand Roque, the only inhabited island in the archipelago.

Must See

On **Dos Mosquises** there's a marine research center that monitors the reproduction of **sea turtles**. Four of the species are indigenous to Los Roques and are protected. Go fishing for the small albacore **tuna**, which are eaten right after being caught. Take a trip to **Cayo de Agua**, which owes its name to the freshwater wells that are found here and has the archipelago's most picturesque beach. To the south, there's a **coral reef** that offers great visibility. Since the water is deep, it's easy to run into large marine life, underwater caves, and **giant lobsters**. Go sailing in a catamaran or yacht or try one of the *peñeros*, the fishing boats used by locals.

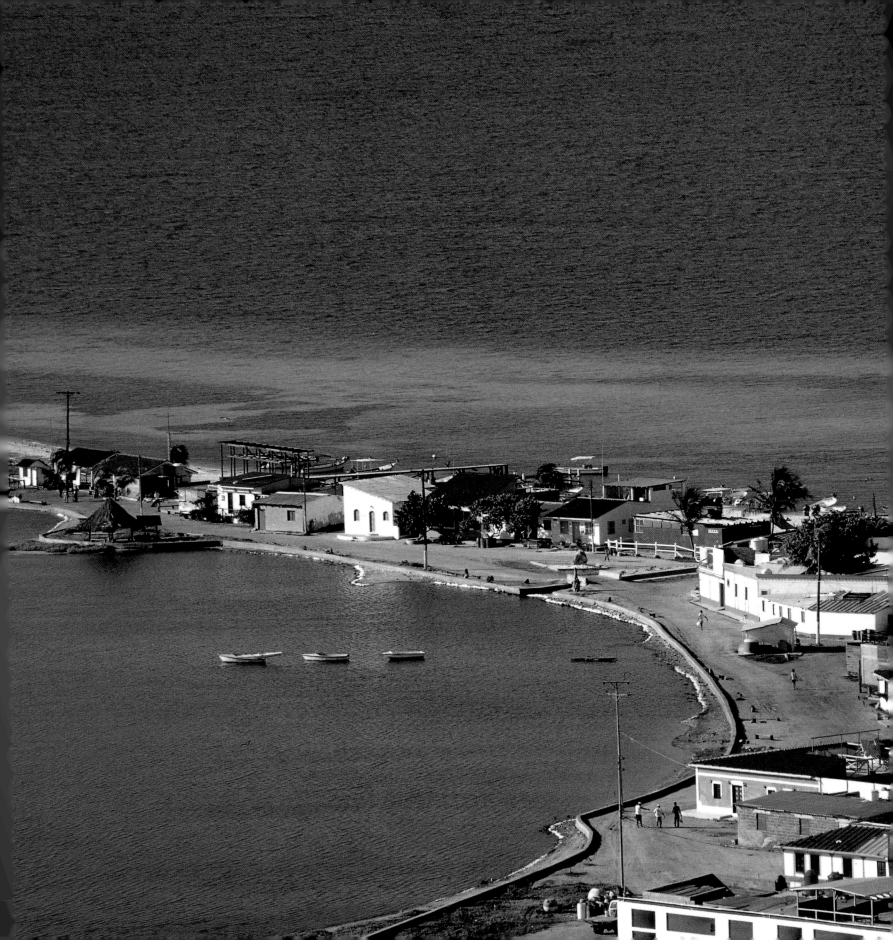

MALDIVES

con of the world's most fantastic islands, the age-old beauty of the Maldives is an incredible symbiosis between land and sea. It's love at first sight from the window of the airplane as you land on the runway near Malé, the capital, located on an Asimovian city-island. The contrasting shades of the dark blue sea, the azure lagoons, the white coral sands, and the lush green vegetation merge into a harmonious vision of an archipelago of 1,200 islands, 200 of which are inhabited and 90 of which are home to exclusive resorts. In reality, the number of islands is ever-changing, as there are new islands continuously being built, and older ones disappearing into the sea because of erosion.

Its warm climate is cooled by the breezes, everything is on a human scale, and the smiling and polite Maldivians make travelers feel at home. Arriving in the Maldives is an emotional experience—it's a tropical paradise offering privacy and unique natural surroundings. Spacious villas on the seashore appear next to crystal-clear lagoons filled with multi-colored sea life and coral; straw-roof bungalows with walls of coral rock are surrounded by verdant greenery and feature private swimming pools. Most beach houses have a private pavilion for lunch in front of the garden and another room for dinner, a large bathtub, and a traditional Maldivian shower outside. In the top luxury resorts, there's a choice of restaurants with local specialties and Asian cuisine, not to mention Italian and other international delicacies. You can enjoy candlit dinners or picnics out on uninhabited isles, and many breakfast buffets are served poolside.

A 25-minute journey by motorboat from Malé International Airport brings you to Kuda Huraa, a

Above: Residents of Malé, the capital. A quarter of Maldives' inhabitants lives here.

Right: Ihuru Island in the North Malé Atoll.

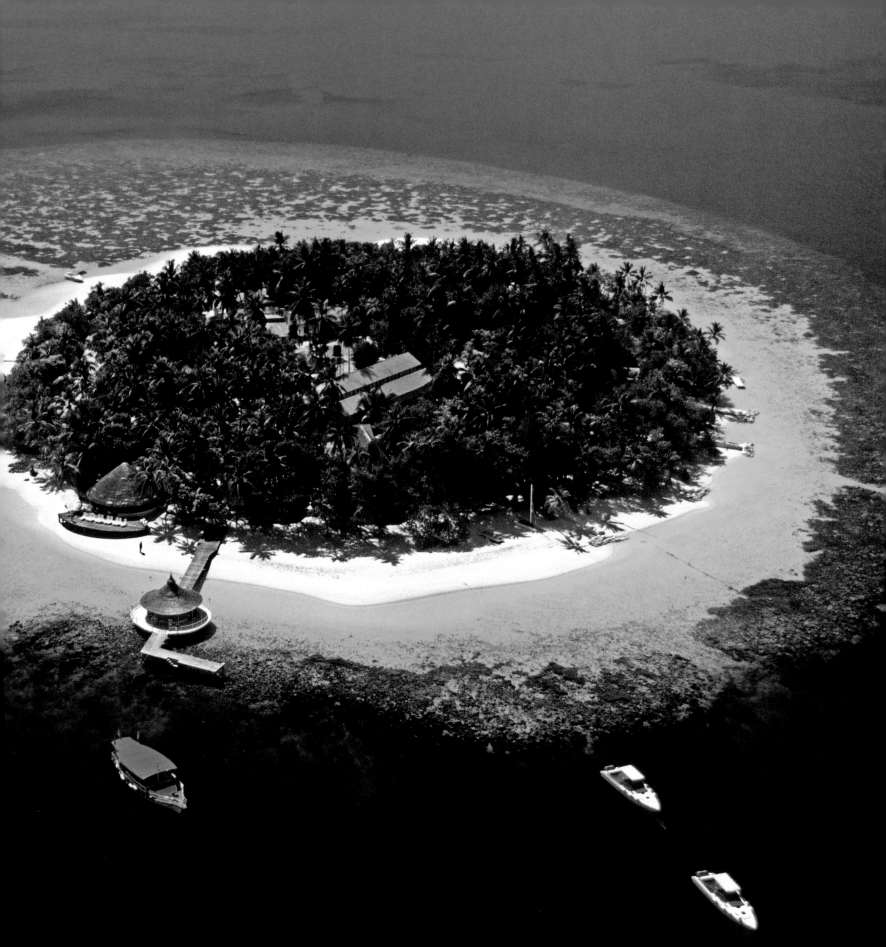

secluded island that features one of the more classic resorts of the Maldives. The property was inspired by a typical Maldivian village, and has a central walkway flanked by straw-roof cottages. Located on a separate islet just a minute away aboard a *dhoni*, the typical Maldivian sailboat, the hotel's spa specializes in Indian, Thai, and Indonesian massages and beauty treatments, and the salt used is taken directly from the ocean.

Since the barrier reef of the Maldives is one of the most fragile and valued ecosystems in the world, a team of biologists works to protect the marine environment. Project Reef Ball grows coral cultures on reefs that have suffered coral bleaching, and they also monitor climate changes. At the resort's Marine Research Center, guests learn about the local ecosystem. When going out on excursions with the aid of a marine biologist to scuba dive or snorkel, you can visit some of the most interesting areas on the barrier reef. Swim with eagle rays, admire the many sea turtles, and interact with the small and curious spinner dolphins.

Must See

Head to the Four Seasons Resort on Kuda Huraa for a vacation of total relaxation in luxurious privacy in one of the beach villas or bungalows overlooking the water. Go **snorkeling** or **scuba diving** at the barrier reef, which is often just a few swim strokes from the hotel beach where you are staying. Catch an aerial view of the archipelago or admire it from a hydrofoil, especially for those who venture out to distant atolls far from Malé. Try an excursion aboard a **dhoni**, a local boat carved from the trunk of a coconut palm, to a deserted island at sunrise or sunset. Sample **Kandumahu Mussanmaa**, one of the best local dishes. It consists of thin slices of rolled tuna and curry in palm leaves cooked in coconut milk.

Above: A view of Ihuru Island.

Right: One of the many resorts surrounded
by the amazing barrier reef.

Opposite: A worker unloads sand on the North Malé Atoll.
The islands are made of white sand that's the result
of erosion from the barrier reef.

Below: Rihiveli Island in South Malé Atoll.

MANIHI

any people travel to Manihi for the pearls—those rare, expensive, black-polished pearls found only in the lagoons of atolls in the Tuamotu Archipelago. Here, skilled Japanese farmers live in stilt houses on tiny reef islets, known as *motus*, like modern-day hermits destined to look after a ritualistic practice. They tend to the cultivation of *poe rava*, as the Polynesians call the pearls. Here, you can purchase pearls at a very reasonable price compared to what jewelers in Papeete or far-off Los Angeles and Tokyo are asking. Indeed, the business of black pearl farming began right here on Manihi in 1968. Cultivating requires four years from spawning to extracting the pearl from the black-lip oyster (*pinctada margaritifera*). In 2003, however, the business suffered a crisis, and many farmers left the island. Today, cultivation has seen a comeback on the nearby Ahe Atoll, but there are still a few on Manihi that grow black pearls. A visit to one of the local farms is an experience you won't soon forget.

For many years Manihi has had first-class tourist accommodations in place, yet it's less frequented than nearby Rangiroa. It's truly incredible how transparent the water is in the lagoon, which is often visited by blacktip reef sharks, making for an unforgettable experience for those who go swimming here. Then there's the joy of letting the current carry you through the only outlet between the lagoon and the ocean; through your snorkeling mask you can see an underwater road below, which is used by mackerels, manta rays, sharks, and barracuda to enter the enchanted kingdom of the lagoon. And don't forget to take a stroll at dawn along the coral reef—at low tide the precious seashells come into view. In Manihi you will feel like you're living in a dream, suspended between the rumbling of the crashing waves and the motionless blue mirror of the lagoon.

Above: A worker extracts the kernel from a coconut.
Below: View of the coral reef.

Opposite: Wreaths made from Tiare flowers are used on festive occasions.

Must See

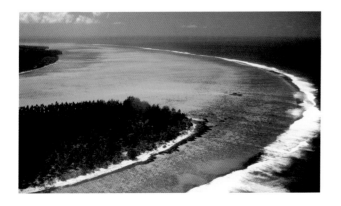

It's a thrill to visit one of the **black pearl farms**, preferably one of the smaller ones that's family-run. Scuba divers will find an amazing sea floor around the coral reef. Also thrilling are the run-ins with harmless **blacktip reef sharks** that you can bump into even when swimming in shallow water. If you can locate a motor-boat and a local guide, make the pleasant journey over to nearby **Ahe Atoll**, only a mile and a half away, where tourism is scarce. Don't leave Manihi without putting a few black pearls in your luggage. Once back home, they'll remind you of the magical atmosphere of this remote atoll.

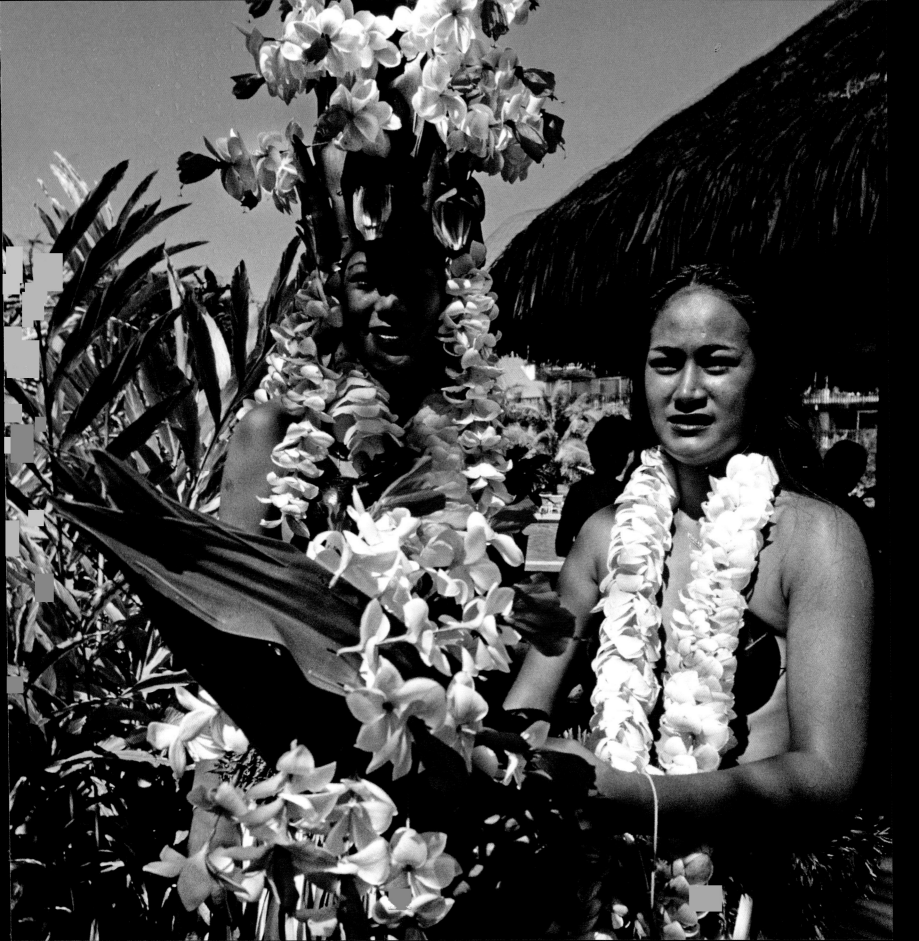

PHI PHI ISLANDS

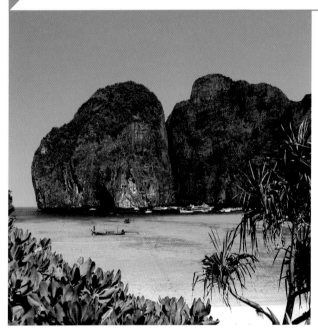

*Above: Maya Bay, on the southern part of the island.
Below: The stunning beach at Nui Bay.*

*Opposite: The famous rock formation in front
of Phi Phi Leh Island.*

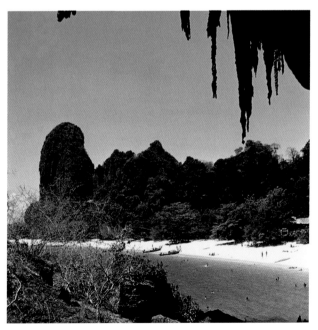

As the location for many famous films, this national park in Thailand has the shape of a huge butterfly resting on the Andaman Sea. The majestic Phi Phi Islands rise up amid white beaches, cliffs covered with thick tropical vegetation, and sea floors rich in multicolored coral and fish.

The first thing that strikes you when you arrive by ferry from Phuket—25 miles and two hours away—is the height of the sheer cliffs rising up from the emerald sea. Then there is the beach and the village of little houses behind it, filled with quaint shops, hotels, restaurants, bars, and discos. By choosing a bungalow up the palm-strewn hill, rich with the scent of flowers, you get the chance to see the locals relax after the day-trippers leave the island. You can also meet travelers from all over the world. The posh resorts on the beach around the island's perimeter offer more convenient lodgings, but perhaps fewer surprises as well. In Tonsai Village, you can start the day by eating the delicious pineapples offered by women on the street if you're late for the traditional breakfast. Then you can climb up to View Point, the island's highest point, where you can see the bonelike shapes of Phi Phi Don, the main island, and—somewhat farther out—the smaller Phi Phi Leh. Both are covered by lush jungle. The former has no roads; the latter is completely uninhabited, and has enchanting bays and beaches. Just a brief stroll from the village, you come across the dazzling white of the nearby beach at Loh Balum Bay, where you can let yourself be rocked for hours upon the shallow water. A ride on the local boats, despite the deafening roar of the motor, enraptures you with the beauty of the empty beaches and offers unforgettable snorkeling as you swim past coral, sea fans, turtles, sea snakes, parrot fish, and the incredibly peaceful zebra shark.

Must See

Phi Phi Leh's national park has enchanting beaches beneath its high cliffs—like the one at **Maya Bay**, more famous today for being the location of the Leonardo Di Caprio film *The Beach* than for its sparkling sand lapped by turquoise waters. Unfortunately, this popularity has led to constant overcrowding. Nearby, there is also a **Viking Cave**. On the steep walls of the cave, sea gypsies climb up on bamboo poles to gather bird's nests for the famous Chinese delicacy—**bird's nest soup**. At the northern tip of **Phi Phi Don**, there's a dollhouse-like island that is just 1,500 feet wide and surrounded by tranquil white sand beaches.

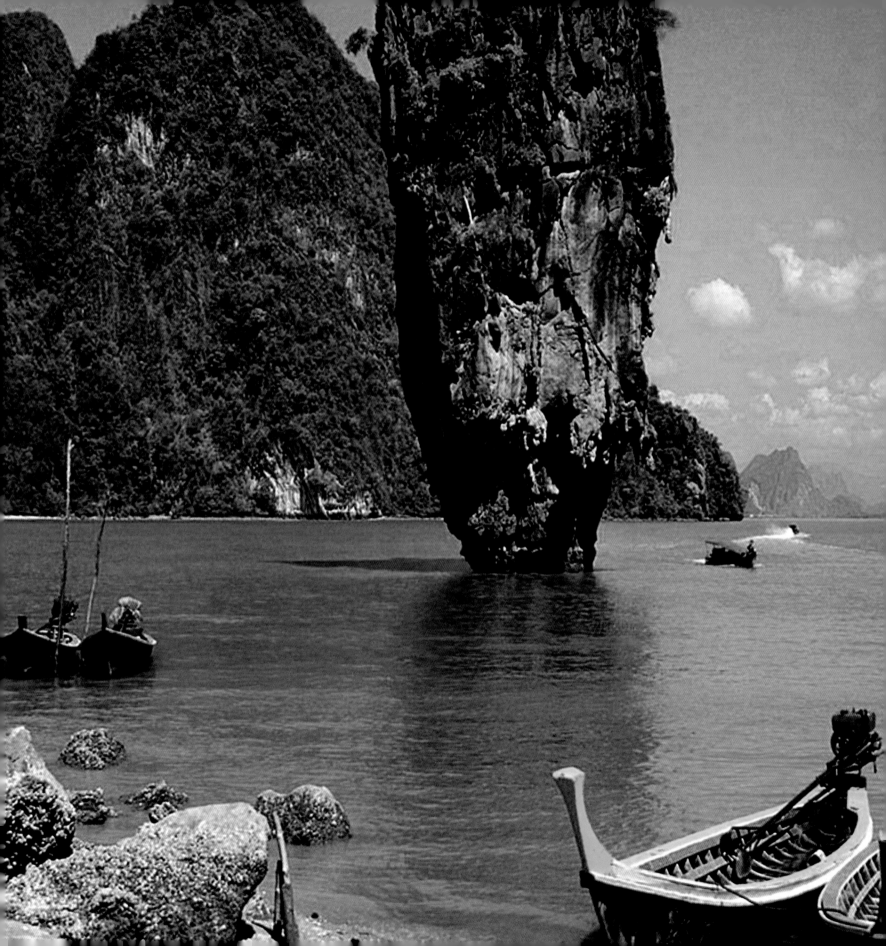

PORQUEROLLES

Above: The harbor and village on Porquerolles.
Below: The 17th-century Fort Grand Langoustier.

Opposite: View of Pointe Prime Cove.

Porquerolles is filled with coral reefs, white sand beaches, pines, and dense shrubs, not to mention 600 acres of vineyards. It's simply irresistible, like a Mediterranean garden set in the peaceful countryside. Its rich biodiversity is a short distance away from the built-up, jet-set world of the French Riviera. Wild but pleasant, raw but just tame enough—it's near perfect, and well-organized, too. Porquerolles, which is barely five square miles in area, is the largest of the Îles d'Hyères, a small collection of islands that are part of the Port-Cros National Park. The nature reserve encompasses Porquerolles, Port-Cros—a harsh and natural terrain that gives its name to the park—and Levant, which is mostly taken up by a military base. Save for a few exceptions, cars are banned here; there's also a limited number of hotel beds, and only a handful of bars and restaurants. All this makes Porquerolles a secret Eden. You can only get around its 33 miles of paved roads on foot or bike. In less than 90 minutes you can reach the rocky coves on the steep southern coast or head toward Cap des Mèdes. Much closer, however, are the crystal-clear waters of Porquerolles' three long white sand beaches, which are quite unique for the south of France. They face the northern coast, and are surrounded by thick vegetation. Plage d'Argent is 30 minutes west of the lone town and its harbor; Plage de La Courtade is 30 minutes east; Plage de Notre Dame is farther east, about an hour away.

There's another way to move around Porquerolles: by sailboat. Yachtsmen from all over the Mediterranean set a course for the Îles d'Hyères, but it's not in order to idle lazily in the turquoise coves that could easily compete with those of Corsica and Sardinia. As you sail, the trees mark the horizon, which appears to sway in the blue yonder as the winds whip up nicely, at times even too much, as the mistral wind forces itself into the narrow strait separating the island from the mainland at Presqu'île de Giens, just south of Saint-Tropez.

Must See

Amidst the lonely vegetation, rocks, wind, and sea, the only other thing in sight is the 16th-century **Sainte Agathe** fortress, which houses a museum of underwater archaeology and offers a stunning panorama of the entire archipelago. The northwestern tip of Porquerolles is captivating not only for its raw beauty, but also for its luxury hotel, **Le Mas du Langoustier,** which is housed in a former soda factory and now features an award-winning restaurant. It may seem odd to find such an exclusive property inside a natural park, but it is the perfect spot for a secluded resort that allows guests some space for much-needed relaxation and introspection.

RURUTU

ook out at the ocean in Rurutu and you'll see nothing until you reach Antarctica. From July to October, the whales arrive here to give birth. Beneath the coconut palms on Rurutu, the main island of the Austral Archipelago in French Polynesia, elderly Polynesian gentlemen sit and tell stories of the sea and their adventures.

Years ago, there was just a single hotel built by a Parisian woman who had sold her carpet store near La Madeleine and escaped to this forgotten corner of the world. She had come to follow the love of a Polynesian she had met in a Tahitian store in Montmartre. Today, people say that when the whales show up at Rurutu, the tourists materialize in order to watch them, as there's no coral reef and the transparent waters make it easy to observe them.

Twenty-five years ago, the residents of Rurutu were still hunting whales aboard fast rowboats using hand-thrown harpoons. These are the sorts of stories the elderly men recount. "We'd first kill the offspring and haul it to the beach. The desperate mother, which was our big prey, would come to look for it. Here, in Ana Aeo Cave they made human sacrifices, and you would hear the echoes of the victims' screaming. Over there, they would be eaten." When Captain Cook, the first European visitor to Rurutu, made landfall in 1769, cannibalism was still being practiced.

Today, the inhabitants are just as pleasant and friendly as the other Polynesians living on islands not yet overrun by tourism. That's because on Rurutu it cools down in the evenings, and the sea's not as inviting as the islands to the north. But you can still soak up the atmosphere of a bygone era, the land of atmosphere chronicled by Robert Louis Stevenson and Herman Melville.

Above: A young islander.
Below: Panorama of Avera Bay.

Opposite: A palm tree-lined beach on the southern coast near Paparai.

Must See

Be sure not to miss the **sacred sites** where locals celebrated ancient Polynesian rituals. Compared to the other islands, the altars, known as *marea*, are better conserved here. Sailing enthusiasts can pay tribute to the tomb of **Eric de Bisschop**, one of history's greatest navigators. Lovers of craftsmanship can admire the expertise of island women, who weave together all sorts of vegetable fibers to make hats and handbags. Those visiting between July and October can go **whale watching**. To get up close, climb aboard one of the boats from the **Raie Manta Club**. Finally, don't miss **Ana Aeo Cave**, where islanders once performed human sacrifices.

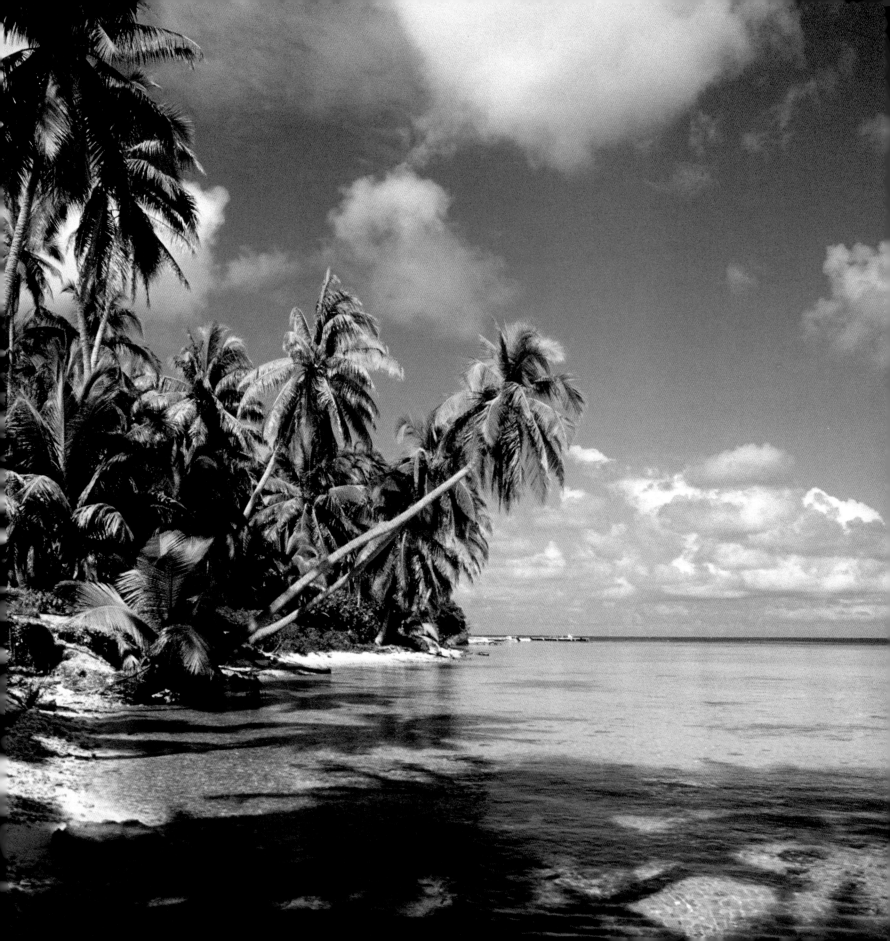

SAINT BARTHÉLEMY

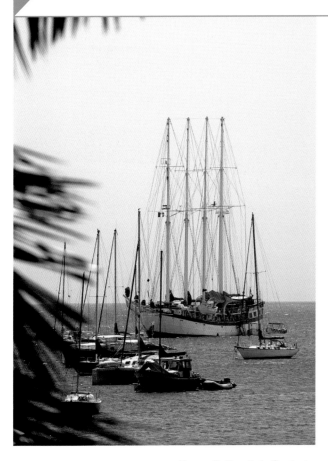

Above: Sailboats in Gustavia.
Below: A pristine beach in Saint Jean Bay.

Opposite: Characteristic homes on the Pointe Toiny peninsula.

There are moments in life when you need to unplug, forget about the daily grind, and get away. Everyone dreams of exotic locales or far-off lands where you can find sanctuary. Yet for those who have been to Saint Barthélemy—or Saint Barts, to the regulars—they find it hard to leave. We're not talking about a deserted island or an unspoiled paradise, but rather a place in the northeastern Caribbean whose nine square miles offer everything you could ever want.

You can arrive here by boat, leaving from one of the larger nearby islands like Saint Martin, or aboard a small airplane operated by one of the local commuter airlines. Arriving by air is an experience you won't forget anytime soon. Flying over the cobalt blue waters, you'll spot the outline of the hills. Then, without warning, you suddenly drop onto the runway. It's a true shot of adrenaline. Having just arrived, you already sense that this is no ordinary vacation.

You bump into people who are elegant yet at the same time down-to-earth. The way of life here makes it a favorite destination for celebrities from around the world. If you can't resist the call of the jet set, there are trendy hangouts and luxury shopping all within easy reach. If you're looking for peace and quiet, just find the right beach. From Shell Beach, also known as "seashell beach," the harbor in Gustavia is close by, and you can climb the rocks and dive into the calm waters at Gouverneur Beach. Being on the shore at sunrise is a mystical experience. Saline is a long strip of golden sand that, when the wind isn't blowing too hard, offers a memorable spot for swimming.

Many visitors arrange to meet up at Saint Jean, while the wide beach at Flamands is an inviting spot for walks along the seashore. Also well worth your time is nearby Colombier, reachable by boat or by walking along the steep trails.

Must See

One of the best times of day to enjoy Saint Barts is at dawn, when the first rays of sun chase away the darkness and make room for the intense colors of the early daylight hours. Whether you're in a hotel or a private home, don't miss out on an invigorating morning walk to take in the scenery as the sun comes up. Admire the unique setting in which you find yourself, as this is the moment when you feel like you have the whole island to yourself. From the city of **Gustavia**, which still slumbers, to the beaches, where the only sound is the undertow, the light, stillness, and serenity that surrounds you is truly unique.

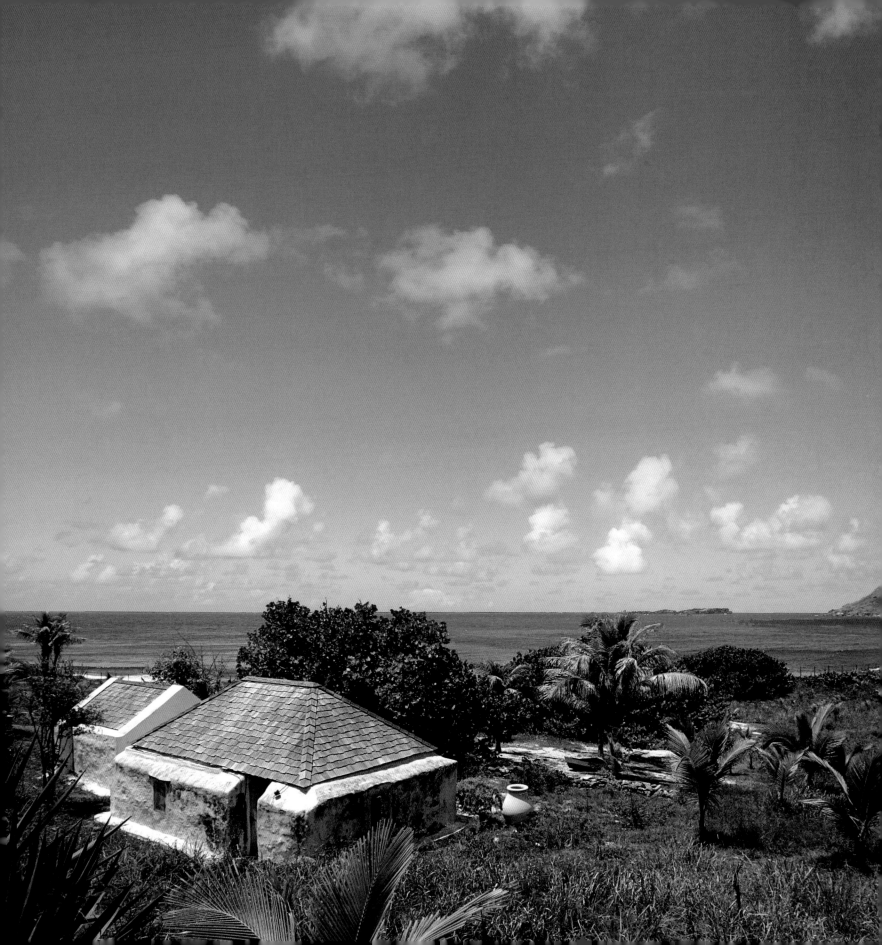

SEYCHELLES

Come ashore and set out on foot, bicycle, or aboard one of the ox-drawn carts and make for the famed beach at Anse Source d'Argent, which has been a backdrop for many glamorous television commercials as well as the setting for *Emanuelle* and *Crusoe,* starring Aidan Quinn. The beach appears right after you pass the indigenous giant tortoises at the Union Plantation Reserve.

The scenery here is truly breathtaking: enormous pink granite rocks frame the immaculate beach; coconut palms shade the warm sands lapped by waves unparalleled in color and form. La Digue is one of three islands that, together with Mahé and Praslin, forms the cultural heart of the Seychelles. Of course, the other 112 isles of this archipelago out in the western Indian Ocean are no less worthy of attention. All have features that render them one-of-a-kind. Together, they are a veritable natural paradise of granite blocks, coral atolls, pure white sand, forests, pristine beaches, calm seas, and exotic creatures like the fascinating Aldabra Rail, the only species of flightless bird in the Indian Ocean.

These islands are an open-air museum, a nature sanctuary with the kind of striking views each of us has dreamed about at one time or another. The Seychelles also feature two UNESCO World Heritage Sites: Aldabra, the world's largest raised coral atoll; and Vallée de Mai, a well-preserved palm forest long believed to be the inspiration for the Garden of Eden. On the well-marked trails you can admire the Seychelles Black Parrot, an endangered species, and some 6,000 palms, the female variant of which yields the Coco de Mer, the largest seed in the plant king-

Above: Aerial view of one of the archipelago's many islets.

Right: Anse Source d'Argent Beach on La Digue Island, famous for its incredible rock formations.

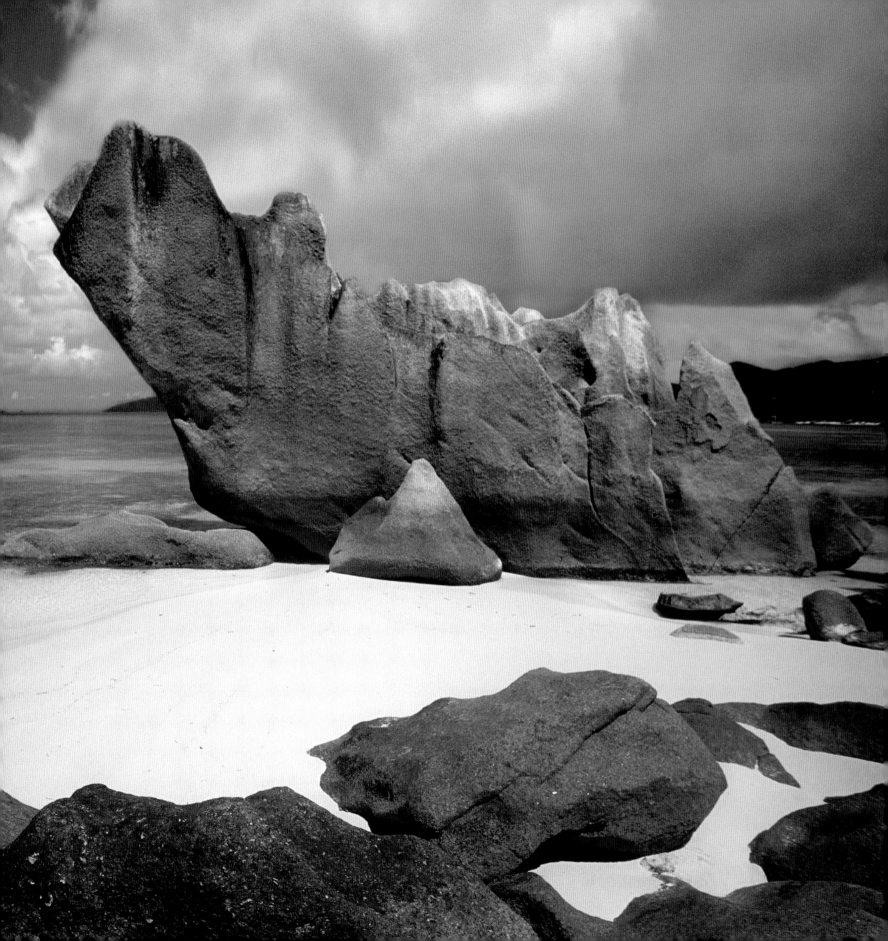

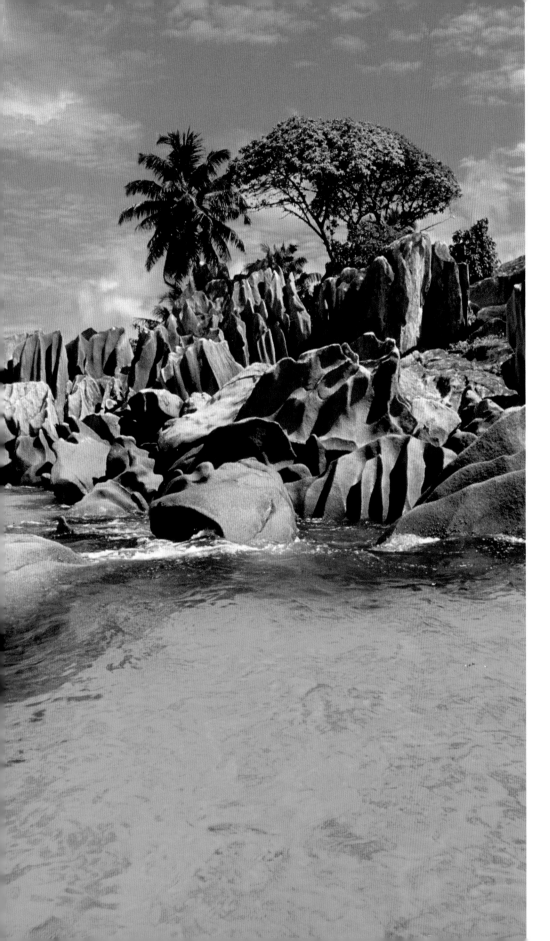

dom. The mature fruit can weigh up to 40 pounds and measure one and a half feet in length. In fact, the Coco de Mer has become a symbol of the islands, as well as of its independence from European colonization—there's even a monument dedicated to it.

But let's get back to its sea, which is second to none with its luminous waters that are the color of diamonds, and its numerous secluded beaches. One of the most stunning, Anse Volbert, is on Praslin. Also known as Côte-d'Or, it is surrounded by palms, hibiscus, almonds, and takamaka trees. From here, venture over to Curieuse Island, an islet inhabited by seven families in charge of watching over the 250 giant tortoises brought here from Aldabra. If you are lucky, you might even bump into a school of dolphins that often swim almost up to the seashore. On Mahé, in addition to the charming beaches, there are granite mountains rising above 3,000 feet, the extremely rare jellyfish tree, of which there are only eight left, vanilla orchids, and carnivorous pitcher plants.

Also worth visiting is Bird Island, the northernmost of the archipelago, home to rare species such as black and white terns, red-tailed tropic birds, plovers, curlews, dolphins, whales, and Esmeralda, the heaviest and oldest living tortoise in the world (more than 600 pounds and close to 200 years old). Indeed, the Seychelles are a real-life paradise lost.

Must See

Sainte Anne was the first island in the Seychelles to be colonized by the French. Today, it's an exclusive destination that hosts a resort with 87 private villas. **Silhouette** is another island of raw beauty, and its 2,400-foot peak, **Mont Dauban**, hides a secret inside: it's supposed to be the location of the hidden treasure buried by the pirate Hodoul. Shellfish in curry and fresh fish courses are served at restaurants on the wide beach at **Beau Vallon**, one of 70 beaches on the island of Mahé. Brave a swim in the waters off **Anse Intendance**, where strong currents meet and form eddies and large waves. Go for a secluded dip off **Anse Georgette** or **Anse Lazio**, considered to be the most beautiful beach on Praslin.

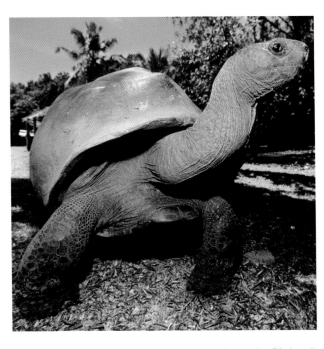

Above: A 100-year-old tortoise on the Bird atoll.

*Right: Nature reserve on Praslin. The beautiful granite
island is home to the Coco de Mer palm tree.*

*Opposite: Anse Source d'Argent Beach, with
its unique granite rock formations shaped
by time and natural erosion.*

Below: The traditional mode of transport on La Digue.

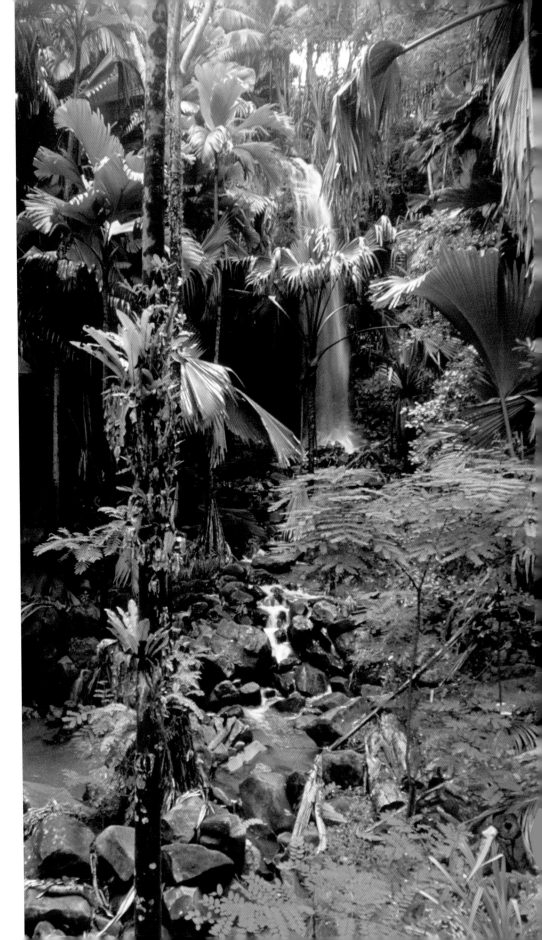

TURKS and CAICOS

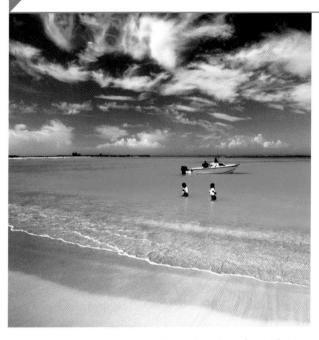

Above: Beach on Grand Caicos.
Below: Typical island buildings in Providenciales.

Opposite: Unspoiled beach and scenery near Providenciales.

The weather is hot and humid, stillness and serenity reign over you, and you can almost taste the fairy-tale atmosphere. Simply close your eyes and listen to the music as the wind accompanies the advancing waves to the shore. It's nice just basking in the simplicity and beauty of unspoiled nature that manifests itself in the crystalline waters and beaches of powdery white sand, while colorful nuances stand out in the enchanted underwater world dominated by the multicolored coral reef, estimated to be the world's third largest. It cools down at night along the seashore, while the clouds in the sky have a tendency to stretch out and vanish under the soft winds, giving you the chance to see a fair share of stars.

For centuries Turks and Caicos, a coral island archipelago in the Caribbean, has been a migratory spot for Atlantic humpback whales, which love the warm waters of the Turks Island Passage that separates the Turks islands from the Caicos. Eight of the 30 islands here remain uninhabited. Here, walking along the beaches and diving into the pristine waters, full of variegated tropical fish, is a one-of-a-kind experience. The gateway to this incredible world is Providenciales, the most populated island, which boasts a collection of parks, nature reserves, and historical sites. On Grand Turk there's Cockburn Town, one of the largest and best-preserved examples of traditional Caribbean architecture in the region. Walking in the shade of the bougainvillea down Duke and Front streets, admire the 18th- and 19th-century Bermudian-style residences. The lighthouse on the northern tip of Grand Turk, which was brought in pieces from Great Britain, where it had been built in 1852, is the perfect spot to watch the humpback whale migration in February and March. Relax in the turquoise lake located inside Chalk Sound National Park, with its sand dunes and hundreds of bird species.

Must See

It goes without saying that the beaches warrant a visit. Grand Turk Island has some of the best: **Cockburn Town, Waterloo**, and **White Sands**. Also beautiful are the sandy beaches of **Salt Cay** and **Providenciales**. Located in the historic stone building of Guinep House, the **Turks and Caicos National Museum** allows visitors to step back in time. Explore the island's oldest stretches of sand and go on exciting underwater adventures. Considered one of the 10 best beaches in the world, **Grace Bay Beach**, like the other beaches here, is an unspoiled strip of sand that stretches out like a blanket. And don't forget to sample ssome lobster and other fresh fish.

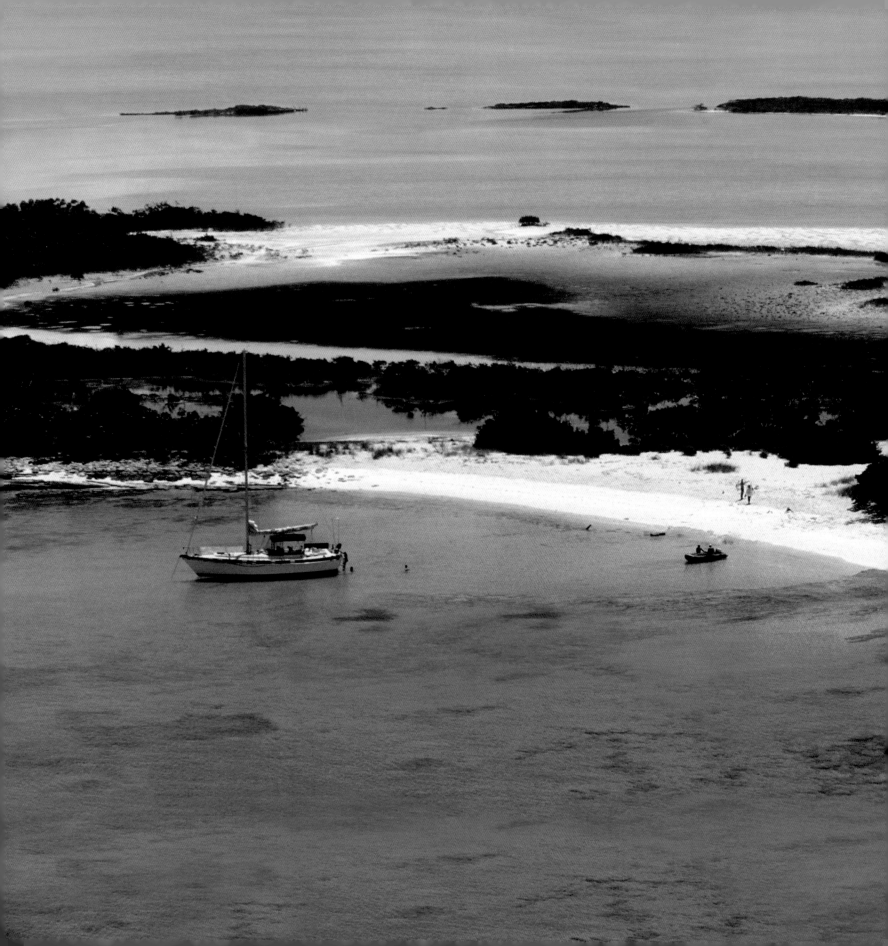

index

Cover and art direction: Sara Cicala
Editorial management: Maria Teresa De Feo, Lidia Rossi
Translation: Ivan Carvalho, Stash Luczkiw
Layout: Ag-Media srl, Milan

Copyeditor: Sabrina Talarico
Photo editor: Gianluigi Sosio

Writers and Photographers:

Fabrizio Angeloro, Adriano Bacchella, Franco Barbagallo, Guido Barosio, Giuseppe Barro, Pia Bassi, Marco Bevilacqua, Maria Luisa Bonivento, Anna Maria Borgoni, Fabio Bottonelli, Paola Brambilla, Germana Cabrelle, Gaetano (Nini) Cafiero, Teresa Carrubba, Marco Casiraghi, Vittorio Castellani (Chef Kumalé), Stefano Cellai, Vincenzo Chierchia, Enrico Maria Corno, Angelo Cozzi, Giovanna De Giglio, Diana de Marsanich, Claudia Farina, Leonardo Felician, Marina Fracasso, Alessandra Fuse, Cinzia Galletto, Emilio Ganzerla, Andrea Ghisotti, Rosalba Graglia, Isa Grassano, Ovidio Guaita, Luca Liguori, Donatella Luccarini, Renato Malaman, Sandro Malossini, Pietro Marangoni, Nicoletta Martelletto, Ada Mascheroni, Pamela McCourt Francescone, Roberto Miliacca, Angelo Renato Mojetta, Marco Morelli, Gisella Motta, Giulia Muttoni, Filippo Occhino, Giuseppe Ortolano, Isabelle Ozan, Stefano Passaquindici, Giancarlo (Jimmy) Pessina, Elena Pizzetti, Gabriella Poli, Anna Pugliese, Francesca Luciana Rebonato, Cinzia Roboni, Mauro Remondino, Maria Cristina Renis, Silvana Rizzi, Carmen Rolle, Barbara Roncarolo, Giancarlo Roversi, Angela Scipioni,Cecilia Sgherza, Manuela Soressi, Gianluigi Sosio (Peps), Beatrice Spagnoli, Simona Stoppa, Edoardo Stucchi, Claudia Sugliano, Sabrina Talarico, Marco Tenucci, Annarosa Toso, Christian Unterkircher, Laura Varalla, Vincenzo Zaccagnino, Leonella Zupo.

First published in the United States of America in 2010
by Universe Publishing, a division of Rizzoli International Publications, Inc.
300 Park Avenue South, New York, NY 10010
www.rizzoliusa.com

Originally published in Italian as 100 Isole da vedere nella vita *in 2008 by Rizzoli Libri Illustratri*
© 2008 RCS Libri Spa, Milano
www.rizzoli.eu

2010 2011 2012 2013 / 10 9 8 7 6 5 4 3 2 1

ISBN: 978-0-7893-2064-3
Library of Congress Catalog Control Number: 2009933830

Printed in China